KU-447-105

THE
ART of RIVALRY

BY SEBASTIAN SMEE

THE
ART of RIVALRY

Four Friendships

Betrayals & Breakthroughs

in Modern Art

SEBASTIAN SMEE

P

PROFILE BOOKS

This paperback edition published in 2017

First published in Great Britain in 2016 by
PROFILE BOOKS LTD
3 Holford Yard
Bevin Way
London
WC1X 9HD

www.profilebooks.com

First published in the United States of America in 2016 by
Random House, an imprint and division of Penguin Random House LLC, New York

Copyright © Sebastian Smee, 2016, 2017

Willem de Kooning, excerpts from an interview with James Valliere, from *Partisan Review*
(Autumn 1967). © 2016 The Willem de Kooning Foundation/Artists Rights Society (ARS),
New York

Fernande Olivier, excerpts from *Loving Picasso: The Private Journal of Fernande Olivier*.
Copyright © 2001 by Gilbert Krill. Translation copyright © 2001 by Christine Baker and
Michael Raeburn. Reprinted by permission of Cacklegoose Press, London.

Title page art from © istock
Book design by Barbara M. Bachman

10 9 8 7 6 5 4 3 2 1

Printed and bound in Great Britain by CPI Group (UK) Ltd, Croydon CR0 4YY

The moral right of the author has been asserted.

All rights reserved. Without limiting the rights under copyright reserved above, no part of
this publication may be reproduced, stored or introduced into a retrieval system, or
transmitted, in any form or by any means (electronic, mechanical, photocopying, recording
or otherwise), without the prior written permission of both the copyright owner and the
publisher of this book.

A CIP catalogue record for this book is available from the British Library.

ISBN 978 1 78125 166 9
eISBN 978 1 84765 987 3

Mixed Sources
Product group from well-managed
forests and other controlled sources
www.fsc.org Cert no. TT-COC-002227
© 1996 Forest Stewardship Council
FSC

SEBASTIAN SMEE has been the *Boston Globe's* a͟ ͟ .nce
2008. He won the Pulitzer Prize for Criticism in 2011 and was
runner-up in 2008. He joined the paper's staff from Sydney,
where he worked as national art critic for the *Australian*. Prior
to that, he lived for four years in the UK, where he wrote for
the *Daily Telegraph*, *Guardian*, *Art Newspaper*, *Independent*,
Prospect magazine and the *Spectator*. He has contributed to five
books on Lucian Freud. He teaches nonfiction writing at
Wellesely College.

"Gripping ... Mr. Smee's skills as a critic are evident
throughout. He is persuasive and vivid ... *The Art of Rivalry* is
rooted in a closely observed theory, but it roams in a way
geared to nonspecialist readers, part mini-biographies, part
broader art history ... You leave this book both nourished and
hungry for more about the art, its creators and patrons, and the
relationships that seed the ground for moments spent at the
canvas." *The New York Times*

"Modern art's major pairs of frenemies are a subject so
fascinating, it's strange to have a book on it only now – and a
stroke of luck, for us, that the author is Sebastian Smee. He
brings the perfect combination of artistic taste and human
understanding, and a prose style as clear as spring water, to the
drama and occasional comedy of men who inspired and
annoyed one another to otherwise inexplicable heights of
greatness." Peter Schjeldahl, art critic for the *New Yorker*

9030 00005 7071 3

"This is a magnificent book on the relationships at the roots of artistic genius. Smee offers a gripping tale of the fine line between friendship and competition, tracing how the ties that torment us most are often the ones that inspire us most." Adam Grant, Wharton professor and *New York Times* bestselling author of *Originals* and *Give and Take*

"With novella-like detail and incisiveness [Sebastian Smee] opens up the worlds of four pairs of renowned artists ... Each of his portraits is a biographical gem, deftly taking social milieus, family backgrounds, and the art controversies of the day into account ... Smee's vivid, agile prose is especially good at evoking the temperaments of the personalities involved ... *The Art of Rivalry* is a pure, informative delight, written with canny authority." *Boston Globe*

"Bacon liked to say his portraiture aimed to capture 'the pulsations of a person'. Revealing these rare creators as the invaluable catalysts they also were, Smee conveys exactly that on page after page ... His brilliant group biography is one of a kind." *Atlantic*

TO JO, TOM, AND LEILA
WITH LOVE

LONDON BOROUGH OF WANDSWORTH	
9030 00005 7071 3	
Askews & Holts	12-Oct-2017
701.15	£9.99
	WW17008094

CONTENTS

LIST OF ILLUSTRATIONS

4 Lucian Freud, *Girl in Bed*, 1952/Private Collection/© The Lucian Freud Archive/Bridgeman Images

5 Francis Bacon, *Two Figures*, 1953. Private collection. © The Estate of Francis Bacon. All rights reserved, DACS 2016. Photo: Prudence Cuming Associates Ltd

6 Edgar Degas, *Monsieur and Madame Édouard Manet*, c 1868–69, Kitakyushu Municipal Museum of Art

7 Edgar Degas, *Interior (The Rape)*, c. 1868–69. Philadelphia Museum of Art. Accession #1986-26-10. The Henry P. Mcilhenny Collection In Memory Of Frances P. Mcilhenny, 1986

8 Édouard Manet, *Le Repos (Repose)*, c. 1870–1871, Oil on canvas; 150.2 x 114 cm (59⅛ × 44⅞ inches). Bequest of Mrs. Edith Stuyvesant Vanderbilt Gerry. 59.027. Museum of Art, Providence, Rhode Island, USA/Bridgeman Images

9 Édouard Manet, *The Execution of Maximilian*, 1867–68. National Gallery, London. Ng3294. © National Gallery, London/Art Resource, NY

10 Henri Matisse, *Woman in a Hat*, 1905. San Francisco Museum of Modern Art. Photo courtesy AMP. © 2015 Succession H. Matisse/Artists Rights Society (ARS), New York

11 Henri Matisse, *Portrait of Marguerite*, 1907. 25½ × 21¼ inches (65 × 54 cm). RF1973-77. Photo: René-Gabriel Ojéda. © Succession H. Matisse/Artists Rights Society (ARS), New York

12 Pablo Picasso, *Les Demoiselles d'Avignon*, 1907. Museum of Modern Art, New York. © Succession Picasso/Artists Rights Society (ARS), New York. Digital Image © The Museum of Modern Art/Licensed by SCALA/Art Resource, NY

13 Jackson Pollock, *Cathedral*, 1947. Dallas Museum of Art, Texas, U.S.A. Gift of Mr. and Mrs. Bernard J. Reis/Bridgeman Images. © 2016 Pollock-Krasner Foundation/Artists Rights Society (ARS), New York

14 Willem de Kooning, *Excavation*, 1950, by Art Institute of Chicago, IL, U.S.A. De Agostini Picture Library/M. Carrieri/Bridgeman Images. © 2016 The Willem de Kooning Foundation/Artists Rights Society (ARS), New York

INTRODUCTION

I n 2013, on a trip to Japan, I took a bullet train from Fukuoka to Kitakyushu to see a painting by Edgar Degas. Often, if you travel long distances to see single works of art, it's with unrealistically high hopes. You set out on the trip with the piety and anticipation of a pilgrim. And when you reach your destination and the longed-for encounter takes place, you feel obliged to whip up a level of excitement that justifies all the mental preparation, the time, the expense. It's either that, or crashing anticlimax.

On this trip to Japan, however, I remember feeling neither. The painting I had come to see was a double portrait [see Plate 6] of Degas's friend, the artist Édouard Manet, and Manet's wife, Suzanne. It shows the bearded, dapper Manet reclining on a couch, his expression blank, his body halfway between seated and supine. Suzanne is seated across from him at the piano.

It's actually quite a small picture—you could pick it up in your arms without having to stretch too wide. And it's fresh—so fresh it might have been painted yesterday. There's nothing rhetorical or grandiloquent about it. Instead, it feels almost aloof,

disinterested; blessedly free of illusions and false feeling.

For all these reasons (and despite my earnest pilgrimage), the painting left no room for disappointment. Nor, however, did it trigger a need to resort to emotional inflation. Standing before it, I found myself absorbed instead by its peculiar coolness.

Degas and Manet had been close, I knew. But there is a quality in the painting of emotional withholding, which in turn stokes an ambivalence that never entirely resolves itself. You can't tell if Manet, in the picture, is experiencing the dismal agony of torpor, a kind of marrow-draining lethargy, as he sits there listening to his wife (who was, by the way, an expert pianist); or if he is instead enjoying the bliss of reverie, an indolence so sweet and complete that it insulates him from everything that might disrupt his luxurious mental drift . . .

The Manets sat for the painting over the winter of 1868–69. A mere half decade had elapsed since Édouard had painted the *Déjeuner sur l'Herbe* and *Olympia,* those infamous provocations that had so appalled the critics, prompting the public to yelps and ridicule. (They are now, of course, the two most famous paintings of their time.) Manet had followed them up with an astonishing gush of creativity lasting several years. But the torrid reception accorded his paintings did not let up. His infamy only increased.

What had it all cost him? Was Degas, by 1868, painting a man exhausted by his herculean labors, undone by antipathy? Or did he have something more subtle and secretive in mind?

AT THIS POINT, it becomes necessary to say that what I had actually come to Japan to see was not the work as Degas had painted it but, rather, its incompletely repaired remains. Not

long after its creation, a part of the painting had been sliced away with a knife. The knife had gone right through Suzanne's face and body.

This was not, it turns out, the deranged act of some maverick museumgoer—the kind who will once in a while throw acid at a Rembrandt or take a sledgehammer to a Michelangelo. It was the act of Manet himself. And this is where the dismay sets in. For everybody (everybody who knew him) loved Manet. He was charming, convivial, self-deprecating—the most gallant, the suavest of men. Why he would do such a thing, at a time when he and Degas were supposed to be friends (close enough friends to cooperate on this intimate portrait), has always seemed baffling. The explanation usually offered—that Manet objected to Degas's less-than-flattering portrayal of Suzanne—sounds plausible, up to a point; but there is something incommensurate about it. You don't take a knife to a painting quite so easily. There must, surely, have been more to it.

I went to Japan not to try to solve the mystery, but really just to get closer to it. Mysteries are magnetic, in this way. But of course, it's not always evidence they attract. Just as often it's further enigmas, deeper questions, stranger suppositions.

UNSURPRISINGLY, THE SLASHING INCIDENT had occasioned a falling-out between Manet and Degas. It was soon patched over. ("One can't stay enemies with Manet for long," Degas is supposed to have said.) But things were never quite the same between them. And then, just over a decade later, Manet was dead.

Thirty years later when Degas died—an isolated, curmudgeonly figure—he was surrounded by a collection that included

not only the slashed painting (which he had retrieved from his friend and tried to repair), but three more of his own drawn portraits of Manet, and then a trove of more than eighty works by Manet himself. Was all this not evidence that Manet retained a special and perhaps sentimental fascination for Degas, long after he was gone? If so, what did it signify?

THERE IS, I BELIEVE, an intimacy in art history that the textbooks ignore. This book is an attempt to reckon with that intimacy.

Its title is *The Art of Rivalry*, but the idea of rivalry it presents is not the macho cliché of sworn enemies, bitter competitors, and stubborn grudge-holders slugging it out for artistic and worldly supremacy. Instead, it is a book about yielding, intimacy, and openness to influence. It is about susceptibility. That these states of susceptibility are concentrated early on in an artist's career, and that they have a limited life span—that they were never going to last beyond a certain point—is in many ways the book's true subject. For these kinds of relationships are inherently volatile. They are fraught with slippery psychodynamics, and difficult to describe with any kind of historical certitude. Nor do they often end well. If this is a book, in other words, about seduction, it is also to some extent about breakups and betrayal.

BREAKUPS ARE ALWAYS DISMAYING. Even if things are later patched up, it's never easy to find a solution to the vexing problem of what happened in the first place. It's almost impossible to achieve the necessary distance. Too big a part of you, perhaps,

was in play, and your debt to the other—whatever form it took—may still be too deep. How, keeping faith with the truth of what happened, do you acknowledge that debt, without losing sight of the damage inflicted on you? And of the damage you yourself inflicted? Such questions sound unhelpfully vague. But they churn beneath the wake of the four stories in this book.

Living in London, in the early 2000s, I got to know the painter Lucian Freud, whose early friendship with Francis Bacon is perhaps the most fabled in twentieth-century British art. Here, too, there had been a falling-out, occasioning much private dismay and bitterness—so much so that ten years after Bacon's death it was still thought unwise to raise the subject with Freud.

In the hush of the meantime, however, visiting Freud's home, one couldn't fail to notice the huge Francis Bacon painting that hung on Freud's wall. It was a haunting image of violent male lovers, teeth bared, blurred on a bed. Freud had bought it for £100 from one of Bacon's earliest shows, shortly before their friendship first began to unravel. He never let it go. And (with only one exception in an entire half century) he never agreed to lend it out to exhibitions. What did this imply?

AND WHAT, FOR THAT MATTER, did it suggest about the uneasy friendship between Jackson Pollock and Willem de Kooning—the two most celebrated American artists of the twentieth century—that, less than a year after Pollock's sudden death, de Kooning embarked on an amorous relationship with Pollock's girlfriend, Ruth Kligman, the sole survivor of the fatal crash?

And then, as well, what did it say about the significance of Matisse to Picasso that, after Matisse's death in 1954, Picasso not

only continued to paint complicated tributes to him, but also kept Matisse's portrait of his young daughter, Marguerite—a painting he had once enjoyed watching his friends throw darts at—in pride of place in his own home?

ALL EIGHT OF THE ARTISTS at the center of this book, I'm well aware, are men. We think of the period I write about—roughly 1860 to 1950—as "modern," but of course modern culture through this period was still overwhelmingly patriarchal. There are many storied relationships between male and female modern artists, and a few between women and women; but most of the significant ones—one thinks, for example, of Auguste Rodin and Camille Claudel, Georgia O'Keeffe and Alfred Stieglitz, Frida Kahlo and Diego Rivera—had a romantic component, one that tends to obscure and complicate the aspects of rivalry I try to lay bare here. Uncomplicated by heterosexual passion or chauvinistic condescension, those aspects hinge on relations that can be characterized, broadly speaking, as "homosocial." They include male status competitiveness, wary friendship, peer admiration and even love, and a hierarchical dynamic that is never settled, even when it seems to be.

Women nonetheless play roles of enormous importance in each chapter. Among them are first-rate artists such as Berthe Morisot and Lee Krasner; courageous collectors including Sarah Stein, Gertrude Stein, and Peggy Guggenheim; and brilliant, independent-minded accomplices such as Caroline Blackwood and Marguerite Matisse.

All eight of the artists I focus on, it's well known, had other friendships, other rivals, other influences and enablers. But there

is sometimes—there is *usually*, I believe—a single relationship more consequential than all the others. Picasso understood, I think, that he would not have painted the *Demoiselles d'Avignon*, his great, breakthrough painting, and pushed through, with Braque, into Cubism without the seductive pressure supplied by Matisse. Freud, too, knew that he would not have stopped drawing in his tight, fastidious style and become the great painter of blooming, livid flesh that he did but for his friendship with Bacon. De Kooning, similarly, would not have opened up his way of working and painted his first full-throttle masterpieces in the 1950s without the influence of Pollock. And Degas would not have stopped painting the past, leaving his studio to go out onto the street and into the cafés and rehearsal rooms, without the impact of his friendship with Manet.

THIS BOOK, THEN, is about the role of friendship and rivalry in the formation of these eight artists, each of them among the greatest artists of the modern period. In four chapters, it tells the story of four celebrated artistic relationships by homing in on the peculiar bubble in time—usually three or four fraught years—that surrounded a particular crucial incident: a portrait sitting, an exchange of works, a studio visit, or an exhibition opening.

In each case, two different temperaments—two kinds of charisma—were magnetically attracted to each other. Both artists were on the cusp of major creative breakthroughs. Each had already made huge advances; but no signature style had been settled on; no single idea of truth or beauty prevailed over others. All was potential.

And then, as each relationship developed—sometimes tenta-

tively, at other times with a headlong intensity—a familiar dynamic set in. Where one artist had an enviable fluency (socially as well as artistically), the other was stuck. Where one was willing to court risk, the other lagged behind through excess of caution, varieties of perfectionism, doggedness, and psychic clogging. The effect of the artist in question encountering his more fluent, more audacious peer was revelatory—and liberating. Cracks of possibility opened up. A new way not only of working but of facing the world was revealed. The direction of one's life was changed.

From that moment, things inevitably became complicated. Initially one-way, the flow of influence soon began to course in both directions. Even as the more naturally "fluent" artist surged ahead, he became conscious of shortcomings in his own repertoire—skills, audacities, and forms of stubbornness that the other artist had in abundance.

Each story here, then, traces a movement away from an urgent attraction to another person, through a phase of ambivalence, and on toward independence—that vital creative process we call "finding your voice." That search for independence, for a kind of spiritual distinction that militates against the yearning for union and collegiality, is a natural part of the formation of any truly potent creative identity. But it also speaks, of course, to the very modern yearning to be unique, original, inimitable; to acquire the solitude, the singularity, of greatness.

And so it's not by chance that the artists I have chosen to write about are both great *and* modern, because this same dynamic—between solitude and recognition, between singularity and belonging—is at the very heart of the story of modernism.

———

IF THERE IS A FUNDAMENTAL difference between rivalry in the modern era and rivalry in earlier epochs, as I believe there is, it is that in the modern era artists developed a wholly different conception of greatness. It was a notion based not on the old, established conventions of mastering and extending a pictorial tradition, but on the urge to be radically, disruptively original.

Where did this urge come from?

It was a response, most basically, to the new conditions of life—to a sense that modern, industrialized, urban society, although in some ways representing a pinnacle of Western civilization, had also foreclosed on certain human possibilities. Modernity, many began to feel, had shut off the possibility of forging a deeper connection with nature and with the riches of spiritual and imaginative life. The world, as Max Weber wrote, had become disenchanted.

Hence the quickening interest in alternative possibilities. These new fascinations opened up huge areas of artistic terrain. But by rejecting inherited standards, modern artists inevitably found themselves out on a limb. They had cut themselves off— not just from all the usual avenues of success (the official Salons, the prizes, the commercial dealers, the collectors and sponsors) but from the psychic reassurance of valid criteria.

The problem of quality in this situation became urgent. If modern artists rejected standards widely shared in their own culture, how could they know how good they were? If they perceived tremendous value in the art of children, for instance (as did Matisse), how could anyone make the determination that their art was excellent—better than a child's; better than some-

one who had trained for years precisely to advance beyond the art of children?

If, like Pollock, they flicked and dribbled paint from a stick onto a canvas stretched out on the floor, how could anyone claim that this kind of art-making was superior to painting by someone who had trained for years with paints and paintbrushes and palettes and easels, following a hallowed tradition? There were critics, of course. But they were usually biased, and often even more convention-bound than the public. There were sympathetic poets and writers. But none could quite grasp the nature of the struggle from an artist's point of view.

For that, a fellow artist was required. More than critics or collectors, fellow artists had the most to gain from the mining of new imaginative potential and the forging of new criteria. If other artists could be persuaded to share your interests, these new criteria would develop credibility, and might eventually become normative. Your audience—the circle of people who recognized your genius—would grow. Just as Delacroix's Romanticism and Courbet's realism had found favor first with fellow artists and eventually with the establishment, so would Impressionism; and so, down the track, would Matisse's flat, saturated color, and Picasso's faceted forms, and Pollock's splattered paint, and Bacon's smudged faces, and so on.

That, at any rate, was the hope. Huge amounts of effort therefore went into various modes of persuasion. In this cauldron of competitiveness, charisma counted. Relations between artists in this context naturally became more intimate, and more fraught . . . Because, after all, what if a fellow artist's ability to impress and charm the relevant collectors—the Steins in Paris, for instance—was superior to yours? What if your rival's inter-

est in African art or in Cézanne had a different quality from your own interest in those things? What if everyone could see that your confrère was a far superior draftsman, or had a better, more intuitive color sense? What if, temperamentally, your friend and rival was simply better equipped for success?

These questions were not academic; they were painfully real. Rivals in the modern era were competing not just to be the most advanced artistically, the most audacious, the most important. They were competing also, as people do, for worldly, practical currencies. And then, of course, they often competed in the realms of love and friendship.

The art of rivalry is, in this sense, the struggle of intimacy itself: the restless, twitching battle to get closer to someone, which must somehow be balanced with the battle to remain unique.

THE
ART OF RIVALRY

FREUD and BACON

The thing is, unless you look at those Muybridge figures with a magnify-
ing glass, it's very difficult to see whether they're wrestling or having
sex.

 -FRANCIS BACON

Lucian Freud's 1952 portrait of his friend, the artist Fran-
cis Bacon, is the size of a pocket paperback [see Plate 1]. Or it
was: It disappeared from the walls of a German museum in 1988
and hasn't been seen since.

It showed Bacon head-on and from very close in. "Everyone
thought of him as a blur," Freud would later say, "but he had a
very specific face. I remember wanting to bring Bacon out from
behind the blur."

In the finished picture, Bacon's famously jowly cheeks ex-

pand to fill the frame, and his ears almost touch the edges. His eyes are cast down—though not to the floor. They have a pensive, faraway look, a suggestion of inward retreat. It is an elusive but unforgettable expression, one that combines self-mourning with a strange hint of inner fury.

Freud went on to achieve worldwide renown for the fleshy amplitude of his pictures and for his use of thick, oily paint, lavishly applied. But in 1952, when he painted Bacon, his style was very different. He specialized in surface tension. Working on a small scale, he kept the paint as smooth as possible—no visible brushstrokes. Control was paramount. So was an evenness of attention, fastidiously maintained across the entire surface of his pictures.

Even so, the contrast between the left and right sides of Bacon's distinctive, pear-shaped head is odd—and becomes more remarkable the longer you study it. The right (Bacon's right), cast lightly in shadow, is a study in placidity. Over on the left, however, everything is slipping and skidding about. An S-shaped lick of hair—you can count the strands—casts a dashing shadow on Bacon's brow. The whole left side of his mouth twists upward, triggering a pouchy swelling, like the body's response to a sting, at the corner of his mouth. A sheen of sweat shines from that side of his nose. Even the left ear seems to convulse and squirm. Most striking of all is the way Bacon's left eyebrow extends its powerful arabesque into the furrow at the center of his forehead. This has nothing to do with "realism" if you take that term literally; no eyebrow behaves this way. But it's the engine that powers the whole portrait, just as the portrait itself is the key to the story of the most interesting, fertile—and volatile—relationship in British art of the twentieth century.

IN 1987, THIRTY-FIVE YEARS after it was painted, and just months before it disappeared, this tiny picture was sent to Washington, DC. If it hadn't been painted on copper, one could have put a stamp and address on the back and sent it as a postcard. Instead, it was carefully packaged and crated and sent along with eighty-one other works to the US capital. It was to be part of a Freud retrospective, organized by Andrea Rose of the British Council, at the Hirshhorn Museum and Sculpture Garden, situated on the National Mall.

Despite its size, the portrait of Bacon was one of the show's most charismatic objects. It helped, undoubtedly, that the subject himself was famous. Bacon, who was still alive at the time (he died in 1992), was a far better-known artist than Freud himself. Since the 1960s, major exhibitions of his work had been mounted not only in London, where he lived, but also in places like the Grand Palais in Paris and the Guggenheim and Metropolitan museums in New York. No British artist of the twentieth century had received more sustained critical acclaim. None had plumbed the darker recesses of the popular imagination with a body of work so bold and broadly influential. Bacon was a bona fide international star.

Freud was a different kind of artist. He was, as the critic John Russell described him, "a worrisome and disquieting presence"— stubborn, perverse, hardworking, immune to fashion. He had exhibited regularly from his early twenties all the way into his sixties (he was now sixty-four), and was enough of a presence in England to be made a Companion of Honour in 1985. But outside the British Isles, he barely registered. And in the United States he was quite unknown.

Less audacious (at least ostensibly) than Bacon's work, Freud's also appeared more conventional in its fidelity to appearances. His kind of painting—figurative, objective, anchored in observation—had been out of fashion for almost a century. His clearest predecessors were not Pollock and de Kooning (the Dutch-born American painter with whom Bacon was most often compared), much less Duchamp and Warhol, the dominant influences on artists in the 1970s and early '80s. They were nineteenth-century painters such as Courbet, Manet, and especially Degas.

His work, what's more, was ugly. His manner of painting—unflinching realism, prolonged scrutiny, a beady-eyed focus on humid, blotched skin and sagging flesh—was a turnoff. It was raw and rash-ridden. Sweaty. You could almost smell it. It certainly didn't fit with the American museum world's notion of advanced art, which, since the 1960s, had tended to be minimal, abstract, conceptual, and altogether more hygienic.

And yet, for all Freud's peculiarity—for all the sense that he was some kind of throwback—a growing number of people in Britain (critics, dealers, fellow artists) had come to feel that he was nearing the height of his powers as an artist. For the best part of two decades, he had been producing paintings of such visceral impact, such sustained intensity and conviction, that although they did not fit into any obvious category or narrative of contemporary art, they were impossible to dismiss.

Keen, then, to extend his reputation beyond the UK, the British Council had organized an exhibition of Freud's work they could send abroad. Organizers at the British Council selected the works and negotiated the loans (most of Freud's works were in private collections). They produced a handsome catalog, too,

with an insightful introductory essay by Robert Hughes, the influential *Time* magazine art critic. Hughes homed in on Freud's portrait of Bacon in the essay's very first sentence. The portrait's even light, he wrote, had "something Flemish" about it; its size conjured the Gothic world of the "miniature"; it was "tight, exact, meticulous and (most eccentrically, when seen in the late fifties, a time of urgent gestures on burlap), it was painted on copper." But what made the picture truly mesmerizing, stressed Hughes, was that it was also uncannily modern. Freud "had caught a kind of visual truth," he wrote, "at once sharply focused and evasively inward, that rarely showed itself in painting before the twentieth century." He had somehow given Bacon's "pear-shaped face the silent intensity of a grenade in the millisecond before it goes off."

THE BRITISH COUNCIL SECURED venues for the show in Paris, London, and Berlin. But they had trouble finding a US venue. Freud wasn't well enough known, American museum curators claimed. His fleshy, indecorous work would be disconcerting to the general public. He was too British, too old-school, too *real*. The American curator Michael Auping later recalled the general consensus: Confronting Freud's work in the context of American postwar avant-garde art, he wrote, was "like discovering pungent moulds on the pristine white walls of the museum."

But the British Council wouldn't give up. They contacted James Demetrion, the director of the Hirshhorn, part of the family of museums in Washington, DC, operated by the Smithsonian Institution. They explained the predicament. Demetrion listened. He was surprised, he later recalled, that no New York

museum was interested. "Apparently Freud was not well-known outside of Britain, which kind of baffled me," he said. He agreed to take the show. And his decision turned out to be a coup, not only for himself and the Hirshhorn, but—in a major way—for Freud.

The show opened at the Hirshhorn—the first of four international venues—on September 15, 1987. Freud would be turning seventy in five years. And yet this was the first major representation of his work outside Great Britain.

Against all expectations, it turned into a blockbuster. Strong reviews in major newspapers, weekly magazines, and art journals up and down the eastern seaboard, along with Hughes's essay (which was published independently in *The New York Review of Books*), and a profile in *The New York Times Magazine*, all helped promote it as a major, galvanizing event. Freud's career took off. Before long, he had dropped his English dealer and was selling his works exclusively through two prestigious New York galleries. And within ten years, he was being acclaimed as the most famous living painter not just in Britain but, arguably, in the world. In May 2008, one of his paintings, *Benefits Supervisor Sleeping*, became the most expensive work by a living artist, selling to the Russian billionaire Roman Abramovich for $33.6 million. (Another painting of the same subject, *Sue Tilley*, sold for $56.2 million in 2015.)

After its spell at the Hirshhorn, the exhibition left the United States for stints at prominent museums in Paris and London. Its final stop was in Berlin, where it opened at the end of April 1988. The venue, here in the city where Freud was born and grew up, was the Neue Nationalgalerie. Other museums in Germany had expressed interest in taking the show, and had been willing to

meet all the costs, but Freud, according to Andrea Rose, "wouldn't hear of it." He insisted that the show be held in Berlin—or not in Germany at all. Unfortunately, the Neue Nationalgalerie was reluctant to get involved. They refused to meet the majority of the exhibition costs, remained aloof from the production of the catalog, and sent no one to see the exhibition in Washington, DC, Paris, or London. Worried about the show's reception in Germany, Rose had to insist that their curator come to London while the show was on at the Hayward. It was only then, she recalled, "that they realized that the show was much bigger than they had anticipated, and had to reconfigure the galleries to accommodate it." (They had originally designated the museum's graphics gallery for the show—about a quarter of the size needed.)

A glass-and-steel building—the last completed commission of the legendary modernist architect Mies van der Rohe—the Neue Nationalgalerie is situated in a vast, leafy culture precinct studded with museums, concert halls, science centers, and libraries. The Tiergarten, Berlin's great park, runs along its northern border, the Landwehr Canal along the south. The actual *tiergarten*—the zoo—is situated to the west of the museum, with Potsdamer Platz less than a ten-minute walk away to the east.

Until he was eight and moved to England, Freud had lived in two successive apartments in this neighborhood. He used to play in the Tiergarten as a boy, and once fell through the ice while skating there ("It was very exciting," he later recalled). He used to swap cigarette cards with dealers around Potsdamer Platz: "You could swap three Marlene Dietrichs for one Johnny Weissmuller, that kind of thing," he said.

Freud's family had been forced to flee Germany when Hitler

rose to power. Freud had had the chance to see the dictator only once, in the very square where Freud's family lived, right across from where the Neue Nationalgalerie now is. "He had huge people on either side of him," he recalled; "he was tiny."

Freud's show opened on April 29, 1988. The Berlin Wall was still a year from falling, the city still divided. The exhibition was reviewed very well in the West German newspapers and art press, and the catalog sold out within the first few weeks. If the response was not as momentous as it had been in the United States, the welcome afforded this long-lost son of Berlin was nonetheless sincere and appreciative. Attendances were higher than expected.

But a month after the opening—it was a Friday, late in the afternoon—a visitor to the museum noticed something awry. Right near the beginning of the Freud exhibition, the part that showed works from the early part of his career, there was an empty space on the wall where it was quite clear there should have been a painting. This was startling. But who should be notified? Security at the museum at that time was slack to the point of invisibility. There hadn't been a single guard on duty in the exhibition between 11 A.M. and 4 P.M., according to one report. The portrait was so small that it would have been easy to slip it into an inside coat pocket and proceed out of the exhibition without anyone noticing.

The visitor found a member of the museum's staff and reported the missing painting. The news went swiftly up the chain of command. The police were called. They sealed the building and systematically questioned and searched every visitor still inside the museum.

But it was all to no avail. Gradually, it dawned on everyone—

museum staff and police alike—that they were too late. The thief, or thieves, had slipped through the net. Or more likely, they had left the scene before the net was even in place.

The Neue Nationalgalerie's director, Dieter Honisch, was deeply embarrassed, as were his staff. Nonetheless, they wanted to keep the show open until the scheduled finishing date, still three weeks off. Freud and the British Council organizers wouldn't have it. There was lobbying from those on the German side—and also from the British ambassador to Germany—to keep it open; but when Freud threatened to ask all the show's private lenders to withdraw their works, they relented, and the show was shut down.

It was agreed with the police and the British Council organizers that a small reward should be offered. Ports and airports were alerted. A couple of tip-offs were pursued. But none of it panned out.

There was nothing about the theft to suggest the work of organized professionals. There had been no break-in, no weapons, no speedy getaway. The crime seemed basically opportunistic. But neither was it the work of bungling amateurs. The painting had not been yanked from its fittings. The thief had had to use a tool, presumably a screwdriver, to remove the mirror plates fastening the frame to the wall. This suggested a certain amount of premeditation. But if the crime had been planned, it was strange that no ransom demand ever materialized, as often happens in such cases.

Then again, just as often it doesn't. The whole affair was mystifying.

One thing was widely noted. When the picture was stolen, the museum had been filled with students. In Germany, as else-

where, the portrait's subject, Francis Bacon, was hugely admired. One of modern art's most vivid personalities, he had, among young people in particular, what amounted to a cult following. He was certainly more popular than Freud, who was still to most Germans—even art lovers—a stranger. Only his family name (he was the grandson of Sigmund Freud) was familiar. So perhaps it was one of the students who stole it—or several working together . . . ? When Robert Hughes tried to console Freud with the thought that the theft was a perverse kind of compliment—someone, he offered, had evidently loved his painting enough to steal it—Freud demurred. "Oh, d'you think so?" he said. "I'm not sure I agree. I think somebody out there really loves Francis."

THIRTEEN YEARS AFTER THE THEFT of Freud's portrait of Bacon, the Tate, which owned the portrait and had lent it to Berlin, was gearing up for a major retrospective of Freud's work. By now, Freud was seventy-nine. He was working on a portrait of the queen, bigger than the Bacon picture but still small enough to fit inside a shoe box (which is exactly where he kept it, stashed under a bed, between painting sessions). He was also racing against time to finish a portrait of the fashion model Kate Moss, who was pregnant and growing bigger by the day. Other subjects included his son Freddy, whom he painted, life-sized, standing naked in a corner of Freud's Holland Park studio; his lover, the journalist Emily Bearn; his studio assistant David Dawson, and Dawson's docile but fine-strung whippet, Eli. Hard at work though he was, Freud had a feeling that this might be the last major show devoted to him during his lifetime. Naturally, both

he and the gallery wanted the best possible sampling of his life's work. The portrait of Bacon was crucial: Freud had painted it while sitting knee-to-knee with Bacon over a three-month period back in 1952. It was one of the first of his paintings—certainly the finest to that date—to convey not only a sense of extreme intimacy but also, at the same time, a kind of ruthless objectivity—qualities that would become hallmarks of his mature art. It marked a vital turning point. It also established a link between his early work, much of it juvenilia, and his commanding later work.

What if, so many years after the theft, the portrait could somehow be retrieved?

A publicity campaign was planned. There was reason to think it might succeed. This wasn't known until after planning for the campaign had begun, but under the German statute of limitations, a crime of this kind cannot be prosecuted after twelve years. So the hope was that the thief, or thieves, could be enticed into returning the painting without fear of penalty.

Andrea Rose of the British Council and her husband, William Feaver, a longtime friend of Freud and the curator of the upcoming retrospective, together concocted an idea: a bold and attention-getting WANTED poster. Freud loved it. He drew a design for it on the spot. The finished poster [see Fig. 1] had WANTED in large red lettering above a reproduction of the stolen portrait of Bacon, in place of the usual mugshot. There was also a generous reward: 300,000 deutsche marks (around US $150,000). The idea, said Freud, was "to make it absolutely plain, like those posters in Westerns which I've always liked very much."

The poster's finished design, based on Freud's initial sketch, added a brief explanatory text in German and a phone number.

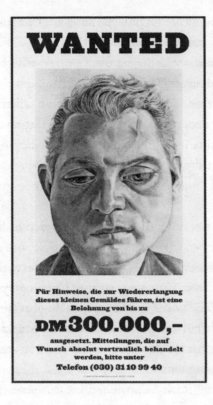

FIG 1. Lucian Freud. WANTED poster. 2001 (color litho).

PRIVATE COLLECTION /
© THE LUCIAN FREUD
ARCHIVE / BRIDGEMAN
IMAGES.

The image of the painting itself was black and white. Since the portrait's disappearance, Freud had never allowed it to be reproduced in color—"partly," he explained, "because there was no decent color reproduction, partly as a kind of mourning . . . I thought it was a rather jokey equivalent to a black armband. You know—there it isn't!" Two thousand five hundred of these posters were printed and then plastered all over Berlin. They were also widely reproduced in newspapers and magazines. Freud even put out an uncharacteristically deferential statement to the

press: "Would the person who holds the painting kindly consider allowing me to show it in my exhibition next June?"

The poster, the media campaign, the scrupulously polite plea . . . none of it had any effect. The Tate retrospective went ahead without the portrait. The campaign may have failed, but for a long time Freud kept the poster prominently displayed at the entrance to his studio. It was the last thing he saw before entering each day and getting down to work.

THEFTS OF ART ARE always perplexing. Even when they leave behind useful evidence, what's really left behind, the heart of the matter, is always an absence. All great paintings have an aura, which derives, in part, from their singularity. There is only one *Storm on the Sea of Galilee* by Rembrandt. There is only one *The Concert* by Vermeer. There is only one *Chez Tortoni* by Manet. All three were stolen from the Isabella Stewart Gardner Museum in Boston, and their absence, a quarter century later, is still marked by empty frames on the museum's walls, as if the aura could somehow continue to exist even if the paintings themselves do not.

When the painting in question is a portrait—certainly if it is a good one—its aura, its special quiddity, is enhanced. The singularity of the image is matched, and deepened, by the singularity of the person depicted. So a stolen portrait can amount to a confusing kind of double loss. One strives to orchestrate its return, but what exactly is it one wants to retrieve? The painting? Or earlier versions of the two people involved—the sitter, of course, but also the painter himself?

In his own portraiture, Lucian Freud always seemed determined to treat these two kinds of singularity as one. "My idea of portraiture," he once said, "came from dissatisfaction with portraits that resembled people. I would wish my portraits to be *of* the people, not *like* them. Not having a look of the sitter, being them." It was as if he was determined to reenact the myth of Pygmalion, the mythical artist who fell in love with the sculpture he had carved.

How sharp, then, was the loss of the portrait of Bacon, which one critic, Lawrence Gowing, had described as exerting "the transfixing spell of an image that is tantamount to the thing itself"?

Freud was a truth-teller. He detested illusions and had little time for sentimentality. He usually claimed not to care about the whereabouts of his pictures. But he cared a lot more about this one. As much as anything, it was a question of quality. This small, ostensibly conventional portrait was electrifying. And he knew it.

But its loss mattered to him for another, more personal reason (although it is a reason that is related in every way to the picture's quality). Very simply, it represented the most important relationship in his career.

AS A YOUNG MAN, Freud was mercurial, ardent and unpredictable, attracted by danger, and, to most people who encountered him, extremely attractive. His famous family had relied on high-level intercessions to escape Hitler's Germany in 1933. When he first arrived in England, he was ten years old. He spoke English,

but not confidently, and kept largely to himself. Wild and secretive, he had a high-spirited, almost demotic side, and a fierce aversion to other people's expectations. He was sent with his brothers to a progressive boarding school—Dartington—in Devon. But attending classes was voluntary, so Freud avoided them. He liked to sleep in the stables with the horses. In the mornings, he would ride the friskiest ones to wear them out for those who rode them subsequently. He later said his first amorous feelings were directed at the groom who looked after the horses, and he filled his early sketchbooks with portraits of horses and of boys riding, kissing, and generally worshipping horses.

For this alert and slender boy, who obeyed only his own impulses and had absolutely no interest in social niceties, animals made for more intimate and responsive company than humans. In 1938, at Bryanston, a school in Dorset where, only four years previously, an Anglo-German youth camp had been established to try to forge links between the Boy Scouts and the Hitler Youth, Freud was expelled for dropping his trousers and exposing his rear end in a street in Bournemouth. He loved to draw. When he was sixteen, his parents enrolled him at the Central School of Art (he earned his place with a sculpture of a three-legged horse carved from sandstone), but he gave up after only two or three terms, bored by the school's rigid approach. His own drawings were cramped, fanciful, childish, their pressurized lines crisscrossing the page like cracks in thin ice. It was only when he enrolled, in 1939, in the East Anglian School of Painting and Drawing at Dedham in Essex, the intimate and informal art school run by Cedric Morris and Arthur Lett-Haines, that he found an environment that felt right. Morris's awkward, intense

painting manner—so pointedly devoid of virtuosity that it suggests a perverse kind of pride—had a huge influence on Freud.

Freud had two brothers, but he was his mother's favorite—and he knew it. As a young man, he acted as he always would: with the flair and impunity, but also the tenderness and sensitivity, of someone whose mother adored him. "I like the anarchic idea of coming from nowhere," he once said. "But I think that's probably because I had a very steady childhood."

The young Freud's effect on those in his vicinity was remarkable. His family connection to the founder of psychoanalysis undoubtedly enhanced his allure, especially during what was then the heyday of Surrealism in Britain (Surrealism arose directly from Sigmund Freud's theories of the unconscious mind). But the effect he had on most people was not at all social, much less intellectual: It was visceral. Lawrence Gowing recognized a "coiled vigilance in him, a sharpness in which one could imagine venom." John Richardson, the art historian who later became Picasso's biographer, was amused to see Freud resent the attention his exhibitionism triggered. John Russell, meanwhile, likened him to Tadzio, the young object of infatuation in Thomas Mann's novella *Death in Venice:* "He was the magnificent adolescent who seemed by his very presence not only to symbolize creativity but to keep the plague at bay . . . Everything was expected of him."

While still a teenager, Freud met the poet Stephen Spender through a friend, Tony Hyndman, who was Spender's lover. When, in 1936, Spender chose to marry Inez Pearn, Hyndman joined the International Brigades and went to Spain to fight in the civil war. Spender followed him there in order to rescue him from a charge of desertion. And although his mission was suc-

cessful (Hyndman could have been executed), it killed his marriage. Early the following year, 1940, Spender visited Freud and his art-student friend David Kentish, at Freud's invitation, in the north of Wales. The two teenagers were spending the winter drawing and painting in a small and isolated miner's cottage in Capel Curig. Spender, who had taught both boys at Bryanston, had just published a novel, *The Backward Son,* and was in the midst of setting up the literary magazine *Horizon* with Cyril Connolly and Peter Watson. He brought along a publisher's dummy, which Freud, drawing by lamplight, proceeded to fill with antic drawings in the "high-spirited, demotic" vein Freud said Spender so admired in W. H. Auden—and which Freud in turn admired in Spender. "He paints all day and I write," Spender wrote in a letter. "Lucian is the most intelligent person I have met since I first knew Auden at Oxford, I think. He looks like Harpo Marx and is amazingly talented—and also wise, I think."

The drawings in the dummy book are full of running jokes and sly allusions, and they match the tone of letters exchanged between Freud and Spender around the same time. These letters, which came to light in 2015, strongly suggest that Freud and the poet, who was twice his age, were in a sexual relationship (Freud signs the letters, for instance, with the saucy pseudonyms "Lucianos Fruititas" and "Lucio Fruit")—although it's also possible they were simply flirting.

Along with the joke drawings, Freud made several portraits and self-portraits that winter. One self-portrait was included in an early issue of *Horizon* that spring. It appeared in the same issue as the art critic Clement Greenberg's breakthrough essay "Avant-Garde and Kitsch."

———

FREUD MARRIED JUST TWICE—both times in his twenties. But over the course of his life he sired somewhere in the vicinity of thirteen children, and had so many lovers that even the most determined biographer would struggle to make a full accounting. Still, at the age of seventy-nine, Freud insisted that he had fallen in love only two or three times. "I'm not talking about habits, nor am I talking about hysterics," he said. "I'm talking about actual, complete, absolute concern, where everything about the other person interests, worries, or pleases you."

Who, one wonders, were those two or three? It's not easy to say. But Freud's first serious girlfriend—"the first person I got keen on," as he later put it—was Lorna Wishart, a wealthy, adventurous, magnetic young mother of three, who was described by Peggy Guggenheim as "the most beautiful woman I have ever seen." Lorna was eleven years older than Freud, who commented later that everyone liked her: "Even," he added "my mother."

Lorna married the publisher Ernest Wishart when she was just sixteen. One of her two children by him was the artist Michael Wishart, who was born in 1928. A third child, Yasmin, was born to the poet Laurie Lee, with whom Lorna had a long-running affair, before meeting Freud, in the late 1930s and '40s. When Lee went off to fight on the Republican side in the Spanish civil war, Lorna reportedly used to send him one-pound notes dabbed in Chanel No. 5. Michael, for his part, remembered that his mother was "often dressed for dancing in clinging sequins" when she said good night to him. Yasmin described her as "amoral, really, but everyone forgave her because she was such a life-giver."

Freud supplanted Lee in Lorna's affections in 1944. He was just twenty-one; Lorna was in her early thirties. The affair had a huge effect on the young artist. Lorna was not only older and more experienced, she was wild, romantic, and unpredictable—inspiring company for any ardent young man. Yasmin later wrote that her mother was "a dream to any creative artist because she got them going. She was a natural muse, an inspiration."

Freud painted Lorna twice in 1945—once with a daffodil, the next time with a tulip. From a taxidermist in Piccadilly, she bought for Freud a stuffed zebra's head, which became a kind of talisman for him. He called it his "prize possession" and used it in a painting, which Lorna promptly acquired from his very first gallery show. The picture was a whimsical, surrealist tableau, featuring a tattered couch, a top hat, a palm, and the zebra's head (its black stripes turned red) protruding through a hole in the wall.

It wasn't long, however, before Lorna discovered that Freud had been conducting an affair with a young actress. She promptly left him, and although Freud tried hard to win her back—on one occasion threatening to fire a gun outside her house if she wouldn't come out (and then actually doing so), on another presenting her with a white kitten in a brown paper bag—his efforts were all to no avail.

FREUD WAS INTRODUCED TO FRANCIS BACON by the older painter Graham Sutherland in 1945. At the time, Freud was living in a condemned building in Paddington. "I used to go down and see [Sutherland] in Kent," Freud said in 2006. "Being young

and extremely tactless, I said to him: 'Who do you think is the best painter in England?' which, of course, he felt himself to be, and was beginning to be regarded to be. He said, 'Oh, someone you'd never have heard of. He's the most extraordinary man. He spends his time gambling in Monte Carlo, and then occasionally he comes back. If he does a picture, he generally destroys it,' and so on. He sounded interesting. So I wrote to him, or called round, and that's how I met him."

Sutherland's appraisal had not been wrong: Bacon, who was in his early thirties, was surging to life in these years. He may have felt racked, as he later professed, by self-doubt. But he was producing paintings that had already set him apart. Troubled, and troubling, works in which alert observers saw something almost reptilian stirring to life, full of menace.

In fact, according to Freud's biographer William Feaver, they may first have met, by arrangement, at London's Victoria Station, on their way down to Kent to stay with the Sutherlands for the weekend. It's fun to try to imagine the two of them on that train trip. Exotic creatures, both. Freud with his preternatural alertness, his air of being unbeholden to anyone, his disorienting combination of shyness and theatricality. Bacon mischievous and ironic, his brutal bluntness somehow in service to his even more devastating charm. The war not yet over. Sutherland's double-edged presence, encouraging yet daunting, hovering oedipally over the meeting.

Both men were striking to look at: Bacon jowly but handsome; Freud's face narrower, pointier, with an aquiline nose, delicate lips, and tousled hair. Incredible eyes, all four—everyone commented on that. Freud was already, at this stage, an object of interest among a host of older gay poets, writers, and artists, in-

cluding Spender and Watson, and the painters Cedric Morris and Arthur Lett-Haines, his teachers at the East Anglian School in Dedham. These men, and others like them, were largely responsible for sustaining young, unconventional artists in England during the war years and immediately afterward. Freud's relationship to them, and to many gay or bisexual men of his own generation—including Wishart, John Minton, Cecil Beaton, and Richardson—was close, curious, sympathetic.

So perhaps a sexual charge was in the air. But what was the conversation like? Was it guarded, hesitant, latently competitive? Or was it all a more innocent form of seduction, in the context of a trip that was essentially a lark? We don't know the answers to such questions. Both men are dead. It was a mistake, one might think, not to ask—to ask for more, to ask again. But perhaps those who did ask quickly discovered that that, in fact, was the mistake. In so many ways, after all, it was precisely the *inability* to know, to truly pin down character, motive, feeling, or social status—all the qualities upon which traditional portraiture had for centuries been based—that soon became the premise both artists began to work from.

However it happened, each had found *something* in the other, something immensely compelling. Three decades later, they were no longer on speaking terms. But now, the two men began to see each other on an almost daily basis.

TWO YEARS AFTER FREUD split from Lorna Wishart, Lorna was magnanimous enough to introduce him to her niece, Kitty, the daughter of the sculptor Jacob Epstein. Kitty shared her aunt's large eyes, if not her confidence and vivacity. She was shy,

which was part of what Freud, who also had a shy, evasive streak, liked about her. They became lovers, and they married in 1948, the same year the first of their two children, Annie, was born. They lived together in London's St John's Wood, just west of Regent's Park. Their home was a half-hour walk from Freud's previous home in Delamere Terrace, where he now kept his studio.

The split arrangement facilitated Freud's developing penchant for amorous complexity. Still married to Kitty, he began an intermittent but long-running affair with the painter Anne Dunn. Dunn was the daughter of the Canadian steel magnate Sir James Dunn. She sat for a portrait by Freud in 1950, the same year she was preparing to marry Michael Wishart, Lorna's son. A party was planned to celebrate the wedding. A three-night bash, it later became legendary and was remembered by David Tennant as "the first real party since the war." Wishart, the groom, was addicted to opium at the time. In his memoir, *High Diver,* he recalled that the room in South Kensington in which the wedding party took place was "cavernous" and "sparsely furnished" with "dowdy chintz and velvet sofas and divans." It had, he wrote, "an air of diminished grandeur, a certain forlorn sense of Edwardian splendor in retreat."

John Richardson, who was there, remembered it as "the coming out party for a new variety of bohemia." Among the guests, he wrote, were "members of Parliament and fellows of All Souls [the Oxford college], as well as 'rough trade,' slutty debutantes, cross-dressers." Wishart boasted that "we bought two hundred bottles of Bollinger for two hundred people, and soon had to send out for more as our gatecrashers snowballed . . . I hired a

hundred gold chairs and a piano. For three nights and two days we danced."

For Freud, what made the wedding diabolically complicated was not just that the groom was Lorna's son, or that he was now married to Lorna's niece, Kitty, while having an affair with the bride, Anne Dunn, but that Freud and Michael Wishart, who had shared rooms in London while still in their teens and then in Paris after the war, had themselves been amorously involved. Thus, finding himself in the unusual position of having been involved sexually not only with the bride but also the groom and the groom's mother, it's no surprise, perhaps, that Freud chose to stay away from the festivities. According to Dunn, he was jealous—and not just of her. Nonetheless, he had Kitty act as his eyes and ears, and as the party progressed she was seen by other guests going to the telephone to give him updates.

That 1950 party was held in the home of Bacon, who lived there—another unusual arrangement—with his older lover, Eric Hall, and Jessie Lightfoot, an elderly woman who had been his childhood nanny. The flat was in Cromwell Place, South Kensington, on the ground floor of a building that had once been the home of the painter John Everett Millais. Bacon used the large space at the back of the flat—it had been a billiards room—as his studio. The same space had also been used as a studio by another earlier occupant, the photographer E. O. Hoppé. A bridging figure in the transition from soft-focus Pictorialist photography to crisp, sharp-focus modernism, Hoppé was an émigré from Munich who turned out the best photographic portraiture in Edwardian London. He also designed for the theater. Various studio props, including hangings, a black, umbrella-

like cloth, and a large dais, all used by Hoppé to make his exquisite, ingratiating portraits of society beauties and great men, remained in the building, and now became props in Bacon's very different style of portraiture.

It was in this studio that Freud had first seen Bacon's work—specifically, a recently completed work called simply *Painting* [see Plate 2]. Half a century on, Freud still remembered the event. He referred to it as "that absolutely marvelous one, the one with the umbrella."

It was indeed Bacon's most dazzling achievement up until then. In a room the color of pink slime with drawn purple blinds, a man dressed in black sits in front of a hanging carcass of meat in the pitch-black shadow of an umbrella. The umbrella obscures all but his chin and mouth, which is open to reveal a lower row of straight teeth and an upper lip that has been pulped and bloodied. Although the paint handling is broad, the composition is peppered with very particular details: the yellow flower pinned to the man's chest beneath his white collar; the Oriental rug below, rendered with a sort of smudged pointillist brio; the semicircular railing that carves out an arena-like space. (This last was a device Bacon, who was nothing if not theatrical, would use again and again in succeeding decades.)

Freud never forgot it.

BACON'S CHILDHOOD WAS VERY different from Freud's. Born in Dublin in 1909, he was the second of five children. Like Freud, he had a famous ancestor—the Elizabethan chancellor and philosopher after whom he was named. His father, Eddy Bacon, was a retired army captain. Eddy had fought in the final stages of the

Boer War with the Durham Light Infantry. He saw four months of action and was awarded a Queen's Medal with clasps. He resigned from the army shortly before his wedding to Winnie Firth, whose family, from Sheffield, had amassed a fortune in steel; but he continued to style himself "Captain Bacon." He was known as an ill-tempered, argumentative bully with a puritanical streak. Alcohol was banned from the house, but he allowed himself to gamble on racehorses, which he trained with scant success. He ran the household along military lines.

Francis spent long stretches of his childhood with his maternal grandmother, Granny Supple, in County Laois. But when living with his parents—and despite chronic and severe asthma—he was made to go pony riding at every opportunity. For days afterward, he would be bedridden, struggling for breath. Intending to "make a man" of his sickly son, Captain Bacon regularly arranged for the grooms he employed to horsewhip him. He would watch, too—or so claimed Bacon. (Much of this period in his life is known only through his own testimony, which tended to emphasize cruelty and drama, possibly at the expense of veracity.) Bacon liked to trail these same grooms around—"I just liked to be near them," he said—and in his early teens he had his first sexual experiences with them.

Just before his fifteenth birthday, Bacon was sent to board for two years at a school in Cheltenham. By this time, he seems to have developed a penchant for dressing up in female attire. A year or two later, his father discovered him admiring himself in the mirror while trying on his mother's underwear. He flew into a rage and cast his son out of the house. Humiliated, rejected, and surely confused (he later declared that as a teen he had harbored erotic feelings toward his father, too), Bacon fled to Lon-

don and was eventually sent to stay with an older cousin, who took him to Berlin. Charged with subjecting the boy to some strict discipline, this new guardian—a racehorse breeder like Eddy—turned out to be bisexual. He was also, Bacon told John Richardson, "absolutely vicious."

AFTER BERLIN, BACON, still a teenager, spent a year and a half in Paris, and it was here that he first became serious about art. He saw films and lots of art exhibitions. One show that particularly caught his imagination was an exhibition of Picasso's neoclassical drawings, inspired by Ingres, at Paul Rosenberg's gallery. He quickly fell under the spell of the protean Spaniard—according to Richardson, "the only contemporary artist whose influence he would ever acknowledge."

When he returned to London in 1928, Bacon set out on a short-lived career as an interior designer, making furniture and rugs in a modernist idiom. He lived with his old nanny, Jessie Lightfoot—a woman who meant more to Bacon than his own distant mother. Nanny Lightfoot was an emotional support—the one steady presence in his life. Much of the day she spent knitting at the back of Bacon's studio, and she appears to have slept through the nights on the kitchen table. She was very nearly blind. And yet, in the broader sense, she looked out for Bacon. She helped him to cook. The two had no regular source of income, and Nanny Lightfoot was not above shoplifting if the situation called for it (although for the most part she confined her role to providing cover for Bacon's own larcenous sprees). She also helped him organize roulette parties—which were very much against the law. The money they brought in was not al-

ways enough to cover the parties' lavish catering, but it was useful nonetheless. Standing guard by the only toilet, Nanny Lightfoot extorted generous tips from gamblers with bloated bladders.

She was also a gatekeeper for Bacon's love life: Using "Francis Lightfoot" as his pseudonym, Bacon placed ads offering his services as a "gentleman's companion" in the personal columns in *The Times* (these ran on the front page in those days). The replies "poured in," according to Bacon's biographer, Michael Peppiatt. It was Nanny Lightfoot who made the selections, and her criteria were primarily financial.

One of these gentlemen was Eric Hall. "Very severe, and very good-looking," as Freud remembered him, he was a high-powered businessman and an epicurean, who was also a justice of the peace, a borough councilor, and the chairman of a London symphony orchestra. He had a wife and family, but after years of staying intermittently with Bacon and his nanny, he chose to join them on a more permanent basis.

Back in 1933, Bacon had painted a work, *Crucifixion*, that was based on Picasso's 1925 painting *Three Dancers*. But it was poorly received, and Bacon was disillusioned. So for most of the next decade, he painted only intermittently, trying out aspects of Surrealism, Post-Impressionism, and Cubism. When the war arrived, Bacon was deemed unfit for service, but he volunteered for the Air Raid Precautions rescue service. He was dismissed when dust released by the bombing of London triggered severe asthma. Hall took him out of the city for a while, and in a cottage in Hampshire he worked on a painting based, very loosely, on a photograph of Hitler getting out of his car at a Nazi rally. The painting is no longer extant, but for Bacon, the formula—

painting portentous images inspired indirectly by photographs—
was a kind of breakthrough.

In 1943, Hall took a lease on the ground-floor flat in the build-
ing at Cromwell Place. It was there that Freud first saw *Painting*.

STARTING IN 1945, FREUD often visited Bacon's Cromwell
Place studio in the afternoons. He also ran into him regularly in
Soho. Freud had been twenty-two when they met; Bacon was
thirty-five. He was painting furiously now, and what went on in
his studio astonished Freud. Bacon was snapping British mod-
ernism out of its complacent, literary, neo-romantic past and
bringing it into line with a new world scarred by war, hollowed
out by futility.

Bacon himself must have been almost as astonished. He had
gained a certain amount of attention within Britain's small and
provincial art circles, but no one had been overly impressed. It
was only in 1944—the year before his first meeting with Freud—
that he had broken through to something strange and troubling
with a painted triptych he called *Three Studies for Figures at the
Base of a Crucifixion*. The figures in question were hideous,
humped, hairless shapes with open maws, bandaged or nonexis-
tent eyes, long necks, and tapering legs. He showed them the
following year in a group show at the Lefevre Gallery in
London—the same gallery that had given Freud his first solo
show the year before.

Part of what distinguished Bacon was that his imagination
was responsive not just to the expected modernist stalwarts im-
ported from the Continent, but to a whole new image bank pro-
vided by photography and film. Ever since he had seen Sergei

Eisenstein's *Battleship Potemkin* and Fritz Lang's *Metropolis* in Berlin, and seen Eadweard Muybridge's stop-motion photographs of humans and animals in motion, he had been obsessed by the speed and discontinuity of these modern media, and especially by the way film footage and photography hinted at loss, disruption, and death. Much of what he attempted misfired—it seemed clumsy, overly contrived, or badly designed, and Bacon destroyed it. But at least he was not looking over his shoulder.

Freud was awed—as much by Bacon's approach to his work as by the imagery he came up with. "Sometimes," he said, "I'd go around in the afternoon and [Francis] would say, 'I've done something really extraordinary today.' And he'd done it all in that day. Amazing . . . He would slash them sometimes. Or say how he was really fed up and felt they were no good, and destroy them."

Bacon described *Painting* as "a series of accidents mounting on top of each other." "If anything ever does work in my case," he said elsewhere, "it works from that moment when consciously I don't know what I'm doing."

IT'S EASY TO IMAGINE the electrifying effect this kind of talk must have had on Freud. His own work, for all its gnarly fascinations, still amounted to juvenilia. He had been painting portraits and still lifes, or combinations of the two. Prickly studies of asymmetrical objects—both human and animal, vegetable and inanimate—all subjected to his intense, hawklike scrutiny. His drawing was increasingly fastidious and stylized. The wandering, high-spirited gaucheness of his teenage years was in the process of being disciplined. He had lately adopted a penchant for

careful cross-hatching and stippling, both derived from engraving techniques. A classical calm, reminiscent of the nineteenth-century painter Ingres and reinforced by close attention to the folds and patterns of clothes, had taken possession of his line. He was toying, too, with unusual effects of light: reproducing every dimple, for instance, on the backlit skin of an unripe tangerine. He made drawings of boys in tailored jackets with scarves or ties and big, brimming eyes. He rendered hair strand by strand. His most powerful painting was a still life of a dead bird—a heron splayed out on a flat surface, every feather of its disheveled plumage accorded its own distinct shade of gray.

How could he not be fascinated by Bacon's risky, theatrical approach? Or by his utter lack of sentimentality about his own efforts? "I realized immediately," Freud said much later, "that his work related *immediately* to how he felt about life. Mine on the other hand seemed very labored. That was because it *was* a terrific lot of labor for me to do anything . . . Francis, on the other hand, would have ideas which he put down and then destroyed and then quickly put down again. It was his attitude that I admired. The way he was completely ruthless about his own work."

Just as important was Bacon's visceral love of oil paint. He handled paint with an urgency that, at this stage, was entirely absent from Freud's own careful filling in of the spaces defined by his lines. There was something chancy and erotic about it. And then there was Bacon's commitment. "He was extraordinarily disciplined," recalled Freud. For days and sometimes weeks at a time, he might float through life. But when it came time to create—usually with a show imminent—he shut himself in his studio and worked without interruption.

BUT WHAT AFFECTED FREUD just as powerfully as Bacon's work was his attitude to life in general. He had an expansiveness, a generosity, a way of negotiating people and situations that came as a revelation to Freud. "His work impressed me," he said, "but his personality affected me."

When asked what had struck him about Bacon when they first met, Freud's reply was both fond and funny. "*Really* admirable," he said, rolling the *r*'s at the back of his throat (a persistent holdover from his Berlin upbringing). "I'll give you a simple example: I used to have a lot of fights. It wasn't because I liked fighting, it was really just that people said things to me to which I felt the only reply was to hit them. If Francis was there, he'd say, 'Don't you think you ought to try and charm them?' And I thought, *Well . . . !* Before that, I never really thought about my 'behavior,' as such—I just thought about what I wanted to do and I did it. And quite often I wanted to hit people. Francis wasn't didactic in any way. But it could be said that if you're an adult, hitting someone is really a shortcoming, couldn't it? I mean, there should be some other way of dealing with it."

The two men were by now close. But there were other artists, in many ways just as important—including Frank Auerbach, who remained Freud's closest long-term friend and most trusted confidant. In the aftermath of war, the atmosphere was alive and permissive: "It was sexy in a way, this semi-destroyed London," recalled Auerbach. "There was a curious feeling of liberty about because everybody who was living there had escaped death in some way." (Like Freud, Auerbach was born in Berlin, but he had not been so lucky; his own parents had died in a concentra-

tion camp in 1942, three years after sending him to safety in England.) They would all meet at night in Soho, hopping among familiar haunts, bumping into one another usually by chance rather than design. There was Wheeler's, Bacon's favorite restaurant. There was also the Gargoyle Club, high above the corner of Dean and Meard streets. It had a ballroom, a drawing room, a room for coffee, and an atmosphere (according to its chronicler David Luke) of "mystery suffused with tender eroticism." Henri Matisse had designed some of the interiors; some were in a Moorish vein, with walls covered in mirror fragments. Opposite the Gargoyle, also on Dean Street, was the Colony Room, otherwise known as Muriel's, after the proprietor, Muriel Belcher. It was a small room at the top of some ramshackle stairs—the sort of place, as Bacon's friend Daniel Farson recalled, "where you couldn't get much for ten bob but you could get an awful lot for nothing." These were the places where men and women would drink, gossip, and dance, in between sessions of poker or roulette. Painting was not often discussed.

Freud would often leave these venues in the early evening and go back to his studio to work from a prearranged sitter—he liked to work through the night. Bacon would stay on, sometimes until morning. His binge-like work habits were less structured than Freud's.

Freud marveled at how Bacon gathered people around, deploying his charm, which seemed to have something volcanic and indiscriminate about it. No matter whose company he found himself in, remembered Freud, Bacon "would get them to talk in the most amazing way. He'd go up to strangers—a businessman in a City suit, for instance—and say, 'It's pointless being so quiet and pompous. After all, we only live once and we should be able

to discuss everything. Tell me, what are your sexual preferences?' Quite often in such cases, the man would join us for lunch, and Francis would absolutely charm him and make him drunk, and somehow just change his life a bit. Of course, you can't bring things out in people that aren't there—but I was amazed at what there was!" Freud's social manner was different. He had a gift for intimate conversation, and for surprising acts. But he was much less extroverted than Bacon. There was something secretive about him.

Freud was attracted, too, to Bacon's derision, his fearless and often hilarious expressions of scorn and contempt. He would later call Bacon "the wisest and wildest person" he ever knew. Both adjectives were carefully chosen, and express utmost admiration. But they were uttered decades later, when Bacon was long gone. In this early period of their acquaintance, Freud's admiration was not distantly reverent but intimate, alive, and responsive. It was complicated.

Inevitably, their friendship aroused jealousy in Eric Hall, who came to loathe Freud—probably, Freud told me, "because he thought, wrongly, that Francis had some kind of relationship with me."

Anne Dunn would later claim that Freud "had a kind of hero-worshipping crush on Bacon, though I don't think it was ever consummated." What seems undeniable is that the relationship was not only intense but asymmetrical. Bacon was attracted to Freud, who had a way of talking about art that the older man found immensely compelling and tried to emulate. Insecure about his own lack of facility as a draftsman, Bacon was also eager to learn what he could from his younger friend. Freud was "funnier and more intelligent than Bacon's average acolytes,"

according to Feaver. But Bacon was indifferent (or so Freud believed) to his work. (When asked if his own interest in Bacon's work was reciprocated by the older man, Freud replied: "I'd have thought he was completely uninterested. But I don't know.") Freud, on the other hand, for one of the only times in his life, was truly in thrall to another person.

INFLUENCE IS EROTIC. Freud was young, and he was surely susceptible—ready to be seduced. And yet, even as he admitted Bacon's example, he now found himself caught up in a struggle to hold true to his own course. He became increasingly aware of what distinguished them, of the differences between them, in temperament, talent, and sensibility, that were most likely unbridgeable. You can hear the ambivalence—the wariness and nervous excitement—in his reactions, remembered many decades later: Bacon "talked about packing a lot of things into one single brushstroke, which amused and excited me," he said, "and I knew it was a million miles from anything I could ever do."

There was, too, another complicating factor, which was that, for a long time, Freud very much depended on Bacon's largesse. Bacon would regularly pull out a bundle of banknotes, saying, "I've got rather a lot of these, I thought you might like some of them."

"It would make a complete difference to me for three months," said Freud.

THE PRESSURE ON FREUD through these years is easy to imagine, impossible to measure. He knew Bacon was ahead of him,

artistically speaking. But it was not as if his achievements up to that time counted for nothing. In many ways it was he, and not Bacon, who had been first out of the gates. He had shown his work in London before Bacon. And although he wasn't known outside a small circle of supporters, many people—people who mattered—had been paying close attention to him. Peggy Guggenheim, who would go on to play a critical role in the discovery of Jackson Pollock, had displayed some of his very early drawings (Freud's mother, according to Feaver, had pressed them on her) in a show devoted to art by children at her London gallery in 1938. More significantly, Kenneth Clark, the art historian and director of the National Gallery in London, had shown sustained interest in his work.

And then there was Peter Watson. The disenchanted heir to a margarine fortune and a well-known collector of European moderns, Watson had the face, said one acquaintance, "of a frog just as he is turning into a prince." Also a taste for young and handsome men. He was one of the richest men in Britain, he dressed in beautiful double-breasted suits, and he hated pretension and pomposity. Cyril Connolly, who adored him, described Watson as "the most intelligent and generous and discreet of patrons, the most creative of connoisseurs." His "cure for boredom," wrote Michael Wishart, "was to interest the young. No one was better at it." He forged crucial links during the isolating war years between his little circle of British protégés and what was going on in Europe and America. And he cultivated and championed the young Freud.

As a teenager, Freud spent hours at Watson's Palace Gate flat, where he was exposed to a collection that included pictures by Klee, de Chirico, Gris, and Poussin. Watson gave him books,

too, including one he treasured for the rest of his life: *Geschichte Aegyptens*, a book of photographs of Egyptian antiquities, which William Feaver has described as "Freud's pillow book, his painter's companion—his bible . . ." Watson offered to pay Freud's art school fees, and found him a flat to live in.

And yet for all the interest Freud generated—as much by the unpredictable force of his personality as by his work—he was not producing, even by the end of the 1940s, work that was in any way revolutionary.

Bacon was. Aside from the few times they sat for each other, the two men never, according to Feaver, actually watched each other at work. But it was clear to Freud that Bacon's approach was really the antithesis of his. Where Freud labored over his portraits for weeks and months, Bacon's painting, when it succeeded, relied on stealth and surprise. Through a combination of chance and high emotion—fury, frustration, despair—he saw himself unlocking "valves of sensation." But he also described feelings of hopelessness as he painted, blurting out that he would "just take paint and just do almost anything to get out of the formula of making a kind of illustrative image—I mean, I just wipe it all over with a rag or use a brush or rub it with something or anything or throw turpentine and paint and everything else onto the thing to try to break the willed articulation of the image, so that the image will grow, as it were, spontaneously and within its own structure."

Thirty years later, when the two men had fallen out, Bacon told a friend, "You know, the trouble with Lucian's work is that it's *realistic* without being real." If the dismissal was unjust in 1988, it may have struck closer to the bone in the 1940s and '50s, when Bacon would not even have needed to say it aloud: With his conventional working methods and his work's fidelity to ap-

pearances, Freud probably felt accusations of backwardness, of timidity, of naïveté and provincialism emanating from his friend and mentor as a kind of background hum.

IN 1946, FREUD WENT to recently liberated Paris, where Watson provided him with introductions and money. He was introduced to Pablo Picasso by Picasso's nephew, the printmaker Javier Vilató. The following year, after a five-month hiatus on the Greek island of Poros, he met Kitty Garman, they married, and Freud began a series of portraits of Kitty that are now among his most famous works. Some were rendered in pastel, others in oil. They have unadorned, slyly romantic titles: *Girl with Leaves, Girl in a Dark Jacket, Girl with Roses,* and *Girl with a Kitten* [see Plate 3].

Coming within two years of Freud's first encounter with Bacon, they announce a new ambition in his work and a sudden, startling intensification in feeling. They generate and somehow contain a psychological pressure that was entirely new in his work, and foreshadow the portrait of Bacon.

Michael Wishart described sitting to Freud "as a trial comparable to undergoing delicate eye surgery. One is obliged to remain absolutely motionless for what seems an eternity. [Lucian] was distressed if I blinked while he was painting my thumb." One wants to believe he is exaggerating. But in the Kitty portraits, the model's unforgettable, almond-shaped eyes seem swollen and brimming from the strain of not blinking. Kitty's eyes seem not only to mirror but also to amplify the artist's own intense scrutiny. Not only every eyelash but every stray hair, every tiny crease in the lower lip, is minutely rendered. The re-

sult is a surface tension, a sort of psychological equivalent to a meniscus stretched across the entire picture's surface, that barely contains a latent, uncanny force. "It seems impossible," wrote Lawrence Gowing, "that she should not have been trembling."

What Freud captures in these portraits is Kitty's acute awareness of being watched. In the intensity of his scrutiny—you feel it most in the masterpiece of the series, *Girl with a Kitten*, which shows Kitty throttling the cat—you detect a threat. Not a threat of violence, but a threat to the sitter's self-possession—which is of course one working definition of love.

The portraits of Kitty are truly emotional exchanges—depictions not just of things (dead birds, sprigs of gorse, unripe tangerines, and the like) but of relationships. And these, of course, are never stable. For all their troubling tension, then, and for all the labored fastidiousness of their rendering, the Kitty portraits were a massive advance for Freud. Perhaps we can also glimpse in them some of Freud's own tension at this time—a tension arising not just from his vexed relationship with Kitty, who was soon pregnant with their first child, but from the pressure of trying not to be blown off course by Bacon.

BACON PARTIALLY REMOVED HIMSELF from Freud's orbit in 1946. He moved to Monte Carlo. It was a place he already knew well, and it was to be his principal residence for the next four years. He and Freud saw each other intermittently in London and Paris. But most of these years they spent apart.

Bacon adored the atmosphere of Monte Carlo. "It has a kind of grandeur," he once said, "even if you might call it a grandeur of futility." This grandeur, and the business of gambling gener-

ally, chimed with Bacon's philosophy of life, which over the next few decades Freud eagerly adapted to his own more instinctive way of negotiating things. "As existence is so banal," Bacon liked to say, "you may as well try and make a kind of grandeur of it rather than be nursed to oblivion." To Freud, this seemed instinctively right. And yet grandiosity was not, in the end, quite his style.

Banality was ubiquitous in the cafés and bars of the Côte d'Azur, which Bacon toured in the company of Eric Hall. His descriptions of these places made them sound like stage sets for plays by Beckett or Sartre: "After a while the boredom was so extraordinary you simply sat there and couldn't believe it." The casinos and hotels of Monte Carlo could be just as life-sapping. Bacon remarked on the way the city acted as a magnet for doctors offering rejuvenating cures; he marveled at "all the incredible old women who queue up in the morning for the casino to open."

But all this was also what he loved about Monte Carlo. There was an aspect to its casinos—lurid, choreographed, theatrical, airless—that he couldn't get enough of. Details of their interior design, such as the polished metal rails encircling roulette tables, found their way into his paintings. He loved the sensation of losing while watching the sun set over the Mediterranean. He loved winning even more. "You can't understand the tremendous draw gambling has unless you've been in that kind of position where you terribly need money and you manage to get it by gambling," he said.

FREUD DIDN'T NEED BACON'S example to spur his own gambling habit. He had always been fascinated by risk. "He courted

danger and tempted fate in ways of his own invention," wrote an old friend. He kept a big table made of window glass in his studio, for instance, and deliberately made it bear gradually increasing weight; he was curious to find out the point at which it would shatter. And he took up gambling in earnest early on. During the war, he said, "I used to go to cellars where there were gambling games going on, with very rough people. When I lost everything—which was quite often, since I'm so impatient (except with working, where patience isn't quite the point)—I always thought, *Hooray! I can go back to work*. Sometimes you lost and lost, and were about to go, and then you won again, so you went on to lose some more. I was often six, seven, eight hours in these basements—and *that* I hated. But generally I lost and would get out very soon. And very occasionally when I won quickly I'd make a run for it."

Gambling, for Freud, was a visceral thrill, and perhaps, too, an expression of his disdain for conventional notions about what matters in life. It was not yet, however, a way of life—much less a philosophy—as it had become for Bacon, whose more extreme and theatrical proclivity for gambling beguiled Freud, as did the beautiful rhetoric Bacon used to *explain* his habit. It was all of a piece with Bacon's attitude toward painting: the emphasis on risk; the willingness to stake all on a spontaneous swipe of a rag or smear of the hand; the conjuring of nightmare and disaster; and the tendency to destroy as much as he created. It all exemplified how Bacon's work, in Freud's own phrase, "related *immediately* to how he felt about life."

All this had almost nothing in common with Freud's own exacting methods. Bacon's approach was rooted in a gambler's

mentality: "only by going too far can you go far enough," as he put it. In truth, he exaggerated many aspects of his approach to making art, and most of his paintings, especially in the 1940s and '50s, actually involved a lot of labor. But his method was still a world away from Freud's patient and concentrated scrutiny, his slow accumulation of observed lines and stylized hatchings. Where Freud spent weeks and months on a portrait, Bacon talked during these years about images being handed to him ready-made, dropping into his mind, one after the other, like slides.

AT MIDCENTURY, BACON HAD entered his most fertile, innovative period. To those who looked on, he seemed capable of producing almost anything. He was enjoying his first public successes, attracting the attention of galleries, critics, and fellow artists. He had taken to painting heads, blurred, in shades of gray, against vertically striated backgrounds that evoked a strange, ambivalent space. These ghostly stripes called to mind both the hatched backdrops in the late pastels of Degas (an artist both Freud and Bacon revered) and the rows of vertical searchlights used by Hitler at his Nuremberg rallies. Bacon's work was full of such lurching, discordant allusions.

Soon, inspired by Diego Velázquez, he was painting variations on the Spaniard's famous portrait of Pope Innocent X. His ambition, he said, was "to paint like Velázquez but with the texture of a hippopotamus skin." He became obsessed with wide-open mouths, screams, and snarls, both human and animal (he saw no distinction), and he returned to these motifs again and again. "I like, you may say, the glitter and color that comes from

the mouth," he later told his friend, the art critic David Sylvester, "and I've always hoped in a sense to be able to paint the mouth like Monet painted a sunset."

Freud, too, was beginning to get more attention. In Paris, he moved in exalted circles. He became friendly with Diego Giacometti, and spent long hours conversing with his brother, the sculptor Alberto Giacometti, who did two drawings of Freud, now lost. He mixed with the likes of Picasso; Balthus; Marie-Laure de Noailles (the patron and friend of Salvador Dalí, Man Ray, and Jean Cocteau); Boris Kochno, the poet, dancer and librettist; and Kochno's lover and collaborator, Christian Bérard, whom Freud drew—a tour de force of torpidity—six weeks before Bérard collapsed during a rehearsal of a Molière play and died.

For all these connections the young Freud had Peter Watson's introductions to thank—but also, no doubt, his illustrious name, his looks, his electrifying manner. Back in London, too, he had a hypnotic effect on people: John Russell remembered Freud living during these years "with an absolute minimum of circumstantial baggage . . . Freud is not so much lawless," he wrote, "as a volatilizer of law: someone who dismisses the general rule as inapplicable and reacts to any given situation as if it were previously unknown."

DURING THIS PERIOD, Freud was still depicting dead things. He drew a dead monkey in 1950, one year after painting a dead squid oozing black ink alongside a spiky sea urchin. The following year, he moved on to painting a decapitated cock's head, with a floridly colored comb. But the challenge of depicting living and

breathing subjects over indeterminate durations was, increasingly, exerting a pull on him. In 1951, on a large rectangular canvas provided by the Arts Council, Freud painted *Interior in Paddington*, his most ambitious painting to date. It was a full-length portrait of his old friend Harry Diamond. It shows the bespectacled Diamond standing on cheap red carpet, dressed dissonantly in a trench coat. He holds a cigarette in one hand and has the other firmly clenched. The fist—like Kitty's swollen eyes—puts the whole painting on high alert. It draws every closely scrutinized detail (the undulations in the carpet, the palm's dying fronds, the stray lace on Diamond's shoe) into a single moment brimming with menace. The effect was so close to the simmering tension—always on the cusp of exploding into room-wrecking fury—in certain portraits by Ingres (especially those of Monsieur de Norvins and Monsieur Bertin) that Herbert Read that same year dubbed Freud "the Ingres of Existentialism."

Interior in Paddington was Freud's first big studio picture, his first concerted attempt at converting the intensity of his smaller portraits to a bigger scale.

In 1951, Bacon's world was upended. His beloved Nanny Lightfoot died while he was away gambling in Monte Carlo. Guilt-ridden and disoriented, he reacted with an extremity that surprised everyone.

"Francis looked as if he wanted to die," remembered Wishart. He put an end to his long-standing relationship with Eric Hall. He sold the remaining lease on the Cromwell Place studio to another painter. And for the next four years, he was basically on the run. He moved for a while into a house shared with the artist Johnny Minton. Between 1951 and 1955, he occupied at least eight different places.

IT WAS EARLY ON in this period—still 1951—that a fascinating little exchange took place between Freud and Bacon. Each artist made his first attempt at portraying the other. The challenge provoked each to try something new. The immediate results were clumsy, and even discouraging. But for both men, it seems, the intimacy of the exchange, and the latent competitiveness it aroused, opened up a new path forward.

It's safe to say that no famous painter ever depicted a fellow painter in a pose quite like the one adopted by Bacon in the three rapid sketches Freud made of him in 1951. They show Bacon [see Fig. 2] with his collared shirt open, his hands strangely hidden behind his back, and his hips thrust forward. His trousers

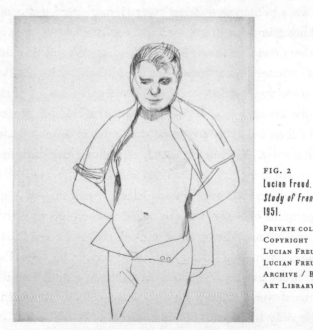

FIG. 2
Lucian Freud.
Study of Francis Bacon.
1951.

PRIVATE COLLECTION.
COPYRIGHT
LUCIAN FREUD /
LUCIAN FREUD
ARCHIVE / BRIDGEMAN
ART LIBRARY.

are suggestively undone at the fly, and they're folded down at the waistline to reveal a hint of underwear and a vulnerable belly.

According to Freud, Bacon himself had adopted the pose, saying, "I think you ought to do this because I think it's rather important down here." Never keen on directing his models' poses—most of the time, they simply took up whichever pose felt most natural or comfortable—Freud nonetheless enjoyed letting his more extroverted models indulge their various whims. In the 1990s, for instance, he painted the Australian performance artist Leigh Bowery in an array of unlikely positions, including one in which Bowery lay on the wooden floor of Freud's studio, propped up by a pile of paint rags, with one leg elevated on the bed, his large penis dangling across his thigh. (Extroverted, gentle-mannered, and reliably outrageous in public, Bowery was in some ways, perhaps, a stand-in later in Freud's life for Bacon.)

Looking at Freud's three sketches of Bacon, each one close in spirit to the others, you can feel something uncharacteristic entering his manner. What stands out most is the swift swoop of Freud's drawing arm as he tries to define the arabesques of his friend's flanks. There's something not quite right about the results: The lines are really too sinuous, and Bacon's torso is improbably slender. His eyes, in the only one of the three drawings in which they are visible, look hooded and docile in not quite the right way, and his mouth is flat and lifeless. Trying to loosen up, to channel some of Bacon's louche painterly energies and arrive offhandedly at something more stalked and intimate, Freud found himself fumbling. This sort of thing was not his forte. But the very attempt to try something new—to try on his friend's clothes, as it were, and see how they fit—tells us something about the sway Bacon was beginning to hold over Freud. To-

gether, what's more, the drawings generate a fascinating little microclimate of contending weather—sexual, artistic, and interpersonal.

AT THIS TIME, ACCORDING to David Sylvester (who was living in the apartment directly below Bacon and Minton), Freud "clearly had a crush on Francis." He was sensitive to it because, by his own admission, he did, too: "We both copied Bacon's uniform of a plain, dark grey, worsted double-breasted Savile Row suit, plain shirt, plain dark tie, brown suede shoes," he said.

Emboldened, perhaps, by Freud's own drawings of him with his pants open, Bacon asked Freud to pose for him in his studio. The painting that resulted turned out to be the first named portrait in Bacon's oeuvre. For this reason alone its significance is huge: Portraiture would be at the heart of Bacon's mature art. From the mid-1960s, when his reputation was peaking, by far the majority of his paintings were portraits of a small number of intimate friends (just as Freud's already were, and would continue to be).

Was this a sign that Freud's approach to painting was beginning to exert a pull on Bacon, just as he was clearly influencing Freud? It's hard to say. Finding evidence of Freud's influence on Bacon has never been as straightforward as identifying the influences going the other way. That's mostly because Bacon became famous decades before Freud. Freud spoke openly about Bacon's effect on him. But Bacon—who was keen to establish his own pedigree and whose acknowledged models (Velázquez, Ingres, Soutine, van Gogh, Picasso) were exclusively Continental—had no reason to acknowledge the influence of a younger, provincial

protégé with whom he subsequently fell out, and whose name would barely have registered with international critics and art historians in any case. But Freud had, and would always have, an impact on almost everyone who knew him. He was anarchic, amoral, and fundamentally selfish; but he had a captivating gift for intimacy. "To be with him in his company is like sticking your finger in an electric socket and being wired up to the national grid for half an hour," said Louise Liddell, a framer who sat for him years later. Bacon was not immune to his effect.

"When I was younger," Bacon later said, "I needed extreme subject matter for my paintings. Then, as I got older, I realized I had all the subjects I needed in my own life." It may well have been Freud, with his nose for the potential for anarchy within intimacy, who helped him arrive at this realization. Certainly, Bacon's focus, from this time forward, on constantly reiterated portrayals of a small group of intimate acquaintances strongly suggests the influence of the younger man.

WHAT WAS UNEXPECTED ABOUT Bacon's first named portrait (although it set a pattern for the future) was that, when Freud arrived, he found the painting of him already on the easel—*and almost finished*. In it, a full-length figure in a gray suit leaned against a blurred suggestion of wall [see Fig. 3]. A flat black shape, like a photographer's shadow in a holiday snapshot, entered the frame from below. The figure's (nominally, Freud's) arms and feet were fudged (the articulation of joints was never Bacon's forte), and he had pinlike eyes and a bland, meaty chin that in no way resembled his.

It turned out that, in lieu of Freud himself, Bacon had used a

FIG. 3
Francis Bacon. *Portrait of Lucian Freud.* 1951 (oil on canvas) / Whitworth Art Gallery. The University of Manchester. UK / Bridgeman Images.

© THE ESTATE OF FRANCIS BACON. ALL RIGHTS RESERVED / ARTISTS RIGHTS SOCIETY (ARS), NEW YORK / DACS, LONDON.

visual trigger—a photograph, as it happened, of a young Franz Kafka that had been used as a frontispiece to the first edition of Max Brod's biography of the writer. What Kafka had to do with Freud is impossible to say and perhaps not really the point: It was a question, instead, of unconscious, almost random suggestion.

The portrait is nothing special. It barely hints at the lavish distortions and ardent injuries Bacon would later inflict on his subjects, all in an attempt to convey what he liked to call "the brutality of fact." What mattered was what it revealed about Bacon's attitude to his subjects—an attitude that, for now at least, was completely at odds with Freud's.

Bacon was interested in capturing what he called "the pulsa-tions of a person." It was an idea that profoundly affected Freud, who later spoke about the effect people make in space and about his desire to try to paint the air around his sitters as much as the sitters themselves: "The aura given out by a person is as much a part of them as their flesh." But Bacon was also very open about the fact that he found the presence of sitters in his studio distract-ing. He preferred to paint alone. "This may be just my own neu-rotic sense," he later told Sylvester, "but I find it less inhibiting to work from them through memory and their photographs than actually having them seated there before me."

Over the years, he found various, always beguiling ways of explaining this preference. When, for instance, Sylvester asked him whether he was saying that the process of painting was "al-most like the process of recalling," Bacon fervently agreed:

"I am saying it," he said. "And I think that the methods by which this is done are so artificial that the model before you, in my case, inhibits the artificiality by which this thing can be brought back." The subject's presence inhibited him, he said, because "if I like them, I don't want to practice before them the injury that I do to them in my work. I would rather practice the injury in private by which I think I can record the fact of them more clearly."

What was the source of Bacon's compulsion to inflict "in-jury" in his paintings? Any definitive answer would surely be pat. It's clear, however, just from looking at them, that Bacon's distortions of conventional likeness, effected via the circuit breaker of photography, communicated a deep ambivalence. This ambivalence—not just "mixed feelings" (the phrase sug-gests dilution) but actively opposed feelings—was at the heart of

Bacon's view of friendship and of love itself. Real friendship, he once said, was "a situation where two people could tear each other to bits." His gorgeous smears and violent swipes of paint amounted, as David Sylvester put it, to "both a caress and an assault." In conversation with Sylvester in the 1960s, Bacon even dredged up Oscar Wilde's famous formulation—"you kill the thing you love"—which was itself merely another version of Degas's diary entry: "The people you love the most are the people you could hate the most."

In the context of his relationship with Freud, the idea of portraiture as an injurious act has specific and ongoing relevance, since Bacon kept on painting images of Freud over several decades. What's notable about all these portraits, according to Peppiatt, is Freud's "unusual resilience and energy":

"Whereas several of Bacon's favorite male sitters . . . seem on the point of succumbing to his furious onslaught of brushstrokes, Freud typically appears to withstand the worst, rearing up through paint attacks—dazed and confused but indomitable."

THE PHOTOGRAPHS BACON WORKED with were not always of the sitter. The more vital source might be a photograph of an animal; it might be a suggestive film still; a trampled reproduction of an old-master painting; an image of an injury in a medical textbook; or a sequence of photographs by Eadweard Muybridge, the pioneer of stop-motion photography. And it wasn't only preexisting photographs Bacon worked from. He also commissioned photographs of prospective subjects from his friend and drinking companion John Deakin. A failed painter, Deakin was superbly effective behind the camera. His photographic por-

traits of the denizens of Soho in the 1950s, which were retrieved from under his bed when he died, many of them torn and tattered, the negatives unidentifiable, have become classics. They have the impact, as his friend Daniel Farson wrote, "of a prison mug shot taken by a real artist." They were images "to recoil from, brutal portraits—intimate close-ups of the face—emphasizing every blemish."

Deakin had his friends, but he was also widely loathed. George Melly, the Surrealist and jazz aficionado, memorably described him as "a vicious little drunk of such inventive malice and implacable bitchiness that it's surprising he didn't choke on his own venom."

But Bacon was attracted by malice. And over several years, Deakin took more than forty portrait photographs at Bacon's behest. To create the psychological effect of having encountered them at random, Bacon liked to work from them after they had been ripped or torn and allowed to settle, like dead leaves, into the trammeled mulch of his filthy, paint-splattered studio floor.

LIKE MANY OTHER MODERN ARTISTS, Bacon was convinced he had seen through "the lie of realism"—even the kind of sophisticated urban realism invented by Manet and Degas in the latter half of the nineteenth century. Realism's pretense at disinterested truth-telling, its slavish fidelity to appearances—these things were of dubious value, he believed, in the more extreme and fragmented circumstances of the twentieth century. A conventional portrait of a face could scarcely convey movement, let alone the gamut of psychological sensations, the human sense of mortality, the apprehension of futility, and of the nightmare of

recent history—all those things that Bacon saw as fundamental
to the modern condition, and therefore more "real" than appear-
ances. Bacon was obsessed by the question of how to communi-
cate these things. Inspired in part by Picasso and Matisse and the
Surrealists, he spoke about distorting the image in an effort to
bring about a greater sense of truth. Instead of painstaking ob-
servation over hours, days, and months, like Freud, he liked the
idea of ambush. He wanted, wrote Russell, "to bait the trap, in
such a way that conventional 'likeness' at first sight seems ex-
cluded, only to be caught unawares at a later stage."

"Tell me," Bacon later asked Sylvester, "who today has been
able to record anything that comes across to us as a fact without
causing deep injury to the image?"

Freud may have been influenced by this kind of talk. But he
was still wedded to appearances. He remained adamant, *contra*
Bacon, that appearances *were* connected to truth; or at least that
the effort to record them as faithfully as possible—the artist and
the model in the same room, hand and eye, feeling and instinct,
all working in concert—carried its own charge of truth. It was in
this matter—the use of photography, the presence or otherwise
of the sitter—that Freud put up his most strenuous resistance to
Bacon's tremendous, potentially overwhelming influence.

For Freud, a successful painting was always the record of a
relationship *in process*. It was a transaction, as he later put it. It
could go on for months, even years: Duration was what enriched
it. Yes, the painter was ultimately in control; but the process de-
manded shifting degrees of domination and yielding from both
parties. ("In a culture of photography," he would later say, "we
have lost the tension that the sitter's power of censorship sets up
in the painted portrait.") What mattered to Freud about painting

in the presence of a model was "the degree to which feelings can enter into the transaction from both sides. Photography can do this to a tiny extent, painting to an unlimited degree."

It wasn't until later that Freud articulated these instincts, but they were already at the core of his creative convictions. They were insights he had held close for years, ones that he knew he couldn't let go of. But he sensed, in the way he acted on them, a limitation. He had an inkling—a useful one, as it turned out—that Bacon's more radical approach might hold the key to overcoming it.

WHEN FREUD CONVINCED BACON to sit for his famous small portrait, the idea (this, at least, is how he seems to have sold it) was to hang the finished work in Wheeler's, the Soho fish restaurant where Bacon liked to hold court. Freud wanted to paint him, he remembered the year before his death in 2011, "not just as an art world person, but as . . . I don't know . . . as a friend, I suppose. I have often painted people because I want to know them."

Bacon was willing. The process took about three months, working every day—not "particularly long," as Freud later acknowledged; his mature portraits could take a year or more. His idea of portraiture was all to do with slow and patient scrutiny, steady accumulation of life-like detail, and the most fastidious attention to atmosphere and mood.

It was a trial for Bacon, who was temperamentally unsuited to posing. "I can hardly sit down for long," he told Sylvester. "I've never been able to sit in a comfortable chair . . . It's one of the reasons I've suffered all my life from high blood pressure. People say: Relax! What *do* they mean? I never understand this

thing where people relax their muscles and they relax every-
thing—I don't know how to do it."(Compare this with Freud,
who later in his life said: "My idea of leisure was to do with that
luxurious feeling of having all the time in the world and letting it
pass unused.")

Bacon's simmering volatility is, of course, exactly what Freud
managed to get over in the finished portrait. It's the source of its
startling force. But getting the thing done—three months of sit-
tings, for several hours each day—cannot have been easy, for
either artist or sitter. Freud remembered much later that Bacon
"complained a lot about sitting—which he always did about
everything—but not to me at all. I heard about it, you know,
from people in the pub." And it really was a case of sitting: Freud
sat so close to Bacon that their knees touched. All the while
Freud rested the copper plate on his lap. It's hard to imagine a
more charged situation. All the more so when you consider what
Bacon at this point meant to Freud.

THE PICTURE WAS COMPLETED, but it never went to Wheel-
er's, because, before the end of 1952, it was purchased by the
Tate, along with Freud's other early masterpiece, a portrait of
Kitty called *Girl with a White Dog*.

A photograph Deakin took of Bacon later that same year sug-
gests that Deakin saw Freud's portrait of Bacon in progress. Like
Freud's small picture, the photograph is a close-up of Bacon's
head, lit from one side in just the same way. Both photograph
and painting are cropped in exactly the same places, except that
Freud's portrait includes Bacon's full head of hair, whereas Dea-
kin's photograph cuts off just above the hairline.

"I like my picture of Francis Bacon enormously," said Deakin, "perhaps because I like him so much, and admire his strange, tormented painting. He's an odd one, wonderfully tender and generous by nature, yet with curious streaks of cruelty, especially to his friends. I think that in this portrait I managed to catch something of the fear which must underlie these contradictions in his character."

The syntax is not Freud's—he never spoke so plainly—but the thoughts expressed could almost be his. What is Freud's stolen portrait of Bacon, anyway, if not a "a prison mug shot taken by a real artist"?

BACON'S HOUSEMATE JOHNNY MINTON saw Freud's portrait of Bacon before it went to the Tate. Impressed, he commissioned Freud to paint him, too. Minton had a long face with thick, unkempt hair and dark, suffering eyes. His relationship with Bacon was vexed. He was talented. He had earned some early notice as a painter, and was well regarded for his distinctive illustrations, which graced the covers of Elizabeth David's first two books on cooking. He was a respected teacher at the Royal College of Art, too. But his reputation as an artist was already in eclipse as Bacon's was beginning to take off. His self-belief was eroding by the month, and he was hobbled by jealousy. "I am sure he watched Francis's ascendency with despair," wrote Farson.

With his forceful personality and deep vein of ambition, Freud was to some extent insulated from too much envy. He liked and admired Bacon too much to let his friend's success eat away at him. He was younger, too—which helps. He must have watched the dynamic between Bacon and Minton play out with

considerable fascination, making mental notes about what to avoid in his own relationship with Bacon. Painting Minton at this juncture was, apart from anything else, perhaps a way to watch the situation more closely.

Bacon and Minton, attention-seekers both, found themselves competing for the limelight, "holding court at opposite ends of [the Colony Room], vying with each other in rounds bought and general outrageousness," according to Peppiatt. At least one of these evenings ended with Bacon pouring champagne over Minton's head. Minton behaved as if he were ashamed of his commercial success and of his inherited wealth. "Let's spend the rest of my trust fund!" he liked to declare as he bought rounds in Soho.

When Freud painted Minton, he portrayed him with a long and horsey face, glassy-eyed with despair. He had come off the worse in his competition with Bacon, and he gradually succumbed to alcoholism and psychic ruin. Within five years of Freud's portrait of him, he was found dead in his own home. He had swallowed a pile of sleeping pills.

IT WAS STRANGE AND NO DOUBT disorienting to both men that, just as their own relationship reached a point of maximum intimacy and intensity, Freud and Bacon found themselves embarking on amorous relationships that were to be the most important, the most destabilizing, the most transformative in each of their lives. These relationships—Freud's with Caroline Blackwood, Bacon's with Peter Lacy—began in the early 1950s and took both artists right to the edge of their own self-knowledge,

upturning earlier assumptions and sparking self-destructive, almost suicidal reactions.

Love life, despite the biographers' best efforts, is impregnably private. But love affairs do have observers, attendants, concerned and involved bystanders. And just as Freud's relationship with Blackwood had, in Bacon, its hovering bad angel, Bacon's affair with the ex-fighter-pilot Peter Lacy was observed, at a more measured, oblique, and baffled distance, by Freud.

"Caroline was the great love of Lucian's life," said Anne Dunn, who was intermittently involved with Freud throughout this period. "With Caroline he behaved terribly well. Very unusual. He didn't love any of us. He must have known that she loved him," she added, "which was a great thing." Strangely, however, and despite their five-year love affair—including four years of marriage—Freud conceded later that Caroline remained to some extent impenetrable to him. "It sounds ridiculous in a way," he told me, "but I never really knew Caroline that well."

Freud cherished what was unknown and unknowable about people, even as he was constantly drawn to greater and greater extremes of intimacy. "When you find something very moving," he told Feaver, "you almost want to know less about it. Rather like when falling in love you don't want to meet the parents."

Caroline's mother was the brewery heiress Maureen Guinness. Her father, the fourth Marquess of Dufferin and Ava, was killed in action in Burma in 1945. The widowed marchioness

had just taken over as director of the Guinness brewery when her daughter's affair with Freud began.

Smart, shy, and verbally adroit (she went on to be an acclaimed author), Blackwood worked as a secretary and occasional writer at the Hulton Press, which published *Picture Post*, a gossip-and-glamour magazine with a political bent. Still in her teens, she was delicate and mercurial, with a hint of quick-witted street urchin under the inviolate veneer of her good breeding. "She wasn't easy socially—everything was in little jerks and silences," said her friend, the magazine editor Alan Ross. "She was a louche, skittish sort of girl . . . She wasn't usually wooed by people."

Freud, despite his strain of theatricality, was just as shy, just as skittish, but he did woo her. They had first met at a formal ball given by Ann Rothermere. Ann, who had sat for a portrait by Freud in 1950, led a privileged and provocative life. She had married the second Viscount Rothermere—Esmond Harmsworth—the owner of the *Daily Mail*, after her first husband was killed in action in 1944, but she had been conducting a long-running affair throughout this period with Ian Fleming, a stockbroker who had worked in naval intelligence during the war and was on the verge of creating the fictional character James Bond. From about 1948, Ann spent part of each year in Jamaica, ostensibly staying with her friend Noël Coward, but for the most part taking up residence with Fleming. The affair was discovered by her husband in 1951; they divorced, and the following year, Ann—now pregnant by Fleming for the second time (their first child was stillborn in 1948)—married Fleming in Jamaica. In the meantime, she had established herself as a society hostess at Warwick House, off Green Park in central London. Seemingly immune to

the privations of the postwar period, she threw glittering parties where aristocrats mingled with selected representatives of the new bohemian crowd, including Freud and Bacon.

She had taken a particular shine to Freud, despite Fleming's distrust of him (he suspected, wrongly, that Freud and Rothermere were having an affair). She "asked me to one of those marvelous parties," remembered Freud, "semi-royal, quite a lot of them were there, and she said, 'I hope you find someone you'd like to dance with,' and that sort of thing. And then suddenly there was this one person and that was Caroline."

More than half a century later, when asked what had caught his eye about Blackwood, Freud said: "She was just exciting in every way and was someone who had taken absolutely no trouble with herself, looking like she hadn't had a wash. But then someone actually said that she hadn't. I went up to her and I danced and danced and I danced and danced."

Soon after, early in 1952, Freud began dropping in on Blackwood at the Hulton Press offices. Behind the scenes, and despite Freud's marriage to Kitty, Rothermere encouraged the liaison.

Bored, restless, enfolded in a fraying aura of childhood privilege and damage, Blackwood was susceptible to Freud's lawlessness. She had a self-centered streak that made her indifferent, and often actively opposed, to others' expectations. That included her mother, who did all she could to sabotage the relationship.

Blackwood recognized a similar trait in Freud. She "had never met someone as exotic and dangerous-seeming as Lucian," wrote Ivana Lowell, her daughter by the British screenwriter Ivan Moffatt. Blackwood herself described Freud as "fantastic, very brilliant, incredibly beautiful, though not in a movie-star

way. I remember he was very mannered, he wore these long side whiskers, which nobody else had then. And he wore funny trousers, deliberately. He wanted to stand out in a crowd, and he did."

The world Freud now entered was new to him. If he was intoxicated by Caroline, he was also slightly intimidated by her milieu. When he accompanied Blackwood and her mother on a shooting trip in Ulster, the other guests included Lord Wakehurst, who had just ended his stint as the (last) British governor of New South Wales and was now the governor of Northern Ireland, and Viscount Brookeborough, the prime minister of Northern Ireland. On that trip Freud struck Caroline's sister, Perdita, as "so shy he couldn't look anyone in the eye. He stood with his head down, eyes darting from side to side."

Freud was not merely an artist and bohemian, of course; he was Jewish. And this—even if his name was Freud—was not to his advantage in the highborn circles in which he now began to move. At one point, early in the relationship, Blackwood brought him to a party at her mother's house. Winston Churchill's son Randolph saw them enter the room, and yelled, "What the bloody hell is Maureen doing, turning her house into a bloody synagogue?" The young couple chose not to react. But the next time Freud ran into Churchill he knocked him down with a punch.

FREUD'S AFFAIR WITH BLACKWOOD soon caught fire. They were harassed by Blackwood's mother, who was doing everything in her power to obstruct the relationship. So they ran off to Paris. They stayed in the run-down Hôtel La Louisiane on the

rue de Seine. Freud painted *Girl in Bed* [see Plate 4], one of several beautiful portraits of Caroline he made that year. Another was *Girl Reading*. In both pictures—and *Girl Reading* especially—you feel artist and subject could not get closer. Blackwood's brow blushes purple, as if bruised by Freud's ardent proximity.

"I felt that the only way I could work properly was using maximum observation and maximum concentration," he later recalled. "I thought that by staring at my subject matter and by examining it closely I could get something from it. I had a lot of eye trouble, terrible headaches because of the strain of painting so close."

The strain would get to him, forcing him to seek new paths forward. But for now what mattered was that Freud's youthful mannerisms were dissolving in a potent new solution: amorous intimacy. He was in love—obsessively so. He later said that he remembered "the obsession more than the person." But Caroline was under his skin, and taking up so much of his mental and emotional life that it was hard for him to work. "I couldn't think about anything else."

It was an intimacy that had something of the secret garden, or the locked hotel room, about it. But it couldn't be prevented from spilling over into other lives. Blackwood had been cut off from her family's money and Freud had also run out. Finding themselves unable to pay the hotel bill, they tried to get Cyril Connolly and his wife, Barbara Skelton, to buy *Girl Reading* when it was finally finished. Connolly, a contemporary of Blackwood's late father, had been one of Freud's earliest supporters. But he had also developed an older man's crush on Blackwood and seemed to want the painting as a kind of talisman. So, against his wife's initial objections, he bought it. He also confessed his

infatuation—which, although it had been persistent and inconvenient, was never going to be reciprocated—to his wife. This precipitated the unraveling of his marriage to Barbara, who left him for the publisher George Weidenfeld. It also contributed to the outside pressure that now began to build on Blackwood and Freud.

THAT PRESSURE INCREASED ANOTHER notch after a disconcerting episode in Paris that Freud liked to recount later in life. Having met Picasso on previous trips, he now took Blackwood to the master's studio on the rue des Grands-Augustins. "Caroline's nails were always bitten down, as much as possible," he explained. When he introduced her to Picasso, he continued, "Picasso looked and he said, 'I'm going to do some drawings on your nails.' He did black ink drawings on them—heads and faces and things. Then he said, 'Would you like to see the flat?' There were at least two floors in the rue des Grands-Augustins. So Caroline went off and shuffled back maybe a quarter of an hour or twenty minutes later. I said to her afterwards, 'Tell me what happened.' She said, 'I can never, ever tell you.' So I never asked her again."

Blackwood remembered it differently in a 1995 interview with Michael Kimmelman. She claimed it was Picasso who made the initial contact, inviting Freud through an intermediary to come and see his paintings. Freud accepted, and brought Blackwood with him. After a while Picasso invited her to see his doves on the roof, which were reached by an exterior spiral staircase. So "off we go," she recounted, "winding round and round to the top, until we reached these doves in cages and all around was the

best view of Paris, the best. Whereupon immediately, standing on this tiny, tiny space, way above the city, Picasso does a complete plunge at me. All I felt was fear. I kept saying, 'Go down the stairs, go down.' He said, 'No, no, we are together above the roofs of Paris.' It was so absurd, and to me Picasso was just as old as the hills, an old letch, genius or no."

Blackwood's own recollection was inflected by a sort of comedic dismay. "What were we supposed to have done if I accepted?" she wondered. "There was no space to make love, with all those doves. And think how many other people he had up there. Did they go through with it? And technically, how did they go through with it? And with the husband downstairs?" Later on, she continued, "Lucian got a call out of nowhere from a mistress of Picasso's who asked him if he [Lucian] could come round and paint her. She wanted to make Picasso jealous. Lucian very politely said maybe he could paint her portrait later, but not now because he happened to be in the midst of doing his wife's portrait." (In fact, they weren't yet married.)

The picture in question was *Girl in Bed*.

FREUD WAS ABOUT TO turn thirty. His emotional life was in turmoil, as were the lives of those closest to him. Kitty was pregnant with their second daughter, Annabel, who was born later that year. But their marriage had fallen apart. *Girl with a White Dog* would be the last picture he made of her.

And so now, as if wanting to come to grips with the person who was at the center of so much turmoil, so much ardor, such confusion, he embarked on a self-portrait. Over a rough sketch in charcoal, he began painting in oil paints, working from the inside

of the image—the eyes, nose, and mouth—out. He showed himself with one hand held up to his mouth—a gesture of thoughtful hesitation, one that Edgar Degas had favored in several self-portraits and portraits of others at a similar point in his career.

The paintwork is looser, less evenly distributed than in almost all his pictures up to that date. But it is hard to tell if Freud meant it to stay this way: He abandoned this exercise in self-scrutiny before it was finished.

In December 1952, just before his thirtieth birthday, Freud took up an invitation from Ann Rothermere—now Ann Fleming (she had married Ian Fleming in March that year)—to cross the Atlantic. It was Freud's second crossing: The first had been during the Second World War when, as a volunteer teenage sailor in the Merchant Navy, his convoy had come under attack by Germans. This time, instead of Newfoundland, where the wartime convoy had ended up, he took a boat to Jamaica and stayed for several months at Fleming's villa, "Goldeneye." He took to painting banana trees and other outdoor plants while Fleming worked inside on his first James Bond novel, *Casino Royale*.

"I noticed I switched away from people when my life was under particular strain," he later explained. "Not using people is like taking a deep breath of fresh air."

While he was away in Jamaica, Blackwood's mother, still trying to thwart the affair, and also wanting Caroline out of the country for the coronation of the young Queen Elizabeth II (Caroline had been snubbed as a maid of honor), had sent Caroline to Spain. She took up work as a tutor teaching English in Madrid, and her address was kept from Freud. But he was not to be deterred. He went to Madrid and began looking, with very

little to go on. "All I knew was she was in Spain and I had the number of the door but not the street name. I knew I would find her."

The divorce from Kitty came through, and Blackwood and Freud were officially married at the Chelsea Register Office on December 9, 1953, one day after Freud's thirty-first birthday. FREUD'S GRANDSON WEDS announced the notice in the newspaper.

"We got married because Caroline said she would feel less persecuted," Freud explained, decades later. "And there was a technical reason. She had a bit of money from her father and she couldn't get that if she was living in sin."

For a time, all seemed intoxicating, incandescent. The two were in love. Freud was succeeding as an artist, earning recognition and admiration from many who mattered, in both London and Paris. Under the spell of Bacon and his gusting sociability, life was rich, unpredictable, fraught with poignant hilarity. The war and its long aftermath were receding as society was swept up in change. Freud and Blackwood were the most beautiful, alluring, enigmatic couple in town. They lived above a restaurant in a run-down Georgian house on Dean Street in Soho, from where Freud would go to his Paddington studio at the crack of dawn. Caroline, who had access once more to her family's money, bought Freud a sports car as an engagement present. They also bought an old priory near Shaftesbury in Dorset—"a beautiful old building beside a large black lake," as Michael Wishart remembered it. Freud kept horses at the priory. He bought a lot of marble furniture. He embarked on a mural of cyclamen, and—his most ambitious picture yet—a double portrait of Caroline

and her sister Perdita. Both paintings—an ominous sign—were abandoned at an early stage.

Blackwood's wealth, combined with her independence and unpredictability, were all part of her attractiveness. Freud had been financially dependent on Bacon for so long, and now very much liked the idea of reciprocating—with her help: "I know I asked her for some money to give to Francis to go to Tangiers," he recalled. "I explained I had a friend who was always giving me money whenever I wanted it and that now I would like to do the same for him as he's met someone special out there." Not only did she give it, she then said, "Is there anything else you really want?"

Bacon's "someone special out there" was Peter Lacy.

IN 1952, THE SAME YEAR that Freud fell in love with Blackwood, Bacon met an ex–RAF Spitfire pilot called Peter Lacy. He had fought in the Battle of Britain. His nerves, Bacon later claimed, were shattered as a result. He was "terribly neurotic—hysterical even."

They met in the Colony Room. Dashing and stiff-jawed, with dark circles under his eyes, Lacy played George Gershwin and Cole Porter tunes on a white piano in a nearby bar, the Music Box. Bacon fell immediately in love. He adored Lacy's looks ("the most extraordinary physique—even his calves were beautiful"), his piano playing, his innate sense of futility (the product, believed Bacon, of his having inherited money), and his humor: "He could be wonderful company . . . He had a real kind of natural wit, coming up with one amusing remark after another, just like that." But above all, he sensed danger in Lacy; the

possibility of being with someone who might utterly dominate him, as no one since his father had done.

Bacon was already over forty, but he claimed that for the first time he had fallen in love. Lacy "really liked" younger men, he said, and didn't seem to realize that he, Bacon, was actually older. "It was a kind of mistake that he went with me at all."

The two men drank heavily together, goading each other on. Lacy could put away three bottles of spirits in a day. He had a house in Barbados, which Bacon painted from a photograph, at Lacy's request, the year they met. The style of the rendering, as dictated by Lacy—who had no time for Bacon's painterly distortions—is blandly conventional. (Bacon actually had to ask a painter friend for advice on the rules of perspective.)

For four years, from 1952, Lacy rented a house called Long Cottage, in a small village near Henley-on-Thames. He invited Bacon to stay with him. When Bacon asked him how the arrangement might work, he replied: "Well, you could live in a corner of my cottage on straw. You could sleep and shit there." According to Bacon: "He wanted to have me chained to the wall." Lacy also had a collection of rhino whips—props in a theater of sadomasochism that frequently tipped over into chaotic reality.

Although Bacon spent a great deal of time at Long Cottage, he never fully moved in. The "arrangement" proved too heady and destructive even for him. Lacy, he said, "was so neurotic that living together would never have worked." In his rages, he would move on from doing horrendous damage to Bacon's person to destroying his clothes and even his paintings. For significant stretches, Bacon was immobilized. Unable to paint, he was overwhelmed by despair.

———

THROUGHOUT THEIR RELATIONSHIP, Bacon was with Black-wood and Freud more than they quite grasped. Blackwood later claimed that she and Freud dined with him "nearly every night for more or less the whole of my marriage to him. We also had lunch." Bacon's charismatic high spirits and his tragic, vulnerable aura tinted relations between his friends even when he was absent.

And he was never, it seems, entirely absent. One of his most brilliant and audacious paintings was hung prominently in the priory in Dorset. Titled *Two Figures,* but more commonly described—with wry affection—as *The Buggers* [see Plate 5], it was Bacon's first painting of a couple, and it was produced in 1953, during the second year of his affair with Peter Lacy. It was based directly on Muybridge's stop-motion photographs of wrestlers. At first, it resembles a mound of mangled bodies. But the setting is no wrestling arena. It's a bed, with white sheets, pillows, and a headboard.

Two Figures was a portrayal of Lacy and Bacon having sex. The two male figures' faces are blurred, evoking movement and a psychic urgency heightened by the bared teeth of the lower figure. Both faces are marked by the vertical lines that also divide the dark background, so that they evoke both prison bars and rows of searchlights pointing skyward. At a time when homosexuality was still very much illegal, and almost never depicted in art, it was an astonishingly raw, honest, and electrifying image. For many years, it was considered too confronting to display in public.

"The creative process is a little like the act of making love," said Bacon. "It can be as violent as fucking, like an orgasm or an

ejaculation. The result is often disappointing, but the process is highly exciting."

Two Figures was first shown in an upstairs room at the Hanover Gallery, and sold to Freud for £100. It was a painting he kept with him until his death. It hung upstairs in Freud's Notting Hill home alongside paintings by Frank Auerbach, and in the same room as a sculpture of a dancer splaying her legs by Degas. Many requests came from museums to borrow it for exhibitions. Freud agreed to lend it to the Tate's 1962 retrospective, but never lent it out after that, and it wasn't seen in public again.

BLACKWOOD WAS FOND OF BACON. She was beguiled by homosexuality in general, and also, of course, by the very particular instance of it that he represented. What's more, their backgrounds had a surprising amount in common. They had both had a horsey, Anglo-Irish childhood and detested fox hunting. They were extremely well read. And they both, in their different ways, had a nose for the abyss—a self-destructive streak.

Blackwood remembered Bacon arriving one lunch at Wheeler's straight from the doctor's: "He came rolling in with the confident walk of a pirate making adjustments to the slope of the wind-tilted deck," she wrote.

"He said that his doctor had just told him that his heart was in tatters. Not a ventricle was functioning. His doctor had rarely seen such a hopeless and diseased organ. Francis had been warned that if he had one more drink or even allowed himself to become excited, his useless heart would fail and he would die.

"Having told us the bad news he waved to the waiter and

ordered a bottle of champagne, and once we had finished it he went to order a succession of new bottles. He was ebullient throughout the evening but Lucian and I went home feeling very depressed. He seemed doomed. We were convinced he was going to die, aged forty. We took the doctor's diagnosis seriously. No one was ever going to stop him from drinking. No one would ever prevent him from becoming excited. We even wondered that night if we would ever see him again. But he lived to be eighty-two."

IN 1954, FREUD AND BLACKWOOD were again in Paris. They had been married less than a year, but something was going wrong. Freud was beginning to sense that Blackwood, for all her brilliance and beauty and wildness, might prove more than he could handle. "The thing is," observed Ross, the editor and poet who later became Blackwood's lover, "you had to be very loving to get the best out of her. I think otherwise you might find yourself in all sorts of chaos."

"It was the coldest winter in history," remembered Dunn. "Caroline was frozen, and depressed by then. She knew her marriage was starting to get unfixed at that time."

A Freud painting from 1954, *Hotel Bedroom*, suggests, if nothing else, the gravity of the young couple's predicament. Blackwood is shown in the foreground, lying in bed, enfolded in white, only her left hand emerging to press long, white fingers to her lips and sallow cheek. (Her whole body's pose eerily foreshadows Freud's much later series portraying his depressed, bed-bound, and freshly widowed mother.) The stalking, anxious

figure in the background, backlit by diffuse sunlight coming in through a large window, is Freud himself. Hands sunk in pockets, he looks haunted, at a loss.

Blackwood was prone to depression, and an incipient alcoholic. Her drinking, which blighted her entire adult life, began in earnest during these years with Freud, and especially in Soho—at the Colony Room, at Wheeler's, and at the Gargoyle. "She was very silent until drinking suddenly switched her on," claimed Ross, "and then she was very dramatic and over-elaborate in her conversation. But very funny."

Freud himself was never a serious, self-destructive drinker; remaining in control mattered too much to him. It was Bacon who led this dance—Bacon with his epic benders, his charisma, his compulsive generosity, all of which Blackwood found terribly seductive.

Neither husband nor wife had been faithful, although Freud's straying was, as usual, more egregious than hers. The collapse of a marriage—especially a marriage between two volatile personalities—is never straightforward. And yet Freud later said, in a typically sly construction, that "if there's such a thing as fault, putting it mildly it was completely my fault." Blackwood herself claimed that the main reason for the collapse of the marriage was Freud's gambling. It was an obsession that lasted decades. Freud was in thrall to it. Breaking even was the one thing he detested.

Even if Blackwood's claim is only partially true, it's certainly the case that Freud's whole mentality through these years was infected by Bacon's devotion to leading a life of chance. When Daniel Farson, who was part of the Soho circle, asked Black-

wood why her marriage to Freud had ended, she asked, "Have you ever driven with him?"

"Yes," he replied, "I was so terrified that when he stopped at a red light, for once, I threw myself out."

"Exactly," came Blackwood's reply. "That's what being married to him was like."

IT WAS BLACKWOOD WHO left Freud, rather than the other way around. She left their home one night and checked into a hotel. Freud was derailed. Nothing like this—nothing so painful—had happened to him before.

Freud responded over the next few years by gambling more than ever, getting into fights, and saying cruel things to Blackwood. Bacon was concerned for his welfare. He asked Charlie Lumley, a young, Cockney neighbor from Paddington, to watch him. He was afraid Freud would jump off the roof. "And so I had to sort of babysit him for a while," said Lumley.

Blackwood later married the Polish American composer Israel Citkowitz and then the poet Robert Lowell, with whom she had a famously tumultuous relationship. Lowell died—the story is often told—in a taxicab in New York in 1977. He was returning to his home after a final failed attempt to repair his relationship with Blackwood. When the driver arrived at his home on 67th Street, he couldn't be roused. A doorman summoned Elizabeth Hardwick, the writer whom Lowell had left for Blackwood many years earlier, but who lived in the same building. She found him slumped in the car, dead, but still clutching to his body Freud's portrait of her, *Girl in Bed*.

———

FOR BACON, THE YEARS between 1952 and 1956 were, according to his biographer, "four years of continuous horror, with nothing but violent rows." Bacon's whole relationship with Lacy, he said, "was the most total disaster from the start. Being in love with someone in that extreme way—being totally, physically *obsessed* by someone—is like having some dreadful disease. I wouldn't wish it on my worst enemy." And yet in many ways Bacon's creativity was stimulated by the unfolding debacle. Despite the turmoil, and the constant moving from house to house and studio to studio, these were the years that saw him truly come into his own as an artist.

He painted around forty pictures in 1952 and '53. Many more were destroyed, either by Lacy or by Bacon himself. He worked, as often as not, in series, painting sets of images that riffed on sphinxes, life masks of William Blake, and screaming heads, often set within transparent boxes and set off by Bacon's signature vertically striated backgrounds. The most celebrated of the series, the set of eight paintings of a pope, inspired by Velázquez, grew out of four abandoned attempts to paint from the critic David Sylvester. The series itself he painted in two weeks. With each picture, the pope's face grows less composed, more contorted with rage and despair. To some extent, it's clear, these are portraits of Lacy.

BACON WAS GAINING IN notoriety. He had his first New York shows in 1953. He wrote his first "manifesto," of sorts—an appreciation of the painter Matthew Smith that articulated many of

his own deeply felt convictions about art. Critics such as John Russell and Sylvester were beginning to write about his work. And collectors were buying it.

Bacon later claimed that Lacy hated his painting from the beginning. His vicious, obliterating tantrums were violent in ways that Bacon could neither anticipate nor steer. But this was precisely why he was so drawn to them. Whatever the reason—his sadistic father; his self-loathing; the simple, desperate need for a transporting loss of self—he yearned for humiliation, and for a total loss of control. It was only Lacy who could convincingly deliver all this.

It was never going to last forever. But Bacon was willing to sustain a huge amount of damage—including to his friendship with Freud—before it became untenable.

FREUD STRUGGLED FROM THE beginning to come to grips with Bacon's new relationship with Lacy. The more deranged and violent Lacy became, the more Bacon seemed to love him. It was a situation that confused and upset Freud. He wanted to understand. Ultimately, however, he couldn't.

On one occasion in 1952, Lacy, in one of his monstrous rages, threw Bacon through a window. Both men were drunk at the time, which may have saved Bacon: He fell fifteen feet and survived, but his face, especially around one eye, was badly damaged. The incident precipitated a quarrel between Bacon and Freud that Freud never forgot.

"When I saw Francis," he told me, still appalled by the memory half a century later, "one of his eyes was hanging out and he was covered in scars. I didn't really understand the relationship—

after all, you don't. But I was so upset seeing him like this that I got hold of [Lacy's] collar and twisted it around."

Freud wanted a fight, but Lacy didn't defend himself, and the challenge fizzled out. "He would never have hit *me* because he was a 'gentleman,'" said Freud—"he would never get into a fight. The violence between them was a sexual thing. I didn't really understand all this." But the upshot was that Freud, at least as he remembered it, didn't really talk to Bacon for about three or four years after that. "The truth is," he said, "Francis really minded about this man more than anyone."

BACON CONTINUED TO PAINT Lacy well after the incident that caused Freud to intervene. In a sense, all his pictures of the later 1950s were attempts to come to grips with him. Their relationship continued even after 1956, when Lacy moved to Tangier and found work playing the piano in Dean's Bar, the establishment opened in 1937 by "Joseph Dean" (formerly a cross-dressing rent-boy, hustler, and drug supplier called Don Kimfull). Tangier was an international haven, commodious to poets, painters, drug takers, criminals, spies, and novelists. When Bacon visited in 1956 and again the following year, he got to know William Burroughs and Allen Ginsberg, as well as Tennessee Williams and Paul Bowles. He took to going around town with the gangster Ronnie Kray, a paranoid schizophrenic who, with his brother Reggie, masterminded protection rackets and other criminal activities, including murder. Ronnie, wrote Peppiatt, "had taken a distinct liking to the ease of homosexual relations in the Arab port."

Bowles remembered Bacon at the time as "a man about to

burst from internal pressures." Lacy, meanwhile, had entered into a fatal pact with the sinister Mr. Dean: To pay off his bar bill, he was to play the piano until closing each night. For an alcoholic—and particularly for one with Lacy's prodigious capacity for self-destruction—this was surefire suicide. The longer he played, the more he ran up his bill, scuttling whatever hope he harbored of paying it off. By the time Bacon arrived for his first visit in 1956, wrote Peppiatt, "Lacy was already indentured to Dean's."

By 1958, Lacy's affair with Bacon was essentially over. But even as both men made full use of the availability in Tangier of other sexual partners, they were still emotionally, psychologically, and sexually intertwined, and the violence between them did not abate. More than once, Bacon was seen wandering the streets at night, badly beaten. At one point, the British consul was moved to intervene, notifying the police chief in Tangier of his concerns. After investigating the matter, the police chief reported back: "Sorry, Monsieur le Consul-General, but there's nothing to be done. Monsieur Bacon likes it."

In 1954, Freud and Bacon were both chosen—along with a third artist, the abstract painter Ben Nicholson—to represent Britain at the Venice Biennale, then as now the world's most prestigious and closely watched international showcase for contemporary art. It was a coup for both artists. The man responsible was the pavilion's commissioner, Herbert Read. Nicholson, who was in his late fifties, might have expected to attract the lion's share of esteem and attention, but he was relegated to a smaller, side gallery. Read, justifying the decision, claimed that

Bacon's "immense and gloomy" work required the large gallery's "cruel light." Even though his works were smaller and much less dramatic, Freud, strangely, exhibited in the same grand gallery alongside Bacon—although, at thirty-three, he was very much the junior partner. But the paintings he exhibited had their own strange force, and they were in many ways a distillation of the last three years of his life. Among them were two portraits of Kitty (*Girl with a Kitten* and *Girl with a White Dog*); one of Caroline and himself in Paris (*Hotel Bedroom*); a painting of a banana tree in Jamaica; *Interior in Paddington;* and the small, subsequently stolen portrait of Bacon.

For the occasion, Freud produced a written manifesto, titled *Some Thoughts on Painting.* It is the only statement of its kind in Freud's entire career. It was a young man's gambit (in his maturity Freud had little time for earnest public utterances)—but also, you suspect, a necessary and vital shoring up. At a moment when his own art was in a state of maximum flux, and most heavily under the sway of Bacon, he was choosing to set down in writing his deepest convictions. They doubled as ambitions, statements of intent.

Prepared initially for a BBC radio interview, and edited by David Sylvester, Freud's words were subsequently published in the July issue of Stephen Spender's magazine *Encounter.* They begin with the statement that his aim as an artist was to produce an intensification of reality. Something that was more than just "realistic," in other words. Everything Freud went on to write in this carefully constructed, highly self-conscious statement— which had none of Bacon's lightning wit or camp bravado— stressed heightened feeling, intimacy, the making known of secrets, and the primacy of truth-to-life over aesthetics.

Many of the statements echo Bacon: the idea, for instance, of giving "a completely free rein to any feelings or sensations." Or the linked notion that art will degenerate if it is not an unimpeded vehicle of the artist's "sensation." And just as Bacon defined art as "obsession with life," so Freud wrote: "A painter's tastes must grow out of what so obsesses him in life that he never has to ask himself what is suitable for him to do in art."

And yet, you also feel Freud fighting hard to etch out crucial differences. He insists, for instance, on keeping his subjects "under closest observation: if this is done, day and night, the subject—he, she, or it—will eventually reveal the *all* without which selection itself is not possible."

He also emphasizes the importance of putting himself "at a certain emotional distance from the subject in order to allow it to speak." In the wake of his long sessions with Caroline Blackwood in Paris, Freud was especially alive to the danger of letting his "passion for the subject overwhelm him while he is in the act of painting."

Bacon painted his portraits from photographs and from memory—the distance, the "slight remove," were crucial for him. Freud, by contrast, was and remained dependent on his models' presence over long periods of time. "The effect that they make in space," he said, "is as bound up with them as might be their color or smell . . . Therefore the painter must be as concerned with the air surrounding his subject as with that subject itself."

But, as if defending himself against the latent charge that his pictures were merely records of his intimate relationships, and that their appeal, as a result, was largely sentimental, Freud also stressed the importance of the autonomy of the finished work of

art—its ability to take on a life of its own. "A painter must think of everything he sees as being there entirely for his own use and pleasure. The artist who serves nature is only an executive artist. And since the model he so faithfully copies is not going to be hung up next to the picture, since the picture is going to be there on its own, it is of no interest whether it is an accurate copy of the model. Whether it will convince or not, depends entirely on what it is in itself, what is *there* to be seen. The model should only serve the very private function for the painter of providing the starting point for his excitement."

BEFORE HE MET BACON, Freud was talented, but in his art—as perhaps in his life—still prone to sentimentality and a kind of adolescent wish fulfillment. In the cauldron of his relationship with Blackwood, which ended in bitter disappointment, and of his relationship with Bacon, then embroiled in an amorous relationship so extreme that it burned away any vestige of romantic sentimentality, he learned the appeal of extremity, obsession, and ruthlessness.

Freud later claimed that his early "method was so arduous that there was no room for influence." But that had changed when Bacon came on the scene.

Bacon's influence touched everything. If his company triggered many changes in Freud's life, it also triggered a veritable, if slow-burning, crisis in his art. It affected not just Freud's method but also his feeling about subject matter and his fundamental sense of what, for him, was possible.

Since before Kitty, Freud's goal in portraiture had been to convey intimacy and attachment. That never changed. But his

way of conveying it did. Early on, he had figured that a uniform and painstaking fidelity to appearances could be enough to convey utmost absorption in his subjects. Now he was not so sure. Swayed in part by Bacon, he began to pay more and more attention to his sitters' three-dimensional presence. He seemed especially interested in volumetric idiosyncrasies: bunches of muscle, pouches of fat, light-reflecting oils on the skin—all those qualities that give such uncanny life to his painted portrait of Bacon. A new sense of amplitude now entered into his pictures. The viewer's consciousness of an overweening, romantic, and somewhat boyish "style" disappeared.

Artistically, Freud was moving into adulthood. But he was still unsatisfied. He only had to look at Bacon's work to realize he had to do more. "My eyes were going completely mad, sitting down and not being able to move," he told Feaver. "Small brushes, fine canvas. Sitting down used to drive me more and more agitated. I felt I wanted to free myself from this way of working."

The ensuing change was extreme. After *Hotel Bedroom*, Freud stood up to paint and, as he put it, "never sat down again." He put away his fine sable brushes and began to teach himself to paint with thicker, hog's-hair brushes and more viscous paint. He was trying to make his touch richer and more ambivalent, to make each contact between brush and canvas more of a gamble.

WHEN IT CAME TO Bacon's relations with Lacy, Freud acknowledged later that he was out of his depth. Was it this that caused Bacon to lose patience with him, to push Freud back down into the category of naïve and foolish ingénue?

A similar inference—an accusation of naïveté, this time about art—was there in his later complaint about Freud's work being "realistic without being real." Actual naïveté, willfully cultivated, was fundamental to Freud's early work, which may have been what Bacon found off-putting about it. Freud had earned what early renown he had through a style of rendering that was conspicuously childish—a style that channeled, in Lawrence Gowing's phrase, "the visionary directness of childhood." Observers often remarked both on the fanciful, dreamlike aspect in Freud's earliest works, and on the youthful romanticism brimming beneath the concentrated focus of his early, wide-eyed portraits.

Superficially, there was always something anomalous about this. Freud, after all, was literate and intelligent, and could hold his own in company that included some of the most sophisticated poets, patrons, and artists of the day—people like Spender, Watson, Bérard, Picasso, Cocteau, and the Giacometti brothers. His "childish" style was not an affectation. But there was something willed about it, a conscious cultivation of childlike ways of seeing that was in line with Baudelaire's famous insistence that "genius is nothing other than the ability to retrieve childhood at will." This was an idea that was taken seriously by many of the giants of twentieth-century art, including Paul Klee, Joan Miró, Picasso, and Matisse, all of whom were directly inspired by children's art. But it was utterly at odds with Bacon's developing vision, which was despairing, cruel-minded, existential, and sexually forthright in very adult ways. Bacon detested illusions of any kind—including the illusion of childhood as some kind of creative Arcadia. Where Freud was able to joke that he liked "the anarchic idea of coming from nowhere . . . probably because I

had a very steady childhood," Bacon was genuinely in flight from his traumatic childhood his entire life. And of course, in the wider context of society—the Holocaust, Hiroshima, Stalin, Franco, Hitler—it was a difficult time, all in all, to be toying with childhood reverie. Surrealism had all but sputtered out after the war for precisely this reason: Its indulgence of the amoral anarchy of unbounded reverie no longer seemed tenable in the wake of such a moral catastrophe. Freud himself was quicker than some to grasp this. He left Surrealism behind in his early twenties. But he hadn't yet found all the ingredients that would transform him into the great painter he eventually became. In a sense, he still needed Bacon for that.

It's not clear how long the breach between the two artists lasted. Freud said it was years, others say it was merely weeks. But Bacon's all-consuming involvement with Lacy lasted a good while longer, ballooning year by year in destructiveness and no doubt leaving Freud sidelined. Although they remained closely connected, both socially and artistically, Freud's friendship with Bacon was never really the same again.

They were close, on and off, throughout the 1950s and '60s as they continued to move in the same Soho circles. But in their art they seemed to be on different tracks. Bacon was entering his best period (roughly 1962–76), turning out paintings of extraordinary vibrancy and command—and earning considerable critical acclaim. In one painting after another, he set bleeding, boneless figures, with pummeled faces and twisted limbs, against bright, clean, geometric backgrounds in saturated, sumptuous, and weirdly artificial colors.

Freud, meanwhile, pursued his solitary, studio-bound path,

painting from life, and sticking to his deepest convictions even as, under the influence of Bacon's example, he slowly expanded his scope. His gambling, meanwhile, threatened repeatedly to career out of control, and his sexual history became hair-raisingly labyrinthine.

Bacon made quite a few more portraits of Freud—fourteen between 1964 and 1971. They were all based on photographs by Deakin, which were found folded, torn, crumpled, and spattered with paint in Bacon's studio after he died. (The American artist Jasper Johns made a series of prints and paintings, called *Regrets*, based on one of these photographs in 2013—a kind of refracted homage to his own lost love, Robert Rauschenberg.) Among Bacon's portraits of Freud were three full-length triptychs. The first was painted in 1964 (the year he also, bizarrely, made a self-portrait fusing his own image with the photograph of Freud), the second in 1966. The third, from 1969, set a world record for an artwork at auction when it sold in 2013 for $142.4 million.

Freud also made a second attempt at painting Bacon—an early instance of his new, looser painting style—in 1956. But the work remained unfinished.

As if to compensate for what went wrong with Lacy, Freud got to know Bacon's next lover, George Dyer, in a more intimate way when Dyer sat for him, twice, in 1965 and 1966.

But by the early 1970s, Bacon and Freud had definitely fallen out. The cause was never made clear. When Stephen Spender asked Bacon if they were still friends, Bacon let George Dyer answer for him: "Lucian borrowed too much money from Francis that he gambled and lost and never paid back. I told Francis, 'Enough, Francis, enough of that.'"

Bacon himself said it bluntly in the 1970s: "I'm not really fond of Lucian, you know, the way I am of Rodrigo [Moynihan] and Bobby [Buhler]. It's just that he rings me up all the time."

Freud claimed a certain amount of resentment came into it. "When my work started being successful, Francis became bitter and bitchy," he said. "What he really minded was that I started getting rather high prices. He'd suddenly turn and say, 'Of course, *you've* got lots of money.' Which was strange, because before then, for a long, long time, I'd depended on him and others for money."

Bacon's character, he continued, "had changed quite a lot, which I think was to do with alcohol. It was impossible to disagree with him about anything. He wanted admiration and he didn't mind where it came from. To some degree he lost his quality. His manners were still marvelous, though. He would go into a shop or restaurant and people were absolutely charmed."

THE STORY OF THE DEVELOPMENT of Freud's art—his increasingly aggressive attack on sentimentality, which caused so many people to find his portraits "cruel" and "ruthless"—is in many ways the story of his fight to keep his romantic susceptibility, his ingenuousness, at bay. It is the story of a long struggle not to suppress but to contain his most intense feelings—feelings that arose from intimate obsession and prolonged proximity. The example of Bacon—profoundly unsentimental, and yet at times, for Freud, uncomfortably theatrical—played a huge part in this transformation. If Bacon's was a model to emulate, it was also one to avoid.

"I think that Francis's way of painting freely helped me feel

more daring," he explained. "People thought and said and wrote that I was a very good draftsman but my paintings were linear and defined by my drawing, and that you could tell what a good draftsman I was from my painting. I've never been that affected by writing, but I thought if that's at all true, I must stop. The idea of doing paintings where you're conscious of the drawing and not the paint just irritated me. So I stopped drawing for many, many years."

The shift was not only momentous but amazingly audacious. Freud had made his early reputation, such as it was, almost entirely on the strength of his drawing. Critics, artists, and art historians, from Herbert Read and Kenneth Clark to Graham Sutherland, had praised him for it.

But now, under Bacon's influence, he stops drawing entirely and begins to loosen up his paintwork. He sticks to his incredibly slow and arduous way of working. But, like Bacon, he incorporates chance and risk, he smears and displaces the face's fixed features, and he utilizes all the viscosity and latent energy of oil paint applied by brush. He focuses more on flesh now than on eyes and faces, and begins to see the human body as a kind of landscape of shifting, almost arbitrary volumes that dissolve and re-form continuously, depending not so much on shifting light as on conditions of the skin and the movements of blood and bone and muscle and the fatty tissue beneath.

It all happens very slowly. His mature style—the Lucian Freud we know now—takes years to develop. And many of the results in this intermediate period are intensely odd and awkward. People watching what is happening can't quite believe it. His supporters feel betrayed. Kenneth Clark basically says, "I think you're mad but I wish you well," and never speaks to him again.

And so for many years Freud stays a respected but minor figure—known more for the force and idiosyncrasy of his personality than for his work, and barely known at all outside Britain. It stays this way until the late 1980s, when Freud is in his sixties, and people can no longer ignore what is coming out of his studio, because it is so immediate and so arrestingly, intensely intimate. (The show in Berlin, from which Freud's portrait of Bacon never returns, comes along at exactly this moment.)

Freud talks about treating the head as "just another limb," and lavishes no more attention on his sitters' facial features than on their thighs, their fingers, or their genitals. Pitting himself against the cliché that the "eyes are a window into the soul," he paints his subjects either asleep or dead-eyed. He undermines the whole traditional idea of portraiture as a function of both psychology and social status. Instead, it becomes a function, a result, of the most intimate scrutiny of another.

BACON, THROUGH ALL THIS PERIOD, goes from strength to strength. Thanks in part to his famous and brilliant interviews with David Sylvester, he becomes something of a celebrity. He is accorded major retrospectives, first at the Tate in London and the Guggenheim in New York, in 1962, and then, in 1971, at the Grand Palais. He is regarded with awe, not only in England but throughout Europe, and eventually in the United States. Famous Continental writers such as Georges Bataille, Michel Leiris, and Gilles Deleuze address his work. He is showered with plaudits.

Bacon's rhetoric—and he was a wonderful apologist for his own work—insisted that his painting should avoid at all costs the tedium of "illustration." "I don't want to tell a story," he told

Melvyn Bragg. "I've no story to tell." Instead, he wanted his paintings to hit "the nervous system" as directly as possible, without having to turn into a "long diatribe" in the brain.

Bacon's run of producing great work was, as Freud himself insisted, "amazingly long." At his best, he was one of the twentieth century's most exciting painters. But in many ways his later work turned into exactly the thing from which Freud—under Bacon's spell—had struggled so hard to escape: a *manner,* an anthology of affectations. Large areas of his canvases remained empty and lifeless. He came to rely more and more on pictorial gimmicks—teasing symbols such as arrows, syringes, swastikas, and artificial newsprint, most of them playing a role of negligible overall importance. The work often seemed to be doing little more than illustrating his own rhetoric—even as that rhetoric calcified into cant.

Bacon compensated for his mediocre drawing with his marvelous painterly touch, so full of movement, color, texture, and unexpected changes of speed. But outside the sumptuous excitement of his subjects' faces and flesh, his canvases—and especially the figures' torsos and limbs—could often feel flatly descriptive, exactly like the "illustration" he claimed to be so intent on avoiding.

TOWARD THE END OF his life, Freud told William Feaver about being so caught up in working that he "noticed that in the big picture I'm doing I was using my brush for absolutely anything. I was amused by it because I was doing something rather delicate and I not only had the big brush but it was all silted with paint. It's like people shouting and using any old word because some-

how the way they are shouting will get through. If you know what you want you can use almost anything. An ungrammatical shout is no less clear. It's to do with the urgency."

The words echo uncannily what we know of Bacon's methods—his willingness to use old rags, sudden swipes of newspaper, even his hands, to force a quality of urgency into his work. It was one more indication of Bacon's sway over Freud, which lasted right up until his own death in 2011.

THE THEFT IN THE most important sense was just that—a theft: brutal, audacious, an act of calculated risk and pragmatism. Freud could probably identify, in this sense, with whoever was responsible. Both he and Bacon had consorted with criminals, and both to some degree empathized with them. Both, too, early in their careers, had indulged larcenous impulses when it suited them. So the brazen theft of the portrait from the Berlin gallery was just a loss—another dumb and random fact in the world.

But I believe the portrait, in its absence, couldn't help but become emblematic, for Freud, of the slippery, volatile, and unknowable aspect of his relationship with Bacon, and of their old but still intimate rivalry.

If the WANTED poster that was designed to get the stolen portrait back was a sort of joke (and I think it was: the idea of Bacon as a "criminal at large," and a nod, perhaps, to Deakin's "mug shots taken by a real artist"), it was nonetheless an immensely poignant one. It was an admission that not just this riveting painting, but this man, this crucial relationship, meant an enormous amount to him, and that somehow, it had slipped through his fingers.

MANET and DEGAS

A picture is something that requires as much trickery, malice, and vice as the perpetration of a crime.

—EDGAR DEGAS

Toward the end of 1868, Edgar Degas painted a portrait of his good friend Édouard Manet. Actually, it's a double portrait: The painting [see Plate 6] shows Manet reclining on a sofa while his wife, Suzanne, sits at a piano, facing away from him.

It is a portrait, one could say, of their marriage.

You can see the picture today in a forlorn museum of modern art on the southernmost Japanese island of Kyushu. The museum is on top of a hill on the outskirts of Kitakyushu, a midsized industrial port facing mainland China. The hill, surrounded by woodland and gardens, has a soft and secretive feeling. But the

building itself, erected during Japan's boom years, has the sad and characterless feel of a modernist ruin. Its boxy exterior is chipped and tarnished, the galleries are vast and often empty, and the whole museum, with its air of cheerful civic idealism in embarrassed retreat, feels strangely at odds with the soft and drowsy intimacy of Degas's painting.

Manet's wife is shown in profile. She wears her light-brown hair up, revealing a small, delicate ear and a thickish neck, around which winds the thin, curving line of a black ribbon. Her skirt is a light, blue-tinted gray, with black stripes that fold and bend as the abundant material falls to the floor. Her blouse is made from a gauzy material—difficult to reproduce in paint—that lets the pink of her skin show through, except at the seams, which Degas keeps opaque—a bravura touch. There is little in the way of vivid color, apart from a red cushion near the center and a lovely, dream-inducing turquoise that accumulates like tropical weather around the figure of Suzanne.

THE CANVAS DEGAS CHOSE for this marriage portrait is not terribly large. The format is horizontal. The painting looks handsome in its rather ornate gold frame. But there's one thing about it that's extremely odd.

You can see it from some distance away: A large part of the right-hand side of the picture—somewhere between a quarter and a third—has been left blank, unpainted. When you get closer, you can see straightaway that a part of it has in fact been cut out and replaced with a new piece of canvas. This piece has been covered with a washy, tan-colored undercoat, presumably in preparation for a repainting that never happened. Half an inch

back from the join is a vertical line of small nails that descends at uneven intervals. Degas's signature appears in red in the bottom right corner of this empty third.

THE SETTING DEGAS HAD chosen for his portrait was a third-floor apartment on the rue de Saint-Pétersbourg, a short walk from Place de Clichy in Paris's Batignolles district. It was here—just down the hill from where Pablo Picasso would later meet tensely with Henri Matisse—that Manet and Suzanne lived, together with their teenage son, Léon, and Manet's widowed mother, Eugénie-Desirée.

Suzanne was a stout but good-looking Dutchwoman, blond and with a ruddy face. She was also an excellent pianist, so it was fitting that Degas chose to portray her at the keyboard. When guests attended the Manets' regular Thursday-evening soirées, to which Degas had a standing invitation, she would invariably play for them.

Everyone who knew Manet personally seemed to love and admire him. He was charming, he was warm, he had courage; you wanted him on your side. Degas was no exception. By the time the portrait sittings began, Degas had been close friends with him for seven years. But he may have felt about Manet that he had not yet had the chance to get to know him as he really wanted. Asking Manet to sit for a portrait was perhaps a way not only to seal their quietly competitive friendship, but for Degas to get closer to him, to make some sort of claim on the intimate life of this most convivial of men.

Degas, like Lucian Freud, was instinctively drawn to the un-known aspects of people, especially those to whom he was clos-

est. It had struck him that, for all Manet's social fluency, his laconic magnetism, there was something about him that remained elusive. And he was sure that, to some uncertain extent, that something involved Suzanne. The more entwined the two men's social lives became, the more it seemed so. Degas was like a hound getting a scent: instinctively, helplessly (perhaps even in spite of his own best interests) caught up in the chase.

We don't know how long the sittings took. We don't know if Suzanne actually played while Degas was painting, or (if she did) what she played. But we do know that when he had finished the picture, Degas—justly proud of his efforts—presented it to Manet.

What happened next has baffled art historians and biographers ever since.

Some time later (no one knows quite how long), Degas paid a visit to Manet's studio. When Degas spied his finished painting, he immediately saw that something was wrong. Someone had taken to it with a knife. The blade had gone right through Suzanne's face.

The culprit, as Degas presently discovered, was Manet himself. We don't know what he said to explain away the deed. Degas, one imagines, was probably too stunned to hear him. He chose simply to leave—"without saying goodbye," he later recalled, "and taking my picture with me."

Back home, Degas took down the little still life Manet had given him after a dinner party at which Degas had broken a salad bowl. He had it wrapped, and sent it back with a note that, according to Ambroise Vollard, said: "Monsieur, I am returning your Plums."

———

ÉDOUARD MANET WAS THE wayward eldest son of two re-
spected members of France's grand bourgeoisie. His father, Au-
guste, was a lawyer who would later become chief of staff at the
Ministry of Justice, then a high-ranking judge, and eventually
court counsel. His mother, Eugénie-Desirée, was the daughter of
a French diplomatic emissary to Sweden. She was also a godchild
to Napoleon's marshal of France, Jean-Baptiste Bernadotte—the
French army officer who went on to become King Charles XIV
of Sweden. Her firstborn son, Édouard, was expected to go into
the law like his father. But in his studies he showed little aptitude,
and even less application. "Wholly inadequate" was the verdict
on one report from the collège Rollin, the prestigious school in
Paris he left soon after. What he did like was art. His mother's
brother, Édouard Fournier, encouraged him to pursue it, and
even gave him drawing lessons. Fournier used to take Manet and
his young friend Antonin Proust to the Louvre, where, more
than a decade later, Manet would meet Degas.

In 1848, a year of revolutions across Europe, Manet sought
permission from his father to enter the École Navale, the naval
academy. His father consented, but Manet failed the entrance
exams. A loophole allowed him to try again if he went first on a
training vessel bound for Rio de Janeiro. And so off he set on a
voyage across the Atlantic. He endured horrible seasickness
("the rolling is so bad that you can't stay below deck," he wrote
to his mother). He crossed the equator—a momentous rite of
passage for any sailor—practiced fencing, and made sketches for
his fellow sailors. When his ship finally reached Rio, he attended

a Mardi Gras carnival, observed a slave market ("a rather revolting spectacle for people like us"), and was bitten by a snake on an excursion to an island in the bay of Rio.

He couldn't wait to get back to Paris. When he did, he was granted his second attempt at the entrance exam. But he failed again. His father, in despair, finally bowed to the inevitable and agreed to let him train as an artist. And so the following year, 1850, Manet found himself studying in the studio of Thomas Couture, a progressive artist, classically trained. Couture was still beholden to academic subjects, but he was willing nonetheless to break with many old-fashioned practices—above all, by letting bright color and texture into his pictures. Manet would stay with him for six long years.

But 1850 marked the beginning of an even more momentous relationship in Manet's life. It was the year he began a secret romantic affair with Suzanne Leenhoff, the Dutchwoman his parents had hired to teach their sons piano. Clandestine visits to Suzanne's apartment in the rue de la Fontaine-au-Roi culminated in her becoming pregnant in the spring of 1851. Suzanne was twenty-two. Manet was just nineteen. And at the beginning of 1852, Suzanne gave birth to a son, Léon.

WHEN MANET HAD EMBARKED on his secret liaison with the piano teacher employed by his father, it was just one of many misdemeanors marking his youth and frustrating his parents. There were the poor school results, the failure to follow his father into the law, the twice-failed entrance exams to the naval academy, and—perhaps worst of all—his insistence on becoming a painter. So his parents were well aware that they had a

wayward, obstinate son. They seemed to have reached the conclusion that there was little to be gained from trying to obstruct him.

But when Suzanne became pregnant with Léon, it was an outright disaster. Impregnating a foreign woman from a lower social class and out of wedlock was, in itself, an outrage against bourgeois propriety. It was notably worse for the Manet family because of the special social position of Manet's father. Not only was Auguste a judge of the First Instance of the Seine, who went to work at the Palais de Justice; he also routinely heard paternity cases. The potential for embarrassment, therefore, was acute. The idea that Auguste should now have to welcome a bastard child into the family was beyond the pale—and Manet must have known this immediately.

It had to be kept secret.

Luckily, Manet could trust and confide in his mother. When he did, she immediately took matters in hand. She informed Suzanne's mother, who came quickly from Holland to Paris. Léon was born on January 29, 1852. He was registered "Koëlla, Léon-Édouard, son of Koëlla and Suzanne Leenhoff" (no mention of Manet), and he was presented in society as Suzanne's brother—that is, as the last-born son of the woman who was actually his grandmother.

Manet, meanwhile, was made Léon's godfather at his baptism. And so for many years he shuttled back and forth between his own home and an apartment in the Batignolles district, where Léon lived with Suzanne, Suzanne's mother, and later her two brothers, who also moved to Paris from Holland.

Manet lived, in other words, a double life—not so much by choice as by necessity. There was a secret at the very center of his

private life that needed to be protected. And it was. In fact, the Manet family was so successful at disguising their secret that we still don't really know details of the circumstances around Léon's birth and early life. It was all very deliberately obscured. How this affected Manet in the long term we can only guess. But it seems certain that it contributed to a pressure, a tension, that lay not far beneath the breezy, insouciant surface of his art.

MANET WAS A FERVENT REPUBLICAN. So he was appalled when, at the end of that same year, 1851, Louis-Napoléon staged the coup that gave rise to France's Second Empire. The brutality of the coup, and the era of censorship that ensued, did much to snuff out republican hopes, which had been so giddy after the up-heavals of 1848. Young artists and writers now became disillu-sioned by the political sphere. They turned away from big public themes toward more private subjects. Manet was part of this gen-eral tendency, and yet his political convictions burned hotly be-neath his cool visage. He had been out in the streets with his friend, Proust, on December 2, 1851, when Louis-Napoléon—or "Napoleon III," as he would style himself exactly one year later—made his grab for power. The two young art students observed much chaos and bloodletting as the day unfolded. They were even arrested and detained for several nights—although more for their own safety than because they represented a threat.

In the coup's aftermath, Manet and his fellow students at Couture's went to the cemetery at Montmartre, where Napo-leon's dead victims had been carried, in order to sketch the bod-ies. A quietly macabre streak—dating, perhaps, to this formative experience—would run through much of Manet's later work. It

fed into paintings like *The Dead Toreador* (1864), *The Execution of the Emperor Maximilian* (1868–69), and *The Suicide* (1877), and it touched—like the "shadow of life passing all the time" so admired by Francis Bacon in the court paintings of Manet's hero, the Spanish painter Diego Velázquez—even his ostensibly sunnier pictures. There was a dollop of melancholy, even of morbidity, behind Manet's legendary charm. This would later fascinate Degas, who was himself an introspective man, a brooder.

MANET MAY HAVE BEEN a burr in the side of his respectable parents, an irresolute, underachieving elder son. But by his midtwenties, he had grown into an agreeable and impressive man. After years studying under Couture, who was just progressive enough to suggest new possibilities, and just academic enough to provide a model to kick against, he was finally coming into his own. He had developed a brisk, bracing new manner of painting, based on sensuous brushwork, strong outlines, and abrupt transitions between lights and darks, and it had piqued the interest of critics. When his painting *The Spanish Singer*—which showed a guitar player, perched on a blue bench, against a dark, empty background—was exhibited at the Salon of 1861, its effect was disarming, earning Manet accolades from conservative and progressive commentators alike.

For more than a century, the Salon had been the most important annual art event in the Western world and the most vital single arbiter of artists' reputations. It was the official, government-sponsored exhibition where, in vast galleries hung floor-to-ceiling, the public came in huge numbers to see a broad cross section of the latest painting. Eclecticism reigned. Every

conceivable style was on display, all vying for attention. Ambitious painters contributed heroically outsized canvases, with eye-catching updates of old subjects. The vast majority of what was displayed was the product of an official culture that insisted that aesthetic excellence be rooted in traditional technique. Subjects that reflected bourgeois proprieties and, wherever possible, the glory of the French state were highly favored. And so almost all of what was depicted was grounded in the past: in episodes celebrating virtue from history, from the Bible, and from Greek and Roman mythology. These works were all aimed at fortifying a grand but largely hollowed-out tradition. Painting that directly reflected contemporary Parisian life was nowhere to be seen.

All this was about to change. But for a painter in the 1860s, success at the Salon still seemed a necessary stepping-stone toward a viable career. Manet, for all his exuberance, was not out to disrupt this assumption. Over the following decade, year in and year out, he dutifully submitted his work to the Salon. Sometimes he was accepted, sometimes not. What he detested was the air of cliché that enveloped the art of his time, and so he was determined to rebel against the Salon from within. He had no interest in producing yet another rendition of Hercules and his labors, or of Napoleon in his pomp. Feminine beauty aroused him, but he held the prevailing penchant for porcelain-smooth and glabrous eroticism, glazed with a thin crust of moral piety, in utter contempt. And he detested above all the refusal to register anything that smacked of real life, of personal appetite, of the present tense.

IN *THE SPANISH SINGER*, the guitarist's tattered white shoes and the white scarf tied under his black hat were enough to make

casual observers brand Manet a "realist." This immediately put him in the same category as Gustave Courbet, whose flinty pictures of laboring peasants, forested landscapes, and plump, erotic nudes had been shaking up the establishment since 1850. The brash and self-promoting Courbet was allergic to fussiness and loyal to concrete, un-idealized truths in ways that appealed instinctively to Manet (and would later have a huge impact on Lucian Freud). Courbet was fed up with the insistent emphasis—at least in officially sanctioned art—on tired mythology and distant historical events. More than any other artist of his generation, he wanted to face up to what it was like to be alive *now*.

But Courbet was from the provinces; it was rural life he was interested in—not the city. In the city (and no city in the world at that time was more sophisticated and manifold than Paris), Courbet's literalism could seem cloddish and crass. Manet wanted to find an urban, or really an *urbane*, equivalent. And so, more by instinct than calculation, he set about developing a new approach, one that combined Courbet's straightforwardness with a secrecy, a playfulness, and a disregard for rules that perfectly expressed his own personality.

Manet's picturesque touches of "real life" in paintings like *The Street Singer* fell deliberately short of Courbet's idea of realism. Even as it expressed an appetite, a freshness, that was entirely new, there was something provocatively ironic and knowing about Manet's gleefully patched-together style. His pictures came with a wink. When it was pointed out that the guitarist in *The Spanish Singer* was left-handed and yet played an instrument strung for a right-handed player, Manet was unfazed, and blamed his mirror: "What can I say?" he blithely replied. "Just think, I painted the head in one go. After working for two

hours, I looked at it in my little black mirror, and it was all right. I never added another stroke."

Manet's so-called realism, that's to say, was actually nothing of the sort. It was, instead, a kind of counterfeit realism, a casual yet elaborate aesthetic game he was just beginning to perfect. What mattered was not so much the game's rules—these were negotiable—as the spirit in which it was played. The impact of these sly, foxy pictures at the Salon was profound.

Several young painters who went together to the Salon of 1861, according to the critic Fernand Desnoyers, were seen looking "at each other in amazement, searching their memories and asking themselves, like children at a magic show: Where could Manet have come from?" Something about not just the subject but also Manet's insouciant handling of it seemed, to them, to hold out the promise of liberation. It was a freighted moment—a turning point. These same painters later came, as a group, to Manet's studio, along with several writers, including the poet and critic Charles Baudelaire and the critic and novelist Edmond Duranty. Manet welcomed all his admirers brightly. And from that moment on, he became, without ever having asked, the de facto leader of a younger generation of painters itching to change the course of art history.

MANET FIRST MET DEGAS that same year, 1861, while wandering through the galleries of the Louvre. He was just shy of thirty. Degas was twenty-six or twenty-seven, a morose-looking young man with a scruffy beard, a high forehead, and hooded eyes, bottomlessly black. He had set himself up in one of the Louvre's grand galleries with an easel and etching plate, and was strug-

gling to etch a copy of Velázquez's painting of the Spanish royal princess, the Infanta Margarita.

Since Manet was in the throes of a sustained infatuation with all things Spanish, and since he lionized the seventeenth-century chronicler of Philip IV's court above all other painters, it was surely no accident that he had wound up in the gallery containing Velázquez's small portrait of the blond infanta (a painting since downgraded to "workshop of Velázquez," but no matter). Manet, moreover, had lately been immersing himself in all the arcana of etching, and so he had a few ready-to-go thoughts on the subject.

He ambled over to Degas and saw immediately that he was making a hash of things. Clearing his throat, he proceeded to offer up a few good-humored words of advice. Degas was touchy, and proud, and the intrusion might easily have irked him. So it's one measure of Manet's sheer congeniality that the encounter produced an opposite effect. Degas later reported that he would never forget the lesson he received from Manet that day, "along with his lasting friendship."

DEGAS WAS THE ELDEST of five children, a favored son from a family, like Manet's, that was affluent. His grandfather, Hilaire, had led an extraordinary life. He was a speculator on the French grain market and a money changer. His fiancée was guillotined by revolutionaries in 1792 for aiding the enemy. He fled Paris the next year after receiving a tip-off that he was about to suffer the same fate. He later joined Napoleon's army in Egypt before ending up in Naples, where he got married and established a successful bank. Soon, he became personal banker to the newly installed

Neapolitan king, Joachim Murat—Napoleon's brother-in-law. Even after the demise of Napoleon and the second restoration of the Bourbon monarchy, Hilaire's rise continued. He amassed a fortune that bought him a hundred-room palazzo in the center of Naples, and he installed his son, Auguste—Degas's father—as head of the Parisian branch of the family bank. Auguste married Celestine Musson, the seventeen-year-old Creole daughter of a successful cotton merchant, whose family had just moved to Paris from New Orleans. She died when Degas, her firstborn child, was thirteen.

Degas was educated at Louis-le-Grand, the best school in Paris (among its illustrious alumni were Molière, Voltaire, Robespierre, Delacroix, Géricault, Hugo, and Baudelaire). He was bright, and held himself to high standards. Although Auguste Degas loved art and had transferred that love to his son, he intended for Edgar to enter the law, just as he had—not to actually *become* an artist. For a short time, Degas was indeed enrolled in the law, but it was no use: He had caught the art bug. He was clearly very talented, and he was not to be deflected, so his father eventually chose to support his wishes, on the condition that he pursue them with rigor. Auguste went to some lengths to find a respectable painter, Louis Lamothe, for his son to study under, and he watched his progress closely. Degas, for his part, internalized his father's high expectations. He lived an ascetic life, utterly dedicated to art.

HAVING LOST HIS MOTHER EARLY, Degas was raised overwhelmingly in the company of men. There was his widower father, obviously, but he also had two widower grandfathers, and

no fewer than four uncles who were bachelors. Bachelorhood was regarded with considerable suspicion in Second Empire France. Linked by the medical profession with nervous disorders, it was seen most often as a moral failing—an indication of homosexuality, libertinism, or—just as bad—impotence brought on by syphilis. In the 1870s, as the new constitution of the Third Republic was debated, attempts were even made to deprive bachelors of the vote.

Despite these wider social strictures, a failure to marry was common both in Degas's family and in the wider circle of bohemian artists with whom he had begun to associate. Almost all the artists in what became the Impressionist group, for instance, avoided early marriage. When they eventually did wed, it tended to be to mistresses of many years' standing, frequently well after they had fathered children.

In Italy during his youth Degas had toyed with the idea of a monastic life. He chose art instead. But it's clear that the monastic mindset stayed with him. "The most beautiful things in art," he said, "come from renunciation."

SOON AFTER THEIR FATEFUL 1861 encounter in the Louvre, Manet and Degas were seeing each other several times a week. There were natural affinities between them—not least social and class factors marking them out from most of their bohemian artist peers. But Manet must also have recognized in Degas something brilliant and inimitable.

As a student, Degas had worked tirelessly at drawing. He had a stupendous aptitude for it, one that far outstripped Manet's. But he was also disciplined. He had taken to heart the advice of

his hero, the formidable neoclassicist Jean-Auguste-Dominique Ingres, whose home he had visited as an awestruck student in 1855. Ingres told him: "Draw lines, young man, and still more lines, both from life and from memory, and you will become a good artist."

For Degas's generation, Ingres's name signaled a proud and unswayable authority. That authority was rooted in his admiration for the restrained, linear art of ancient Greece and Rome, which tipped over into fervor. It had something semi-mystical about it: "The ancients saw all, understood all, felt all, depicted all," said Ingres. Line, in Ingres's conception of art, was supreme—and not just in a technical sense. There was a moral aspect to his conviction, reflected in sayings of his, such as "Drawing is the probity of art," that are still routinely repeated in art schools. Clinging to tenets like these, Ingres upheld notions of propriety and steadiness. Enduring values.

Ingres was wilder and more audacious than his reputation suggests. But he carried forth an idea of art that was academic: It depended, that is, on established standards and disciplined training. Also, on the idea that things should be difficult, not easy.

Ingres represented everything Manet was instinctively kicking against. But for Degas, it was different. Ingres's strict, disciplined, and ideological view of art not only met with Degas's father's approval but also answered to something deep down in Degas's own temperament. Where Manet seemed increasingly set on achieving a look of spontaneity and freedom (he wanted his paintings to have the brevity, the sudden acceleration, of wit), Degas—perhaps as a result of his father's influence—seemed almost to require the feeling that he was overcoming obstacles in order to feel serious about what he was doing.

"I can assure you," he said years later, "no art is less sponta-
neous than mine. What I do is the result of reflection and study
of the great masters."

Ingres was one of those great masters for whom things really
were immensely difficult. His nudes and society portraits radiate
calm; but to attain this calm, he experienced genuine torments.
He had endless problems bringing things to completion. "If only
they knew the trouble I took over their portraits," he said of the
commissioned work he notoriously resented, "they would have
some pity for me." He was forever making preparatory studies.
He frequently abandoned conceptions after months and even
years of work. And then, as if haunted by the idea of perfection,
he would return to the same subjects again and again over the
course of his long career.

All of this made Degas Ingres's true heir. He, too, cultivated
difficulty. For each new composition, he produced dozens of
drawings. His paintings, elaborately conceived, were constantly
being revised and reworked. Unlike Manet, who seemed to dash
off paintings almost as afterthoughts, and who gleefully disre-
garded conventional notions of "finish" (his pictures struck
many people as no better than sketches), Degas experienced tre-
mendous difficulty even approaching the point where he might
call a picture finished.

Degas never abandoned his reverence for Ingres. But in Italy,
where he spent two years at the end of the 1850s, he came under
the influence of Gustave Moreau. And it was Moreau—an ex-
perimentalist in technique and a true eclectic in his tastes (he
would later be Henri Matisse's teacher)—who turned Degas
on to Delacroix, Ingres's great rival. Delacroix, by now an old
lion, was in many ways a conservative in person. But he was

perceived—or he had been, back in the 1820s and '30s—as a radical, the representative of a new force in art, Romanticism.

Delacroix had no time for Ingres's neurotic obsession with the discipline of drawing. He was taking calculated aim at such piety when he claimed that there were "no lines in nature." He was making the point that things in the world were three-dimensional, picked out by patches of colored light, modulated by the atmosphere around them and by conditions that were constantly in flux. Neoclassicism, he believed, in trying to get at eternal things, too often ended up imposing stasis on the world. For Delacroix, life, myth, and history were in *motion*.

Not surprisingly, his philosophy caught on with the younger generation, including Manet, who embraced Delacroix's love of color, his visible brushstrokes (in contrast with Ingres's smooth-licked surfaces), and his attempts to express dynamic movement.

Delacroix had voted for the inclusion of Manet's *The Absinthe Drinker* (his shadowy portrait of an alcoholic ragpicker named Collardet whose turf was the streets around the Louvre) in the Salon of 1859. Unfortunately, Delacroix's was the only vote, and the painting was rejected. But Delacroix seemed interested in the young Manet's progress, and willing to offer his support.

MUCH OF WHAT DELACROIX SAID—especially his ideas about color and movement—made sense to Degas. And so, in the face of his father's skepticism, he, too, began experimenting with looser brushwork, stronger color, and more dynamic composi-tions. Degas was determined to find a way to marry these two opposing philosophies—the neoclassicism of Ingres and the Ro-manticism of Delacroix.

His impulse in this regard was hardly original: Many artists at midcentury were trying to steer a middle path between the poles of Classicism and Romanticism. But Degas wanted a synthesis that was all his own. And so for many years, he plotted large-scale canvases illustrating willfully obscure episodes from history and mythology in an idiom that combined the two styles. He brought great (and still underappreciated) originality to these attempts. But it was all a terrible struggle. He was depressed, indecisive, and pent up, and in all his efforts he continued to feel thwarted. He had terrible trouble getting his paintings to where he wanted them to be, and the ideas jostling for supremacy in his mind were so incommensurate that, aesthetically speaking, his work simply fell between stools. He worked on paintings like *Young Spartans* for two years, beginning in 1860, but was still not satisfied. (He returned to it, completely overhauling it, eighteen years later.) He made dozens of drawings including some of the most beautiful figure drawings of the nineteenth century—in preparation for another painting, *Scene of War in the Middle Ages,* but the finished canvas, which was presented to the Salon of 1865, has a fake, stilted feel, like an over-elaborate and slightly preposterous museum diorama. He worked on another painting, *The Daughter of Jephthah,* his largest and most ambitious history painting, for more than two years—just as Delacroix's influence over him was peaking. And yet he left it abandoned, unfinished.

DEGAS'S ENCOUNTER WITH MANET could not have happened at a better time. It had the simple effect of shaking things up for the struggling young artist. Manet had natural charisma. He

seemed to combine a kind of boyish impunity with adult manners that moved so fast and fluently, they won you over before you had even registered them. His face, in which Émile Zola detected "an indefinable finesse and vigor," was animated, expressive. He was one of few men, said one acquaintance, who knew how to talk to women; he knew, that is, how to *listen:* He would signal attentiveness with repeated nods of his head, and when something earned his admiration, his tongue would click approvingly—a soft sound emitted through a blond beard, flecked with red.

He had a limber, flowing gait and slender feet. He spoke in a drawl that mimicked the argot of working-class Parisians, and yet his clothes were beautifully cut. He wore jackets nipped at the waist, light-colored trousers, sometimes English jodhpurs, and a tall silk hat. In his vest he wore a gold chain, and in his gloved hand he carried a walking stick. But he wore this uniform insouciantly, adopting, wherever he went, a carefully careless manner, a kind of nonchalance.

In the eyes of his admirers, Manet seemed to have perfected a certain idea of civilized life in Second Empire Paris. Out in the city, he epitomized the midcentury figure of the flâneur. After lunching each day at the Café Tortoni, the very center of boulevard society, he and Baudelaire would wander in the Tuileries. Manet made rapid sketches as they went. He had imbibed the romance of Velázquez's position as court painter to Spain's King Philip IV—noble, aloof, austere—and so styled himself, with mischievous élan, the "Velázquez of the Tuileries." In the afternoons, returning to the Café Tortoni, between five and six o'clock he was usually surrounded by admirers heaping praise on the day's sketches.

In more private settings, disdaining formality, he liked to sit

cross-legged on the floors of his hosts' homes. He would hunch his body, wringing his hands and narrowing his eyes into an appraising squint.

This same disdain for formality underpinned his painting. He slapped vivid colors straight onto the canvas in large, brushy blocks—no conventionally painstaking buildup from darker layers to light. He favored frontally lit subjects (which flattened them out further); free handling in the manner of Frans Hals or Delacroix; and rich blacks that set off an otherwise light palette, nonchalantly disregarding intermediary tones. You felt that everything he painted he loved, and in his very nonchalance there was something not just erotic but briskly violent—as if one way of thinking of love was as a kind of glancing blow.

Manet also had a playful streak—a gentle, mocking side. His conversation was laced with needling ironies; little jabs that could arouse resentment only in the prickly or paranoid. When, for instance, years later, Zola sent him the preface he had written to the second edition of his controversial novel *Thérèse Raquin*, Manet wrote to congratulate him: "Bravo, my dear Zola, it's a splendid preface, and you are standing up not only for a group of writers but for a whole group of artists as well." And then, signing off, the characteristic little parry: "I must say that someone who can fight back as you do must really enjoy being attacked."

Manet never seemed to envy the success of his fellow artists. He "always approves," said his friend Fantin-Latour, "of the painting of people he likes."

ENCOURAGED BY THE SUCCESS of *The Spanish Singer*, Manet proceeded to turn out one utterly fresh masterpiece after an-

other. His *Boy with a Sword* of 1861 (a portrait of his son Léon in costume) was followed in quick succession by *Young Woman Reclining in Spanish Costume, The Street Singer, Mlle V . . . in the Costume of an Espada, Music in the Tuileries, Lola de Valence,* and a whole series of etchings, all produced in 1862. These pictures were cheeky, bright, drenched in appetite. They hummed with life. Manet had a sense at this point that he could pull off almost anything. He dressed up his brother as a toreador and painted a full-length portrait of him; and then—since she was his new favorite model—he did the same with a fresh-faced young woman called Victorine Meurent, even sketching in a bullfight behind her. It didn't make sense. It didn't need to. Manet's instincts and infatuations were in perfect harmony with his technique and abilities; he had the inner conviction that his ideas, no matter how outlandish, would somehow win through—just as *The Spanish Singer* had in 1861.

"Manet has his admirers, quite fanatic ones," observed the critic Théophile Gautier. "Already some satellites are circling around this new star and describing orbits of which he is the center."

Degas would never submit to being anyone's satellite. But in the midst of his own struggles, he must have watched the beginnings of Manet's creative explosion with astonishment and more than a little envy. While Manet was improvising his way to notoriety and positively bursting with confidence, Degas was laboriously copying crucifixions by Andrea Mantegna, devoting years of his young life to reworking elaborately conceived set pieces, and going to inordinate lengths to incorporate the latest discoveries by Assyriologists into paintings such as *Semiramis Building*

Babylon—paintings that came into the world, despite all the labor he put into them, stillborn.

While Manet was enjoying his first successes with an attitude toward the past—even to heroes and role models such as Velázquez and Delacroix—that was casually playful and insouciant, Degas was still earnestly pitting himself against the great painters of times gone by. "Our Raphael," his father observed, "is still working but has completed nothing so far, yet the years march on." And two years later, in another letter: "What can I say about Edgar? We are waiting impatiently for the opening of the exhibition. I have good reason to believe he will not finish in time."

As he labored over his own unfinished canvases, Degas couldn't help but be impressed by the ease and seeming impulsiveness with which Manet, "whose eye and hand are certainty itself" (as Degas himself sighed), committed his impressions to canvas. "Damned Manet!" he later complained to the English artist Walter Sickert. "Everything he does he always hits off straight away, while I take endless pains and never get it right."

He probably felt similarly envious as he watched Manet perform socially. And yet there were many compensations. Just as Francis Bacon's effect on Lucian Freud was to enlarge his world—to enhance the pleasure he took in new people, new situations, new forms of social and aesthetic potential—Manet helped pull Degas out of himself. His example made Degas realize what could be achieved through sheer temerity. It was Manet's underlying sense of conviction that was perhaps the most impressive part of him at this point. It made Degas conscious of the need to cultivate a similar boldness in himself.

———

IN THE YEARS THAT FOLLOWED their first meeting, Degas abandoned history painting and allegory altogether. He turned his sights instead on life as it was lived in Second Empire Paris—the same life that so captivated Manet. Drawn out of himself and his own hermetic obsessions, he entered Manet's intoxicating social world and fell in love with the spectacle of the city. He became "a veteran first-nighter, stroller, and café man," wrote his biographer, Roy McMullen. More important, he acquired a larger, more flexible notion of what he wanted to achieve in his art.

There were stimulants other than Manet, of course—most obviously Courbet, whose headlong painting style and abrasive personality had done so much to shake up French painting over the previous decade. Degas's colleagues, Whistler and Tissot, were also influences in the 1860s. But it was Degas's relationship with Manet that was the most fertile, the most fruitful, the most consequential of his career.

A LIFELONG BACHELOR, Degas stared at the marriages he knew—including the marriage between Manet and Suzanne—with a kind of dismay, tinged at the edges with rancor. Part of him envied those who seemed to have found happiness in marriage. In his youth, he had confided to his notebook a sentimental hope for future conjugal contentment: "Couldn't I find a good little wife, simple and quiet, who understands my oddities of mind, and with whom I might spend a modest working life! Isn't that a lovely dream?" But at the age of thirty-five, he already

struck one friend as an "old bachelor, embittered by hidden disappointments."

Relations between men and women, both within the institution of marriage and outside it, preoccupied him as a subject in his art. He had a gift for sniffing out disharmony and tensions between the sexes, and an obsession with capturing these tensions on canvas. In one early painting after another—most notably in *Young Spartans Exercising* and *Scene of War in the Middle Ages*—a woman or group of females on the left is placed in an antagonistic relationship with a man or group of males on the right. By the end of the 1860s, when he came to paint Manet and Suzanne, a specific preoccupation not just with conflict between the sexes but with marriage itself was rising to a kind of crescendo in his work.

Degas's feelings about women were nothing if not complicated. Deeply moved by female beauty, charmed and even seduced by intelligent female company, he nonetheless had a classically chauvinist nineteenth-century aversion to feminine "softness"—a silent, abiding fear of woman's potential to soothe, unman, enfeeble. Among artists and writers, his attitude was by no means unusual. In *Cousin Bette,* Balzac had described the destruction of a talented sculptor by the sapping effect of his marriage. In their 1867 novel *Manette Salomon,* the Goncourt brothers' fictional artist, Naz de Coriolis, believed that celibacy was the only state that left artists with their liberty, their strength, their brains, and their consciences. It was because of wives, believed Coriolis (who was based in part on Degas), that so many artists slipped into weakness, into complacent modishness, into concessions to profit-making and commerce, and into denials of

earlier aspirations. And marriage, of course, eventually involved paternity, which turned artists even further away from their true vocation. The painters Corot and Courbet avoided marriage, lamenting what they saw as the dissipation of creative energy that any committed relationship with a woman entailed. "A married man is a reactionary," Courbet said. And even Delacroix became uncharacteristically agitated when a young painter told him of his plans to marry: "And if you love her and if she's pretty, that's the worst of all," he said. "Your art is dead! An artist should know no other passion than his work, and sacrifice everything to it."

Degas, as McMullen has pointed out, took all this kind of thinking to heart. He was persistently patronizing toward the category of "wives" in general. About his choice to remain a bachelor, he explained, "I was too afraid that after I had finished a picture I would hear my wife say, 'What you've done there is very pretty indeed.'"

These generally defensive and contemptuous feelings must have played into his attitude toward Manet's—from the outside—rather baffling marriage to Suzanne.

SCHOLARS HAVE WONDERED WHETHER Degas's skepticism about marriage was merely symptomatic of his vocation and his times, or whether it was an extension of something darker, more disturbing. "Art is not a legitimate love," he once said: "one does not marry it, one rapes it." In the literature on Degas, this uncomfortable metaphor has often been linked with a highly ambiguous, partly scratched-out diary entry from 1856, when Degas was twenty-one. Degas seems to have tampered with the

entry himself. But the cryptic note does suggest some kind of shameful encounter:

"I find it impossible to say how much I love that girl, since for me she has . . . Monday, April 7. I cannot refuse to . . . how shameful it is . . . a defenseless girl. But I'll do it the least often that is possible."

It's impossible to know what actually happened here; easy to jump to conclusions. But whatever it was, it may have triggered feelings that were hard for the young Degas to overcome.

The dealer Vollard, who would go on to play such a key role in the careers of Matisse and Picasso, was one of many people who knew Degas intimately and rejected the "commonplace" that he hated women. "No-one," he said, "loved women as much as he." Rather, said his friends, his problem was essentially shyness—a fear of rejection or a squeamishness that prevented him from pursuing women who attracted him. The cause of this embarrassment may have been impotence, as some believe, or it may have been something else. But whatever it was, his art had a detached and at times voyeuristic quality, charging his subjects with hidden drama.

THE HARDEST THING in the world, at times, is to be oneself. Manet, at least on the face of it, seemed to have no such problem. For Degas, however, it wasn't so easy. His well-fortified social persona failed to hide the fact that he was never quite comfortable in his own skin. Manet must have sensed this about him. Degas was certainly aware of it himself, and it ate away at him. In his twenties, he had been inordinately obsessed with himself; by the time he was thirty, he had produced no fewer than forty

self-portraits. So it's telling that he ceased painting self-portraits soon after meeting Manet. He also abandoned his attempt to win plaudits for grand historical or mythological pictures. He busied himself instead with portraits. Portraits of *other* people.

His last self-portrait, painted in 1865, was actually a double portrait. It showed Degas sharing space with another artist. Degas did not attempt at this stage to immortalize his friendship with Manet, or indeed with any of the other talented painters he had come to know well; he didn't want, perhaps, to invite invidious comparisons. Instead, he chose Évariste de Valernes, a struggling painter, devoid of talent, doomed to obscurity.

Degas liked Valernes, who was ambitious, and convinced that he was on the verge of success. Degas almost certainly knew better. But—as he admitted in a moving letter to Valernes several decades later—he felt scarcely any better about his own prospects. At that time, he wrote, "I felt myself so badly formed, so badly equipped, so weak, whereas it seemed to me that my calculations on art were so right. I brooded against the whole world and against myself."

Degas was a "queer specimen," as he himself openly admitted. He had few close friends. No one seemed to know what to make of him, or where they stood in his eyes. Those eyes, dark and deeply recessed, seemed to be forever withdrawing into a private place from which it was easier to cast judgment. If this made him slightly terrifying to others, in truth Degas was no easier on himself: His diaries are full of self-reproach. Those early self-portraits, meanwhile, have a doleful, self-lacerating intensity unlike anything else in art.

He developed impressive compensatory strategies. His famously withering wit, for one thing; you didn't want to be its

target. Also, a nose for similar insecurities in others. Years later, in the 1880s, the English painter Walter Sickert was both impressed and intimidated by Degas, whose dismissals of other artists were notorious. Feeling insecure, Sickert tended to show off in his company and talk a lot. (This was a story Lucian Freud loved to tell.) Degas, in contrast, remained very, very quiet—until one day he turned to Sickert and said: "You know you don't have to do that, Sickert—people will still think you're a gentleman."

TO UNDERSTAND THE EFFECT that Manet's attitude toward art had on Degas in the early 1860s—and to grasp what it was that Degas would soon begin to kick against—it is necessary first to register the impact that the poet Charles Baudelaire had on Manet.

Manet was a dandy. He was in love, above all, with the city—the characters, the disguises, the secrets, and the play of illusions that were all part of life in Second Empire Paris, a city fraught with tensions and social disharmony, theatrical in the extreme, and constantly in flux. He wanted to represent it. But he had little interest in doing so as a realist, per se. His inspiration, beyond the city itself, was Baudelaire.

For a time in the early 1860s, Manet saw the poet on an almost daily basis. Baudelaire's impact on him was profound, but it was as much a question of sensibility and temperament as of anything more theoretical or programmatic. Outwardly blasé, Baudelaire was internally tortured. An apolitical dreamer and sensualist, he nonetheless had a humanist's sympathy for the outcast and downtrodden, and he was a magician of martyrdom:

"I want to turn the whole human race against me," he once wrote. "The delight this would give me would console me for everything." It was the very extremity of Baudelaire's contradictions that made his company so electrifying, his friendship so flattering.

Born in 1821, he was Manet's senior by ten years. He was a prolific drug taker. A scourge of the bourgeoisie, he had turned to journalism—and specifically to art criticism—in 1842. When he became friends with Manet in the mid-1850s, most of his criticism—the greatest, most prescient writing about art of the nineteenth century—was behind him. His mistress, Jeanne Duval, had been an invalid for a dozen years, and Baudelaire himself was not only sick with advancing syphilis, but constantly in debt. Manet was one of many called on to help, without much hope of being paid back.

In the essay that is still his most famous, "The Painter of Modern Life," Baudelaire had made a case for *particular* beauty— transient, partial, and improvised—over *general* beauty—the timeless and classical kind. Raphael, he wrote, "does not contain the whole secret." Instead, he argued, a fashionable dress, a stylish fan, the latest milliner's concoction were all true expressions of the transience of the modern city, and this transience made up at least one half—and perhaps the more interesting half—of the sum of its beauty. So he called for artists to paint what he described as "the pageant of fashionable life and the thousands of floating existences," the "attitudes and gestures of living beings," "external finery," "the beauty of circumstance and the sketch of manners," and "unknown, half-glimpsed countenances"— everything that was not, in other words, addressed in the pictures artists submitted to the annual Salons. All this chimed with con-

victions Manet had already arrived at himself. In his paintings of the 1860s, he, too, was enamored of the idea that, as Baudelaire put it, "each era has its own forms of beauty." And so he set out to depict the parade of urban life in all its many facets, and in a wholly fresh style.

Neither the artist nor the poet-critic was a documentarian, looking at the city with cool, detached eyes. Instead, both cultivated an idea of Paris as an incessant spur to the imagination, a locale of masks and of mystery, of suffering and sensuality, one that changed "faster, alas, than the human heart." Baudelaire's understanding of the modern city was personal, provisional, and erotic. The key words in the poet's lexicon were *languid, idle, furtive, secret, private,* and they found equivalents in Manet's signature motifs: the black cat, the bunch of flowers, the black ribbon, the cascading dress, the half-peeled orange, the fan, and the blank, unrevealing face.

IN 1863, JUST TWO YEARS after his success at the Salon with *The Spanish Singer,* three of Manet's paintings and three etchings were included in an exhibition of paintings rejected by the official Salon jury, the so-called Salon des Refusés. Napoleon III had personally sanctioned this runoff display—the first of its kind—after receiving a petition protesting the harshness of that year's jury for the official Salon. It was an ignominious situation for Manet to be in. Given his success in 1861, he must have been hoping for more.

One of his paintings, exhibited as *Le Bain,* is known today as *Le Déjeuner sur l'Herbe,* or *Luncheon on the Grass.* A knowing pastiche of Renaissance pictures (including Giorgione's *Fête*

Champêtre in the Louvre), it shows a naked woman enjoying a picnic with two clothed men. The models were Victorine Meurent, the nineteen-year-old girl who had posed for an earlier picture, *The Street Singer;* Manet's brother Eugène; and Suzanne's brother, Ferdinand.

Even today, the picture seems bizarre—albeit in beguiling, even delightful ways. It's clearly not meant to be taken as a scene from real life. At the time, it aroused only angry perplexity. What was the woman doing with no clothes on in the middle of a park? Why were the men dressed? Why was she staring out of the picture directly at us, while they carried on with their picnic as if this were the most normal thing in the world? And what was the story with the bather in the background, so sketchily rendered! Nobody knew. One critic called it "a practical joke, a shameful open sore not worth exhibiting."

Manet's other pictures, which stood out in the Salon environment thanks to their bold local coloring, their poster-like flatness, and their stark contrasts in tone, didn't fare much better. The public came by the thousands to ridicule the Salon des Refusés. Their mockery was focused on Manet, partly because his work stood out so starkly, and partly because they were following the lead of the emperor himself: On his official visit to the exhibit, he had allegedly paused in front of Manet's *Déjeuner*, made a gesture of moral revulsion, and moved on in silence. Manet's taste, wrote one critic, "is corrupted by infatuation with the bizarre." "I seek in vain for the meaning of this uncouth riddle," wrote another.

But Manet was nothing if not stubborn. He had tasted success in 1861. He knew that it would be a mistake to retreat. Buoyed by

his supporters, he chose instead to become more audacious, both in style and in subject matter.

Nonetheless, with each new submission, the vituperation only grew in intensity. Manet took the blows. But he was not immune to criticism, and he suffered. In 1864, when his *Episode with a Bullfight* was scorned for its ungainly perspective and flat handling, he responded by cutting it up into separate pieces. And then, in 1865, Manet submitted *Olympia,* a large painting for which he had Meurent pose as a prostitute waiting to receive a client. It was sent to the Salon along with a religious picture, *Dead Christ with Angels.* The combination—sacred and profane—was in itself a provocation. The *Dead Christ* fared badly. Even people whose previous support had cheered Manet proffered needling comments. The older Courbet, annoyed by Manet's growing notoriety, asked wryly whether Manet had seen enough of angels to know that they had backsides and big wings. Even Baudelaire, while doing his best to proselytize behind the scenes on Manet's behalf, pointed out that the wound in Christ's torso was on the wrong side.

But all this was as nothing compared with the response to *Olympia*—an uproar unprecedented in the annals of art history. Manet had painted Victorine, naked but for a ribbon tied around her neck, two satin slippers, and a gold bracelet around her arm, reclining on a bed and staring implacably out of the picture. While clearly alluding to Titian's *Venus of Urbino,* the painting was also inspired by "Les Bijoux" (The Jewels), a poem in Baudelaire's *Les Fleurs du Mal,* which begins: "The darling one was naked, and, knowing my wish / had kept only the regalia of her jewelry." The poem goes on to describe the "darling one" in

question as a prostitute who was "naked . . . / Smiling in tri-
umph from the heights of her couch / At my desire advanc-
ing . . . / Her eyes fixed as a tiger's in the tamer's trance, /
Absent, unthinking . . ."

The critical reaction to the painting was stunningly brutal.
"Art sunk so low doesn't even deserve reproach," wrote Paul de
Saint-Victor. Ernest Chesneau, a critic who had actually pur-
chased a painting by Manet earlier that year, deplored Manet's
"almost childish ignorance of the first elements of drawing," his
"bent for unbelievable vulgarity." He derided *Olympia* as a "lu-
dicrous creature," and found comedy in Manet's "loudly adver-
tised intention of producing a noble work, a pretension thwarted
by the absolute impotence of the execution." Another critic de-
scribed Manet's submissions as "terrible canvases, challenges to
the mob, pranks or parodies."

The response of the general public was no better. In front of
Manet's canvases, wrote Ernest Fillonneau, "an epidemic of
crazy laughter prevails." The painting had to be rehung above
the doorway of the last gallery—so high that you couldn't tell
"whether you were looking at a parcel of nude flesh or a bundle
of laundry"—after several people threatened to attack it with
more than words. (An earlier Manet painting—*Music in the
Tuileries*—had already been attacked by a man wielding a walk-
ing stick during Manet's one-man show at the Galerie Martinet
two years earlier.)

"Like a man falling into a snowdrift, Manet has made a hole
in public opinion," wrote the critic and champion of realism
Champfleury in a letter to Baudelaire at the time of the Salon.
The criticism was so loud, so ubiquitous, and so personal in tone
that Manet, on the verge of a nervous breakdown, wrote plead-

ingly to Baudelaire. "Insults pour down on me like hail. I have never before been in such a fix . . . I should so much like to have your sound opinion of my work, for all this outcry is disturbing, and clearly somebody is wrong."

SOMEBODY WAS WRONG. But who was it?

Baudelaire, more than anyone, was qualified to understand what Manet was going through. When his own volume of poetry *Les Fleurs du Mal* had been published in 1857, he, his publisher, and the printer were all prosecuted and fined for offending public morality. Six of the poems were suppressed, and Baudelaire's name became a byword for depravity.

And yet despite this firsthand experience, and despite his admiration for Manet, Baudelaire was not able, or not willing, to offer up the support and relief Manet so badly needed at this critical moment. He replied to Manet's letter with exasperation. After a chatty opening, in which he wryly noted that "it seems that you have the honor of inspiring hatred," he seemed to emit an impatient sigh:

"So I must speak to you of yourself. I must try to show you what you are worth. What you demand is really stupid. *They make fun of you; the jokes aggravate you; no-one knows how to do you justice, etc., etc. . . .* Do you think that you are the first man put in this predicament? Are you a greater genius than Chateaubriand or Wagner? Yet they certainly were made fun of. They didn't die of it. And not to give you too much cause for pride, I will tell you that these men are examples, each in his own field and in a very rich world; and that you, *you are only the first in the decrepitude of your art.* I hope you won't be angry at me for treat-

ing you so unceremoniously. You are aware of my friendship for you."

Baudelaire had, as he admitted himself, "one of those happy natures that enjoy hatred and feel glorified by contempt." Manet was more easily undermined, and the ailing poet knew it. His rough words were the response of a man who has decided his best contribution to a friend in danger of losing his nerve is a good, brisk slap around the cheeks.

The following day, in a letter to a mutual friend, Champfleury, Baudelaire noted: "Manet has a strong talent, a talent which will resist. But he has a weak character. He seems to me disconsolate and dazed by the shock. I am also struck by the delight of all the idiots who think him ruined."

If nothing else, Baudelaire's response reminds us of the precariousness of Manet's position at this point. There was deep uncertainty around the nature of his achievement. Was he to be taken seriously? Or was he instead a kind of joker, a provocateur, a passing fad? Today, we regard the 1860s as Manet's great decade—the decade that saw him produce the majority of his most famous and audacious pictures. But it was also a period of steadily increasing pressure and demoralizing setbacks. Each year, Manet marshaled his resources, planned his approach, and sent his finest pictures to the Salon. And each year, he was either spurned—his submissions rejected by the jury—or subjected to the humiliating white heat of public contempt. There was, in fact, no nineteenth-century painter who was so relentlessly and brutally battered by criticism. For a man who craved public approval and yearned for official honors, this reception was crushing. Manet emerged from the drubbings like an exhausted swimmer from torrid surf: standing, sun-bleached, even smiling

(he had asked for it, hadn't he?), but more groggy and dazed each year.

By 1867, he had lapsed into a sustained period of gloom and dismay. Usually prolific, he painted barely more than a dozen pictures over the following two years. On the outside, he remained his sociable self, but he let his circle of trusted intimates contract. "The attacks directed against me broke in me the mainspring of life," he later said. "No one knows what it is to be constantly insulted. It disheartens you and undoes you."

Manet's relationship with Baudelaire was always doomed to dissatisfaction. Baudelaire was a poet, not a painter, and he was a decade older. For all the influence he exerted on the younger generation of painters, he was too infatuated with his old hero Delacroix to really see what the next generation hungered to express, or to comprehend the ways in which they sought to express it.

Manet therefore looked toward his fellow painters for the kinds of stimulus and approbation he could never quite get from Baudelaire. No one, in this sense, was more useful to him than Edgar Degas.

MANET KNEW THAT HE had found, in Degas, not only a friend, but a brilliant acolyte. This was encouraging—at a time when Manet sorely needed encouragement.

But Manet was no fool, and he must have known that to think of Degas as a kind of protégé, a loyal sidekick, was to court trouble. Temperamentally, Degas was in no way suited to such a role. And then as well, he knew how ambitious Degas was. As they circled each other in these first few years, Manet had many

opportunities to reflect on Degas's skills. The two men often went to the racetrack together in the mid-1860s. Several deft sketches by Degas show Manet standing in his top hat, his weight on one leg, a hand elegantly at rest in his jacket pocket, peering intently into the distance—a picture of casual elegance. These and other drawings, which Manet saw on visits to his studio, were almost frighteningly virtuosic. Degas was as good a draftsman as Ingres, but his sure hand could also, if he chose, convey the energy and spontaneity of Delacroix.

Indeed, from the beginning of the 1860s, Degas had been quietly building on strengths—both technical (drawing and composition) and temperamental (a steely determination)—that were in many ways lacking in Manet. Manet's drawing was often a bit iffy. He struggled with compositions and with the rules of perspective. He had to resort, more than once, to taking a knife to paintings that failed to cohere—because the perspective was out of whack or the image unbalanced—and selling off the separate parts.

Degas's awkward attempts at etching in the Louvre may have given Manet an early sense of superiority in technical matters, but that initial dynamic was soon overturned. Degas's sheer brilliance put him streets ahead of Manet in matters of technique. Watching, at once impressed and unnerved, Manet no doubt felt his deficiency even as he registered, and secretly relished, the huge impact he was having on his young friend.

MANET AND DEGAS BELONGED at the time to a growing circle of artists, writers, and musicians, for the most part in their late twenties or early thirties. Their favorite meeting place during the

second half of the 1860s was the Café Guerbois. The Guerbois consisted of two long rooms joined end-to-end. The first, fronting onto the street, was presided over by a female cashier. It was decorated in the generic Second Empire manner, much like the nearby cafés on the boulevard des Italiens. There were mirrors, and the walls were painted white with gilt trimmings.

It was here that, once or twice a week, various members of the Batignolles group, as it was named (after the district they met in), would gather around two tables reserved specially for them. Other members of the group included the artists Fantin-Latour, Alphonse Legros, Alfred Stevens, Giuseppe De Nittis, Pierre Renoir, Frédéric Bazille, James Whistler (when he wasn't in London), and occasionally Claude Monet and Paul Cézanne. But not all the group's members were painters: the photographer Nadar was a regular, and so, too, were the poet Théodore de Banville, the musician Edmond Maître, and several critics and writers, including Émile Zola, Théodore Duret, and Degas's friend and co-conspirator Duranty.

These large, regular gatherings had a reliable, semi-organized feel. But there were other nights, too, when smaller clusters of two or three would meet for coffee or a game of billiards in the back room. Here, the atmosphere was darker, more intimate. The room had lower ceilings supported by rows of columns. It was big enough to contain five massive billiards tables placed all in a row, and it was usually smoky. In the dim gaslight, people appeared from a distance as blurry silhouettes, playing cards, relaxing on red banquettes, ducking in and out of view behind columns.

The proprietor, Auguste Guerbois, was sympathetic to these artists and writers and their various travails. He welcomed their

presence. Looking back thirty years later, Claude Monet remembered the atmosphere of the place, and the tenor of the conversations: "Nothing could have been more interesting than these talks, with their perpetual clashes of opinion. You kept your mind on the alert, you felt encouraged to do disinterested, sincere research, you laid in supplies of enthusiasm that kept you going for weeks and weeks, until a project you had in mind took definite form. You always left the cafe feeling hardened for the struggle, with a stronger will, a sharpened purpose, and a clearer head."

Manet—whose name had only recently been confused with Monet's in a review—benefited hugely from the camaraderie of these occasions. "Supplies of enthusiasm" were exactly what he required.

Every such group, no matter how informal, tends to establish a kind of pecking order, and there's no doubt that Manet was the Batignolles group's informal leader. For all his problems with the critics and the public at large, his status among like-minded fellow artists seemed unassailable. Not only was he charming and congenial as a man, but he had credibility as an artist. Among progressive artists, poets, and writers, no one had been more bold, no one braver, no one more admirably pigheaded than Manet. Certainly, no one was more talked about.

DEGAS WAS ACUTELY CONSCIOUS of Manet's standing in the Batignolles group. But since he enjoyed a closer connection to Manet than almost all the other members of the group, he could also bask, to some extent, in Manet's glow. Degas cut a lively and restless figure at the Guerbois. In the back room, around the bil-

liards tables, he rarely sat down, preferring to dart in from the periphery with his barbed and brilliantly ironic remarks. He was intolerant of fools. He despised sentimentality. But he was modest and funny—people said he was a brilliant mimic. Despite his privileged background, he lived a Spartan existence, dedicated entirely to his art. If he had his "nose in the air," wrote the art critic Armand Silvestre, it was "the nose of a searcher."

Away from the cafés, the Manet and Degas families had become closely intertwined. Léon, at fifteen, was working as a runner for the bank owned by Degas's widower father, Auguste. The two painters, meanwhile, attended intimate evening soirées several times a week. Auguste Degas liked to reciprocate the hospitality of the Manets by hosting regular musical soirées at his own home. And lately, both artists had begun to frequent musical evenings hosted by the mother of the three charming Morisot sisters, Berthe, Edma, and Yves.

If Manet's charisma made him the dominant figure at the Guerbois, he and Degas were more evenly matched in the intimate settings of these weekly soirées. In the more feminine realm of these bourgeois interiors, Degas's quick wit seemed particularly brilliant, his brooding presence magnetic. His superior feeling for music, too, must have been noticed by Suzanne and the other performers. He may not have been as naturally convivial as Manet, but he was more widely read, and he had succinct, well-informed things to say on subjects that often left Manet indifferent.

WHEN YOU FALL UNDER the spell of someone, there is often a dual movement within you: Even as you succumb to the other

person's powerful influence, you feel an equal and opposite impulse to bolster your own identity, to fortify yourself—in a sense, to push back. If your own sense of who you are is still to some extent unformed, as was Degas's at this point, you must hurry on and form it.

You must do this, however, under duress, since the other person is all the while exerting his seductive influence and, in the process, unintentionally reminding you of all the ways in which your earlier self was weak and insufficient. This dynamic is a tremendous spur to creativity. But it makes for volatile relations.

In the 1860s, even as Degas was growing closer to Manet, not just socially but artistically, addressing some of the same subjects and inching toward him in style, he felt an increasingly urgent need to carve out aesthetic differences between them.

One major difference began to push through around 1865, and slowly, it hardened into a clear line between them. It was visible on the canvas, but the difference had less to do with painterly style or subject matter, and more to do with a philosophical attitude. It boiled down to each artist's very different feeling for *truth*.

For Manet, truth was slippery and manifold. Consequently, he enjoyed the surface play of social interactions, of flirtations, and of wit. He was always dressing up his subjects in fancy costumes, and he relished the fluidity of individual identity, the essential unknowability of people beneath their various masks.

Degas's inclination—an inclination that he began about now to bolster and fortify so that very quickly it became almost a personal signature, a seal—was exactly the opposite. He had developed a determination to pierce the festive veil; to skewer the truth. He carried around a persistent sense of hidden truths that

must somehow be exposed to the light. If Manet came to feel threatened by this, it was no doubt because there was so much in his own private life that he deliberately kept away from the light.

As HE BROODED, and as he meditated on Manet, Degas seems to have noticed that not all was as it seemed with his talented friend. Manet was renowned as a ladies' man, but he had a wife, Suzanne, and they cared for a boy, Léon. Evidently, he had been involved with Suzanne for many years. They lived with Manet's mother, and they introduced Léon as Manet's godson, or else as his half brother. The arrangement was hard to parse. They had married very soon after Manet's father, the respected judge, had died in 1863. Had they simply been waiting for him to go? It certainly looked that way.

Auguste Manet had stopped reporting for work in 1857, having lost the ability to speak. He was suffering from paresis, a fatal, neurological form of tertiary syphilis, that also reduced him to blindness. He would live for five more years, but he never spoke again. "You would be moved to tears if you could see him," wrote his wife, Madame Manet, to one of his colleagues prior to his death.

Manet had hidden his affair with Suzanne so effectively and for so long that when he mentioned he was going to Holland to get married, even close friends were surprised. "Manet just gave me the most unexpected news," wrote Baudelaire in a letter. "He is leaving tonight for Holland and will be bringing back a wife." Since Baudelaire scarcely knew anything about it, it's doubtful that Degas, who at this point had known Manet for only a year, had any inkling at all.

Léon was eleven when the wedding took place. He claimed later that he never knew for certain who his real father was. Nonetheless, he became Manet's favorite model, and over the years he appeared in seventeen canvases, more than anyone else who modeled for Manet. The boy's shifting appearances in all these images have contributed to the aura of fevered speculation that today surrounds his identity. Some scholars have argued that Léon was actually fathered by Auguste Manet. But the theory, which was advanced in 1981 by Mina Curtiss and developed in 2003 by Nancy Locke, remains hard to credit. Curtiss's contention was based on rumor. Locke, years later, built her case around the mystery of why Léon was never legitimized, even after Manet and Suzanne were finally married. The mystery is resolved, she argued, if Auguste Manet was the father, because this would mean that Léon was born not just out of wedlock but as a result of adultery. (Under French law at the time, a child born as a result of adultery could not be legitimized.)

There is, however, another, simpler explanation for why Léon was never legitimized. In the Manet family's social milieu, legitimizing a child born out of wedlock—and eleven years after the fact—was simply not done. It was done frequently by Manet's more bohemian Impressionist colleagues, but their families were not so highborn. The implications for Léon's future were admittedly grave. He remained ignorant, or at best confused, about his parentage. Even at his mother's funeral he left a business card identifying himself as her younger brother. He was denied, too, the excellent education to which the Manet name would have entitled him. When he could have been at university or in the military, he had to resort to taking a job as a runner for the bank owned by Degas's father.

In declining to go through the process of legitimizing Léon, Suzanne may have been guilty, as Manet's early biographer Adolphe Tabarant wrote, of "excessive respect for hypocritical morality, for 'what-will-people-say.'" But the submarine pull of such social strictures—especially for an outsider, as Suzanne was—can be stronger than law.

Manet evidently agreed to abide by the whole elaborate deception, but he was also wounded by it. Tabarant was convinced that it "pained and poisoned his life." And indeed, Manet's many portraits of Léon, which guaranteed much time in his company, do have an air of compensation about them.

IF IT WAS TRUE that Manet's example had been the most important factor in making Degas want to be truly modern, to express his own time, to be "up-to-date," it was also the case that Degas was developing his own ideas about what being modern meant. For him, above all, it entailed new psychological conditions and a new way of being in the world, of forming and maintaining a self. Degas had perceived a divide between interior life and outward appearances, a divide that seemed difficult to bridge, difficult even to account for. (His insights were in many ways an early version of the conditions—the sense of psychic dislocation—dramatized later by Picasso and Francis Bacon.) He was developing a sense that his subjects would reveal most about themselves when they were caught, so to speak, *off guard*—when they were ambushed, or somehow surprised into giving up their secrets. And so, inspired in part by the arbitrary cropping and asymmetries of Japanese prints, he began, from about 1865, to toy with dislodged, crowded, or unbalanced compositions. His paintings

were still heavily grounded in drawing—his great forte—and on traditional modeling that proceeded gradually from dark into light. But slowly, something new, and something only he, Degas, could have produced, came into being.

In 1865 he painted a breakthrough portrait, *A Woman Seated Beside a Vase of Flowers* (now in New York's Metropolitan Museum of Art). He depicted the woman in question—probably the wife of Degas's friend Paul Valpinçon—as if caught in a state of unguarded self-absorption. What's immediately striking about the composition is its asymmetry. The figure has been shoved to the side of the horizontal composition by an enormous bunch of late-summer flowers. This and in fact everything else about the painting, right down to the woman's hand lifted hesitantly to the corner of her mouth (a gesture Degas used repeatedly after this), contributes to a feeling of hesitation or thought in transition. Compared with the distortions and dramatizations of facial expression that became routine in twentieth-century portraiture, the innovation seems very subtle. But it was entirely new in portraiture.

THIS IS WHERE DEGAS'S relationship with Edmond Duranty becomes important. Unlike Manet, who had a series of fruitful relationships with writers, beginning with Baudelaire and continuing on through Émile Zola and Stéphane Mallarmé, Degas was suspicious of writers in general. But when he met Duranty in 1865—the same year he painted *A Woman Seated Beside a Vase of Flowers*—there was something familiar about him; something he could relate to. Duranty was a journalist whose articles on art, written in crisp and well-schooled prose, appeared in *Le*

Figaro. He was rumored to be the bastard son of Prosper Méri-mée, the author of *Carmen* (the novel upon which Bizet based his opera), but no one was quite sure. With Champfleury, he had established a periodical in 1856 called *Le Réalisme.* It collapsed after only six issues, but Duranty continued to write about the fine arts, and about painters' attempts to come to grips with modern subjects.

For Duranty—and Degas—being modern meant committing oneself to an ideal of disinterested truth-telling. By cultivating an air of almost scientific detachment, they believed they could suffocate sentimentality and banish cliché. In his writings on art, Duranty saw no contradiction between championing the cause of realism and, at the same time, admiring the masters against which the realists rebelled. In this, as in so much else, he and Degas were at one. Duranty shared Degas's love, for instance, of the aloof neoclassicism of Ingres. Reflecting lingering old-school tastes that he and Duranty held in common, Degas worked hard at this time to entrench a style that was cooler and calmer, less passionate and painterly than the dashing model presented by Manet.

Among the many interests Degas shared with Duranty, the one that engaged them most was physiognomy, or the notion that facial expression can be studied as an index to character. The two men discussed the subject frequently. And in 1867, two years after they met, Duranty published a pamphlet, titled *On Physiognomy,* which seems to have grown directly out of his conversations with Degas.

Physiognomy was a mainstay of earlier-nineteenth-century literature, and it had long been accepted as a necessary component of training in art. It had been popularized as a science

by the Swiss poet and scientist Johann Kaspar Lavater in the late eighteenth century, and Lavater had, in turn, derived his ideas from the seventeenth-century artist and theorist Charles LeBrun. LeBrun's 1696 volume, *Characteristics of the Emotions*, was a guide to an extensive range of facial expressions, and it was used as the basis for an art school exercise called the *tête d'expression*—a study of the face intended to evoke a particular state of mind: melancholy, for instance, obstinacy, shock, or boredom. His book was illustrated with drawings of various facial "types" set against neutral backgrounds. It became available in a pocket edition and was much sought after by artists.

By the middle of the nineteenth century, much about LeBrun and even Lavater's ideas looked stale and unsophisticated. And yet the idea that a person's character and social station could be read in his or her face had greater currency than ever. There were social and political reasons for this. Since the 1789 revolution, social hierarchies in France had undergone seventy years of unstinting, often violent upheaval. With the deck of class violently shuffled by a series of political disruptions, and industry rapidly changing the face of the city, fears of conspiracy and criminality were rife among the bourgeoisie and the upper classes. Not even fashion and dress brought clarity to the situation, since people could no longer be depended upon to dress in ways that reflected their social standing. Instead—and increasingly—people's clothes expressed their social *aspirations*. Those whose status had once been relatively settled wanted reassurance. They needed to feel the city was legible, knowable, and at least potentially under control. (It's not by accident that the genre of the detective novel, in which a hero endowed with preternatural abilities at reading clues solves puzzling crimes,

emerged at the same time.) In these new, unstable social circumstances (which are a large part of what we mean by modernity), the pseudoscience of physiognomy was immensely appealing. It was reassuring to feel, as did Baudelaire's friend Alfred Delvau, that merely by closely observing the faces of one's fellow citizens "one could divide the Parisian public according to its various strata as easily as a geologist distinguishes the layers in rocks."

Degas was too smart, and too much a child of nineteenth-century positivism, to buy wholeheartedly into physiognomy. But he *was* obsessed with faces. And so facial expressions now became a central pillar in his attempt to renovate his aesthetic, to make himself modern in ways that marked him out from Manet.

Manet's signature, after all, was the blank, inscrutable stare. His utter refusal to impose any kind of heightened significance on faces and facial expressions was part of what made his pictures—especially the paintings of Victorine Meurent and of his son, Léon—so mystifying. The critic Théophile Thoré accused him of cultivating "a sort of pantheism which places no higher value on a head than a slipper." Weren't faces the whole key to portraiture? Wasn't it for good reason that people paid special attention to them? Manet did not. He was as likely to dwell lovingly on a tattered shoe, a white dress, a pink sash, or a fan, as on any face.

Degas saw this as an opportunity to etch out a major difference between him and Manet. Like many artists, he had a competitive relationship with literature. So he was deeply attracted to the idea that something purely visual—a face, a certain setting—could tell us more about a person's interior life than all the lumbering verbiage of a nineteenth-century novel. Since

painting *A Woman Seated Beside a Vase of Flowers*, he had be-
come convinced that a good, a *penetrating* portrait was no longer
merely a question of making the sitter's face and demeanor ex-
press identifiable character traits. Instead, it was about the very
modern notion of flux—the notion that inner life was an unsta-
ble, mercurial phenomenon that was no less revealing for being
so slippery.

The face was still key; it was what Degas sought to convey by
it that was different.

His convictions about this played into the drama that envel-
oped his portrait of Manet and Suzanne. "Do portraits of people
in familiar, typical attitudes," he jotted in his notebook, not long
before embarking on his portrait of Manet's marriage, "and
above all give their faces and bodies the same expressions."

INFLUENCED BY BAUDELAIRE, Manet also connected modern,
urban life with flux and instability. But for him, the whole point
was the charade itself, the play of disguises, the apprehension, as
Edgar Allan Poe put it in "The Murders in the Rue Morgue,"
that "there is such a thing as being too profound." Manet liked
the idea that truth (Poe again) "is not always in a well. In fact, as
regards the more important knowledge, I do believe that she is
invariably superficial." His whole approach to art was in deep
accord with this idea. His most famous pictures reflect that part
of his personality that liked "to be light-hearted, enamored of all
the most obvious things in life and wanting no complications."
For his letterhead he chose an appropriately unblinking motto:
"Everything happens."

Manet's insistence on surface values and whim has contrib-

uted to the feeling that his pictures are willfully opaque. Their meanings, then as now, are never clear. Seldom has a great painter produced so many bizarre anomalies: inappropriate clothing (or lack of clothing); strange mash-ups of genre; head-spinning combinations of contemporary realism and allusions to art history. Their mysteries are legion. But these mysteries sit on the surface, where their solutions cease to matter, and where they reflect instead—and above all—the pleasure of their own making.

Degas may have admired aspects of all this. But he didn't buy it. He was predisposed to see art in ethical terms, as an endeavor requiring both courage and sobriety, and he began to feel that Manet's approach—his "pantheism"—resulted in a moral thinness, an attenuation of art's profounder possibilities. He had little time for whimsy and a fundamental impatience with illusions. He believed that art must be in service to truth. His job was to reveal that truth; to catch it unawares; to ambush it. In this sense, there was something almost predatory about the way Degas painted.

"A picture is something that requires as much trickery, malice, and vice as the perpetration of a crime," he once said.

MANET HAD ATTEMPTED TO win over critics by setting up a pavilion of his own outside the 1867 Exposition Universelle. He filled it with fifty of his paintings. But the gambit backfired. The show failed to sell, leaving him in debt to his mother to the tune of 18,000 francs. By the next year, he had slipped into a serious funk. He was mourning his friend and confidant Baudelaire, who died at the end of August 1867. His rate of production had slowed

almost to a halt. It seemed to him that whatever he ventured forth as an artist was delivered back at his door in tatters.

He had retreated to Trouville, on the coast, whence he awaited the daily mail. Much of this merely brought news of more critical drubbings. "Here comes the muddy stream," he would say. "The tide is coming in."

IT WAS SOBERING, BUT perhaps also obliquely helpful, for Degas to see Manet in this weakened, needy state. Over the previous two or three years, the two men had grown especially close, so that by 1868 Degas was aware that something wasn't right with his friend. He was concerned. But he may also have been intrigued, and obscurely buoyed, as we often are when people we care about are seen to be struggling.

Things had not improved by the summer, which Manet spent with his family in Boulogne-sur-Mer. Again, he was bored and restless, oppressed by a sense of defeat. His mind kept turning to Degas. Crucially, Degas was someone in whom he, Manet, could see evidence of his own impact. To recognize talent in one's peer and to see one's own hand among the forces shaping that talent is always a tonic—especially for an artist confronting his own crisis of confidence. It was Manet's example, after all, that had persuaded Degas to turn his attentions away from history and mythology and toward contemporary subject matter. It was his example that had made Degas fall in love with the life of the city. And it was his example that made Degas see the attractions, in art as well as in life, of insouciance, improvisation, and brevity, in place of all that was plodding, painstaking, and overly planned.

Manet could take heart from all of this. Trying to rouse him-

self, he had an idea. He wrote to Degas: "I'm planning to make a little trip to London. Do you want to come along?"

He tried to sound offhand about it, explaining that he'd been tempted by the low cost of the journey: "You can go from Paris to London 1st class return for 31 francs 50." But there was a peculiar urgency in the request. "Let me know immediately," he wrote, "because I will write and tell Legros [a fellow artist, resident in London] what day we'll be arriving so that he can act as our interpreter and guide."

In truth, Manet was close to desperate. "I've had enough of rebuffs," he complained to Fantin-Latour around the same time. "What I want to do today is to make some money. And since I think, as you do, that there is not much to be done in our stupid country, in the midst of this population of government employees, I want to exhibit in London."

He made the same point, in a more comradely spirit, to Degas: "I think we should explore the terrain over there, since it could provide an outlet for our products." He enclosed a list of departure times, and suggested they try to leave on the afternoon of August 1—a Saturday. That way, he explained, they could embark the same evening on the midnight boat.

"Let me know by return," he signed off, "and keep the luggage to a minimum."

MANET'S REASONS FOR GOING to London went beyond the prospect of making sales. He and Degas were both Anglophiles. Degas had come back from the Exposition Universelle of 1867 raving about the English paintings he had seen. Manet, a habitué of the Café de Londres in Paris, admired English sporting prints,

which he drew on for his occasional depictions of the racetrack. Both men loved the English tradition of caricature.

London was also, of course, the birthplace of dandyism, that special attitude toward dress and demeanor that expressed an individual's relationship to the world—a relationship that was at once independent and nonchalant, stylish and original, avoiding overdiligence. Manet and Degas were both attracted to dandyism, which had first emerged in early-nineteenth-century London in the figure of Beau Brummel and was reincarnated in, among others, the carefully cultivated persona of Manet's and Degas's friend James Whistler. Manet had every expectation they would see Whistler in London.

All this feels relevant only because, around this time, Degas jotted in his notebooks an observation that fed into his painting of Manet in his waistcoat and pointy shoes, draped nonchalantly across the couch. "There are some people who are badly turned out well; and some who are well turned out badly," he wrote. Manet, you feel sure, was in the first category; he had the kind of effortless attitude toward dress and demeanor that someone like the overfastidious Whistler could only envy. Degas seemed to be homing in on this special quality in Manet when he added, in the same notebook, a quotation from the midcentury dandy Barbey d'Aurevilly: "There is sometimes a certain ease in awkwardness which, if I am not mistaken, is more graceful than grace itself."

Both quotations were surely in his head when he painted Manet's marriage later that year. Manet might have been flattered. Except that Degas didn't fail to include in his depiction of Manet another ingredient, the flip side of the dandy's nonchalance, which touched directly on Manet's relationship with Suzanne: Ennui. Boredom. Indifference. A hint, even, of contempt.

In the end, Degas declined Manet's plea to make the voyage to London. No one knows why. It may have been simply that the timing was inconvenient. More likely, however, it was because Degas was finally beginning to sense the need—and the opportunity—to establish his own artistic independence from Manet. Trailing along as Manet's junior sidekick in London—where Manet would doubtless impress everyone as more convivial, seductive, and charming than he, and where he was certainly more notorious—was not in his interests.

And so Manet ended up going to London alone. He found the English capital "enchanting," he told Fantin, and he was welcomed warmly wherever he went. Only Whistler's absence—he was out of town on someone's yacht—disappointed him. All in all, he came away feeling once again hopeful about his prospects: "I believe there is something to be done over there," he wrote; "the feel of the place, the atmosphere, I liked it all and I'm going to try to show my work there next year."

What he could not understand was why Degas, who was by now most likely plotting his painting of Manet and Suzanne, hadn't joined him. "De Gas was really silly not to have come with me," he wrote to Fantin. In a follow-up letter, two weeks later, he was still brooding: "Tell Degas it's about time he wrote to me, I gather from Duranty he's becoming a painter of 'high life'; why not? It's too bad he didn't come to London . . ."

Degas was right to sense that if he wanted to conquer London, it would be better for him to do it on his own terms. As it

turned out, that's exactly what he did. Three years later, he made his own trip there—without Manet—and within a year of that first visit, he was selling pictures through the Bond Street dealer Thomas Agnew. By the 1880s, Degas was a celebrity in England. He was known as the "chief of the Impressionists" and acclaimed for his "interesting, brilliant, and vivacious" pictures. Walter Sickert, chief among Degas's many English protégés, described him as "the one great French painter, perhaps one of the greatest artists the world has ever seen." And a generation later, Sickert's heirs, Francis Bacon and Lucian Freud, were also Degas devotees. Bacon kept reproductions of Degas nudes in his studio, and was obsessed by Degas's ability, through drawing, not just to reflect but to "intensify reality"—exactly what he aimed for in his own art. Freud, meanwhile, owned two Degas sculptures, which he kept in his Notting Hill home and used to caress absentmindedly . . .

As his friend Manet was being savaged in the press and pilloried by the public, Degas quietly worked away in his shadow. He never yearned for recognition in the way Manet did. He held officialdom more or less in contempt.

"You, Degas, are above the level of the sea," Manet said later, "but for my part, if I get into an omnibus and someone doesn't say 'Monsieur Manet, how are you, where are you going?' I am disappointed, for then I know that I am not famous."

Although Degas did intermittently submit work to the Salon throughout the 1860s, he did so with a reluctance quite at odds with Manet's somewhat naïve enthusiasm. Manet may have perceived that Degas's contempt for the Salon, for critics, and even for most of his peers, masked a secret pride. Where Manet seemed happy to take praise from wherever it might come, Degas detested the idea of being soiled by the appreciation of people

he didn't respect. There is "something shameful about being known," he wrote in a notebook years later.

DEGAS SUBMITTED WORK TO the Salon for the last time in 1867, the year before he painted Manet and Suzanne. Curiously, the painting he put forth was also the portrait of a marriage. Now regarded as Degas's early masterpiece, *The Bellelli Family*, as it is called, shows Degas's beloved aunt Laura standing with her two daughters, Giulia and Giovanna. Their father, Gennaro— Laura's husband—is seated in a leather chair, facing away from the viewer but looking to the side, so that his bearded face, with its reddish hair and blond eyelashes, is seen in profile.

Coolly executed yet strangely unnerving, *The Bellelli Family* reveals, as Paul Jamot wrote in 1924, Degas's "taste for domestic drama." It also hints at his penchant for uncovering "hidden bitterness in the relationships between individuals."

Degas had completed the painting almost ten years earlier. He had labored over it for several years, both in Florence, where he had been living with family members for two years, and back in Paris. It was ambitious both in size and conception, and its creation had been a source of unceasing anxiety to him. He had planned it back then as his Salon debut. But, unable to complete it to his satisfaction, he put it aside in order to work on various historical and mythological canvases more in keeping with the Salon jury's—and his father's—expectations. The canvas became an albatross, a symbol of all the difficulties he had had at the start of his career.

It was close to his heart. And only now, after a gap of many years, did he feel ready to show it to a large audience. In prepar-

ing it for the 1867 Salon, he did some last-minute retouching, and was soon informed that it had been accepted by the jury. But when he came to the exhibition itself, he saw that it had been hung in such an out-of-the-way place that very few people saw it, and no one—not a soul—commented on it.

Degas was enraged. The painting had cost him so much, he had put off exhibiting it for so long, and now, after it had finally made its debut, it had been sabotaged. Degas undertook never to submit himself to the humiliation of the Salon again. Once and for all, he rejected the official path to fame and fortune. When the Salon ended, he retrieved the picture from the Palais de l'Industrie and brought it back to his studio. He kept it there, rolled up in a corner, for the rest of his life.

It's a very beautiful picture—lavishly upholstered, fastidiously composed, flecked with gorgeous color. Psychologically, however, it is fraught with tension. Dressed in voluminous white pinafores, the two young Bellelli daughters adopt stiff but somehow unsettled poses in front of their mother, while between Laura and Gennaro you sense an alienation that borders on loathing. And so there was. At the time Degas painted his aunt Laura, she was feeling hopelessly trapped in what she described, in letters to Degas, as "a detestable country" and with a husband she found "immensely disagreeable and dishonest." He was a man, she wrote, "without any serious occupation to make him less boring to himself." She was close to despair. She had recently lost a child in infancy, her health was fragile, and she was also mourning her own father (whose recent death explains her mourning dress, and the portrait of him on the wall behind her). She genuinely feared for her own sanity. "I believe you will see me die in this remote corner of the world, far from all those who

care for me," she wrote. The young Degas, whom she loved, was her only consolation and support.

Living with the Bellellis had been Degas's only firsthand, close-up experience of married life, and it was not a happy one. The experience dovetailed with his own natural inclinations to convince him that a serious life in art was not compatible with marriage.

As well as being the portrait of a marriage, Degas's ill-fated picture was also a painting about music. Degas's decision to portray Manet listening to Suzanne at the piano was no accident. Since becoming a regular at the Manet home on the rue de Saint-Pétersbourg, Degas had come to know Suzanne well. A devoted lover of music himself, he would have appreciated her musicianship. She was reputedly brilliant. She not only played for the guests herself but also introduced their social circle to other musicians, including the four Claes sisters, who formed their own string quartet and were frequently invited to perform. Composers like Chabrier and Offenbach hovered on the edge of the circle.

Degas would also have seen Suzanne most Wednesdays, when the painter Alfred Stevens hosted a soirée, and on Mondays when Degas's own father organized little concerts in the rue de Mondovi. Music played a vital role at all these gatherings. The French had discovered Wagner by now—sending many, including Baudelaire, into raptures. Schumann was the latest Teutonic discovery: Many in Manet's circle heard his music first through the fingers of Suzanne.

Manet himself is said not to have had much of an ear for

music. If he enjoyed it (we are told he loved Haydn), his interest was casual. Degas, on the other hand, was genuinely absorbed. Since the age of twenty, he had held a season ticket to the opera. He had contrarian tastes. He mocked the Wagner cult, preferring Verdi. He also liked Gluck, Cimarosa, and Gounod—which, taken together, marked him out as something of a conservative. He was friendly with several composers, including Bizet, and with many musicians besides Suzanne, among them the amateur pianist Madame Camus; the bassoonist Désiré Dihau; Dihau's sister Marie, a pianist who gave singing lessons; and the tenor and guitarist Lorenzo Pagans. All these musicians were portrayed by Degas in the act of playing, and usually with other people listening, just as in the portrait of Manet and Suzanne.

In fact, concentrated in the years between 1867 and 1873, these paintings of musical performance in intimate settings constituted a vital intermediate stage in Degas's move toward the series of paintings that made him truly famous, truly "Degas"— the crowded orchestra pits, the café concert performances, and, above all, the ballet rehearsals. Off kilter, caught on the fly, secretly observed, these later, signature compositions linked music with movement. But they—and really, the bulk of Degas's entire oeuvre from the mid-1870s on—were primarily about *physical movement,* whereas the paintings of domestic performers and their intimate auditors were still deeply concerned with the movements of the mind, with *psychology.*

Degas was not just amused by the social pageant of these private musical soirées. Nor was he trying to illustrate or embellish his love of music with topical pictures. Rather, he was on the hunt for something, something that had been in his head since painting *A Woman Seated Beside a Vase of Flowers.* He had an

idea, which was that when people were listening to music, their habitual self-consciousness switched off. Their tendency to *present* themselves, and to respond defensively to their awareness of being watched, was no longer an impediment to truth-telling. They had lost the power to censor themselves. Something more essential, more truthful would emerge, and play across their faces. Degas wanted to capture it.

WHY DID MANET AND SUZANNE agree to sit for Degas in the first place? Suzanne had had the chance to get to know Degas well by now, and she might have liked the idea that one of the most talented artists of his day, an educated man from a notable family, seemed willing to depict—and therefore, in a round-about way, to legitimize—her marriage to Manet.

Manet, for his part, might have been encouraged by the several drawings and etchings Degas had already made of him. These light, lovely, admiring images, made between 1864 and 1868, show Manet looking buoyant and enviably debonair, at the racetrack or seated casually on a wooden chair in his studio. Looking at them, you sense a deep affection for their subject on the part of the person who made them. Manet must have been curious to see what Degas could achieve, in a similar vein, in paint. But these early works on paper—comparable, in intent, to the three drawings Lucian Freud made of Francis Bacon before finally painting him—also served a purpose that, in retrospect, seems clear: Degas was gearing up for something bigger. A longer, more calculating look.

The other artists of the Batignolles group had recently taken to portraying one another in casual settings—living rooms,

studies, and studios. Degas's portrait of Manet and Suzanne was part of this improvised, exuberant, lightly competitive tradition. One famous example was painted by Frédéric Bazille in 1870—shortly after Degas's portrait of Manet and Suzanne, and just months before Bazille was killed leading an assault against Germans in the Franco-Prussian War. It shows Manet standing with the air of an instructor in front of a large canvas on an easel in the studio Bazille shared with Renoir. In the picture, the canvas on the easel is Bazille's. Other canvases, by Renoir and Bazille, both large and small, hang on the walls—all silent rebukes to the Salon jury, which had rejected them. Edmond Maître plays at a piano in the far corner. Other, unidentified men—perhaps Zacharie Astruc, perhaps Monet and Renoir—stand around talking. The picture hints at the casual camaraderie that existed among these young painters. But it also emphasizes Manet's authority (he is the only one of the six bearded men who wears a hat), and his willingness to use that authority to influence and even adjust his friends' pictures. According to Bazille, it was Manet himself who painted in the tall figure shown from the side, holding a palette. That figure is Bazille, and it's clear from their body postures that he is listening intently to Manet's advice.

Other artists besides Degas had already painted Manet—most recently Fantin-Latour—and Degas himself had portrayed several other artists, including James Tissot. But tellingly, no one in the group had ever tried to paint Degas.

Sitting for a portrait takes time. It takes patience. Forbearance. A willingness to yield. Perhaps none of the other Batignolles artists could ever quite picture their brilliant young comrade, Degas, submitting to such a process. Or perhaps they simply didn't trust him not to criticize their efforts, not to remark on the

resulting work's shortcomings in ways less congenial than Manet had apparently mastered.

For, unlike the socially fluent Manet, Degas was fundamentally a loner. He judged others by his own standards of dedication. "There is love and there is work," he said, "and we only have one heart."

This was Degas's public front, anyway. Could his friends have known that this was the same Degas who, in private, felt himself "so badly formed," as he wrote to his friend Valernes? Who, despite everything, had confessed that he longed for the joys of children? Who worried about loneliness and about the heart being "an instrument that rusts if it is not used"? Who asked: "Without a heart, can one be an artist?"

BY THE TIME HE CAME to paint Manet and Suzanne, Degas had grown so preoccupied with the subject of marriage that it bordered on an obsession. On Christmas Day 1867—not long after his disappointment with *The Bellelli Family*—he made the first sketch toward a painting that he would later refer to as "my genre painting." Dated 1868–69—the same dates as his portrait of Manet and Suzanne—it has been called by others "a masterpiece," even "*the* masterpiece," of Degas's career.

The painting [see Plate 7] shows a man and a woman in a bedroom lit by lamplight. The woman, dressed only in a white chemise that falls off one shoulder, is seated at the far left of the picture. She faces away from the man, in a posture of shame or distress. Items of her outer clothing—a cloak and a scarf—have been tossed across the foot of the bed on the other side of the room; her corset is strewn on the floor.

Known today as *Interior*, it was for many years also referred to as *The Rape*, following the lead of several writers who knew Degas personally and insisted that this was the title he intended. (Other friends, however, claimed that Degas was "incensed" by the widespread adoption of *The Rape* and denied that a rape was its subject.) The man in the picture, tall, bearded, and fully dressed, stands with his hands in his pockets at the far right. Leaning back against the door, as if to block the woman's way out, he casts a menacing shadow that rises up behind him. The effect induces instant claustrophobia. Near the center of the painting, on a round table, is an open sewing box with vivid red lining that catches the lamplight. The intensity of the red makes the box by far the most eye-catching object in the painting. Open and exposed, it hints at violated secrets.

Degas put a tremendous amount of thought into the painting. "Genre" pictures traditionally show episodes from everyday life, often with an inferred narrative and an accompanying moral. Moral rhetoric had never been Degas's style—not even earlier in the decade, when he was absorbed with his ambitious Salon paintings illustrating scenes from history and mythology. But Degas was, as those earlier paintings made clear, preoccupied with relations between the sexes. And in his drive to bring his work into line with the times, he wanted to find a way to grapple with his obsession in a modern way. As he struggled to do so, he thought of the picture almost like a scene from a theater set.

What was the nature of the drama he had in mind? Although the finished painting is not a direct illustration, he seems to have been inspired by specific scenes in two different novels recently published by Émile Zola, *Thérèse Raquin* and *Madeleine Férat*.

Zola was Manet's friend. They had grown especially close

over the previous two years, ever since Zola had written rous-
ingly in Manet's defense when one of his pictures—*The Fifer*—
was rejected by the Salon jury of 1866. Shortly thereafter he
became part of Manet's circle, where Degas also got to know
him. Although the two men would later fall out (Zola accused
Degas of being "constipated" and of "shutting himself up";
Degas described Zola as "puerile" and, rather more brilliantly,
as "a giant studying a telephone book"), for two or three years
they got along well.

In 1867, Zola had written a short study of Manet that tried to
make the case for his art. His early novel *Thérèse Raquin* came
out in serial form the same year and instantly became a cause
célèbre. This, like his link with the scandal-plagued Baudelaire,
may not have helped Manet. Critics, who generally disliked the
book, noted its vivid visual details. "There are in 'Thérèse Ra-
quin,'" wrote one critic, "paintings that would be worth extract-
ing as samples of the most energetic and the most repulsive that
Realism can produce."

In *Interior*—but never again (it was to be his last "genre
painting")—Degas appears to have taken up the implied chal-
lenge. He wanted to construct a picture that would be as charged,
as fraught, as psychologically complex as a scene in a realist
novel.

Thérèse Raquin's climactic twenty-first chapter describes the
wedding night of Thérèse and her lover Laurent. Having plot-
ted together to murder her first, sickly husband, they finally suc-
ceed in drowning him. They wait more than a year to get
married. But during this time, tormented by guilt, they grow
apart, and so their wedding night is intensely strained. The rel-
evant chapter begins:

Laurent carefully shut the door behind him, then stood leaning against it for a moment looking into the room, ill at ease and embarrassed . . . Thérèse was sitting on a low chair to the right of the fireplace, her chin cupped in her hand, staring at the flames. She did not look round when Laurent came in. Her lacy petticoat and bodice showed up dead white in the light of the blazing fire. The bodice was slipping down and part of her shoulder emerged pink . . .

The fireplace is missing from Degas's *Interior*, but almost everything else is in place. Where details do diverge—the painting's narrow bed, for instance, does not comport with a wedding night—it seems likely that Degas drew on details (the floral wallpaper, "a bed singularly narrow for two people," "a piece of carpet under the round table," the "blood-red" tiles) from a similarly dramatic scene in Zola's *Madeleine Férat* (which appeared in the fall of 1868).

Pictorial details aside, the psychological point for Degas was surely that, in *Thérèse Raquin*, Laurent and Thérèse had become alienated from each other because of a shared secret that was too burdensome to manage. They may have successfully attained the status of husband and wife, but they were, like the Bellellis, "doomed to live together yet without intimacy."

When Degas heard reports that one of the trustees of a major New York museum was thinking of acquiring *Interior* but was worried about the painting's subject matter, he protested, in his deadpan manner: "But I would have furnished a marriage license with it."

It is fascinating to think that Degas was working on *Interior* at the same time that he was making his portrait of Manet and Su-

zanne. There are haunting parallels. Both pictures show a man and a woman dispersed at opposite ends of a horizontal composition. In both cases, the woman is seen in profile (displaying one prettily painted ear) and facing away from the man. And both paintings have an enigmatic red shape near the picture's center. What's more, *Interior,* like *Monsieur and Madame Édouard Manet,* portrays a married couple seemingly alienated from each other.

MANET'S VARIOUS PORTRAITS OF Suzanne indicate a deep and lasting affection. But he was just nineteen when they first fell in love, and although he was discreet, it's clear that over the course of their marriage he was less than entirely faithful. He loved beautiful women, and was loved in return. One of those beautiful women, the painter Berthe Morisot, is the third person—the invisible presence—in the room with Manet and Suzanne in Degas's painting.

Morisot had come into the circle of Manet and Degas toward the end of 1867. She was introduced to Manet by Fantin-Latour in the galleries of the Louvre—the same place Manet and Degas had met. The Louvre was one of the only places artists of both genders could mingle freely, responding to the art of the past on their own terms, without the intercession of formal teachers or the academy. This time, instead of Velázquez—as it had been eight years previously when Manet met Degas—Morisot was copying from Veronese, and Manet from a nearby Titian.

Morisot was sensitive, well read, and already, at the age of twenty-eight, highly accomplished. Her looks were unsettled, alluring. She had dark hair and recessed eyes that gazed out with

extravagant intensity. Something unmistakably erotic combusted between her and Manet almost immediately.

She was one of three sisters, all with artistic ambitions. They were in many ways a mirror image of Manet and his brothers, all three the sons of a high-ranking judge, none of them gainfully employed. Berthe and her sister Edma had studied painting under Camille Corot. (Their granduncle was the great eighteenth-century painter Jean-Honoré Fragonard.) Berthe's painting had earned her favorable reviews and the admiration of fellow painters. In many respects, she was ahead of most of her male peers. But like other talented women of her class and age, she was torn between a pressure, coming from within—to advance herself as an artist—and another imperative, more conventional but no less urgent: to fall in love, to find a husband. Unfortunately, to be a gifted, ambitious, forward-thinking painter was not an advantage for a woman of the 1860s who hoped for marriage. Morisot was acutely conscious of her predicament.

MANET WOULD CRYSTALLIZE HIS feelings for Morisot in a series of paintings he made of her over the next few years. These paintings, twelve in all, stand as one of the most electrifying records of intimacy in the history of art. Outwardly decorous, they squirm with a concealed erotic turmoil [see Plate 8]. In the gear shifts of Manet's painterly touch, in the sensual relish of his blacks, and in the private language of the attributes he gives Morisot (a fan, a black ribbon, a bunch of violets, a letter), you feel Manet's inimitable nonchalance complicated by an unmistakable urgency. Perhaps the most striking thing about them is

the directness of Morisot's intelligent, challenging gaze. Unlike the faces in Manet's other portraits, her expressions are *never* neutral. They make it clear that Morisot was someone Manet wanted neither to flatter nor to toy with, but to contend with. It was as if he saw her not as an actor ironically playing a part, as in so many of his other pictures, but as she really was. He saw her whole.

Degas met the Morisots through Manet, and he, too, was intoxicated by them. Indeed, Berthe and her sisters, Edma and Yves, had made an immediate impact on their whole circle, and soon enough both the Manets and Degas were turning up regularly at Madame Morisot's Tuesday-evening salons, while the Morisots were regular guests at Madame Manet's on Thursdays.

The Morisot sisters seemed to bring Degas out of himself. He was especially attracted by Berthe and, even as he must have been conscious of the ardor that had ignited between her and Manet, he made efforts to court her.

Did he feel he could compete with Manet? Certainly, as a bachelor, he may have felt that his right to pursue her outweighed his married rival's. The Morisots, for their part, were intrigued by Degas. And they had the opportunity to get to know him well. It was not unusual for him to spend entire days at their house in the rue Franklin. He disarmed them by talking to them as if they were men. He was mischievous. He was caustic. He told them frankly what he thought. They were amused, flattered, provoked. At the same time, confusingly, Degas acted out charades of chivalrous courtship that were full of provocation even as they bordered on the preposterous. In a letter from early in 1869, Berthe wrote to Edma: "M. Degas came and sat beside me,

pretending that he was going to flirt, but his flirtation was limited to a long commentary on Solomon's proverb: 'Woman is the desolation of the righteous.'"

SOON AFTER MEETING HER, Manet had asked Berthe to model for *The Balcony*, his latest, ill-fated attempt to make a favorable impression at the Salon. The request itself carried a frisson of social risk: Berthe and her sisters were daughters of a high-ranking civil servant and a respected salon hostess. Posing for the latest confection by a painter notorious for his bizarre imaginings and slipshod style was not without dangers for a spinster approaching thirty. But as a painter herself, Berthe had enough of a pretext to accept. She was curious to see Manet at work; she knew his achievements, and had long ago recognized his prowess. She had the measure of his strengths and also, perhaps, his weaknesses. (In a letter to Edma, she compared Manet's paintings to "wild fruits, or even those that are a little unripe"—a superb insight—adding, "They do not displease me in the least.")

Berthe did not pose for the picture alone. *The Balcony*'s other models were the viola-playing Fanny Claus (Suzanne's closest friend; her presence was intended most likely as a check on Manet's behavior), the painter Antoine Guillemet, and Léon, who was now sixteen, and whose obscured face can just be made out in the interior gloom of the picture. (The picture's composition was based on a painting by Goya much admired by Manet.) The modeling sessions, which probably coincided with Manet's and Suzanne's sittings for Degas, took several months, months that came to seem interminable to Berthe. All the while, Berthe's

mother, acting as chaperone, sat with her embroidery in a corner of the studio, scrupulously observing not only her daughter's unsettled feelings but also Manet's obvious agitation. He was full of optimism and vitality one moment, hobbled by paralyzing doubts the next.

It's clear that, however deftly it was handled socially, the mutual attraction between Manet and Morisot was a source of private confusion in both. Berthe had her sisters and mother for moral support. But when, toward the end of the year, Edma broke ranks and married a naval officer, Berthe fell into a depression. Now she was not only frustrated but also alone. Even as she was trying to forge ahead with her own painting, she was reduced to fending off her family's intrusive attempts to find her a husband. She appears in Manet's best portraits of her as at once agitated, cross, and full of secret yearning.

Unfortunately for Berthe, Manet's interest in her was briefly diverted by a talented younger Spanish painter called Eva Gonzalès. Gonzalès was twenty. She was an immediate hit with the Hispanophile Manet. She persuaded Manet to take her on as a student—something Morisot had scrupulously avoided—and before long he was painting her portrait. When Berthe's mother, Mme Morisot, paid Manet's studio a visit on the pretext of returning some books, she found Gonzalès there posing, and reported back to Berthe: "At this moment," she wrote, "you are not in his [Manet's] thoughts. Mlle G[onzalès] has all the virtues, all the graces."

This can't have helped Berthe's mood. Mme Morisot may have liked Manet as much as everyone else, but the situation, she knew, was unhealthy. She was concerned for her daughter. She wrote to Edma about having found Berthe "in bed with her nose

against the wall, trying to hide her weeping . . . We have finished with our tour of artists," she wrote. "They are brainless. They are weathercocks who play ball games with you."

BUT EDMA WAS NOT quite convinced. She wrote to tell Berthe that her own "infatuation with Manet" was over (she was married now, after all) but that she continued to be intrigued by Degas. He was different, she said. She was drawn to him, his intelligence, his way of seeing through pretense and cant. "The commentary on Solomon's proverb must have been very pretty and piquant," she told Berthe. "You can think I'm foolish if you want to, but when I reflect on all these painters, I say to myself that a quarter of an hour of their conversation is worth a lot of more solid things."

It's not easy to read back through such letters and understand their veils of irony and wit, or, conversely, to know when true things are being plainly stated. We cannot know what Degas might have intended with his little commentary on Solomon's proverb, nor how serious he was about courting Berthe. Like many artists, he was generally more comfortable communicating through images. So it's interesting to note that at around this same time, early in 1869, he presented Berthe with a fan. On it, he had painted a strange scene: the Romantic writer Alfred de Musset (famous for his many liaisons with women, including George Sand) was shown, guitar in hand, serenading a dancer, in among a troupe of Spanish dancers. The imagined scene is sprinkled with men prostrate or on their knees before women, entreating them to love.

Morisot cherished the gift for the rest of her life. And in a

moving double portrait she made at the time, shortly after Edma's marriage, she painted herself and Edma, wearing identical white dresses with frills and dots, with black ribbons around their necks, on a floral sofa in their own home. Prominent on the wall behind them is Degas's decorated fan.

WHILE MANET WAS PAINTING Eva Gonzalès, Degas was spending more time at the Morisot home than ever. He had persuaded Berthe's older sister, Yves, to sit for a portrait, which gave him the perfect excuse to be there every day. For Manet, who was not allowed to spend time with Berthe without multiple chaperones, all this may have been galling. Did he somehow warn Degas off Berthe? Being married, he had little right. But he did wield influence over Berthe. And he knew Degas well enough to know where he was weak. So he did what he could. Conversing with Berthe, he offered ("in a very droll way," according to Berthe) the devastating judgment that Degas lacked "naturalness," and, worse, that he was "not capable of loving a woman, much less of telling her that he does or of doing anything about it."

The remarks were clearly an attempt to influence Morisot—and on the face of it they were successful. Morisot reported the conversation to her sister Edma, evidently in a spirit of agreement: "I definitely do not think that he [Degas] has an attractive character," she wrote. "He's witty, and that's all."

Had Degas heard the judgment, there can be no doubt he would have been wounded. "Droll" or otherwise, Manet's comments were too close to the truth for him merely to shrug them off.

SEBASTIAN SMEE

Perhaps the same was true of Degas's portrait of Manet and Suzanne? A portrait, after all, is a reading of someone. A double portrait of the kind Degas attempted in 1868–69 is the reading not just of two individuals but of a marriage. And Manet was in too exposed and vulnerable a state simply to shrug off what this marriage portrait seemed to be saying.

A marriage, of course, is never just a relationship between two people. And Manet's marriage, at this point, was unusually crowded. Manet liked crowds. (If they were masked balls, all the better.) But he also loved privacy. He had his secrets, and he wanted to keep them. What may have irked him about Degas's portrait of his marriage was not, perhaps, anything as tepid, or as literal, as Degas's supposed failure to flatter Suzanne, the explanation traditionally given for his attack on the canvas. It was more likely the culmination of a gathering threat.

Degas, quite simply, was getting too close to Manet's marriage and the secrets it veiled. If the portrait of Manet and Suzanne expressed Degas's feelings about marriage in general (feelings he had already conveyed in *The Bellelli Family* and *Interior*), they also expressed a judgment on Manet's marriage in particular. With cool deliberation, Degas had depicted Suzanne absorbed in her music-making, facing away from her disaffected husband. He is off in his own world, dreaming, one could infer, of someone else. Of Berthe Morisot, perhaps.

Manet's lashing out at the picture may have been motivated in part, then, by anger at Degas's unwanted intrusion into the delicate situation with Morisot. It may also have been fueled by his underlying suspicion—enhanced by the aborted proposal

to go to London together—that Degas was no longer either protégé or friend but a genuine rival, a threat—someone who was thriving even as he, Manet, was sinking into a quagmire. Degas was someone, what's more, who had come to know too much about him, was too perceptive, and loomed too large in his life.

And then, of course, there is also the possibility that Manet's anger may have been stoked by marital frustration. It was the specific image of Suzanne, after all, at which he had cut away. Was it because Degas's portrait seemed to be reminding him of something dismal, something hastily cobbled together and vaguely shaming about their union? Was Manet's slashing of the canvas perhaps even triggered by a terrible fight with Suzanne? As a couple, they may have been compatible enough. But their marriage had been laced with deceit and hypocrisy from before it had even commenced. In the midst of his creative slump, and of his thwarted infatuation with Morisot, Manet may well have entertained a growing suspicion that Degas's bias against marriage was in some way justified: Wouldn't he, he may have wondered, have had a freer hand to create and invent and generally do as he pleased if he didn't have to maintain the front of his marriage to Suzanne?

Beyond even this, there was the fact that Degas's eye, his way of looking—although more and more artistically compelling—was so mercilessly detached and analytical! Degas dissected the world in front of him. Rather than seeing relations intuitively, and whole, enhanced by feeling and imagination, as Manet saw the world, he pulled them apart, the better to see what they were made of. But in the process he tore at the invisible threads that connected them. Staring at Degas's portrait of his marriage,

Manet might have seen the distinction between his own view of the world and Degas's etched more starkly than ever, and found it—however briefly—intolerable.

BUT ALL THIS IS to see the incident only from Manet's point of view. What about Degas's perspective? After all, it was his painting that was vandalized. The question then becomes: Did he know what he was doing with this painting? Was he doing it deliberately, calculatingly? Was he trying to cause damage?

Probably not. Such things tend to be more complicated, less conscious. The poet James Fenton once wrote of the complex relationship between Samuel Taylor Coleridge and William Wordsworth. He noted Coleridge's reverence for Wordsworth, his sincere belief in the older poet's primacy. Of course he, Coleridge, was also brilliant—and very ambitious, too—but Wordsworth's self-regard overwhelmed all potential rivals. He was, in this sense, like Ingres, the immense and jealous artist who "could not live under the hypothesis of a rival."

For whatever reason, Coleridge didn't quite see this side of Wordsworth, and so he was dismayed by the older man's meanness about his, Coleridge's, creative efforts—especially his mockery of "Kubla Khan." Nonetheless—and here is the extraordinary thing—when Coleridge later wrote his two-volume *Biographia Literaria,* he devoted an entire chapter to enumerating the defects in Wordsworth's poetry—the *defects*!—and he did this, contends Fenton, without ever quite realizing "what he, Coleridge, was up to."

"He couldn't manage to fall out of love" with Wordsworth, concluded Fenton. "He couldn't leave him alone."

———

Soon after slashing Degas's picture, his anger having subsided, Manet made his own, much softer and more sympathetic portrait of Suzanne at exactly the same piano. It was as if he wanted to say, *Watch. This is how it should be done.*

But also, perhaps, as if he were apologizing.

He had painted Suzanne earlier, in 1865, dressed in white, seated on a sofa upholstered in white, against white lacy curtains. Her blue eyes, fair hair, and pert features seen head-on give her the delicate appearance of a porcelain doll. (When he repainted the picture, in 1873, he added the figure of Léon, now fully grown, standing behind the sofa reading a book.)

But now, after slicing the figure of Suzanne from Degas's double portrait, he determined to portray his wife again in another, fresher image. He omitted himself, focusing exclusively on her. The painting shows her in profile (as in the original Degas), dressed in a deep black, her pale white face a picture of absorption as she reads the sheet music and her fingers move over the keys. Reflected in a mirror on the wall behind is a clock, which was presented to Manet's mother by her godfather, the Bernadotte king of Sweden, Charles IV, as a wedding gift in 1831. The picture evidently gave Manet some trouble. The silhouette of Suzanne's nose is pretty enough, but it has been worked and reworked, and it still bears the traces of Manet's efforts to get it right. It mattered—it mattered deeply—that he get it right.

Manet and Degas's friendship remained intact. So did their rivalry. Throughout the 1870s, after the watershed of the

Prussian siege of Paris, when both artists had fought together to defend the city, and the ensuing Commune—which marked the demise of the Second Empire—they often addressed the same subjects in what seemed like a competitive spirit: milliners' shops, women's fashions, café concerts, courtesans, the racetrack. The two needled each other about who had been the first to address certain modern subjects. They mocked each other's attitudes toward public recognition. And each was occasionally heard muttering pointed things about the other's personality. But by and large, their rivalry grew less fraught.

When they were jousting, there were as many veiled compliments as criticisms. "Manet is in despair," Degas once said, "because he cannot paint atrocious pictures like [Carolus-Duran], and be feted and decorated." Another time, in the middle of an argument with Manet about official honors, Degas suddenly interjected, with disarming sincerity: "We have all, in our minds, awarded you the medal of honor, along with many other things even more flattering."

BOTH PAINTERS CONTINUED RAPIDLY to evolve. In some sense, their styles grew closer together in the 1870s as they each embraced a look of spontaneity and the sketchy, unfinished style associated with Impressionism. But Degas never again toyed with narrative, as he had in *Interior*. He gradually dropped his preoccupation with facial expressions, too. Within ten years, when ballet dancers, horses, and female bathers were established as his signature subjects, faces were conspicuous only by their absence. Women's backs he found much more interesting.

He did not paint a married couple again for almost forty years.

Manet, meanwhile, let his infatuation with fake, studio-based realism—with cross-dressing, and role-play, and hammy recreations of past paintings—fall by the wayside. Under the influence of Monet, he took to plein air painting, letting more and more light into his pictures. There were no more proposed trips to London, no more proposals to sit for each other. The friendship remained, but the intensity was missing, and the sense of somehow being in it together had waned. Still, according to George Moore, who knew them both, Manet remained "the friend of [Degas's] life."

Certainly, Degas's admiration for Manet never waned. He just liked to keep it under wraps. A mutual friend reported on a visit he made to Manet's studio: "Degas looked at the drawings and pastels. He pretended that his eyes were fatigued and that he could not see very well. He made almost no comment. Shortly afterward Manet met the friend, who said, 'I ran into Degas the other day. He was just leaving your studio and he was enthusiastic, dazzled by everything you had shown him.' Manet said, 'Ah, the bastard . . .'"

BERTHE MORISOT'S FEELINGS FOR Manet never waned, either. But the situation, as was clear from the beginning, was impossible. When Manet encouraged her to marry his brother Eugène, it seemed sensible for her to comply; it was the next best thing to marrying Manet. But it was also the worst: Eugène was not Édouard. "My situation is unbearable from every point of

view," she wrote as she weighed her options. She eventually consented, and when she did, Degas was there (as always) to mark the occasion by painting Eugène's portrait.

Berthe and Eugène had a daughter, Julie Manet, whose companionship Berthe treasured all her life.

Manet died in the spring of 1883. He suffered for years from locomotor ataxia, brought on by untreated syphilis, and spent his final six months in unremitting, splintering pain. In the early spring of 1883, gangrene developed in his left foot, so the leg was amputated. The operation was in vain. Eleven days later, he died.

Degas was one of many who missed him acutely.

AFTER MANET DIED, NOT a single work by Degas was found in his private collection. When Degas died, on the other hand, in 1917, an extraordinary trove of Manets was revealed to the world: eight paintings, fourteen drawings, and more than sixty prints.

Degas's great art collection, which at one time he had considered turning into a museum, had been assembled in the 1890s, more than a decade after Manet's early death. It was then that Degas had begun earning enough money to indulge what quickly became an obsession. Along with the dozens of Manets (some of which he already owned), he acquired paintings and drawings by his heroes Ingres, Delacroix, and Daumier. He also acquired works by members of the younger generation, including Cézanne and Gauguin; prints and pastels by Mary Cassatt; paintings by Camille Corot; and more than one hundred printed pictures, books, and drawings by Japanese artists.

Twenty years later, by the time of the Great War, this aston-

ishing collection was a rumor, at most. Degas had ended his life virtually blind and notoriously reclusive, so hardly anyone had seen it for years. When it came on the market after Degas's death in 1917, it hit the art world with the force of a revelation. "The event of the season" is how the journal *Les Arts* described the series of three Paris sales in March and November 1918. (Five further sales were held to disperse Degas's own unsold works.) American collectors, such as Louisine Havemeyer, and institutions, like the Metropolitan Museum in New York, sent bidding instructions across the Atlantic to their agents in Paris. The Louvre, too, was a heavyweight contender—all the more so because the overwhelming majority of the artists Degas collected were French. But the most substantial share of the collection went to London. The renowned economist and Bloomsbury associate John Maynard Keynes, convinced of the collection's quality by his friend, the critic Roger Fry, sensed a special opportunity. He persuaded the British Treasury to award the cash-strapped National Gallery in London a one-off grant of £20,000 to bid for the paintings.

War was raging when Keynes went to Paris. The city was under attack. The dull thud of bombs could be heard from inside the salesroom, in the Galerie Roland Petit, getting uncomfortably close. After one such explosion, according to Keynes's friend and traveling companion Charles Holmes, "there was quite a considerable rush to the door," as most of the bidders fled to safety. The majority of those who fled failed to return, and as a result, many of the sale's finest pictures came under the hammer that afternoon before a greatly diminished audience. Keynes and Holmes stayed on; the British public reaped the benefit.

———

COLLECTING—EVEN IF YOU ARE an artist yourself—is a sublimating activity, a way of turning pleasure into control, chaos into order. It is a classic outlet for the proud and lonely man of passion. It is also a method by which to repair, restore, retrieve.

From this point of view, Degas's collection of pictures by Manet told an unusually personal story. Many of the pictures portray people who had played central roles in Manet's brief and scintillating life—and not entirely incidental roles in Degas's. A painting and a print, for instance, both depict Berthe Morisot. Several more prints depict Léon. There is also a fine etching of the head of Manet's father, and two etchings depicting Baudelaire. All in all, quite a cast. Degas lived amid these pictures and they reminded him that, for a time, he had had special access to Manet's seductive yet subtle, secretive world.

But it was a world from which he always felt slightly excluded. His collection, in this sense, had something compensatory about it: It was a way for Degas, as the years went by, to remain connected to people who, in reality, had somehow eluded him, slipped through his grasp. The most important of these was Manet himself.

WHEN IT CAME TO damaged pictures—and perhaps, too, in the singular matter of his friendship with Manet—Degas had a healing instinct. He could not forever hold Manet's attack on his painting against him. "How could you expect anyone to stay on bad terms with Manet?" he said to Vollard.

Regretting his piqued return of Manet's still life ("What a beautiful little canvas it was!" he remembered), he later tried to get it back. Alas, Manet had already sold it.

Meanwhile, he did what he could to repair his painting of Manet and Suzanne. He prepared it for a restoration and, as he told Vollard, planned to repaint Suzanne and return the whole picture to Manet. But this never happened: "By putting it off from one day to the next, it's stayed like that ever since."

Nonetheless, years later, he did go to great lengths to repair another damaged canvas—a creation not of his, but of Manet's. It was one of four paintings Manet made in the late 1860s— around the same time as Degas's portrait of Manet and Suzanne. All of them depicted the execution of the Mexican leader Maximilian [see Plate 9]. These paintings were Manet's political statement, his protest against the botched and dishonorable foreign policies of Napoleon III, and his attempt to bring his own, insouciant style to the by-then-moribund genre of history painting.

Since Manet was Manet—and since in many ways his best instincts were journalistic, attracted to the fluttery irresolution of the present rather than the settled dust of the past—the subject of this "history" painting was actually a contemporary event. A Habsburg aristocrat, Maximilian had recently been installed as emperor of Mexico by the French government of Napoleon III. It was a puppet government, entirely dependent on European, and specifically French, support for its survival. But the French abandoned Maximilian when Mexican rebels began to get the upper hand. He was captured in 1867 and executed. French newspapers suppressed the news. But it was reported elsewhere,

and soon enough the public learned the unsavory truth. All across Europe, people were appalled.

Manet's efforts to take on the subject purled out over three years (the same three years during which he and Degas were closest: 1867–69). Details of what had actually happened in Mexico kept changing as new information, previously suppressed, came to light. But his ideas about how to paint it were shifting too. In many ways, the questions he faced were similar to the questions Degas faced when painting *Interior* and the portrait of Manet and Suzanne: How does one tell a story in a painting—or, conversely, how does one *avoid* doing so? How explicit should one be? And what exact moment should one depict? Was it the raw, split second of the assassination one was trying to capture, or something more flexible and expansive, a kind of envelope of time that somehow encompassed context and hinted at judgment?

There was also, of course, the question of facial expression: How much expression should be put into the faces of the executioners? And how much emotion should there be in the faces of Maximilian and his two generals as they faced the firing squad?

In the end Manet created four large versions of the subject. Today, they are considered masterpieces: remarkably cool, almost disinterested treatments of a very hot subject. But at the time, the whole enormous effort ended, like so much Manet attempted, in disappointment. The events in Mexico were still too raw, too shaming, and the French government censored the painting, forbidding him from exhibiting it.

"What a misfortune that Édouard worked so stubbornly on that!" Suzanne later lamented. "How many beautiful things he might have painted during all that time!"

———

AT SOME POINT BEFORE his death, Manet took a knife—and here again, we don't know why—to one section of the version of *The Execution of Emperor Maximilian* that he kept in his studio. He removed most of the figure of Maximilian and the entire figure of his fellow victim, General Mejia. After his death, his heir, Léon, having let the painting deteriorate in storage, sliced it into several more pieces. "I thought that the sergeant looked better without those legs that dangled like a rag," said Léon. He then sold the central part of the canvas, the massed firing squad, to Vollard.

Degas, by this time, had already acquired from Léon another fragment from the same painting. It was the section of canvas that showed a soldier loading his rifle and preparing to deliver the coup de grâce. By happenstance, Vollard and Degas both sent their separate pieces to the same restorer, who showed Vollard the Degas-owned fragment. When Vollard then told Degas that their separate purchases had been cut from the same painting, Degas was incensed. He sent Vollard back to Léon to retrieve the remaining pieces, and did his best to reunite them all on a single canvas.

The result is the partially rehabilitated canvas that now hangs in London, having been bought for the National Gallery by Keynes at the Degas sale in 1918.

Whenever others saw the patched-together painting in his home, Degas used to mutter: "Again the family! Beware of the family!"

MANET HAD BEEN DEAD only eighteen months when Degas wrote to a friend: "Fundamentally, I don't have much affection.

And what I once had hasn't been increased by family and other troubles; I've been left only with what couldn't be taken from me—not much . . . Thus speaks a man who wants to finish his life and die all alone, with no happiness whatever."

He was to live another thirty-three years.

MATISSE and PICASSO

A little boldness discovered in a friend's work was shared by all.

—HENRI MATISSE

Early in 1906, telling himself he had nothing to lose, Henri Matisse paid his first visit to the studio of Pablo Picasso. He went there in the company of his daughter, Marguerite, and Gertrude and Leo Stein, the Jewish American sibling collectors who had recently made Paris their home.

Picasso's studio was across the Seine and up the hill in Montmartre. It was spring. The party of four set off on foot. Leo was tall and wiry and wore a wispy beard. He and his sister had an odd way of dressing. They both wore leather-strap sandals, and Gertrude liked to wear shapeless robes of brown corduroy. Mar-

guerite, a self-conscious girl of twelve, was embarrassed to be seen strolling down the fashionable avenue de l'Opéra in their company. But the Steins were oblivious to what others thought.

Picasso was twenty-four, Matisse thirty-six. It was a crucial period—in many ways *the* crucial period—in both artists' careers. Their situations were precarious, but for the first time, after years of struggle and doubt, both were beginning to enjoy some provisional success. Among outsiders, no one was more responsible for these lately improved prospects than Leo Stein. He and Gertrude had forged relations with both artists independently over the previous few months, so it seemed natural that they should now want Picasso and Matisse to meet. The Steins wanted to bear witness to the first stages of a relationship they felt certain would bear fruit.

IN HIS STUDIO PICASSO awaited their arrival. He was surely anxious. To show a rival artist one's work is to risk everything. The sixteenth-century Flemish sculptor Giambologna used to tell a story (it was brilliantly related in 1995 by the poet James Fenton) that later became famous: In his youth, newly arrived in Rome (just as Picasso was new in Paris), he had taken to the great Michelangelo a small sculpture. It was modeled in wax and exactingly finished. Its surfaces were so smooth that the piece seemed to tremble with incipient life. Michelangelo, by then in his prime, took the model in his hands and inspected it. He put it down on the table in front of him, lifted his fist, and smashed it down onto Giambologna's little wax figure. He repeated the action several times until he had a formless lump in front of him.

Giambologna watched all this. Michelangelo then set about re-modeling the wax himself, with Giambologna still looking on. Once he had finished, he handed it back, saying, *Now go and learn the art of modeling before you learn the art of finishing.*

It was not in Matisse's nature to behave this way. To begin with, although he was older than Picasso, his own standing as an artist was in no way comparable to Michelangelo's during the High Renaissance. More to the point (because after all, wasn't Michelangelo's behavior the reaction of a man who sensed a serious threat?), Matisse took pride in the idea that he could not only tolerate rivals but thrive in their presence. "I believe that the artist's personality affirms itself by the struggle he has survived," he once said. "I have accepted influences, but I have always known how to dominate them."

SHORT BUT SOLIDLY BUILT, Picasso had moved to Paris from Barcelona less than two years earlier. He was not yet fluent in French. But he had the kind of charisma that can dislodge even strong personalities from their earlier selves. He lived with his mistress, Fernande Olivier, and a large dog—a cross between an Alsatian and a Breton spaniel—called Frika. Their home was a barely furnished room in a dilapidated block of tenements known as the Bateau-Lavoir. Doubling as a studio, it was cluttered with brushes, canvases, paints, and easels. It was stifling in summer and warmed in winter by a massive coal-fired stove.

Matisse, who had cropped hair, a thick beard, eyeglasses, and a vertical crease that permanently bisected his brow, lived on the other side of Paris. His circumstances, on the face of it, were

very different. He was married, for one thing. Nonetheless, he and his wife, Amélie, had not had an easy time of it. For years, they had lived in straitened circumstances, as Matisse, a late developer with a stubborn streak, had tried to carve out a viable career as a painter. Their situation had been so dire, at times, that Matisse couldn't afford new canvases; he'd had to scrape the paint off old ones and use them again.

JUST THREE YEARS EARLIER, in 1903, the Matisses had endured an extraordinary social ordeal: Amélie's parents, Catherine and Armand Parayre, had been embroiled, unwittingly, in a massive financial fraud that ruined countless creditors and investors across France. It rocked the French government, put banks in jeopardy, and led to suicides all over the country. The elaborate deception, as Hilary Spurling explained in *La Grande Thérèse: The Greatest Scandal of the Century*, was perpetrated by Thérèse Humbert, the wife of a deputy for whom the Parayres not only worked but were confidants and supporters. Because of their association, the Parayres fell under suspicion. Amélie's father was arrested, Matisse's own studio was searched, and Amélie's entire family was menaced by some of the many who had been defrauded. Her parents were reduced to the level of penniless outcasts.

This social nightmare compounded the problems Matisse was already facing as a failed painter. His clumsy-looking efforts had made him an object of derision in his hometown in the north of France, where just the idea of a young man choosing to become an artist was an invitation to ridicule. The pressure on Matisse

became so excruciating that he suffered a nervous breakdown and, for two years, virtually stopped painting.

He recovered. But one of the outcomes of the Humbert scandal was that, in its aftermath, it became important to the Matisses—as it was not to the younger, more carefree Picasso and his girlfriend Olivier—that they maintain an orderly and respectable home. They also had three children, which made it all the more important that they live with prudence and propriety. The youngest, Pierre, was about to turn six. His brother, Jean, was seven. Marguerite was the eldest. She had a small dimple in her chin and frizzy hair that she kept loose or else tied in a casual ponytail or bun. She wore a black ribbon around her neck, which reinforced the luster of her big, dark eyes. But the ribbon was more than just an ornament. It covered a disfiguring scar.

PICASSO HAD HEARD A good deal about Matisse well before they met. He could hardly have failed to notice that the dealer Ambroise Vollard, after several years of circling, had given Matisse his first solo show in 1903, because the very same Vollard had given *him* his first show even earlier, in 1901. When that had happened, Picasso, who was nineteen, hadn't even settled in Paris yet. His hopes of doing so in some style were given a boost by Vollard's invitation to show. The reviews of the exhibition when it opened had been encouraging: One critic, Félicien Fagus, hailed the young Spaniard's "prodigious skill."

Picasso was used to this kind of attention. Raised in Spain in a middle-class family, he had been celebrated as an artistic wunderkind for as long as he could remember. But the show with

Vollard had led nowhere. The immediate success it seemed to promise was derailed by a tragedy that poisoned the next three years of Picasso's life.

He had come to Paris for the first time in October 1900. One of his paintings, *Last Moments*, a dramatic, large-scale canvas that advertised his allegiance to the modernista movement in Barcelona, had been selected for display in the Spanish section of the Universal Exposition—in itself, an extraordinary feat, since Picasso was only eighteen at the time. Intending to bask in the moment, he had come to Paris with his Spanish friend and close confidant Carles Casagemas. The son of a diplomat, Casagemas was a year older than Picasso. He was better educated but psychologically in every way the opposite of Picasso: He was a vulnerable soul, hobbled by doubt. He was addicted to morphine—and addicted, too, to Picasso, whose energy and bravado he depended on to lift him out of his mental quagmire. Both artists had rejected their formal training, embracing, instead, the rebellious bohemianism of the modernistas. Having shared a studio in Barcelona, the two came to Paris together and were taken in by a circle of Spanish expatriates living in Montmartre. They went to exhibitions together and got a taste for the dance halls and cafés of their hilly quartier. They shared living quarters, models, and lovers.

One of these lovers was a twenty-year-old laundress and model named Laure Florentin. She called herself Germaine. Casagemas was infatuated with her, but she eventually rejected him, and the rumor spread that it was because he was impotent. Picasso's friendship with Casagemas had always been characterized by ribbing and teasing, most of which went in one direction only: Picasso liked, for instance, to make caricatures of Casage-

mas, exaggerating his morose appearance, his long nose and heavy-lidded eyes. Now, in response to the rumors about his friend's impotence, he made a drawing of a naked Casagemas covering his genitals with his hands.

The two men returned to Spain in December 1900 and celebrated the New Year together in Málaga. Picasso then moved temporarily to Madrid while Casagemas returned to Paris, hoping to win back Germaine.

On February 17, 1901, in a state of despair, Casagemas organized a dinner party at a café in Montmartre. At 9 P.M., he stood up, handed Germaine a pile of letters, and then launched into a frantic, incoherent speech. The first letter on the pile was addressed to the chief of police. As soon as Germaine noticed this, she suspected something was wrong. She had just enough time to slide under the table as Casagemas pulled a pistol from his pocket and fired at her. Not realizing he had missed, he turned the gun to his temple, shouted "Et voilà pour moi!" and shot himself. He died in the hospital before midnight.

The whole, shocking incident threw Picasso into a tailspin. He was haunted by what had happened—the more so because he and Germaine soon became lovers. He returned to Paris, slept with Germaine in Casagemas's bed, and painted in Casagemas's vacated studio.

What ensued was Picasso's so-called Blue Period. Mired in poverty and a prolonged depression, he painted in a deliberately gauche and melancholic manner that found few supporters. His palette, reflecting his mood, was blue, and his subjects included beggars and blind men, circus performers and itinerant musicians, all with emaciated bodies and shadowed eyes.

People around him felt that he was squandering his talent. He

had forfeited whatever advantage he had gained by the show at Vollard's.

Now, FIVE IMPOVERISHED and disappointing years later, it was Matisse's name—not his—that was everywhere. The previous fall, after a breakthrough summer painting with André Derain in Collioure on the Mediterranean coast, Matisse had exhibited a series of small, frenzied-looking landscapes and portraits in bright, splashy, nonnaturalistic colors at the 1905 Salon d'Automne. Established in 1903 by a group of artists headed by Auguste Rodin and Pierre Renoir, the Salon d'Automne was a lively, more youthful alternative to several annual public exhibitions of recent art. The public response to Matisse's paintings had been vicious, and most of the notices unforgiving. Matisse was accused of exhibiting graffiti, not painting. According to Marcel Sembat, the socialist politician, "The good public saw in him the incarnation of Disorder, of a savage wholesale rupture with tradition . . . a sort of conman in a silly hat." The uproar was so bad that Matisse attended the show only once, and he forbade his wife, Amélie, from visiting at all, lest she be recognized and publicly harangued.

All this only compounded the tension that already existed in Matisse's wider family. His own parents were deeply unimpressed by his efforts. When he brought one work home to Bohain to show his mother, Anna, she was bewildered: "That's not painting!" she said. Matisse took a knife to the work and destroyed it. He and Amélie had already been through the Humbert affair. More scandal was the last thing they wanted.

But back in his studio, he persisted—he could not turn

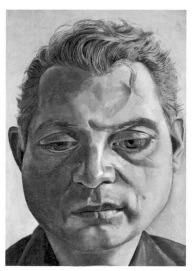

PLATE 1
Lucian Freud,
*Portrait of
Francis Bacon,*
1952.

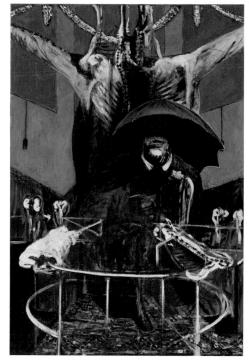

PLATE 2
Francis Bacon, *Painting
1946.*

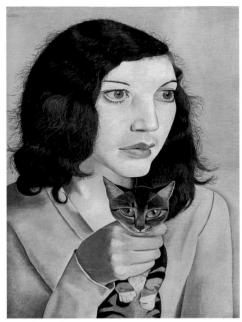

PLATE 3
Lucian Freud,
Girl with a Kitten,
1947.

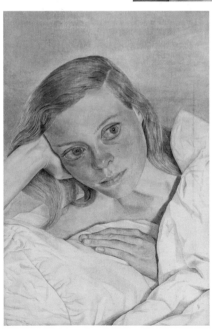

PLATE 4

Lucian Freud, *Girl in Bed*, 1952.

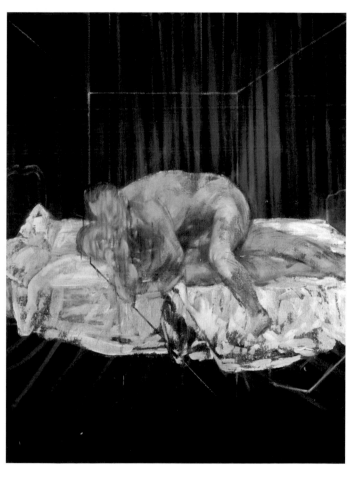

Francis Bacon, *Two Figures*, 1953.

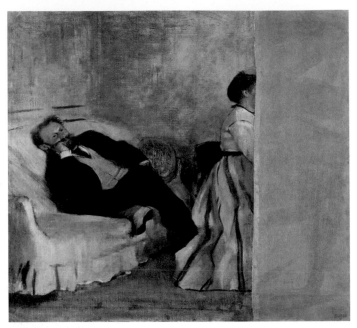

PLATE 6 Edgar Degas, *Monsieur and Madame Édouard Manet*,
c. 1868–69.

PLATE 7 Edgar Degas, *Interior (The Rape)*, c. 1868–69.

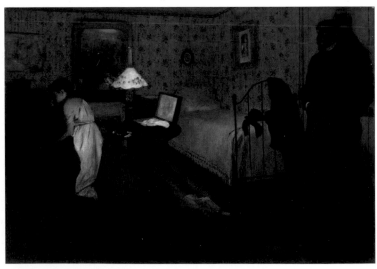

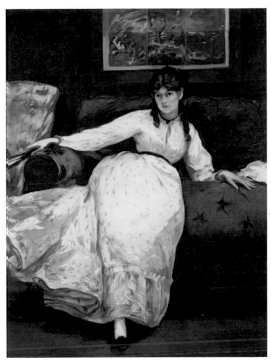

PLATE 8
Édouard Manet,
Le Repos (Repose),
c. 1870–1871.

PLATE 9 Édouard Manet, *The Execution of Maximilian,* 1867–68.

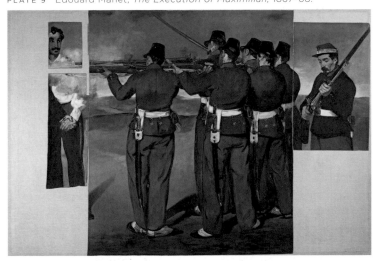

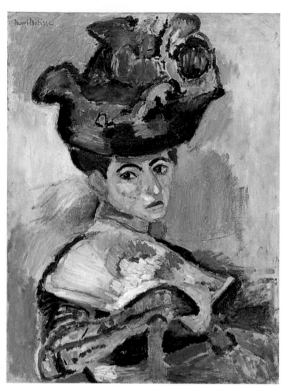

PLATE 10
Henri Matisse,
Woman in a Hat,
1905.

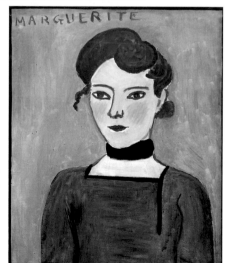

PLATE 11
Henri Matisse, *Portrait
of Marguerite*, 1907.

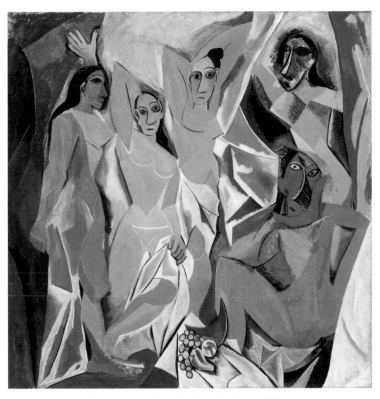

PLATE 12 Pablo Picasso, *Les Demoiselles d'Avignon*, 1907.

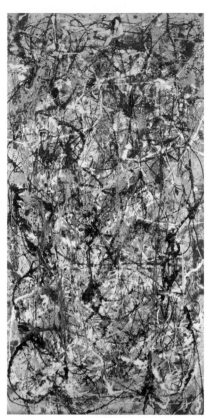

PLATE 13
Jackson Pollock,
Cathedral, 1947.

PLATE 14
Willem de Kooning,
Excavation, 1950.

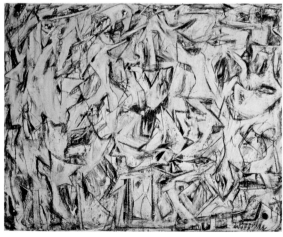

back—and his fellow artists could smell the audacity in what he was doing, the uncompromising intelligence behind it. It was an audacity that no one interested in the future direction of art could ignore.

Six months later, a few key people in the art business were beginning to come around. Matisse was touted in one magazine, *Gil Blas,* as the leader of a new school of painting. His second solo show—featuring fifty-five of his paintings, plus sculptures and drawings—was due to open at the Galerie Druet that spring (shortly after Matisse's visit to Picasso's studio). The day after the vernissage of that show, Matisse's bold new work, *Le Bonheur de Vivre,* was to go on display at the Salon des Indépendants, a public exhibition, set up in the 1880s, for artists working outside the narrow, officially sanctioned mainstream.

So as he made the march to Montmartre, Matisse could sense not only that, after years of struggle and experiment, he had hit upon something genuinely revolutionary, but also that his worldly predicament, after years of crippling poverty and humiliation, was looking increasingly hopeful.

For this last, he could thank the Steins. Recognizing something new and exciting in Matisse's work, Gertrude and Leo had bought *Woman in a Hat* [see Plate 10], the most electrifying of his paintings from the Salon showing. This portrait of Matisse's wife, Amélie, was part of a collection at the Steins' house on the rue de Fleurus that was growing—in size and in audacity—month by month.

JUST AS VOLLARD HAD GIVEN Picasso a show before turning his attention to Matisse, Leo Stein had acquired two Picassos be-

fore he bought anything by Matisse. Here again, though, the Spaniard's precedence was quickly overturned.

The first Picasso that Stein bought was a large work in gouache, *The Acrobat Family*. It showed a circus couple tenderly bent over their child with a seated baboon looking on. The second was a bigger, more ambitious oil. It depicted a full-length adolescent girl, her body in profile, her head turning to face the painter. She wears a necklace high on her neck and a ribbon in her thick, dark hair. But she is otherwise entirely naked. In her hands, cupped self-consciously at the level of her belly, is a basket of bright crimson flowers—a pretty touch that only seems to emphasize the awkward, not-quite-formed look of the girl's body.

The model was a teenage flower seller from the local market who was known as Linda la Bouquetière. At nights she worked outside the Moulin Rouge selling not only flowers but also sex. Picasso had initially planned to paint the girl (with whom he'd most likely slept himself) dressed for her first communion. It was a characteristically sly joke inspired by his friend Max Jacob's attempt "to reform Linda" by enrolling her in a Catholic youth organization called the Children of Mary. But he had changed his mind and painted her nude.

When Leo showed his sister the painting, Gertrude was, he claimed later, "repelled" and "shocked"—ostensibly by the stiff, gauche rendering of the girl's legs and feet, but perhaps also by the disturbing incongruity of her mature, knowing face and child's body. Still, despite his sister's objections, Leo bought it. "That day I came home late to dinner, and Gertrude was already eating," he later recalled. "When I told her I had bought the picture she threw down her knife and fork, and said, 'Now you've spoiled my appetite.'"

Gertrude's amusing reaction is made more memorable by the story's underlying irony: Picasso would soon become Gertrude's favorite. But what mattered at the time was that Picasso now had an in. His work had been bought by a man who was rapidly turning into one of the new century's most influential and articulate tastemakers. Even if Picasso had little to say to Leo (he didn't have the American's yen for intellectual argument), he was smart enough to sense Leo's personal force, his passion, and to know how important his support could be. And so he flattered Leo and did a portrait of him—a casual sketch, in gouache on cardboard, which he presented to his new patron as a gift.

LEO STEIN WORE GOLD-RIMMED spectacles and had a long reddish beard. Like Matisse, he was often compared to a professor. He had been twenty-eight when he and his sister Gertrude came to Paris from San Francisco to visit the World's Fair in 1900—the same year Picasso made his own first trip to the French capital.

Leo at that time was casting about for a sense of purpose in life—he had no real commitments back in America—and so he decided to stay on in Europe. He went to Florence, where he became friends with the art historian and connoisseur Bernard Berenson (both men had studied at Harvard University under William James). Eventually, having decided to become an artist, he returned to live in Paris. He found an apartment on the rue de Fleurus, on the Left Bank, and immersed himself in the city's vast store of art treasures.

Leo had not set out to become a collector, but he was avid for knowledge, and after buying one work—a painting by a student

of Gustave Moreau (Moreau had also taught Matisse)—he found he couldn't stop. As an American Jew in Paris, he was a kind of outsider with an affinity for the underappreciated, the untamed, the uncategorizable, and his little coup seemed to boost his craving for challenging, obscure, or surprising art. He had nothing like the funds freely available to other American collectors in Paris at the time. But he was thorough, and curious, and he soon added works by Bonnard, van Gogh, Degas, and Manet to his burgeoning collection.

His sister Gertrude (Berenson's wife, Mary, described her as "a fat, unwieldy person, the color of mahogany . . . but with a grand, monumental head, plenty of brains and immense geniality—a really splendid woman") came to live with him in 1903. After failing her medical school exams, she had been traveling in Europe and North Africa, and now was ready to take on Paris. She arrived just in time for the opening of the first-ever Salon d'Automne. The sprawling exhibit was held in the humid, stuffy basement of the Petit Palais. She and Leo returned to see it several times—Leo passionately holding forth, hungry for discoveries, Gertrude less zealous (she knew precious little about art), responding freely, instead, to whatever took her fancy.

They were an odd but impressive couple. But they were not for long the only Steins in Paris, and they would not be the only Steins who would go on to play a transforming role in the lives of Picasso and Matisse. Early in 1904, Leo and Gertrude's brother Michael, along with his wife, Sarah, their young son, Allan, and their au pair also moved to Paris from their home in San Francisco. For a short time they lived on the same street as Gertrude and Leo. But they soon moved to a spacious third-floor apartment on nearby rue Madame.

Sarah, a penetrating, persuasive woman, was as avid for knowledge about art as Leo, and it wasn't long before a current of competition began to run between her and her sister-in-law Gertrude.

WHEN LEO INTRODUCED PICASSO to Gertrude, it didn't matter that she hadn't liked his painting of Linda la Bouquetière: They developed an immediate rapport. Picasso had more than a bit of the clown in him, and he made Gertrude laugh. She was charismatic, mercurial, powerful, perverse, and she had a laugh, according to the Steins' friend Mabel Weeks, "like a beefsteak." Picasso straightaway sensed a soul in sympathy with his. He knew that his job was to win her over. And he did: At their very first meeting, he suggested that she sit for a portrait by him. She agreed immediately.

Picasso was used to producing portraits in a day or two, in a single sitting, or—just as often—from memory. It was an ability he'd had since adolescence, and he would continue to work that way throughout his life. But the sessions for which Gertrude sat were—famously—an exception. She later said she had sat for Picasso ninety times. What this meant was that several times a week Gertrude had to take the omnibus across Paris and then clamber up the Butte Montmartre. As if to signal his serious intent Picasso had chosen a canvas with dimensions exactly the same as the most valuable painting the Steins owned at that time—a large portrait by Cézanne of his wife holding a fan. It's not clear if it was Picasso who was more eager to spend time with Gertrude, or the other way around. But there was undoubtedly a mutual fascination between these two magnetic individuals, and

the sessions were still going on when Gertrude and Leo accompanied Matisse and Marguerite to Picasso's studio. Matisse must have known about the portrait in progress, and been curious to see it.

SPENDING SO MUCH TIME on the portrait of Gertrude turned out to be one of Picasso's masterstrokes. Gertrude would become one of his staunchest supporters. Because of her later literary fame, her version of what unfolded in these early years, recounted in *The Autobiography of Alice B. Toklas* and elsewhere, would win out over those told (or not told) by Leo and by Sarah Stein. And yet, at the time, when it came to decisions about buying art, it was not Gertrude who wielded influence (in matters of art, according to Georges Braque, Gertrude "never went beyond the stage of a tourist") so much as her brother and sister-in-law. Leo and Sarah were not only more knowledgeable about art but also more engaged—and fearless—as collectors.

Had Picasso, in his devotion to Gertrude, somehow backed the wrong horse? As he plugged away at her portrait, he now had to watch as the Steins' pooling attentions receded from around his own earnest efforts and began to lap instead at the feet of the older, but edgier, Matisse.

It happened quickly: Not long after he had introduced Picasso to Gertrude, Leo took Sarah and Michael Stein to the 1905 Salon d'Automne—the one that made Matisse notorious. This third incarnation of the annual exhibition, which had quickly established itself as the city's most important showcase for new painting, was held in the Grand Palais. It included established artists along with the younger brigade, and featured, in two ad-

jacent rooms, posthumous retrospectives devoted to a pair of nineteenth-century greats: Jean-Auguste-Dominique Ingres (who had died in 1867) and Édouard Manet (who died in 1883). Matisse and Picasso visited both, as did the Steins.

Leo was desperate to acquire a Manet that year and looked very intently at the show, which included one of Manet's most beautiful portraits of Berthe Morisot. Morisot is seen in three-quarter profile, arrayed in black, and set against a brown background. Her eyes are dark, her nose is slender and pert, and she wears a thick black ribbon around her neck.

By now, of course, three decades after he painted it, Manet's bravura style was no longer controversial. If anything, the Morisot portrait's brown-and-black palette must have looked sedate in the context of recent developments in the Parisian avant-garde—above all the full-blown emancipation of color inaugurated by the Post-Impressionists and advanced, most recently, by Matisse. Yet people admired the confident brevity of Manet's touch and his palpable modernity more than ever. Like everyone, Leo knew about the scandals his work had provoked at the official Salons of the 1860s. He identified, too, with the courage Manet's few early supporters had shown in the midst of the uproar. And so it's easy to imagine the Steins comparing Manet's portrait of Morisot with Matisse's portrait of his wife, Amélie, which was on show not far away in gallery seven.

That gallery had been dubbed the "Gallery of Dangerous Lunatics." And Matisse was lunatic in chief. The main question that animated those who found themselves in it (and soon enough, word had spread and people were coming in the thousands) was whether or not to take the paintings seriously. The landscapes were wild enough. The portraits were utterly bewil-

dering. Matisse had portrayed Amélie, like Morisot, seated, and holding what appears to be a fan in one hand. She turns to face the viewer directly—oblivious to the mad unchoreographed frenzy of colors that compose her features, to the utter lack of modeling, and to the conspicuous absence of finish. Her stare, set in a face made up of green, yellow, pink, and red daubs atop a neck of livid yellow and orange, is unapologetic, somehow reinforcing the challenge Matisse himself seemed to be laying down.

The artists showing in Salle VII were labeled Fauves when the critic Louis Vauxcelles described a Renaissance-style sculpture in the same gallery as "a Donatello among the wild beasts" (*fauves*). "A pot of paint thrown in the face of the public" was how another critic, Camille Mauclair, described their work. The public was similarly indignant. And initially *Woman with a Hat* had struck Leo, too, as "the nastiest smear of paint" he had ever seen. But the Steins—Leo, Gertrude, and especially Sarah, who was the first to see merit in it—returned many times to gallery seven. Again and again, as Spurling writes in her biography of Matisse, they found themselves drawn to *Woman with a Hat*. "The young painters were just laughing themselves sick about it," remembered a young American woman who was staying with Michael and Sarah Stein at the time. "And there stood Leo, Mike and Sally [Sarah] Stein, very impressed and solemn about it."

It was a challenge that excited the Steins. At Sarah's impassioned urging, Leo bought *Woman with a Hat* for 500 francs, and displayed it prominently at the rue de Fleurus. Picasso saw it there every Saturday night. He heard Leo and Sarah and even Gertrude talking incessantly about it as they tried (not always

successfully) to persuade their guests that they were not, in fact, insane—and neither was Matisse.

FOR THE MATISSE FAMILY, the sale had come at a key moment, both financially and psychologically. But it affected both Stein households, too. From that moment on, the whole character of the two collections—the one on the rue de Fleurus and the one at rue Madame—changed utterly. In effect, the Steins said good-bye to the nineteenth century. And as they threw themselves into the twentieth, it was Matisse, more than anyone, they looked to as a guide.

They had met the artist soon after making their momentous purchase. And it's clear they were moved by him—by the force of his intelligence, his grace under pressure, his surprising com-bination of personal propriety and almost reckless ambition. Matisse was charismatic: He knew, as his assistant Lydia Delec-torskaya said of him much later, "how to take possession of peo-ple and make them believe they were indispensable." And he loved taking risks. The Steins liked this about him.

They liked his family, too. When Gertrude met Amélie, she grew instantly fond of her. Amélie was tough. "I'm in my ele-ment," she said years later, "when the house burns down." When the Steins had made their initial offer on *Woman with a Hat*, they had tried to negotiate a lower price. Matisse was willing to give ground—no other buyer seemed remotely interested—but Amélie had held out, insisting on the full 500 francs.

Marguerite, too, the Steins adored. She soon became a play-mate to Sarah and Michael's son, Allan. Both Stein households

acquired portraits of her that year: Sarah and Michael had pictures Matisse had painted of her in 1901 and 1906, while Leo and Gertrude acquired a tumultuous portrait of Marguerite in a hat. They displayed it immediately beneath Picasso's suddenly tame-looking portrait of the underage prostitute, *Girl with a Basket of Flowers.*

AS A YOUNG GIRL, Marguerite had contracted diphtheria, a disease of the upper respiratory tract. Her breathing became so badly impeded that she had to be given an emergency tracheotomy on the kitchen table, while Matisse held her down. The incision in Marguerite's throat allowed her to take in air, but for some time her life had hung in the balance. As she was recovering in the hospital, she contracted typhoid fever, and this, too, very nearly killed her. She eventually got better, but her larynx and trachea were damaged, and ever since her health had been delicate. Too frail to go to school, she had been educated at home.

Unlike her two younger brothers, Marguerite was not Amélie's daughter. Rather, she was the child of Matisse's former lover, a shop assistant and artist's model called Camille Joblaud. Matisse's relationship with Joblaud had lasted five years. It prospered, too, until Matisse's seemingly endless struggles as an artist, the trying realities of bohemian life, and the birth of Marguerite placed intolerable strains upon it. The couple separated in 1897, and after a few unhappy years living with her mother, Marguerite came to live with her father, who was by then with Amélie. Amélie welcomed Marguerite into her home, and the two formed a close bond. But it was to her father that Marguerite was most tightly bound. He had seen her life almost

slip away. He had seen, too, how his split from her mother had torn and demoralized her. She, meanwhile, had observed Matisse's meandering evolution as a painter. Over the years, his studio had become for her a kind of refuge, and as she grew, Matisse came to depend on her more and more. She helped arrange his paints, brushes, and canvases. She posed for him. In subtle, unspoken ways, she vouchsafed his equanimity.

UNLIKE PICASSO, THE ANDALUSIAN wunderkind, Matisse was a late starter. He had first experimented with paints as a twenty-year-old. He was in his hometown of Bohain-en-Vermandois at the time, convalescing from a serious illness and in a fragile, susceptible state. Somehow, the simple experience of working with brushes and colored paint prompted a kind of epiphany. So when, as a seven-year-old, Marguerite herself came terrifyingly close to death, Matisse revived some of those old emotions by painting her as she convalesced over the summer. Now, five years later, she was on the cusp of adolescence, recovering yet again from a serious illness the year before. As he had during earlier scares, Matisse asked her to pose for him. He painted her during the day, her head down, buried in a book. And at night she posed nude—standing tensely, her hair in a bun—for a sculpture, *Young Girl Nude*.

Marguerite was much more than a convenient model for Matisse. She and her younger brothers were also muses to their father. He had lately taken a special interest in their own efforts at picture-making with pencils, brushes, and paints, and had begun to make ambitious paintings directly inspired by them. One of these, executed in a deliberately flat and childlike man-

ner, showed Marguerite with rosy cheeks, dark-green hair to match her top, and a thick black ribbon around her neck [see Plate 11].

IN 1894, THE YEAR Marguerite was born, Picasso's younger sister, Conchita, whom he adored, also contracted diphtheria. There was an outbreak in Corunna, a town on the northwest tip of the Iberian peninsula, where Picasso's family had reluctantly moved from Málaga three years earlier. Conchita was seven. Picasso was thirteen and in the throes of a tumultuous puberty. His family was not especially religious. But as they watched Conchita weaken, there was little they could do except pray, and pretend in front of the girl that everything would be fine.

It was not fine—and Picasso knew it. He was distraught, tormented by feelings of helplessness. Up until now, the only agency he had managed to carve out in his life—the only power he had—was all bound up in his art. People were constantly marveling at his drawing. His gifts were so abundant, and so obvious, that even his father, a painter and art teacher himself, had begun to feel outstripped. And so there was a certain logic to what Picasso did next, which was told by his biographer, John Richardson.

Faced with the loss of his beloved Conchita, he made a vow to God that, if her life was spared, he would never, ever paint or draw again.

Ten days into the new year, in the late afternoon, Conchita died in her bed at home. On the following day, a new antidiphtheria serum, ordered weeks before by her doctor, belatedly arrived from Paris.

For the rest of his life, Picasso was haunted by Conchita's death. At a moment when his whole adolescent self vibrated with a burgeoning consciousness of his own creative powers, her death had exposed the shame of his helplessness. But it also, perversely, confirmed him in his calling: God, he could tell himself, had chosen his art over his sister's life.

The deal Picasso had made, which he kept secret from almost everyone (in later years he only ever told his lovers about it), left him with a confusing burden of guilt. It was the guilt of any survivor who loses a sibling; but also, perhaps, the guilt of someone with an outsized gift, a calling, who, even as he does not yet know how to take possession of it, is haunted by the temptation to relinquish it. Picasso's deathbed pledge was entirely natural. But it was almost certainly a bargain made in bad faith, one he was never truly prepared to keep.

The episode is of crucial importance in Picasso's life, since it helps to explain what Richardson described as Picasso's "ambivalence towards everything he loved." It may also account for the various ways in which, for the rest of his life, as Richardson wrote, "young women, young girls in a way had to be sacrificed on the altar of Picasso's art."

Two years later, at the age of fifteen, as if to rehearse or exorcise his guilt, Picasso embarked on a series of sickroom and deathbed scenes. All of them showed ailing girls or young women. They were given titles like *Deathbed Scene with Violinist*, *Woman Praying at a Child's Bedside*, and *Kiss of Death*. These efforts culminated in a major painting of the same subject—a sickroom scene with a young girl—called *Last Moments*. This was the work selected to show in the Spanish section of the Paris World's Fair of 1900, prompting Picasso's first trip to Paris. The

painting was barely noticed, and before long it was back in Picasso's studio. But when he moved back to Paris the following year, hoping to make a name for himself, he took it with him.

HAVING CROSSED PARIS ON FOOT, Matisse, Marguerite, and the two Stein siblings began their trudge up the hill to the Bateau-Lavoir. The building was an old piano factory, since converted into artists' studios. It had a single-story street front, but behind this façade, it extended down a steep hill.

The Bateau-Lavoir—or "washing boat" (it was named for its resemblance to an old laundry barge on the Seine)—was a habitat unto itself. Gorgeously anarchic, it was a warren of antic high jinks, revelry, poetry, and petty crime. Among its other inhabitants over the five years Picasso lived there were the composer Erik Satie; the artists Amedeo Modigliani, André Derain, Maurice Vlaminck, Juan Gris, and Georges Braque; and the mathematician Maurice Princet.

For Picasso, however, its most important resident was Fernande Olivier. Olivier was considerably taller than Picasso. She had a full figure, almond eyes, and an idle air of sensuous curiosity. She had been raised by a single aunt, who forced her to marry a shop worker called Paul-Emile Percheron when she was eighteen. Percheron raped her, and kept her locked in the house when he went out. Only after she had suffered a miscarriage did Olivier manage to escape. She took up with a sculptor, Laurent Debienne, who went by the pseudonym Gaston de la Baume, and found work as an artist's model. As a young girl, she wrote in her memoirs, "I'd dreamed of knowing artists. They seemed to me to inhabit an enchanted world where life

must be so wonderful that it was too much to hope that I might one day share it."

She and la Baume took up in the Bateau-Lavoir, "a weird, squalid" place where, as Olivier wrote in her journal, "everything echoes around the building and no-one has any inhibitions." La Baume, too, was violent, but she didn't leave him until the summer of 1901, when she returned one day from a modeling session to find him in bed with a naked girl of twelve or thirteen who had been posing for him. "What a hypocrite!" she wrote, "with all his fine talk of the beauty and fragility of children!"

Three years later, she ran into Picasso, who had only recently settled in Paris for good. "For some time now I've been bumping into him wherever I go," she wrote at the time, "and he looks at me with his huge deep eyes, sharp but brooding, full of suppressed fire." She couldn't place him on the social scale, and she couldn't discern his age. Everything about him intrigued her. But she was understandably reluctant to give herself over to a man again (especially one who could barely speak French).

Picasso, for his part, was smitten. There was something touchingly obsessive about his early treatment of Olivier. He was openly besotted with her—in a way he never quite would be again with anyone else. "He drops everything for me," she wrote. "His eyes plead with me, and he treats everything I leave behind like a holy relic. If I fall asleep, he's beside the bed when I wake up, his eyes anxiously fixed on me." And yet despite all his attentions, Olivier remained reluctant to move in with him, as Picasso was urging. She detested the squalor he lived in, and was wary of his jealous streak. When he implored her to stop modeling, she resolved to put an end to things. She came to his studio and told him they could not be lovers—although she was willing

to be friends. Picasso was "devastated," she wrote, "but he would rather have that than nothing."

FOR PICASSO, WHAT ENSUED was a period both of confusion and of avid exploration. He persisted with Fernande (he had set up a kind of mock-altar to her in his studio) even as he haunted brothels and formed intense new friendships with two poets, Max Jacob and Guillaume Apollinaire. It was Jacob who introduced Picasso to the poetry of Baudelaire, Rimbaud, and Mallarmé. The two men were like brothers. They shared Picasso's bed and embroidered their friendship with insider jokes and improvised intimacies. Jacob called Picasso "the door to my whole life."

But it was Apollinaire's influence on Picasso that was especially profound. Still at the beginning of his career as a poet, Apollinaire had also embarked on an underground career as a writer of extreme (even by today's standards) pornography. He had not yet tried his hand at art criticism, although his impact later would prove enormous. There was an extremity in Apollinaire's vision that seemed uncompromisingly modern. It burned away incidental concerns and tired conventions. And it deeply impressed Picasso. Under Apollinaire's spell, after several years producing work saturated in pathos, superstition, and self-pity, Picasso now began to cast off secondhand literary tendencies and to wrestle with feelings and forms that felt genuinely new and fresh.

OLIVIER HAD MEANWHILE MET a good-looking Catalonian artist called Joaquim Sunyer. He was from Barcelona, where he had belonged to the same group of artists and anarchists—the

Quatre Gats—as Picasso, and he painted nightlife in the manner of Degas. Olivier soon moved into Sunyer's studio—a setback to Picasso. But she was not entirely content. Sunyer aroused her physically, but she did not feel that he actually loved her, "and I can only stay with a man if I believe I'm loved." So she continued to see Picasso, confiding in him and no doubt communicating some of her confusion. He was eager to kindle any kind of intimacy he could. And so one day he told her that he had recently tried opium with some friends. He would buy a lamp, a needle, and a pipe, he promised, and share some with her.

"Here's something new at last, and of course I'm fascinated," she wrote in her diary. They tried it soon after. They were awake until dawn that first night, and Olivier stayed in the studio for the next three days.

Picasso finally had what he wanted. "It's probably thanks to opium that I've discovered the true meaning of the word 'love,' love in general," wrote Olivier. Under the spell of opium, she felt an instinctive sympathy for Picasso. "I made up my mind almost instantly to bind my life to him," she wrote. "I no longer think of getting up in the middle of the night and going to find Sunyer, as I was still doing only recently because of the pleasure his lovemaking gave me."

Picasso, who was never religious but was deeply superstitious, must have felt a force akin to magic in this turnaround. He had only had to sprinkle a kind of fairy dust in the air—this drug called opium—and his wishes had been granted.

OLIVIER QUICKLY BECAME PART of the tight group of eccentric, penniless, and wild-living friends that had formed by now

around Picasso—the so-called *bande à Picasso*. There were Jacob and Apollinaire, there was the poet André Salmon, and then various other Bateau-Lavoir residents and visitors, a changing cast of artists, models, and circus performers. Opium played a major part in their fledgling society, which, inevitably, involved as many dismal lows as exhilarating highs. Picasso was still prone to fits of jealousy, and the relationship remained fragile over the next year, as he continued to shake off the sentimentality of his Blue Period and pursue a tougher, more stripped-down vision.

Artistically, he was coming into a new kind of maturity. His emotions were being stretched beyond the bounds of his own self. He grew less maudlin; his interests seemed to range more widely. His friendships—with Jacob and Apollinaire, above all—were in many ways as ardent as his feelings for Fernande, who finally moved in with him in late 1905. Under the influence of love, of opium, and of poetry, his art was becoming simultaneously more expansive and more self-aware.

WHEN THE RELATIONSHIP WITH the Steins had begun, Olivier, like Picasso, had immediately sensed tremendous possibilities. "We've had some surprise visitors at the studio," she noted in her journal. "They are two Americans, a brother and sister, called Leo and Gertrude Stein ... They really admire avant-garde artists and seem to have an instinctive understanding, a kind of flair for it. They know exactly what they are doing and bought 800 francs worth of pictures on their first visit, far more than we ever dreamed possible."

By this time Gertrude had already agreed to sit for her portrait. The Steins invited Picasso and Olivier for dinner, and the

couple quickly became regular guests at their Saturday-evening soirées.

In many ways, however, these evenings at the Steins' were a trial for Picasso. His French was poor, and when, soon enough, he began to have to contend with the Steins' new darling, Matisse, they became especially trying. Bearded and bespectacled, Matisse would hold forth in his native French with sober charm and impressive command. He was *persuasive*. His self-possession was intimidating, his grown-up demeanor a far cry from the behavior indulged in by Picasso's friends around the Bateau-Lavoir and the nightclubs of Montmartre. In Matisse's presence, Picasso must have felt acutely conscious that he was behind him in almost every way—in achievement, in maturity, and, above all, in creative audacity.

Matisse, for his part, could surely smell Picasso's ambition, and he had picked up—either directly or from the whisperings of others—on his brilliance. But if he felt threatened, he wasn't ready to admit it to himself, much less betray it to others. Instead, it seems, he was inclined to think of the Spaniard almost as a younger brother. There was something special about him, no doubt, and something attractive, too. Instead of hostility, it brought out in Matisse an impulse toward magnanimity.

Trying as these evenings were, Picasso knew how important it was that he attend them. And he, like Matisse, was stimulated by the works the Steins had on their walls. "If you get bored with the conversation," wrote Olivier, "there are always the works of art cluttering the studio to look at, and they also have a very good collection of Chinese and Japanese prints, so you can disappear into a corner, sit down in a comfortable armchair and lose yourself in contemplating these beautiful masterpieces."

Like Picasso, Olivier couldn't help but notice the many Matisse paintings that had begun to populate the walls, both at the rue de Fleurus and at Sarah and Michael's home at rue Madame. She watched Matisse closely: "With his regular features and thick golden beard, he had the look of a classic Great Master," she recalled. He was warm and agreeable. But she noticed how, when the subject turned to art, "he would talk for ages, arguing, explaining, trying to convince his listeners and get them to agree with him. He possessed an astonishingly lucid mind and argued clearly and precisely."

WHEN PICASSO WAS PAINTING GERTRUDE, Olivier was often there, too, reading aloud from the fables of La Fontaine. When the two women were alone—either at the Steins' or in Montmartre—Olivier would confide in Gertrude, describing the ups and downs of her amorous life, complaining about Picasso's jealousy, admiring his dedication to his work, relishing his adoration. She may also have gossiped with Gertrude about Matisse. Olivier was perceptive. She realized that, for all his talk and outward demeanor, Matisse was "a good deal less straightforward than he liked to appear."

This was something Picasso, who was almost preternaturally alert to weakness in others, must have grasped, too. He would have sensed as soon as they met that, for all his outward displays of social command, Matisse was a man under enormous pressure. He suffered panic attacks, nosebleeds, and insomnia, and was plagued by insecurities. His audacity in the studio, his willingness to go where feeling led him, came at a cost. What he was doing with color was genuinely unprecedented in the history of

Western art. He was frightened by what he had unleashed, and couldn't be sure of its validity. His "rampant self doubt," as Spurling wrote, "made him desperate to know what sympathetic observers thought about his work."

A part of Matisse probably hoped that Picasso might be just such an observer, and even that he might somehow make of the young Spaniard a kind of protégé. He was on the lookout for acolytes, for anything or anyone that could shore up his position. He already had Derain, Braque, and a number of others in his corner. Why not also Picasso?

And yet Matisse could also see, like everyone else, how magnetic Picasso was, and he will have noted from very early on that the Spaniard had the kind of fluency and skill as a draftsman that he could only envy. So another part of Matisse must have realized how unlikely it was that Picasso—young as he was—would ever be anyone's acolyte.

WELCOMING MATISSE TO HIS STUDIO was a way for Picasso to wrest back some of the control he had lately relinquished, both in his relations with the Steins and in the incipient rivalry with Matisse. The Bateau-Lavoir may have been wild and ramshackle, but it was also, for Picasso, sovereign territory. It was a place he was proud to show off—to all comers. In the summers when, as Fernande wrote, his studio was "as hot as a furnace," he would often strip down and, with regal nonchalance, receive visitors half naked, or entirely so, "with just a scarf tied around the waist." On one occasion, Gertrude had arrived unannounced with a young woman from California, Annette Rosenshine. Gertrude "turned the doorknob and pushed," remembered Rosen-

shine, and encountered a scene strangely akin to the trio in Manet's *Luncheon on the Grass:* "There on the bare floor of a completely unfurnished room lay an attractive woman between two men—Picasso on one side . . . They were fully clothed . . . lying there to rest from a bohemian revelry the night before . . . [Since] Picasso and his companions . . . were disinclined to get up or incapable of it and did nothing to detain us, we left."

The Bateau-Lavoir, in other words, was a place that thrived not on drawing room disputation, on endless explaining, but on youth, ardor, and spontaneity. Picasso knew that whatever else Matisse had going for him, he no longer had access to all this. And he relished the opportunity to remind him, the way any person in his twenties—free from marriage, from children, from financial responsibility, still the master of his own life—enjoys flaunting his freedom before his elders. If, at the Steins', Picasso couldn't help but feel inferior, here, at the Bateau-Lavoir, his potency would be unmistakable.

AS SOON AS MATISSE AND MARGUERITE, with Gertrude and Leo, approached the entrance to the Bateau-Lavoir, Matisse must have felt this difference between his own life and Picasso's. But it was also, of course, as Spurling pointed out, a life he recognized. He, too, had lived for many years in poverty with a vivacious, bohemian girlfriend, in the company of other artists. He, too, had scrounged for money, pawning his watch, doing mindless jobs, dressing carelessly, oblivious to outward appearances. He was probably not yet ready to romanticize those days—they were still too raw; they had led to too much strife; and the strife was not yet verifiably over. The girlfriend—Marguerite's

mother—was gone, and in her place he had a wife. Together, they were strong. But they were still mired in poverty, still out on a limb.

As they all entered Picasso's studio, Gertrude, one feels (at this point one can only speculate), would have been brusque and convivial, belching out her disarming beefsteak laugh in the suddenly crowded room. Leo surely looked around avidly, hoping to see some new image, the beginnings of some new manner to get excited about. Both were probably on the lookout for any signs of tension between the painters. (The idea of rivalry—which was well and truly alive in their own sibling relations—stimulated them.) Olivier, one imagines, would have greeted Matisse with warmth and respect; but perhaps also some trepidation on Picasso's behalf: "Matisse shone on occasions like this," she later noted, "and was always in complete control, whereas Picasso was shy and diffident and appeared rather sullen." To break the tension, she may have fawned over Marguerite—the more so, perhaps, since her miscarriage during the nightmare period with Percheron had left her unable to have children of her own. (This was something Picasso had only recently become aware of, so the subject was raw. Picasso was not above taunting the people in his life through his art, and the series of images he had recently embarked on of mothers nursing children may have functioned partly as a cruel reproach.)

Matisse had presumably spoken with Picasso about Marguerite in the context of explaining his (highly unusual at the time) interest in the art of his own children. Picasso was intrigued: Matisse's interest dovetailed with a feeling for innocence and purity that had lately found its way into his own pictures. But Picasso never adopted an interest or influence without complicating

it. And almost always the complications related to sex. (If Matisse hadn't grasped this yet, he would soon enough.) Sex, and a related drive toward visual possession, were part and parcel of Picasso's whole way of seeing. When he looked at a drawing or print, claimed Leo Stein, it was surprising "that anything was left on the paper, so absorbing was his gaze." A long list of women and girls—beginning with Olivier—attested that his gaze had a similar effect on them. So it's possible that Matisse may have noticed, with some unease, how Picasso now looked at Marguerite.

WE DON'T KNOW WHAT pictures were hanging or stacked up against the walls that day—although Matisse, peering ferociously through his spectacles, would probably have seen the unfinished portrait of Gertrude. There may also have been several of Picasso's stripped-back, early Rose Period works with young boys, mothers with infants, and circus scenes. To Matisse, it must have seemed admirable stuff, and in some ways even quite exciting. But there was nothing that could have struck him as extraordinary. Nothing remotely as audacious as what Matisse himself was then in the grip of. So for Matisse there was nothing to lose by dropping a few supportive comments, perhaps even asking a few pertinent questions. Matisse, according to Leo Stein, "liked giving his opinion," but just as much, he "liked hearing the opinion of others." He had "great maturity and the temper of the eternal pupil: he is always willing to learn anyhow, anywhere, and from anyone."

But of course, it's always a very delicate business, talking to someone about their creative endeavors. So easy to get it wrong. So easy for something patronizing to slip out, or something ac-

cidentally barbed—some thinly veiled rebuke, perhaps, whether real or imagined . . . Whatever Matisse said, whatever the general manner or particular comment, it's fair to guess that this very tendency toward prolixity got up Picasso's nose. "Matisse talks and talks," he complained to Leo Stein. "I can't talk, so I just said, *Oui oui oui*. But it's damned nonsense all the same."

When the visit was over, after Picasso and Olivier saw Matisse and Marguerite and the Steins off, dispensing thanks and jokes and best wishes as the four of them set out on the return journey, it's easy to imagine Picasso's temples throbbing. After a brief interlude, we might speculate, he will have reentered his studio, demanding to be left alone. His eyes, staring again at the pictures on his walls, will have blinked, looked away, looked back, and blinked again, as he struggled to compare what was here with what he had seen by Matisse at the Steins'. And with each passing minute, he will have grown more determined to prove that Matisse *did*, in fact, have something to lose.

WITHIN DAYS OF MATISSE'S first visit to the Bateau-Lavoir, he exhibited his latest picture, *Le Bonheur de Vivre* (*The Joy of Life*), at the Salon des Indépendants. When he saw it, Leo Stein balked. Matisse's latest concoction was a radiant Arcadian vision—languorous nudes, embracing couples, a boy playing pan flutes, a ring of dancers linked by hand, all cavorting in an outdoor setting framed by sinuous tree branches and a rainbow canopy. The picture conjured a paradise, but everything about it was jarringly odd. The figures were out of scale and had weird proportions. Some were outlined with thick, colored shadows. It wasn't clear how they related to one another, or if they did at all. The color

was ecstatically vivid—so rich it was almost blinding. But the vision seemed barely related to reality, or anything even approaching it. As an exercise in bright, saturated color, it was unprecedented, certainly. But in most people, it triggered total bewilderment.

But, just as he had with *Woman in a Hat,* Stein soon recovered from his initial shock, and before long he was calling it "the most important work of our time." He bought it for the walls of the rue de Fleurus, where, on account of its astonishing coloration, it quickly became the most talked-about picture on display.

Picasso was blindsided. The idea of Arcadia—of an imaginative return to a delicate, primitive, dreamlike state marked by tranquility and bliss—was in the air at the time. A rash of new translations of Virgil's *Eclogues*—the Roman source of the vision—had appeared in France over the past half century, and as the country was convulsed by political upheavals, the dream appealed increasingly to artists and the public alike. Puvis de Chavannes, the muralist, addressed it repeatedly, giving the dream a stately, classical tint. Paul Gauguin, meanwhile, took the idea—and specifically, Baudelaire's Arcadian poem, "L'Invitation au Voyage"—quite literally and went off in search of such a society in the South Seas. His Arcadian masterpiece, *Where Do We Come From? What Are We? Where Are We Going?* was sent back to Paris from Tahiti, and was on display in Vollard's gallery in 1898 and 1899, where Matisse must have seen it.

Infected by the same dream of a classical, Arcadian past, Picasso had spent months planning a painting of a similar subject, *The Watering Place.* It was to be a large canvas showing young

naked boys and horses by a watering hole. It was to be a return to essentials, to a mood of archaic simplicity, to something unaffected, inviolate, aloof from the hubbub of the modern metropolis. He wanted to use this painting to broadcast a new level of ambition.

But when he saw the Matisse, he realized at once that he'd been outflanked. He abandoned *The Watering Place*. There was simply no point exhibiting a work that would look so unadventurous beside the *Bonheur de Vivre*. Matisse wasn't producing pale, watery imitations of Greece, or Gauguin, or Puvis de Chavannes. Whatever you thought of them, his paintings were new, and they were resolutely themselves.

WHAT HAPPENED OVER THE following eighteen months was a drama unlike any in the story of modern art. It was a fight between two geniuses of invention—in many ways equally endowed but in sensibility and temperament utterly different—for a true and radical originality. Ultimately, what was at stake was election to greatness. More immediately, however, it was a struggle over how much each man was prepared to see—to truly *see* and recognize—the other, and how much each would instead elect to defend himself against the other—to *not* see, or to see with deliberate perversity.

Remarkably, it was a fight that Matisse, for a surprisingly long time, doesn't seem to have quite registered he was even in. Taking Picasso's later ascendancy as a given, accounts of the period have tended to assume that Matisse recognized Picasso as a rival from the outset. But his behavior suggests otherwise. It

suggests not only that he admired the younger man and was happy to befriend him, but that he did not see much in his work that posed a serious challenge to him.

The two men saw a lot of each other. Picasso was not just a reliable presence at the Steins' but a regular visitor to Matisse's studio, too. They wandered together through the Luxembourg Gardens. Both, in their different ways, were charismatic and full of charm, and despite Picasso's poor command of French and Matisse's seniority in age, it's easy to imagine them enjoying each other's company, feeding off each other's responses to various contemporaries or predecessors (perhaps those archetypal rivals of the previous century, Delacroix and Ingres, or the more intimately connected Manet and Degas; certainly Gauguin and Cézanne), and joking about mutual acquaintances—the Steins, perhaps, or Vollard.

Matisse, at this delicate stage of his career, was acutely conscious of outside opinion. With others looking on, he was eager to be seen extending the hand of friendship to the young Spaniard. Encouraging him, complimenting him, asking considerate, thoughtful questions, welcoming him into his studio, introducing him to his family, to Amélie, and to Marguerite, who was always around the studio, posing for her father, helping him put things in order . . . These were the right things to do, and they came easily to Matisse.

Partly, of course, he was taking the long view: He and Picasso and the other artists around them were involved in a bigger fight. They were modern artists in search of a public. It was a search fraught with risk and uncertain reward, as they knew from the stories of their immediate predecessors: the Impressionists, who struggled for so long in poverty; Manet, who was

so relentlessly abused; van Gogh, who took his own life; and Cézanne, who labored his entire life in obscurity. Very few of these role models had met with fates that were encouraging. Nothing came easily to them, and there was no reason to think it would come any easier to Matisse and his avant-garde peers. And so it made sense to support one another. They were all in it together, and each among them would surely benefit from the success of the others.

This was Matisse's basic impulse. But of course, since he was already the established frontrunner, his attitude—a sort of noblesse oblige disguised as camaraderie—was one that he could afford to take. For Picasso, the calculation was different. He had always been surrounded by people who recognized his preeminence. He could not abide the idea of being a follower.

MANY YEARS LATER, Matisse told Picasso that Picasso knew, "like a cat, that whatever somersault you attempt, you will always land on your feet." To which Picasso replied, "Yes, that's only too true, because I was imbued early with a damned sense of balance and composition. Whatever I venture, I don't seem to be able to break my neck as a painter."

In 1906, Matisse, as a painter, was very much breaking his own neck. Watching, Picasso—really for the first time in his life—was thrown off balance. It wasn't a single, destabilizing blow, from which he could quickly recover by falling back on his own best instincts. It was an experience repeated each week, as bizarre, eye-catching new work—bolder, brighter, rougher, more dazzling than anything yet seen—kept appearing in Matisse's studio and on the walls of the Steins. All through 1906

and well into 1907, Picasso was continually being made to re-calibrate his judgment to match what he was seeing. And in such pressurized circumstances (Matisse always articulating his various theories, always impressive; the Steins promoting him heavily as they poured persuasion into the minds of their multiplying guests; Picasso sullenly looking on, testily answering questions about his own work—questions for which he had no real answers), the effort was immense.

It was a relief to go back to Montmartre. On Sundays, after their regular evenings at the Steins', Picasso and Olivier would sleep in. Around eleven o'clock they would head down to the local open-air market on Place Saint-Pierre beneath the still-unfinished basilica of Sacré-Coeur. Picasso would be wearing his workman's overalls. Olivier draped herself in a Spanish mantilla. The markets were full of life—just what Picasso needed to revive him after the ordeal of the Steins and a week spent fretting in his studio. Picasso, wrote Olivier, "loves all this working class hubbub and it takes him out of himself, away from his preoccupations with his creative life."

MOMENTUM CONTINUED TO BUILD for Matisse. His *Bonheur de Vivre* caught the attention not just of the Steins but also of a fifty-six-year-old textile magnate from Russia called Sergei Shchukin. Shchukin's wife and youngest son had died the previous year, and when he saw Matisse's visionary painting, this wealthy but emotionally shattered man was overwhelmed. He asked Vollard to introduce him to the artist, and over the next decade he became Matisse's bravest, most important, and—after Sarah Stein

(who was now so bewitched by Matisse that she and Michael were soon collecting nothing else)—most trusted patron.

With its large passages of flat, saturated color, its atmosphere of riotous abandon and extravagant sensuality, the *Bonheur de Vivre* triggered a flood of visitors to 27 rue de Fleurus, and thence to 58 rue Madame. In Paris, the two Stein households had become the most important place to go for anyone interested in modern art. And evidently, many people were. It was six years into the new century. A sense of being on the cusp of unprecedented things prevailed. Paris had been the capital of the nineteenth century. Would it—with its sky-piercing tower, its busy, sweeping boulevards, its world's fairs, its underground network of pneumatic tubes, and its constellation of grand railway stations—also reign over the twentieth? People came to the city to find out. At that time, aside from the cacophony of the annual Salons, the only place to go to see an official selection of recent art was the Musée du Luxembourg. But the latest developments— the ones that so enthused the Steins—had made even that museum, filled as it was with conventional-looking landscapes and portraits and history paintings, look beholden to an earlier era. Things were far more exciting at the nearby rue de Fleurus. There you could see the latest works by Matisse and Picasso alongside paintings by Manet, Cézanne, Bonnard, Maurice Denis, Eugène Delacroix, Toulouse-Lautrec, and Renoir. Both Stein families had bought heavily from Matisse's second retrospective in the spring. By the end of the year, Sarah and Michael's rue Madame apartment boasted a whole ensemble of his latest paintings.

At first, visits to the Steins' were ad hoc. But the constant

disruption caused by so many requests to see the collections be-
came too much, especially for Gertrude. She had started using
the atelier at the rue de Fleurus as her writing studio. To solve
the problem, visiting hours were established, and both apart-
ments were opened on Saturday evenings to anyone who carried
a reference. Seeing the paintings properly was often a problem,
since neither Stein home was wired for electricity. For the strong
colors of the Matisses, candlelight was not ideal (Picasso, by con-
trast, enjoyed all his life the magical effects of candlelight on his
work). As a result, many guests requested return visits during
the day, and the Steins were loath to deny them. They were, as
Vollard wrote, the "most hospitable people in the world." And
so the crowds only grew.

For many passing through, going to the Steins' was almost
like going to a show: It was a kind of theater—deadly serious for
the cast of artists and collectors, but less so for the skeptical ma-
jority, who often came away bemused and baffled both by the
pictures on the walls and the atmosphere of earnest sobriety
around them. Picasso, always slightly on the edge, may have felt
an urge to side with the baffled skeptics—especially since it was
the work of Matisse above all they struggled to see. He, Picasso,
struggled too.

VOLLARD WAS AMONG THE MANY who came to the Steins'. At
the end of April, he swooped, buying up 2,200 francs' worth of
pictures from Matisse's studio. For Matisse, the money (equiva-
lent to about $10,000 today) was a godsend. He would have liked
to have been in a position to decline it—he didn't trust Vollard—

but the reality was that it came at a good moment. Despite the attention his work was getting, he was still close to broke. The Steins had asked Matisse to let them delay payment for the *Bonheur de Vivre*, because the earthquake that devastated San Francisco on April 18, 1906, had plunged their own finances into uncertainty.

Only a week or two later, Matisse received surprising news in a letter from Leo Stein: "I am sure that you will be pleased to know," he wrote, "that Picasso has done business with Vollard. He has not sold everything but he has sold enough to give him peace of mind during the summer and perhaps longer. Vollard has taken 27 pictures, mostly old ones, a few of the more recent ones, but nothing major. Picasso was very happy with the price."

PICASSO'S SALE TO VOLLARD was indeed a major boon. He had been experiencing intense frustration in his studio. After ninety sittings, his portrait of Gertrude was stuck. He had set out to portray her in the same bulky and casually authoritative pose as Ingres's portrait of the press baron Louis-François Bertin. But this simple idea had turned into an excruciating ordeal. He could not get the painting to where he wanted it. He kept on seeing new problems, new inadequacies. The difficulties were only compounded each time he came back from Matisse's studio or the Steins'. The portrait—his whole conception of it—was insufficiently bold.

The sittings themselves had become a trial. It was no longer just he and Gertrude and occasionally Fernande in the studio, for Leo would often stop by, too. And since all the Steins, but espe-

cially Leo, had Matisse on the brain and would not stop talking about him, this meant that, in effect, Matisse was there, too, always looking over his shoulder.

Finally, Picasso's frustration boiled over. He scraped away Gertrude's face, telling her he had to stop. "I don't see you anymore when I look at you," he said.

THERE FOLLOWED A GREAT HIATUS. Summer was coming, and with the windfalls they had received from Vollard, both Matisse and Picasso left Paris. Picasso, in particular, needed to be away from the Bateau-Lavoir; away from Gertrude; away from Saturdays at the Steins'; away, above all, from Matisse.

Matisse went to North Africa. He spent two weeks in Algeria before returning across the Mediterranean to Collioure, where he stayed through October. Picasso, meanwhile, went home to Spain. Taking Fernande with him, he went first to Barcelona and then to a remote mountaintop village in the Pyrenees called Gósol.

Barcelona was a homecoming. There, among old friends, Picasso was once again the celebrated wunderkind, the brilliant young artist who had so impressed on his home turf that going to Paris, the center of the art world, was his only real option. The intervening five years had not been easy. But now, thanks to the Steins' early interest and Vollard's renewed vote of confidence, he finally had something to show for himself. He was happy to see family and old acquaintances again, and proud to show off his new love, Olivier. The visit was reassuring: It bolstered his faltering sense of himself.

But in Gósol, where the couple decamped after the city,

something even more enviable happened. In this rustic and isolated village the two lovers experienced a kind of honeymoon that was also, for Picasso, a creative transformation. For Picasso, the two phenomena—love life and creative stimulus—were inseparable and always would be; but the link was never more forceful, and never more affecting, than during this summer sojourn in Gósol.

They stayed with the local innkeeper, a ninety-year-old former smuggler called Josep Fontdevila, who sat for Picasso several times. They were drawn into the villagers' daily life. They observed and participated in several festivals, including the Feast of Santa Margarida, Gósol's patron saint. Without money or the venal bustle of the city to think about; away from the poets, the pornographers, the drugs, and the melodramas of the Bateau-Lavoir; away from the pressure of dealers and collectors and fellow artists, they at last began to thrive. Picasso was able to see Fernande not as an object of veneration or a cause for frustration but as simply his lover. "The Picasso I saw in Spain," she later recalled, "was completely different from the Paris Picasso; he was gay, less wild, more brilliant and lively and able to interest himself in things in a calmer, more balanced fashion; at ease, in fact. He radiated happiness and his normal character and attitude were transformed."

Olivier, too, was as content as she had ever been: "Up there in air of incredible purity," she wrote, "above the clouds, surrounded by people who were incredibly amiable, hospitable and without guile . . . we found out what happiness could be like."

All this fueled Picasso's sense of artistic potential. Gósol acted on his imagination much as the fishing village of Collioure had on Matisse. He was prolific. He recorded the locals dancing,

just as Matisse had been engrossed by the peasant dances in Collioure. Under the magnetic pull of his lover's body, his lines became harder, more adamant, carving out volume and mass with increased economy but also more emphasis. The emaciated circus performers and flimsy ephebes he had specialized in over the past several years gave way to wide-waisted, full-breasted figures with pouchy stomachs and muscular arms. Looking at the images that emerged, it is as if Picasso's eyes had been flushed, rinsed of confusions and false feeling. He was suddenly able to see again, cleanly, without the distorting prism of Matisse always before him.

Shorn of the pathos and self-pity of the Blue and early Rose periods, the new work had a timeless, inviolate quality, an almost imperious detachment. With ancient models in mind—Greek kouroi, ancient Iberian sculpture, the classical dreaming of Ingres—Picasso was searching for a quintessential line, an emphatic nudity (his pictures contain no hint of body hair), and the distant perfume of an archaic, untutored youth. There is a sense in the results of a concerted harking back, an attempt to arrive at a kind of simplified vision that predates civilization and stands poignantly aloof from social life.

UNFORTUNATELY, SOCIAL LIFE CAME crashing back in, bringing this lovers' idyll to an abrupt end. The ten-year-old granddaughter of Fontdevila, to whom Picasso had become deeply attached, became ill with typhoid fever (the same highly contagious, frequently fatal bacterial disease Marguerite Matisse had contracted). As soon as Picasso, who hated illness and was haunted by the death of his sister Conchita, found out, he and

Olivier fled. The journey back to Paris was long and arduous. They traveled north over the Pyrenees, first by mule (an encounter with a herd of wild horses on this first leg almost ended in disaster when some of the mules bolted and lost their loads, causing Picasso's rolled-up canvases, drawings, and sculptures to be scattered in the dust), then by coach, then by train.

When they arrived in the city, it was the end of July, high summer, and the Bateau-Lavoir studio was a furnace. Mice had eaten away at everything in sight, and both their bed and the sofa were infested with bedbugs.

Picasso called on Gertrude and asked her to resume the portrait sittings. Having earlier erased her facial features, he now painted them back in, this time greatly simplified, and marked by a blockish faceting of the face. He endowed Gertrude's eyes with a hypnotic asymmetry, evoking an inner intensity of vision, a seer's blindness. Looking at the finished portrait, you feel the memory of the earlier drama—"I don't see you anymore when I look at you!"—brilliantly resolved with this suggestion of a whole new way of seeing—more internal than external.

Gertrude had wanted Matisse, too, to paint her portrait, but he had declined. His demurral had caused tensions between them that were exacerbated by Matisse's increasing intimacy with Sarah Stein. But Gertrude was happy now. She had a full-fledged Picasso: an original, masterly portrait, noteworthy for many things, including its conspicuous refusal of Matissean color (the picture instead is a symphony in brown). And there were other ways, too, in which Picasso seemed to be trying to position himself as a kind of anti-Matisse. Where the breakthrough paintings of Matisse and his fellow Fauves were marked not just by vivid color but by an unfinished look and a lack of underpinning

drawing—qualities that had provoked accusations that their pictures were anarchic and diseased—Picasso's new work was soberly colored, classically symmetrical, and anatomically accurate.

It was not enough, however, for Picasso to carve out his own, opposing ground, because Matisse himself would not stop moving. As the *Bonheur de Vivre* had shown, he was already shifting away from Fauvism. With an urgency that Picasso may partly have prompted, he was trying to regain control over the anarchic side of his sensuous response to color—not by dimming it (on the contrary, he was constantly intensifying color) but by finding alternative ways to impose balance and lucidity. Drawing, henceforth, played a key role. Carving out large areas of flat, unmodulated color, Matisse's lines, swelling and receding, helped him achieve the composure he sought.

In this search for lucidity, Matisse did not pursue Picasso's more conventional, academic line, but instead sought answers in a more primitive or untutored approach. He had been repeatedly accused by his critics of celebrating deformity. As if to goad them, he now actively embraced the idea of deformation.

WHEN PICASSO WAS EFFECTING his solution to the portrait of Gertrude, Matisse was still in Collioure, working on two portraits of a local fisherman. Collioure was Matisse's haven, his sanctuary. It was a busy fishing village on a small, curving bay, surrounded by the arid foothills of the same range, the Pyrenees, that Picasso had recently crossed with Olivier. Pockmarked by palm trees, radiant clumps of spiky agave, fig trees, date and banana palms, and pomegranate and peach trees, the village was

close to the border with Spain. The town specialized in ancho-
vies and sardines preserved in brine, and as a result a pungent
smell permeated the port where the fish were gutted and salted
and their heads left to rot. Geographically, it was the part of
France that was closest to Africa, and centuries of trade and ex-
change had given the town a strong Moorish flavor. Collioure
was where Matisse had painted in the company of Derain in 1905
and, under the spell of the port's intense light, had produced the
first Fauvist paintings. So it was a place he returned to, just one
year later, with a tremendous sense of potential.

The model for his fisherman portraits was a teenager called
Camille Calmon. Matisse had the boy, who lived in the house
next door, sit on a chair in a casually hunched, off-kilter pose not
entirely unlike Gertrude Stein in Picasso's portrait. The first ver-
sion Matisse painted was roughly but conventionally drawn, the
brushwork still essentially Fauvist—which is to say loose and
unfinished-looking. The second version, painted on a canvas ex-
actly the same size, began as a free copy of the first. But Matisse,
who was thinking about how to anchor and intensify his pictures'
expressiveness, soon began altering the contours, flattening and
simplifying the boy's face, exaggerating rhymes and rhythms in
the figure's silhouette and in the folds of his clothes. He trans-
formed the parti-colored background of the first version into a
uniform bubblegum pink, and filled in the colors of his pants and
shirt so that they, too, were uniform, flat, and saturated, rather
than porous and incomplete.

By conventional standards, the first picture was bizarre
enough. But the second ran the risk of appearing as a flat-out
parody. Not for the first time, Matisse was thrown off balance by
what he had done. Anticipating outside responses, he was more

anxious than usual. When he returned to Paris and showed the painting to Leo Stein (an audience as sympathetic as any he could hope for), he initially pretended it had been painted by the local postman in Collioure.

Disowning the picture may have been a jest—he admitted soon enough "that it was an experiment of his own"—but it was a revealing one. Matisse's own audacity and inner conviction were again racing ahead of what seemed permissible.

With the insults and accusations of depravity still ringing in his ears, Matisse was growing more and more convinced that *deformation*—distorting the outlines and proportions of subjects in order to arrive at something more concentrated and powerful—might point the way forward. It was an idea he had been heading toward himself. But it also chimed with notions articulated by a friend of his—a poet and art critic called Mécislas Golberg. Despite being on his deathbed, Golberg was at that time helping Matisse formulate a short essay he hoped to publish. "In art," Golberg had written, "deformation is the basis of all expression. The more the personality becomes intense, the clearer also deformation becomes."

The statement appealed to Matisse, above all because the idea of expression was at the very heart of his beliefs about art. He loved, too, the satisfying paradox of deformation leading to greater "clarity."

Leo later described this second version of the *Young Sailor* as the "first thing [Matisse] did with forced deformations." He didn't buy it. Nor did Sarah and Michael Stein—although they did acquire the first version. The second, it seems, was harder to swallow than anything Matisse had yet done. And that, of course, only made it more intriguing—and more deranging—to Picasso.

For Picasso, intensification of personality was not just an ideal but a compulsion, so he, too, must have loved Golberg's idea. But if he was to pursue deformation in his own work, he needed to do it on his own terms. Intensity of color—and the flatness Matisse had begun emphasizing in order to achieve it— were not his concerns. The deformations he was interested in were sculptural; they had to do with three-dimensional aware- ness. The sculptural distortions he now began to produce, with Matisse at the back of his mind, were fired in part by the sensual immediacy of Fernande's body, but also by the ancient Iberian sculpture he had recently discovered. Atavistic and full of block- ish, unrefined potential, these were stone carvings made during the long interval between the Bronze Age and the Roman con- quest of the Iberian peninsula; they bore traces of Assyrian, Phoenician, and Egyptian influences. Picasso had seen a newly excavated group of them, made in the sixth and fifth centuries B.C., at the Louvre. Their impassive, simplified features seemed magnetic to him. Best of all, they were Spanish—and Andalu- sian; he could almost claim a patent on them.

They soon led to a breakthrough: a picture of two naked, pneumatically inflated women standing side-on to the viewer and facing each other. Their legs are stumpy, their breasts block- ish, and their faces, as in the recently completed portrait of Ger- trude, faceted and simplified. The result was stranger—and strangely more compelling—than anything Picasso had yet pro- duced.

WHEN IT CAME TO INFLUENCES, Picasso was a magpie. There was nothing his avid eye would not consume, digest, and then

transmute into something new. But it seemed that he was becoming aware around this time that nothing he had so far invented was adequately his own. Nor was it as unambiguously modern as the work of Matisse. Picasso had gone through his Toulouse-Lautrec phase, his El Greco phase, his van Gogh and Gauguin phases. He had been swayed by Puvis de Chavannes and Ingres and the Greeks and lately the Catalonian Romanesque and the Iberians. It was all quite dazzling. But (unsurprisingly, perhaps: He was only twenty-five years old) his efforts were not yet *real*. They were not yet sufficient unto themselves. Picasso was obviously on his way somewhere, but what was just as obvious was that he had not yet arrived. *Two Nudes,* with its odd deformations, suggested that he was close. One could point to influences, one could trace the steps that led up to it. And yet there was something about it—something fresh and audacious, something no one but he could have made.

It was around this time—toward the end of 1906—that Picasso began plotting a picture that he hoped would establish his immediate ascendancy over Matisse.

Originally conceived as a sexual allegory about venereal disease and the wages of sin, it became a picture of five prostitutes, clustered together in a brothel, flaunting their bodies as they stare out at the viewer with aggressive intent. In its finished form it shows the five women haunting a compressed, fragmented space described in a palette of airy pinks, icy blues, and neutral brown. But it took a long time for the picture, later titled *Les Demoiselles d'Avignon* [see Plate 12], to reach that finished form.

Its conception was partly inspired by Apollinaire's porno-

graphic novel *Les Onze Milles Verges,* which the poet had given Picasso in manuscript form. It was an extreme Sadean romp involving necrophilia, pederasty, and an orgy in a brothel. Picasso read it and treasured it. But of course there were many other sources of inspiration—including Picasso's own experience in brothels, and his abiding sense, since the suicide of Casagemas and his subsequent affair with Germaine, that sex, death, and creative fecundity were ineluctably connected.

He was determined that the painting be something no one else could have made. He seems to have intuited that the only way to guarantee this was to make it explicitly about his own psychosexual preoccupations—the deep-down drama of his desire both to see and not to see. Since it was a picture about voyeurism that was set in a brothel, that desire related most obviously to his feelings about girls and women. But it also related to his competitive fascination with his most potent contemporary, Matisse. That fascination had itself taken on a voyeuristic quality: Picasso needed to see what Matisse was doing, and at the same time to conceal this need from Matisse by converting it into something quite unrecognizable.

The creation of the picture would enact this buried drama. It tormented Picasso for nine months and called on all his reserves of energy. He worked on it in seclusion. Money from the Steins enabled him to rent a second, smaller studio on the floor below his main one. There, he could shut himself away and work in solitude, mostly at night. He became, wrote his friend Salmon, "uneasy. He turned his canvases to the wall and threw down his paintbrushes. For many long days and nights, he drew . . . Never was labor less rewarded with joy . . ."

IN THE COLD, DECREPIT, rat-riddled Bateau-Lavoir, after the idyll in Gósol the summer before, Picasso's relationship with Olivier began to deteriorate. For a time, the intimacy they had forged in Spain lingered on. But Picasso's obsession with besting Matisse gradually began to squeeze Olivier out of the picture. He seems not to have discussed his big picture with her—except to compare her with the prostitutes he was painting. Sexual jealousy, too, reared its head again. Picasso had caught her flirting with another man; his response was to keep her in the studio under lock and key—to forbid her to go out unless in his company. This meant Picasso had to do all the errands himself. Olivier was initially philosophical: "What does it matter if Picasso is jealous or forbids me to go out?" she wrote. "Where would I be better off than at his side?" But inevitably, the relationship festered. Even as she continued to inspire his work, her constant presence became an irritant. "In the mountain paradise of Gósol," wrote Richardson, "Fernande had been treated—and painted—like a goddess. Back in the Bateau-Lavoir, she was treated as a chattel and depicted as a whore."

In retaliation, or out of desperation, Olivier somehow contrived to have a brief liaison—probably early in 1907—with the poet Jean Pellerin. The result was that Picasso redoubled his efforts to punish her on his canvas.

FOR MOST OF THE PERIOD that Picasso worked on the *Demoiselles*, Matisse was in Collioure. But in March, he returned to

Paris with a painting that once again threatened to derail his young rival.

Just as the *Bonheur de Vivre* had made the last major composition Picasso had planned, *The Watering Place,* seem insipid, Matisse's latest painting—his only entry into that year's Salon des Indépendants—forced Picasso to radically rethink what he was doing. *Blue Nude: Memory of Biskra* was inspired by Matisse's recent trip to North Africa. It showed a female nude, awkwardly twisted, with one arm jackknifed over her head, against a roughly painted but decorative background of spreading palms. Matisse, whose most valued possession was a small painting of three bathers by Cézanne, had adopted Cézanne's blue-green palette, as well as his obsession with rhythms that disperse sensation across the picture like rustling leaves or rippling waves. But compared with Cézanne, Matisse's picture was shockingly raw. It was a nude, yes; but it refused to offer the seductions of soft flesh or familiar curves. There was something brutal and disruptive about it. Matisse had taken the deformations of the *Young Sailor II* a step further. Strewn with evidence of the artist's revisions, the painting didn't try to hide the process of its own clumsy and strenuous making. For all its coloristic intensity and formal boldness, it had a look of having been abruptly abandoned.

Its origins, too, were violent. The painting had been triggered by an accident in Matisse's studio. A clay sculpture of the same subject—a reclining nude with expressive distortions— on which Matisse had been working obsessively (most of his early breakthroughs in painting came via discoveries in sculpture) had been accidentally knocked to the floor and smashed into pieces. Matisse erupted. He was so beside himself that

Amélie had to take him out for a walk to calm him down. The frustration and anguish fed directly into the creation of *Blue Nude*.

When it was hung in the Salon, an uproar ensued—for the third year in a row. Many critics could barely bring themselves to credit it as a work of art, failed or otherwise. The public thought it another hoax by a man intent on proving to the world that he was mad. Even fellow artists were dismayed: Derain, in particular, seems to have thrown up his hands and resolved no longer to try to follow Matisse.

But the Steins bought *Blue Nude* and promptly installed it on the walls at the rue de Fleurus. At one of the Saturday-night salons, Picasso was seen staring at it—caught in yet another agony of avid eyeballing and willed-resistance-to-seeing—by Walter Pach, a young American, recently graduated from art school in New York. Picasso turned to him and asked, "Does that interest you?"

"In a way, yes," replied Pach. Sensing, however, the Spaniard's agitation, and suspecting that he had set off on the wrong kind of answer, he quickly changed tack: "It interests me like a blow between the eyes. I don't understand what he is thinking."

"Neither do I," replied Picasso. "If he wants to make a woman, let him make a woman. If he wants to make a design, let him make a design. This is between the two."

IT WAS PROBABLY IN GÓSOL, or during the immediate, love-flushed aftermath, that Picasso and Fernande got the idea of

adopting a child. The adoption finally took place on April 6, 1907, at an orphanage that was only a five-minute walk from the Bateau-Lavoir. "You want an orphan," said the mother superior, "take your pick."

They chose a girl called Raymonde. She was the twelve- or thirteen-year-old daughter of a French prostitute who worked in a Tunisian brothel. Raymonde had been rescued and brought to France by a Dutch journalist and his wife, but they had subsequently abandoned her, and she had wound up at the orphanage in Montmartre.

If the decision was Olivier's idea, it could not possibly have been made without Picasso's consent. And given the balance of power in their relationship, one cannot imagine him agreeing to such a momentous plan without at least some measure of enthusiasm. If, what's more, the main goal of the exercise was to offer Olivier the experience of parenting, it also seems odd that, instead of adopting an infant or young child, they chose an older girl, the same age as Marguerite. Perhaps Picasso thought a child would satisfy Olivier's need for intimacy and affection. Perhaps he thought it would prevent her from straying, freeing him to pursue his creative obsession unimpeded by her. Or perhaps he had other reasons to like the idea. But it seems plausible that Picasso was still thinking about the sickly but spirited Marguerite. Marguerite was also thirteen. Since meeting her early in 1906, Picasso had seen her regularly on his visits to Matisse's studio. He must have watched her intently, and envied, perhaps, the role she played in Matisse's studio life. Would he not benefit, just as Matisse did, from such a presence around the Bateau-Lavoir: a helpmeet, a companion, a muse?

———

HAVING BEEN PICKED OUT and brought back to the Bateau-Lavoir, Raymonde seems to have had a galvanizing effect on the place. Spring was beginning to break out (it was now a year since Matisse and Marguerite's first visit), but Picasso was withdrawing further and further into himself, to the dismay of his tight-knit group of friends. Raymonde's arrival buoyed them all. Olivier indulged her, the more so because she was herself illegitimate and had suffered at the hands of a cruel foster mother She dressed the girl in pretty clothes, brushed her hair endlessly, beribboned it for school. The other residents also delighted in her company. Max Jacob and André Salmon brought her presents and sweets. Picasso himself did sketches to amuse her. But on some level, it seems, he was made uneasy by her. "Young girls," according to Richardson, "excited Picasso. They also disturbed him. They put him in mind of his dead sister, Conchita."

BEFORE THE SALON HAD closed at the end of April, Matisse returned once more to Collioure. Picasso, meanwhile, was busy rethinking and revising his big picture. A month later, he felt he had made good progress, and began to show the painting to certain invited guests. The response, after so much secret labor, was deflating. Bewilderment reigned. What sort of painting was it? It fit into no preexisting category. Why the cartoon faces with the staring, asymmetrical eyes? Why the preoccupation with triangles? Why the gauche drawing and the dissonant registers, the lack of finish? It was ugly and, at the same time, ludicrous.

Everyone saw, what's more, what a fragile state Picasso was

in. Anxious, demoralized, obsessed, he didn't seem to know what he had done. Even by his own invented criteria, he couldn't tell if he had succeeded. If he was almost but not quite there (as he hoped and suspected), he didn't know how to conclude it. There was no one who could tell him.

There was, however, one person who, the previous fall, had unwittingly provided him with the key to a possible solution.

SIX MONTHS EARLIER, Picasso had come to the rue de Fleurus one Saturday night. Matisse was already there. He was showing Gertrude Stein an object that he had recently bought from a small curio shop called Le Père Sauvage on the rue de Rennes. Matisse often stopped by the shop, which was just a few minutes' walk from the Steins' apartment. It had, he later recalled, "a whole corner of little wooden statues of Negro origin." Matisse became fascinated by these sculptures. They seemed to have been released from conventional ideas of human anatomy. They were made instead, he later said, "in terms of their material, according to invented planes and proportions."

One day, he went into the store. He paid fifty francs and came away with the object he was now showing to Gertrude, having taken it straight to the rue de Fleurus. It was a wooden statuette made by the Vili people of the Congo, a seated figure with a disproportionately large, masklike head. The figure had a hollow mouth and eyes. Mysteriously, it held two hands up at its chin.

In his own art, Matisse was struggling at this point to close the gap between the description of objects and their emotional impact. He was on the lookout for forms that would make his emotions, his sensations, endure. To him, these African objects

suggested a new freedom: They weren't beholden to inherited notions of what sculptural figures should look like. His response to them chimed with his recent attempts to intensify his paintings' expressiveness through distortion. And it even related to his interest in the art of his own children—not because he saw the African objects as unsophisticated, but precisely because he admired their inventiveness, the way they suggested a potent and uninhibited alternative to Western cliché.

As Matisse was showing the Vili statuette to Gertrude—and no doubt trying earnestly, in the face of flickering interest, to explain what he meant by "invented planes and proportions"—Picasso walked in. Turning from Gertrude, Matisse showed him the statuette. They "chatted," according to Matisse. One imagines Picasso turning the sculpture over in his hands, both listening to and at the same time trying not to hear what Matisse was saying about it.

MATISSE'S WIDER INFLUENCE AT this point was such that his discovery set off a run on tribal objects among the avant-garde painters of Paris. His fellow Fauves and many younger artists on the lookout for new stimuli began sifting through Parisian shops for whatever African masks and wooden figurines they could find. If Matisse saw something in these objects, they thought, then there must be something worth paying attention to.

If Picasso was initially resistant, it's easy to imagine why. Something about these objects must have called out to him; but the very fact that they had struck a chord deep within Matisse first deterred him. Under no circumstances did he want to be cast as Matisse's follower. And besides, he was in the grip of his own discovery—the strangely haunting Iberian carvings whose styl-

izations he had been incorporating into his work since returning from Gósol.

Still, Picasso could not ignore the African carvings. He could see the liberating impact they were having on Matisse's work—especially the *Blue Nude*. And he could see the excitement of other colleagues as they talked about these previously unheralded objects. So it could not have been by accident that, six months after Matisse had shown him the Vili figure, as his struggles with the *Demoiselles* dragged on, Picasso found himself inside the Ethnographic Museum of the Trocadéro.

In those days, the Trocadéro was a neglected, dingy place, cluttered with objects. It was "disgusting," recalled Picasso in an interview with André Malraux, three decades later. "The smell," he continued. "I was all alone. I wanted to get away. But I didn't leave. I stayed. I stayed. I understood that it was very important: something was happening to me . . ."

Picasso had intuited something about the objects he saw at the Trocadéro, and specifically about the masks. They weren't, he said (revealing his lifelong flair for dramatization),

> just like any other pieces of sculpture. Not at all. They were magic things . . . [They] were *intercesseurs*, mediators; ever since then I've known the word in French. They were against everything—against unknown, threatening spirits . . . I understood, I too, am against everything. I too believe that everything is unknown, that everything is an enemy! Everything! I understood what the Negroes used their sculpture for . . . The fetishes were . . . weapons. To help people avoid coming under the influence of spirits again, to help them become independent.

" 'Les Demoiselles' must have come to me that day," Picasso concluded, "but not at all because of the forms but because it was my first canvas of exorcism. Yes, absolutely."

The visit to the Trocadéro, and Picasso's long-delayed account of it, is given enormous importance in the literature on his oeuvre, and it's easy to see why. If we are to believe him, it was here, at the Trocadéro, that his whole creative philosophy crystallized in an apprehension that linked the anxiety of seeing—the sexual and mortal anxiety of confronting *others,* and particularly women—with the magical, transformative powers that he believed inhered in art. From this central apprehension—dramatized, intensified, endlessly reiterated—Picasso would go on to forge a career of unprecedented variety and pyrotechnic brilliance.

But of course, the visit was just as important in the immediate context of his rivalry with Matisse. For someone so caught up in the struggle to become independent, to get out from under the influence of a rival and make good on his early promise, Picasso's intuition about tribal masks could hardly have been more significant. They were weapons, he said, *to help you "become independent."*

WHEN PICASSO DID FINALLY adopt African art, it was with a precipitous intensity that was utterly characteristic of him. Throughout the spring and summer of 1907, he turned out a series of violently "Africanized" nudes. Like his Iberian-style heads, they were radically simplified, but now they had angular bodies, curving, scythe-like noses, and cheeks marked by parallel striations and cross-hatching—drawn directly from the scarification lines he had seen on African masks.

At the same time, he returned to the *Demoiselles* with renewed purpose. In a series of studies he made in ink on paper, striations and hatchings begin to appear in the backgrounds and around the borders of his pictures, recalling the decorative palm fronds in Matisse's *Blue Nude*. Like Matisse, and even more like Cézanne (whom Picasso was now beginning to revere as much as Matisse did), Picasso was striving to establish visual rhymes that would strengthen his picture's unity, knitting together background and foreground. But rather than the fluid, serpentine line so beloved by Matisse, Picasso's rhymes were established with sharp angles, and with an idiom of fragmentation and splintering that may well have reflected the state of his mind.

PICASSO SURELY TOLD HIMSELF that what he got from African art was very different from what Matisse saw in it. It was more extreme, more potent. The discovery, by his account, was not only more dramatic than Matisse's curio shop pottering; it was fired by superstition, by magic.

Matisse, for his part, would never have dramatized his conception of art in this way. It was not in his interest to do so: People thought he was crazy enough as it was. Better to emphasize "planes and proportions" rather than magic and exorcism.

In any case, an idea of harmony, achieved through sublimation, mattered profoundly to Matisse in a way that it did not to Picasso. Matisse was always shoring himself up against chaos. Picasso meanwhile thrived on dissonance. He welcomed collision and strife.

In the immediate term what was at stake for Picasso was his ability to bring off his great canvas—to endow it with the kind of

force and shock value that would outdo the dissonance of Matisse's *Bonheur de Vivre* and the deformations of his *Blue Nude*. He wanted to up the ante in terms of both, and to jettison what he perceived as Matisse's fatal ambivalence (a "design" or a "woman"?). The faces of his five prostitutes were all initially painted in the blockish, wide-eyed Iberian style that Picasso had made his own after the portrait of Gertrude. But in June or July, the Iberian heads no longer seemed satisfactory. And so, in the high summer of 1907, with Matisse still away in the south, Picasso made a momentous decision. Over the faces of the two prostitutes on the right of the picture—one squatting, the other standing behind her— he painted African-style masks. He gave both faces long, curving noses, crude, elongated features, and small open mouths. The background figure has one eye that is entirely black, like an empty socket, while the squatting figure has blue, asymmetrical eyes with small pupils. Picasso left the Iberian-style faces of the other three women the same. Their stares are more piercing but also more familiar. The "Africanized" faces on the right, on the other hand, are like fright-masks. They do not seem to see us at all. They represent something profoundly unfamiliar, foreign, and in no way sexually seductive. They seem to ward us off.

TODAY, WE'VE BECOME ACCUSTOMED to the dissonant registers of the *Demoiselles*—Picasso's most acclaimed painting. Pictorial dissonance does not surprise us anymore, in large part because Picasso went on to make it a hallmark of his oeuvre, inspiring no end of modern artists to follow suit. But at the time, he seems to have been as unsure about what he had done as anyone. Was it too much? Had he wrecked the picture? Was it finished?

All he could be sure of was that he had made something the likes of which had not been seen before. Whether it worked, or whether the whole concoction—the discordant faces, the borrowings from African and ancient Iberian sculpture, the squatting figure stolen from Matisse's cherished little Cézanne, the *Three Bathers*—was rather a sign of toxic confusion, he could not know.

In the meantime, Picasso's domestic life had been infected by another kind of confusion—equally toxic. For Raymonde, the adopted orphan, the consequences were tragic. Picasso, it seems, had begun to show a disturbing new interest in the girl. At some point in the four months Raymonde spent at the Bateau-Lavoir, Olivier became aware of his unhealthy fascination. Consequently, she no longer trusted Picasso to be in the same room with Raymonde if the girl was bathing, dressing, or trying on new clothes.

Her concerns may have been triggered, or perhaps simply confirmed, by a drawing he made of her, seated on a chair, examining her foot. A washbasin can be seen on the floor in front of Raymonde. The pose in itself is innocuous, its art historical pedigree impeccable: Derived from the *Spinario*, a famous Roman sculpture of a boy removing a thorn from his foot, it also echoed *Thorn Extractor*, an impressionistic sculpture Matisse had made the previous year (probably with Marguerite as his model). The same pose would reappear in the summer as an "Africanized" woman, and—combined in Picasso's imagination with the right-hand figure in Cézanne's *Three Bathers*—it would finally be transposed into the squatting prostitute in the *Demoiselles*. In itself, however, there is something disturbingly voyeuristic about Picasso's rendering of Raymonde. No more than a rudimentary sketch, it nonetheless makes a conspicuous point of showing the girl's exposed genitals.

It wasn't long before Olivier felt she had no choice but to return Raymonde to the orphanage. The Bateau-Lavoir residents threw a party to say goodbye at Apollinaire's apartment. Raymonde, not surprisingly, was withdrawn and confused. Jacob put her dolls and a ball in a box, which he tied up, before taking her by the hand and, "with a profoundly sad smile," leading her away.

BY THE TIME MATISSE arrived back in Paris at the beginning of September after his long summer in the south, Picasso was exhausted and demoralized. Some time after Raymonde's departure, Olivier herself had moved out. Their long love affair appeared to be over. Picasso's work had lurched ahead during this period, but his creative advances had come at a cost. His obsession with the *Demoiselles*—a painting that confounded and even humiliated Olivier, since it seemed to enact his feelings toward her—had cast her into its shadow. And now she was gone.

The fate of the painting itself was entirely uncertain. The negative responses of friends, collectors, and dealers who had seen it in its pre-"African" state may have done as much to inspire Picasso's revisions as the visit to the Trocadéro. But the two Africanized masks had made the painting even more difficult to swallow, and Picasso seems to have remained in an agony of indecision about it. The picture remained in his studio for almost ten years. And for most of that period, he seemed unable to decide whether it was finished.

Matisse could have related to his doubts. He may in fact have been one of the only people Picasso knew who had it in his power to allay them, just by sympathizing. His own inability to see, to measure what he had achieved with any kind of objectivity, had

haunted him since the Fauve breakthrough two years earlier. It was the source of all his anxiety.

Matisse had already heard talk about Picasso's state of mind and about his bizarre new painting before he arrived back in Paris. He had taken a break from Collioure in late July and early August to travel to Italy. There, especially in Florence, where he met up with Gertrude and Leo Stein, he had fallen under the spell of the Italian primitives, the late Gothic and early Renaissance artists such as Giotto and Duccio. These frescoes, their forms rounded, stable, essential, gave him a model that would complement and rein in the wilder impulses unleashed by African art. They chimed, too, with his own interest in the clean, flat colors and simplified contours of children's art. Best of all, they seemed to brim over with a kind of spiritual fullness, a purity and silence that made the richly colored oil paintings he went on to see in Venice seem decadent and corrupt by comparison.

But on this same trip, tensions arose between Matisse and Leo Stein. With Matisse's reputation at its height (thanks in no small part to the Steins' support), Leo's own frustrated artistic ambitions may have contributed to the ill feeling. But it was their enforced intimacy in the aesthetic hothouse of Florence that caused the more immediate problem. Matisse responded to what he saw in Florence with an artist's intimate urgency, an almost larcenous drive to possess his experiences and exploit them for his own purposes. Stein's susceptibility was different. His zeal was unmistakable, but it had a disinterested, intellectual quality that was foreign to Matisse. And so these two proud men—both so intelligent, so articulate, so eager to press their insights on others— struggled to connect, and increasingly got on each other's nerves.

Back in Paris, these frictions proved difficult to smooth away.

Gertrude and Leo were also increasingly in competition with Sarah and Michael Stein, whose rapport with Matisse was growing ever closer. The upshot at this crucial time was that Leo and Gertrude began to turn away from Matisse and put more and more weight behind Picasso. *Blue Nude,* as it transpired, would be the last Matisse they ever bought. And it wasn't long before they gave almost all their Matisses to Sarah and Michael.

MATISSE FINALLY SAW THE *Demoiselles* soon after his return to the city on a visit to the Bateau-Lavoir, with the critic-turned-dealer Félix Fénéon. He was surprised, to say the least, and he may once again have made the error of saying too much, or saying the wrong thing, or simply not saying the right thing. One report has Matisse and Fénéon seeing the picture and braying with laughter. Twenty-five years later, Olivier claimed that Matisse was furious when he saw it, and vowed to get his revenge, to make Picasso "beg for mercy." None of this rings true. The most credible account has him saying, more mutedly but with evident bitterness: "A little boldness discovered in a friend's work is shared by all." The implication was that while he, Matisse, had dedicated years of experiment and honest inquiry to making a high-order aesthetic breakthrough, here, now, was Picasso, stealing ideas he didn't fully grasp in order to produce a painting that was deliberately and senselessly ugly—all for the sake of looking equally bold.

In truth, Picasso had put everything he had into the *Demoiselles.* And yet his efforts were met by universal dismay. The people whose support he needed most went missing in action.

Daniel-Henry Kahnweiler, the dealer who would go on to mastermind Picasso's career (after trying and failing to strike up a relationship with Matisse), deemed the *Demoiselles* a "failure." "What a loss for French painting," said the Russian collector Shchukin. Fellow painters began "giving him a wide berth," according to his friend André Salmon. Derain, knowing how much Picasso had staked on the picture, worried for his friend's sanity and predicted that "one fine morning" he would be found "hanged beside his large canvas." Even Apollinaire was silent.

And now, to cap it all off, the artist who was the clear leader of Paris's avant-garde, whose intelligence Picasso had experienced at close quarters at the Steins' homes, and whose audacity he had witnessed in galleries and on multiple visits to Matisse's studio—the artist who knew, moreover, what it felt like to be truly out on a limb—was dismissing the work not just as a failure, but as a bad pastiche—a parody.

THERE WAS, OF COURSE, a lot about the *Demoiselles* that Matisse might have found galling. So much about the picture seemed aimed directly at him. Where his own paintings, even when roughly executed, were always concerned with wholeness, stability, and calm, the *Demoiselles* was splintered, aggressive, jagged. The picture's construction was opposed, in every way, to that of the frescoes he had just been looking at in Italy. How could he fail to be provoked by the squatting figure at right, drawn directly from a figure in his own most cherished possession, Cézanne's *Three Bathers*? And how could he not notice the African masks on both the squatting figure and the woman be-

hind her? He, after all, had been the one to introduce Picasso to African art; he never expected his discovery to be adopted in such a blatantly literal way.

But there was something else about the painting, something more fundamental—something that had nothing to do with borrowings or larceny or sabotage. It was the sheer confrontational force of it. Picasso wanted to unsettle the viewer (and himself) with an image of brazen sexuality. The result was like Manet's *Olympia*, but without the knowing wink; it was amplified, compressed, nakedly combative.

Whatever the reason, Matisse failed to see the *Demoiselles* for the masterpiece that it was. Like so many others, he could not face down those leering nudes, and the intensity of the sexual power they presented. What's more, the message of the painting in relation to him—the thing Picasso seemed to be telling him—was too complicated, too ambivalent, for him to read cleanly. He might have read aspects of the picture as a kind of backhanded homage. But he also suspected that what the *Demoiselles* was really telling him was that Picasso was not his to claim, either as protégé or follower. Picasso, it announced, was his own man. A man with the same ambition—to be a great modern painter— but a very different idea about what that meant.

AT THIS CRUCIAL POINT, Matisse's influence on avant-garde art was actually stronger than ever, his precedence beyond dispute. At the 1907 Salon d'Automne, which opened at the beginning of October (and which featured major retrospectives of the work of Berthe Morisot and of Paul Cézanne), it seemed every other young painter was trying to paint like "the Fauve of

Fauves" (as Apollinaire had dubbed Matisse). Seeing so many crass imitations of his style caused Matisse acute distress. Most of those under his spell had utterly failed to understand what he was trying to do. This wouldn't have mattered, except that their clumsy efforts only gave more ammunition to his detractors. (Picasso's "borrowings" in the *Demoiselles,* although they were of a different kind, might have struck him in the same way, and carried just the same danger.)

Even as he was worrying about bad imitators, Matisse was also beginning to face a backlash. The more talented and thoughtful of his followers, including his close confrère Derain and the more independent Braque, had started to break away. They had worked alongside him during the brief Fauvist period. But since then, Matisse had been pursuing an increasingly private path. After the *Bonheur de Vivre* and the *Blue Nude*—impressed as they may have been—they were unable or unwilling to follow him.

In the end, Matisse was too solitary by temperament to be a leader of movements. But at this point—with his work striking many as unconscionably ugly and bizarre ("Why this hateful contempt for form?" one critic had asked of his latest canvas, *Le Luxe,* a strange dream image of three gauchely drawn women involved in a mysterious rite on a beach)—his need for validation and reinforcement was as profound as Picasso's.

GERTRUDE STEIN, NOW VERY much in Picasso's corner, soon began to divide the world into "Matisseites" and "Picassoites." Picasso's other supporters also exacerbated tensions. They were ready to exploit any advantage over Matisse they could find.

Aware of Picasso's disappointment over the *Demoiselles*, they had registered his frustration at having to play a subordinate role. Indeed, for Picasso, it was this, above all, that was intolerable. Leo Stein recalled how, standing in line at a bus stop, Picasso became furious. "This is not the way it ought to be," he said. "The strong should go ahead and take what they want."

And yet, despite all this, it seems the painters themselves remained on civil and even friendly terms. Friendly enough, at least, to agree to an exchange of works in the late fall.

The exchange was elaborately planned. It took place in Picasso's studio at the Bateau-Lavoir. A special dinner was arranged. Salmon, Jacob, and Apollinaire were all there, as were Braque, Maurice de Vlaminck, and Maurice Princet. They themselves may have had a hand in planning the evening, since Picasso, according to reports, was a reluctant host.

He was clearly at a low ebb. The *Demoiselles* was stacked in a corner of his studio, a sheet thrown over it. Fernande and Raymonde were gone. Among friends, Picasso's situation elicited plenty of sympathy, but no straightforward solutions. "I wish I could convey to you the heroism of a man like Picasso," wrote Kahnweiler half a century later. His "spiritual solitude at that time was truly terrifying, for not one of his painter friends had followed him. The picture he had painted seemed to everyone something mad or monstrous."

It's not clear what protocols governed the exchange, but it seems that Picasso had been given the opportunity to pick a work during an earlier visit to Matisse's studio, and now it was Matisse's turn to choose from his.

The painting Picasso had chosen was the portrait of Marguerite. Executed in a deliberately naïve style, it had the name

MARGUERITE printed in bold capitals across the top. The painting was large enough that it must have been awkward to carry, and Matisse may have felt uneasy as he cradled it under his arm on the way to Montmartre. Eighteen months earlier Marguerite herself had accompanied him on this walk in person. This time it was his portrait of her.

For Picasso, it was a striking choice—not least because he had only recently given up his own thirteen-year-old adopted daughter. Was he sick at heart? Was he trying—motivated by some kind of envy, or by the memory, perhaps, of his own lost sister Conchita—to make some kind of claim on Marguerite? Or was it simply that he felt fond of her?

We only know that he kept the picture all his life.

Matisse, in return, chose a still life that Picasso had recently painted. It had jagged angles, satisfying rhymes, and—for a Picasso of this period—unusually vivid colors. In her classic account of the exchange, Gertrude Stein claimed that, while each artist pretended to choose a work he admired, they actually "chose each one of the other one the picture that was undoubtedly the least interesting either of them had done.

"Later," she continued, "each one used it as an example, the picture he had chosen, of the weaknesses of the other one." This description is more a symptom of Stein's desire to cast the two painters as enemies than anything else. Both pictures are in fact full of confidence and conviction. If Picasso was pleased to see Matisse respond to his new interest in angular forms and ambiguous spatial relations, Matisse was similarly pleased to have it confirmed that Picasso took seriously his interest in children's art. "I thought then that it was a key picture," Picasso said near the end of his life, "and I still think that."

———

THE DINNER DRAGGED ON. Picasso stayed sullenly reserved. The rest of the company felt ill at ease. This odd, stilted drama bore no relation to how evenings in Montmartre usually unfolded. And Picasso's friends blamed Matisse. To Salmon, he was pompous and detached. He had no feeling—so Salmon thought—for lightheartedness, pranks, and teasing—all those things that were at the heart of social life at the Bateau-Lavoir. Matisse's recent ascendancy only entrenched their disdain. The claustrophobia in Picasso's crowded studio, and the obligation to keep up a level of politesse that matched the older Matisse's, seems to have placed an almost unendurable strain on the company. They couldn't wait for the dinner to be over. And as soon as it was, as soon as Matisse had departed, hostilities broke out.

According to Salmon, "We went directly to the bazaar in the rue des Abbesses [a two-minute walk] where, poor but unafraid to make sacrifices in the interest of pleasure, we bought a set of toy arrows tipped with suction pads, which I have to say were wonderful fun back in the studio as we could shoot at the painting without damaging it. 'A hit! One in the eye for Marguerite!' 'Another hit on the cheek!' We enjoyed ourselves immensely."

It was all obviously designed to cheer Picasso up. With the same motive, his friends also ran around Montmartre scrawling graffiti that mimicked government health warnings on walls and fences: MATISSE INDUCES MADNESS! MATISSE IS MORE DANGEROUS THAN ALCOHOL. MATISSE HAS DONE MORE HARM THAN WAR.

The actions betray an awareness of just how much Matisse

meant to Picasso at this point—how charged and infuriating was his presence, how maddening was his assumption of superiority (no matter how benignly he presented himself), and how desperate was Picasso to reverse their positions.

AT THE END OF 1907, with his first sighting of the *Demoiselles* and the exchange of paintings still fresh in his mind, Matisse was interviewed for an article that was to be written up by Apollinaire. The piece was commissioned by Matisse's dying friend, Mécislas Golberg. Matisse's renown, combined with the fact that he had never previously given an interview, made this a huge opportunity for Apollinaire (in fact, it ended up launching his career as an art critic). But the poet worried about being disloyal to Picasso and was reluctant to follow through with the job. He delayed and delayed, and missed the deadline. Golberg was only days from death when the article finally appeared—not where he had wanted it but in a rival publication.

The short piece contains just four quotations by Matisse (who did not trust Apollinaire and soon came to detest him). It's the last of them that—given the charged state of his relations with Picasso—seems the most carefully considered: "I have never avoided the influence of others," said Matisse:

I would have considered this a cowardice and a lack of sincerity toward myself. I believe that the personality of the artist develops and asserts itself through the struggles it has to go through when pitted against other personalities. If the fight is fatal and the personality succumbs, it means that this was bound to be his fate.

Matisse never did succumb. But over the next decade, the tables were certainly turned. Matisse would never again enjoy the clear-cut preeminence he had in 1906 and 1907. From now on, Picasso would always be there, performing his pyrotechnics, and drawing the louder applause.

OVER THE COURSE OF 1908, Matisse was honored with shows in Moscow, Paris, Berlin, and New York, and a retrospective late in the year at the Salon d'Automne. And yet he began to appear, even amid all this acclaim and recognition, an isolated figure.

He tried to prevent this. In an effort to shore up his position, he fell back into the role of pedagogue. Encouraged by Sarah Stein, he established a school early in 1908—a short-lived attempt to counter what he saw as the rampant misunderstandings of his work. But he had spawned unruly children. "Matisse himself," wrote the American poet and journalist Gelett Burgess,

denies all responsibility for the excesses of his unwelcome disciples. Poor, patient Matisse, breaking his way through this jungle of art, sees his followers go whopping off in vagrom paths to right and left. He hears his own speculative words distorted, misinterpreted . . . He may say, perhaps: "To my mind, the equilateral triangle is a symbol and manifestation of the absolute. If one could get that absolute quality into a painting, it would be a work of art." Whereat, little madcap Picasso, keen as a whip, spirited as a devil, mad as a hatter, runs to his studio and contrives a huge nude woman composed entirely of triangles,

and presents it as a triumph. What wonder Matisse shakes his head and does not smile!

Derain and Braque, once Matisse's fellow Fauves, had by now defected to Picasso's side. They spent all their time at the Bateau-Lavoir and began painting in a muted palette, completely suppressing Matisse's chromatic splendor. This was a serious blow: They were two of the most talented painters in France.

Picasso's friends, in the meantime, had basically declared war on Matisse: They mocked his school, his aloof and sober social manner, and his latest work, which they disparaged as lightweight, decorative, and fundamentally unserious. On one occasion, Matisse walked into a café, saw Picasso and his friends, and approached them to say hello, only to be pointedly ignored.

For Matisse, who had seen so much of Picasso over the previous two years, who had welcomed him into his studio and even presented him with his portrait of Marguerite, these new circumstances must have been dismaying.

The initial shock of the *Demoiselles* abated, and Matisse reconciled himself to this bold new Picasso—the Picasso who was not just a potential protégé but an electrifying innovator, someone Matisse himself now needed to take into account, and possibly learn from. In the meantime, determined not to let their relations be defined by the absurdity of open hostility, he continued to sympathize with the younger man's plight, to admire his talents, and to cultivate his friendship. As if to prove that he was not rattled, toward the end of 1908 he took the Russian collector Sergei Shchukin—his own most important collector—to Picasso's studio. Impressed by what he saw, Shchukin soon became a supporter, and an avid collector of Picasso's work.

———

AROUND THIS SAME TIME, 1908, Matisse's former protégé Braque, taking his lead from sections of the *Demoiselles*, and even more from his own intense study of Cézanne, was on the verge of minting an entirely new manner of painting. After a period experimenting in Cézanne's old stomping ground of L'Estaque, near Marseilles, he submitted several new paintings to the Salon d'Automne.

Matisse (the subject of a retrospective at that same Salon) was serving on the jury that year. When he saw Braque's L'Estaque paintings, he seems to have smelled more bad faith. Not only had Braque abandoned Matisse's own principles (above all, his emphasis on colored light), but he had taken up Cézanne—Matisse's beloved Cézanne, his talisman ("If Cézanne is right, then I am right," Matisse said)—in ways that seemed to misread him completely.

Matisse was convinced he could see through the conceit of Braque's new manner. He described Braque's paintings to the critic Louis Vauxcelles—the same critic who had coined the term *Fauvism*—as pictures constructed of "little cubes." To show Vauxcelles what he meant, he even did a quick sketch, like a schoolteacher demonstrating a student's erroneous thinking on the blackboard.

Braque's paintings were rejected, and Matisse—rightly or wrongly—was blamed. But the new style now had a name: Cubism.

CUBISM WOULD REVOLUTIONIZE THE construction of pictorial space and, in the process, change the course of modern paint-

ing. In cahoots with Picasso, whose energies he quickly enlisted, Braque advanced and honed this new style over the course of the following year. Impersonal and pointedly devoid of Matissean color (they were made in shades of brown and gray), Cubist paintings were brilliantly inventive and freshly poetic. A picture no longer had to be like a window onto a coherent, static, infinitely receding world that obeyed unbending physical laws; it could be more like a moving scrim, with faceted parts projecting forward or folding back into shallow space. In this sense, Cubist paintings seemed more like consciousness itself, and they were more in tune, claimed some, with the way modern science was beginning to describe the world. But the Cubist pictures of Picasso and Braque are also, of course, tremendously witty. They are redolent of whispered secrets at the back of the classroom. They turned representation into a beguiling game of "now-you-see-it-now-you-don't."

The new movement caught on quickly. Matisse, stuck out in front of the classroom, did his best to ignore the rising, insubordinate chatter at the back. He preferred to keep on advancing his own agenda, delving deeper and deeper into the enchantments of saturated color, expressive decoration, and a new kind of monumental simplicity. In the process, he produced some of the greatest works of his career—and indeed of the entire century. But by around 1913, he could no longer ignore the hubbub. Gushing invention, Picasso and Braque had established themselves with astonishing speed as the new leaders of a pan-European avant-garde.

They did not do so alone. Picasso, in particular, was championed by Kahnweiler, who brilliantly finessed the Spaniard's career behind the scenes; by Gertrude Stein, who did so much to

fuel the beginnings of the Picasso myth (especially outside of France); and by Apollinaire, whose idea it had been to scrawl anti-Matisse graffiti on government health warnings. Over the next decade, Apollinaire would carve out a reputation as the most influential art critic of his generation. When he later described Matisse as "an instinctive Cubist," the irony must have been galling to Matisse, given his own unintentional role in coining the term.

Cubism dominated discussion of avant-garde art all over Europe, from Italy (where the Futurists had taken it up) to the UK (where Vorticists fell under its spell). Increasingly, Matisse was pushed to the periphery. But by 1913, as if grimly determined to follow through on his commitment never to avoid the influence of others, Matisse actually began—albeit tentatively—to embrace Cubist methods. In the face of deliberate provocations ("He's captured! He's ours!" cried the Cubists), he cut back on his use of bright colors, favoring instead agitated grays, matte blacks, and drenching blues. For the next three or four years he also emphasized angular geometry, extreme simplifications of form, and ambiguous relationships between figure and ground— all indications of his fascination with the new style. He even repainted a favorite Dutch still life—a work he had copied earlier in his career—in an overtly Cubist idiom. And in this way he turned potential defeat into a combination of initial yielding and fresh, unforeseen potency.

AFTER THEIR FIRST BREAK, in 1907, Picasso and Fernande Olivier had reconciled. But Olivier later had an affair with the

Italian Futurist Ubaldo Oppi, and in the wake of this, the couple had split for good. As if to exact his revenge, Picasso had taken up with Fernande's close friend and confidante Eva Gouel.

By 1913, Picasso had moved out of the Bateau-Lavoir and was, for the first time in his adult life, financially well off. Kahnweiler had become his dealer, and the two were thriving. But 1913 was also the year that Picasso's father died, and soon after, Picasso himself fell ill with a persistent, undiagnosed fever. He recovered slowly.

During his convalescence, Matisse came to visit him, bringing flowers and oranges. By now, these two formidable artists were ready to reconcile. The gush of invention had continued from both their studios. If the pack of followers trying to keep pace with Picasso now seemed bigger than those following Matisse, it was not, finally, a reflection of Matisse's inferiority. And yet, unquestionably, the power dynamic had shifted, and the two men—civil and mutually admiring now that their reputations seemed more securely established—maintained a wary distance.

Not long afterward, however, they went horse riding together in the company of Eva Gouel. The rapprochement surprised many. "Picasso is a horseman," Matisse wrote Gertrude Stein. "We go out riding together, which amazes everyone." But if people were amazed, it may have been because they wanted these two painters to be sworn enemies more than, in reality, they ever were.

THERE IS NO DOUBT that Matisse was rattled by Cubism. Things had not panned out as he had expected. The uncontain-

able Spaniard had never been his protégé. He was far more for-midable, more inventive, and more ferociously ambitious than Matisse had ever quite realized during those early encounters at the Steins, or as they talked and looked and made mental notes in each other's studios, or during their walks in the Luxembourg Gardens.

But what's striking is how willing—how almost eager—he was to avoid the obvious reaction. He refused to lash out at Pi-casso. He refused to hunker down or to block out the possibility of influence. In fact, he went the other way, actively seeking out lessons he might learn from the Cubists, just as Picasso had been willing to learn from him.

Famously, this pattern—of yielding, twisting, overcoming, and yielding once more, as if both artists were engaged in a series of subtle martial arts maneuvers transposed to the aes-thetic realm—was to be repeated at regular intervals, right up until Matisse's death in 1954. Major exhibitions and countless books have addressed the relationship. Scholars have traced the pattern—of influence and challenge, homage and resistance—painting by painting, drawing by drawing, sculpture by sculp-ture. At times, Picasso was looking more intently at Matisse; at other times, it was the other way around. Never, however, was the one far from the other's mind.

ONE OF THE STRANGEST of Matisse's productions from the 1913–17 period was yet another portrait of Maguerite. It was the culmination of a series of paintings he made of her in 1914 and '15, by which time Marguerite was twenty. She was becoming more confident, more womanly, and she evidently enjoyed dress-

ing up. In each picture in the series, although the poses are the same, she wears a different hat (each one with flowers attached) and a different blouse or dress. She had even begun to innovate with the black ribbon around her neck—the accessory that had always been a poignant sign of her illness. In three of the five portraits, there is a gold pendant hanging from the ribbon.

The first four portraits in the series are fairly straightforward: Matisse applied thinly painted but vividly colored oils in a simplified formal vocabulary reminiscent of his early, childlike portraits of Marguerite. At a certain point, however, he seems to have grown restless. He turned to Marguerite and said, "This painting wants to take me somewhere else. Do you feel up to it?"

Marguerite gave her consent.

What Matisse proceeded to paint was one of the oddest portraits of his career. *White and Pink Head,* as the painting is called, is intensely colored and emotionally distilled in a way that only Matisse could have carried off. But it's also a painting that has manifestly been filtered through the prism of Cubism. Angular shapes escape their contours, confusing background and foreground; lines intersect and rhyme with other lines; and lips and eyes are reduced to distilled symbols that could easily, you feel, have been rearranged. All this makes the picture feel like a tribute, of sorts, to Picasso, funneled through the very emphatic presence of Marguerite.

White and Pink Head was so odd that Matisse's dealers didn't know what to do with it, and after a while they politely asked Matisse to take it off their hands. He did, and he kept it in the family for the rest of his life—just as Picasso held on to Matisse's earlier portrait of Marguerite.

POLLOCK and
DE KOONING

Betrayal is an uncanny form of intimacy.

—ADAM PHILLIPS

Outside the Cedar Tavern in Greenwich Village one night in the early 1950s, someone observed two painters sitting on the curb, passing a bottle back and forth. One of them, Willem de Kooning, was in his early fifties. He had a mind made for mischief. A sense of irony gurgled beneath his habitually open and generous manner. "Self-protection bored him," said his friend Edwin Denby. And he did not like to be bored. De Kooning was fiercely intelligent. He had seen it all—and yet the world continued to astonish him. "Jackson," he was saying, as he slapped the

back of Jackson Pollock, his fellow painter and friend, "you're the greatest painter in America!"

Pollock had a volatile temper. It got the better of him when he was drunk; and these days he generally was—certainly at the Cedar Tavern, a gathering place for painters and their retinue and a boozy stage for displays of strutting machismo. Pollock was also intelligent in his peculiar, inarticulate, combustible way. He yearned to make connections with people, but he habitually sabotaged those connections. He liked and admired de Kooning. And although they were far from best friends, for most of the ten years they had known each other the feeling had been more or less mutual. Still, it was complicated.

The two men had been cast as rivals. And in a way they were. But it hadn't started out that way, and the role didn't entirely suit them. In fact, for both men the pressure to perform as rivals before an audience that seemed to be ballooning by the month had become wearying and absurd.

And so now, in their drunkenness, they hammed it up: "No, Bill," replied Pollock, as he passed the bottle back to de Kooning, "you're the greatest painter in America." De Kooning demurred. Pollock insisted. The performance went on, the bottle going back and forth, until Pollock finally passed out.

IN 1938, WILLEM DE KOONING made a beautiful portrait of two standing boys [see Fig. 4]. The drawing is so finely rendered you feel you might deplete the graphite marks just by breathing too close. When you look at the work two things are immediately self-evident. The first is that de Kooning—whose name means "the king" in Dutch—could draw. He was a marvelous

FIG. 4 Willem de Kooning. *Self-Portrait with Imaginary Brother.* c. 1938.
pencil on paper. 13 1/8 x 10 1/4 inches (33.3 x 26 cm). Kravis Collection.
© 2016 THE WILLEM DE KOONING FOUNDATION / ARTISTS RIGHTS
SOCIETY (ARS), NEW YORK.

draftsman, virtuosic in conventional ways, but with his own par-
ticular feeling for spellbinding idiosyncrasies—an odd pair of
boots; a pair of tucked-in-trousers; an unfocused gaze.

The second thing you notice is a weird sensation of doubling.
Although the two boys in the portrait wear different clothes, are
different heights, and convey different degrees of self-possession,
they are also uncannily alike. Are they both, in fact, the same
person? De Kooning later said yes—he had simply drawn him-

self twice. But his friend, the artist and cartoonist Saul Steinberg, had a different idea. Steinberg bought the drawing and later gave it the title—*Self-Portrait with Imaginary Brother*—that is still in use today.

What Steinberg didn't know, at least not at the time, was that de Kooning actually had a half brother, Koos, and that he was, for all intents and purposes, imaginary: De Kooning had cut him off more than a decade earlier, acting as if the half brother and the rest of his family simply didn't exist. In 1926, at the age of twenty-two, he had fled his native Holland as a stowaway on a British freighter, the SS *Shelley*. He told no one—not his parents; not his beloved sister Marie (who had just had a baby); and not Koos, the young half brother who had always looked up to him.

In a life marked by a genius for evasion (both in his personal relationships and in his refusal to be pinned down to any particular style or aesthetic program), this original, shattering evasion always haunted de Kooning. For him, the severing had opened up a whole world of opportunity: De Kooning went on to become one of the two leading figures in an American movement, Abstract Expressionism, that changed the course of art history. But what had been the cost?

WILLEM, MARIE, AND KOOS had endured a blighted childhood in Rotterdam. The city at that time was a rapidly expanding port near the mouth of the Nieuwe Maas, an artificial channel in a delta formed by the Rhine and the Meuse rivers as they spill into the frigid North Sea. De Kooning's father, Leendert, had been a flower seller. He later established a small business that bottled and distributed beer for the nearby Heineken brewery,

among others. He met Cornelia Nobel, a working-class girl with an explosive temper, in 1898. By September of that year, Cornelia had become pregnant with Marie. She was born in 1899, six months after her parents' hasty marriage. Twin girls followed, but they died very soon after being born. Cornelia's fourth baby died at eight months.

And then came Willem. Born in 1904, he grew up in desperate poverty. In the six years since their marriage, Cornelia and Leendert had lived in seven different apartments, and the moves continued after Willem's birth. In 1906, de Kooning's parents' marriage unraveled. Leendert, a distant, emotionally thwarted man who later described his wife as "hysterical," initiated divorce proceedings. De Kooning's biographers, Mark Stevens and Annalyn Swan, suggest that Cornelia was likely violent at home, lashing out physically not only at her children but with Leendert, too. Nevertheless, she won custody of both Willem and Marie. In the spring of 1908, she was about to remarry, but her little boy Willem was in the way—an impediment to the budding relationship—so she sent him back to his father. Later, perhaps out of guilt, she tried to make others (including de Kooning) believe that Leendert had kidnapped him, forcing her to fight a long custody battle to win him back. But Stevens and Swan find no evidence for this.

Soon after, Leendert also remarried. He had found a second, much younger wife, and when she became pregnant at the end of 1908, the four-year-old de Kooning was once again in the way, so he was dispatched back to his mother's house. Cornelia's anger was unpredictable. As de Kooning grew, she drew him into spectacular arguments, full of spit and sarcasm, characterized on both sides by verbal flair and a stubborn refusal to give ground. She

was domineering, garish, and theatrical, and it's easy to imagine that a refracted memory of her fed into de Kooning's notorious *Woman* series—the hectoring, histrionic paintings of cartoonish figures with big shoulders and busts, leering grins, and comically demented eyes that shot de Kooning to fame forty years later.

De Kooning was eight when Cornelia had another child, this time with her mild-mannered second husband, Jacobus Lassooy, then a coffeehouse keeper. The boy, known as Koos, grew up in the shadow of his stepbrother, whom he revered. Willem had developed into a good, competitive student, even as his family descended further into financial insecurity and was reduced to living on potatoes and turnips.

Privately, he had cultivated an interest in drawing, and at age twelve he was hired as an apprentice at a prestigious decorating firm, Gidding and Sons. His gifts were quickly recognized by the firm's co-owner, Jay Gidding, who urged him to enroll in a course at the nearby Academy of Fine Arts and Applied Sciences. The academy had real prestige. Along with traditional fine arts training, it offered technical training aimed at preparing students for modern industry. De Kooning took evening classes there for four years, from 1917 to 1921. The instruction was exacting and strict, the atmosphere competitive. De Kooning spent six hundred hours and—working two days a week—the best part of a year on a single drawing: a still life of a shallow ceramic bowl, a pitcher, and a jug on a table.

The whole point of the academy's fastidious approach, de Kooning later explained, was "to clear the students' eyes of conventional seeing and to urge them to record nothing but their first-hand experience." Put that way, it sounds liberating and almost modern—but it was not. It was intensely laborious. Stu-

dents had to train themselves to keep their eyes at fixed levels and to maintain the same distances between themselves, the still life arrangement, and the paper. They had to resume this same position week after week, month after month. The eventual effect, said de Kooning, was "like a photograph, except more romantic."

Not everything de Kooning did was as refined as the exercises that absorbed him at the academy. He had also had a taste for cartoons and caricatures and a knack for reproducing their confident, expressive, often exaggerated lines. It was a knack that stayed with him, and inflected his mature art at least as much as his classical training.

In 1920, midway through his adolescence, de Kooning found work with a designer interested in modernism, Bernard Romein, whose main client was a fancy Rotterdam department store. Romein introduced de Kooning to the art of Piet Mondrian (who, decades later, would play a brief but crucial role in the career of Jackson Pollock). He was also introduced to De Stijl, the Dutch design movement founded in Amsterdam in 1917, with which Mondrian was closely associated. De Stijl (the name means simply "the style") sought to blur the lines dividing art, craft, and design. Its success had removed some of the stigma attached to commercial art—which was essentially what de Kooning had been practicing until then. But de Kooning's imagination was already beginning to wander away from functionalism, away from commerce, and away from his disciplined training. He began to travel, spending time in both Antwerp and Brussels. He had an uncle who worked as a seaman on the Holland America Line. From him, he heard stories about America. De Kooning, who loved dancing to American jazz and looking at American pinup

girls in magazines, also loved the movies. "There were cowboys and Indians, you know," he said later; "it was romantic."

He applied for a job as a deckhand on the Holland America Line, but without success. He then tried several times to get on board ships bound for America as a stowaway, but these attempts all came to nothing. Finally, a tenuous connection with a man who was planning to return to New York but needed to pay union dues he couldn't afford gave de Kooning his chance. He paid the man's dues ("borrowing" the money from his father) and waited for his opportunity. For months, nothing happened, and de Kooning assumed he had been conned. But finally, without any forewarning, the man reappeared and smuggled de Kooning into the engine room of the SS *Shelley*.

It was July 18, 1926. Not only had de Kooning told no one, but he had taken nothing with him—not even the portfolio of artwork he planned to use to find work in America. Credentials, it turned out, would not be necessary.

DE KOONING'S ROUGH CHILDHOOD and his later, precipitous departure for America were of a piece with what Philip Roth once called "the drama that underlies America's story, the high drama that is upping and leaving—and the energy and cruelty that rapturous drive demands." It left damage in its wake—though how much is hard to say. It also seemed to inflate within de Kooning a yearning for fellowship, for the magical double act of brotherhood, for the camaraderie of sharing unspoken, unaccountable things with a pilgrim on the same hard path. If he found that fellowship again and again in the early years of his career, it was because he was seeking it.

———

YEARS LATER, HIS BROTHER-IN-LAW, Conrad Fried, told Stevens and Swan the story of a teacher at de Kooning's school in Rotterdam who had done much to encourage the young boy's interest. "See that guy sitting over there?" the teacher had said to de Kooning during one class when the students were all drawing. "Go and see what he's doing."

De Kooning did what he was told and saw that the other student was drawing freely and fluently. His own drawing was tight and controlled. The two began talking, whereupon the other student told de Kooning that the teacher had said exactly the same thing to him: "Go and see what that kid is doing."

A similar story played out years later, on a much bigger stage. The artist in the role of the other student was Jackson Pollock.

POLLOCK WAS THE YOUNGEST of five brothers. He was the most pampered—by his overbearing yet in other ways emotionally distant mother—and also the most troubled. His father, LeRoy McCoy, had grown up in Tingley, Iowa, with foster parents whose family name was Pollock. LeRoy was treated as cheap labor by these Pollocks, and by anyone they could rent their foster son out to. Later, feeling betrayed and undermined by the memory of this dismal childhood, LeRoy tried to change his name back to McCoy, but he couldn't afford the legal fee.

Jackson's mother, Stella, also grew up in Tingley. Together, she and LeRoy had four sons before, on January 28, 1912, Jackson arrived—limp, blotchy, bruised, and needing to be slapped to life.

At the time, the Pollocks were living in Cody, Wyoming. Stella later found out that the complications attending Jackson's birth meant that he would be her last child. He was, as a consequence, coddled. She exempted him from chores, excused his misdemeanors, and indulged his various whims. But his childhood, as his biographers Steven Naifeh and Gregory Smith point out in *Jackson Pollock: An American Saga*, was—like de Kooning's—hobbled by poverty and poisoned by the domestic friction that so often accompanies it. In 1920, when Jackson was eight, LeRoy moved out of the family home. And so—again like de Kooning—he was essentially fatherless during his formative years. LeRoy stayed in touch intermittently, and there was an attempt to reunite the family in Arizona, where they had moved after the failure of various enterprises in Cody and California. But it didn't last long.

JACKSON WAS A SENSITIVE BOY with a febrile imagination. His older brother Charles had resolved at an early age to become an artist. It was obvious to all that he had talent. But artistic ambition was the last thing expected of a boy in America's rural West, so Charles was self-conscious about his choice of vocation, and cultivated a matching sense of style. He grew out his hair and dressed in bohemian clothes. Despite his initial insecurity, he played the part with increasing conviction, and he struck people, including his own family, as a wise, mature soul. Jackson, nine years his junior, was entranced. "When Jackson was a little boy and was asked what he wanted to be when he grew up," recalled his mother, Stella, "he'd always say, 'I want to be an artist like brother Charles.'"

When Charles moved to Los Angeles to study art at the Otis Institute, Jackson and Sande, the brother closest to Jackson in age, both dreamed of following in his footsteps. Charles enjoyed his trailblazing role and the authority his own adventures in Los Angeles had conferred on him. He mailed home copies of *The Dial*, a high-minded monthly magazine sprinkled with features on modern art and writings by the likes of T. S. Eliot and Thomas Mann. Jackson and Sande devoured these issues. They not only conjured an exciting new world, but represented a spiritual connection with their absent brother.

Charles's communications were sporadic, but they carried weight. And so when, in 1928, aged sixteen, Jackson did pull out of high school, moving from Riverside, California, where his mother was based, to Los Angeles to study at the Manual Arts High School, it was very much with his brother's example in mind.

But Jackson was not Charles. He was inarticulate and hypersensitive, with a wild temper and a proclivity (having imbibed his first alcoholic drink at the age of fourteen) for self-destructive binge drinking. And so he struggled.

Charles had meanwhile moved from Los Angeles to New York in 1926 to study with Thomas Hart Benton, the charismatic muralist and champion of American Regionalism. Hearing of Jackson's plight, Charles sent a letter filled with solicitude: "I have myself gone through periods of depression and melancholy which threatened to warp all future efforts," he wrote. "I am sorry I have seen so little of you these past years when you have matured so rapidly. Now I have the vaguest idea of your temperament and interests. It is apparent tho that you are gifted with a sensitive and perceptive intelligence and it is important that this quality should develop normally and thoroughly to its ultimate

justification in some worthy endeavor and not be wasted . . . I am delighted that you are interested in art."

The letter had a galvanizing effect on Jackson. Despite lacking any obvious aptitude, he decided once and for all to follow Charles and pursue a life as an artist.

POLLOCK'S DETERMINATION TO BECOME an artist was unbreakable, but at Manual Arts his lack of technical ability was repeatedly exposed. His drawing, in particular, was awkward and heavy-handed. He was twice expelled from the school, and by 1930 he was reduced to attending on a part-time basis, one half-day a week. He appeared to be going nowhere.

EVERY TRULY MEMORABLE SUCCESS comes in spite of a handicap. But the handicap is not always a deficiency. Sometimes it's an aptitude, an outsized talent or skill that is somehow in the way, or surplus to requirements. If Pollock's life in art was a struggle to find a way around, or through, his own manifest shortcomings, de Kooning's was the exact opposite: It was a prolonged effort to set aside, or pick apart, his native mastery.

Amazingly, it was the example provided by the inept stumblebum—Pollock—that helped de Kooning, the trained virtuoso, unpick his mastery and find a way through to true originality.

UNLIKE POLLOCK, WHO STRUGGLED for years with his drawing, de Kooning had arrived in America as a brilliant draftsman

with years of classical training, an apprenticeship in sign paint-
ing, and firsthand exposure to a key movement in modernism
already behind him. But what he really wanted was to purge
himself of these hard-won advantages, to somehow trip himself
up. "I'm in my element when I am a little bit out of this world,"
he later said. "When I'm falling, I'm doing all right; when I'm
slipping, I say, hey, this is interesting!"

After four years in the United States, de Kooning had worked
in Manhattan as a sign painter, a window dresser, and a carpen-
ter. He was getting to know modern artists. And he had found a
girlfriend—a tightrope walker from a circus family named Vir-
ginia "Nini" Diaz. The two moved to Greenwich Village to-
gether in 1932. Diaz remembers de Kooning drawing all the time.
To supplement their joint earnings (he worked for a design fac-
tory called Eastman Brothers), she tried hawking the results
around town. Had de Kooning not been growing more and more
committed to modern art around this time, she may have had
more luck. His modernist leanings made his drawings less and
less salable. Over conventional refinement and finesse, modern-
ism cherished raw immediacy, fresh ideas, personal originality,
and, above all, sincerity. And so de Kooning endured a period of
schizophrenic tension. Even as aspects of his academic training
adhered to him—and even as he turned out virtuosic drawings
like *Self-Portrait with Imaginary Brother*—he repeatedly kicked
against that training. Using traditional templates—still lifes,
portraits, and posed nudes—as the basis for his experimentation,
he explored the innovations of Matisse, Picasso, Miró, and de
Chirico.

A rigorously instilled discipline that is so powerfully aligned
with native talent is not an easy thing to unpick. In the self-

consciously modern-looking paintings de Kooning made in the late 1930s and early '40s, you can see him struggling with his own disassembled technical arsenal, wanting to find a way forward that was instinctive and free but never fudged. Spatial relations among parts of the body, and in particular the challenge of fore-shortening, became immensely difficult in the new, modernist idiom that emphasized flatness and shunned detail. Hands—which are tremendously complex three-dimensional forms, but of course small in relation to the rest of the body—bothered him enormously. Knees—which push forward in space from the rest of the seated body—he found even more troublesome. All these challenges were so absorbing that he couldn't even begin to ad-dress the problem of hair: His portraits showed bareheaded men with fudged or simply erased hands and boneless legs that don't seem to know where to be. His friend, the dance critic Edwin Denby, was one of the first people to acquire his work during this period. He noticed a beauty in these knotty pictures—"the beauty that instinctive behavior in a complex situation can have." But there was also a quality of bug-eyed madness, an immense and building pressure in them. "I often heard him say that he was beating his brains out about connecting a figure and a back-ground," wrote Denby.

WHEN IT CAME TO drawing, Pollock suffered deeply from his lack of aptitude—in comparison not only with Charles and with his brother Sande (who sketched away almost as ceaselessly and fluently as Charles) but also with his classmates at art school. Proximity to more gifted students only reinforced Pollock's frustration. His efforts in life-drawing classes were ham-fisted

and clunky. Many of his classmates were precociously gifted, and had enhanced those gifts with years of dedicated practice. Instinctively competitive, Pollock tried to match their dedication. He hoped for signs of improvement.

He took inspiration, in part, from a music student named Berthe Pacifico, a junior at Manual Arts. They had met at a party. Pollock watched her playing the piano and was mesmerized by her composure. He began coming over to her house every afternoon after school to watch her practice. She played five hours a day. Pollock would sit there sketching her, over and over. "All the time I was playing, that darn old pencil never stopped," she recalled. And yet Pollock never showed her what he had done—presumably because, no matter how hard he tried, he never seemed to get it right. "My drawing I will tell you frankly," he wrote to Charles from LA in 1930, "is rotten it seems to lack freedom and rhythem /sic/ it is cold and lifeless. it isn't worth the postage to send it . . . the truth of it is i have never really gotten down to real work and finish a piece i usually get disgusted with it and lose interest . . . altho i feel i will make an artist of some kind i have never proven to myself nor any body else that i have it in me."

Pollock's problem, in other words, was not just confidence—although that was certainly part of it ("this so called happy part of one's life youth to me is a bit of damnable hell," he wrote to Charles). It was talent: "If you had seen his early work," said Sande, "you'd have said he should go into tennis, or plumbing."

IN THE SUMMER OF 1930, a time of economic upheaval and political unrest right across the country (the Wall Street crash

had occurred barely six months earlier), Charles and Frank—another Pollock brother who was studying literature at Columbia University—returned to LA. Charles took Jackson to see *Prometheus,* a new mural by the Mexican muralist José Clemente Orozco at Pomona College, in Claremont, east of Los Angeles. The work's full-throated embrace of epic drama, its heroic figure outlined against a furnace of dancing flames, and its sheer ambition all impressed Jackson deeply. As they talked about the Mexican muralists, about leftist politics and art, the brothers bonded. Jackson seemed ready to leave his life in the West behind. And so in the fall, Charles and Frank took their eighteen-year-old brother back to New York.

New York was the only city in America at that time where contemporary art was seen through a truly international lens. The city's diverse population, with its many immigrants, had helped to spread an awareness of modernist movements coming out of Europe, and also out of Mexico. These different styles and approaches to art—some politically charged, others, such as Surrealism, aligned with different philosophical worldviews—were met with skepticism and even outright hostility by the public at large. But the issues around modernism were at least debated in New York, which was not the case in most of the rest of the country.

At the end of September, Jackson enrolled at the Art Students League in Thomas Hart Benton's class. Benton had already had a big impact on Charles. He and his students were on a mission. Employing dynamic but legible figurative imagery—related in style to Soviet Socialist Realism but inflected by strong nationalist flavors, and in frank opposition to abstract modernism—they wanted art to play a role in opening eyes and effecting political

change. That meant getting their pictures seen by as many peo-
ple as possible. Against the idea that art was associated with the
stuffy decadence of Europe—that it was a pastime for dilettantes
and aesthetes—they were determined that it be regarded as a
manly pursuit, something virile and active that implied poten-
tially world-altering agency. For Jackson, whose ego was fragile
and whose sense of purpose was always teetering on the brink of
an abyss, Benton's rhetoric was not just stirring, it was medici-
nal. It gave him a ready-made sense of purpose. He joined the
cause, and before long he had adopted Benton and his Italian
wife, Rita, as a surrogate family—in the process supplanting
Charles as Benton's favored protégé.

At the Art Students League, Pollock met threats to his ambi-
tion with calculated aggression. He was on guard against anyone
who was obviously more talented than he was—which meant
most of his fellow students. He could be charismatic, and enor-
mously sweet and considerate to those he liked; Benton and Rita
were not the only ones seduced by this side of him. But people
sensed in him a dangerous volatility. According to one classmate,
"He'd look you over real quick, almost as if he was deciding
whether to punch you in the nose or not." The worst of his be-
havior was reserved for women, who represented another zone
of frustration. Unable or unwilling to find girlfriends, he subli-
mated his sexual confusion in misogynistic outbursts that were
frightening—and often physical.

During this early period in New York, Pollock stayed with
Charles and his wife, Elizabeth. Elizabeth had little tolerance for
Jackson's outbursts. But it was Charles—urbane, talented, mar-
ried, and still in many ways his mentor—who caught some of
the worst of Pollock's behavior. At one end-of-winter party at-

tended by the Pollock brothers in Charles and Elizabeth's 10th Street apartment, Jackson quickly drank himself into a raging state. He became abusive with one of the guests, a single girl named Rose, first verbally, then in a pushy, physical way. When Rose's friend Marie tried to intervene and pull him away, he erupted. He picked up an ax he had earlier used to chop wood for the stove, and held it over Marie's head. "You're a nice girl, Marie, and I like you," he sneered. "I would hate to have to chop your head off." Several seconds of silence ensued. And then, suddenly, Pollock turned and brought the ax down on one of Charles's paintings, splitting it apart, and leaving the ax embedded in the wall.

DE KOONING FORMED ONE of the closest bonds of his life with Arshile Gorky, an Armenian refugee he met in 1929. During the Depression years in New York—a time when, as Denby put it, "everyone drank coffee and nobody had shows"—the two men shared a studio, talked, looked, painted together, and were generally inseparable. They were both penniless for much of the decade, but they were perversely proud to be so. "I'm not poor. I'm broke," de Kooning liked to announce. They discussed modern art endlessly. They braved long, cold winters together and, like an impregnable club of two, simply disregarded public indifference to their efforts. In the late 1930s, they even collaborated on a mural for a New Jersey restaurant. Gorky would be quiet when others gathered in the studio to talk with de Kooning. One day, the talk was all about the injustice of the situation faced by painters in America. "People had a great deal to say on the subject, and they said it," recalled Denby, "but the talk ended in a gloomy

silence. In the pause, Gorky's deep voice came from under a table. 'Nineteen miserable years have I lived in America.' Everybody burst out laughing. There was no whine left. Gorky had not spoken of justice, but of fate, and everybody laughed openhearted."

When it came to art, Gorky was ruthless and unsentimental. He held himself to high standards, and knew the difference between what was great and what was fake. ("Aha, so you have ideas of your own!" he said when he first saw de Kooning's work. "Somehow," recalled de Kooning, "that didn't seem so good.")

Throughout the '30s, Gorky's attitude—extravagant, highminded, honorable—bolstered de Kooning, who came to revere him as an older brother. So it's no surprise that many observers have found a connection—one wants to call it a fraternal connection—between de Kooning's exquisite *Self-Portrait with Imaginary Brother* and a famous, and heartbreaking, Gorky painting, *The Artist and His Mother*. That work, which exists in two related versions, is based on a 1912 photograph, which shows the artist with the woman who sired and nurtured him. The photograph was sent to Gorky's father, who had earlier emigrated to America, perhaps as a reminder of their existence, a plea not to forget about his family back in Armenia. (He had in fact met another woman and started a second family in the United States.) Events in the meantime overtook Gorky and his mother. During the Armenian genocide, their town was besieged, and they were sent out on a death march. Gorky's mother died of starvation, in her son's arms, in 1919. After his own emigration to the US, Gorky found the photograph in a drawer in his father's home, and painted the two versions of *The Artist and His Mother* from it.

Both pictures—de Kooning's drawing and Gorky's painting—are double portraits. And in both, the subjects meet the viewer's gaze with doleful, haunted eyes, profoundly cognizant of loss.

TO DE KOONING, GORKY was the embodiment of integrity. So he was dismayed to discover, after a decade of close companionship, that his friend, his brother-in-arms, secretly harbored social ambitions. In early 1941, Gorky was introduced to Agnes Magruder, the wealthy daughter of a naval commodore, through de Kooning and his own future wife, Elaine Fried. They fell in love and married that same year. As a consequence, Gorky suddenly found himself mingling with an affluent uptown crowd, even as de Kooning continued to labor in obscurity and near-destitution. The dissonance was too much for Gorky, who essentially dropped de Kooning, befriending instead the patrician European Surrealists who had moved en masse to New York during World War II.

De Kooning let him go, but privately nursed a lingering hurt—a sense of dismay that echoed, perhaps, the dismay of his own half brother Koos all those years ago. "To see Gorky sail away into the world of privilege," wrote Stevens and Swan, "represented for de Kooning nothing less than the loss of his American brother."

UNDER THE INFLUENCE OF BENTON, Pollock had finally begun to acquire some skills. The older man was looking for students who were not merely good at making faithful copies, but

could communicate dynamism and movement. In Pollock's clotted and half-baked attempts—coastal landscapes; nighttime scenes with dancing flames; strange, expressive dreamscapes involving animals and human figures—he saw promise where few others did. "I want to tell you I think the little sketches you left around here are magnificent," he wrote to Pollock. "Your color is rich and beautiful. You've the stuff old kid—all you have to do is keep it up."

Benton dedicated extra time to Pollock, appointing him class monitor (to exempt him from paying tuition) while he and Rita continued to treat him as one of the family. As the Depression ground on, Pollock kept sketching and kept attending classes. He met José Clemente Orozco, the Mexican artist whose *Prometheus* mural he had traveled to see with Charles at Pomona College, and who was now working on murals with Benton. But Benton departed the league at the end of 1932 to work on a major mural commissioned by the state of Indiana. And then, early the next year, Jackson's father LeRoy became ill and died back in LA. The brothers—Charles, Frank, and Jackson—could not afford to go back for the funeral.

LeRoy's death triggered a period of excruciating anguish and confusion for Jackson. He seemed to be losing father figures and actual fathers, along with brothers, every other month. When in 1935 Charles moved with his wife, Elizabeth, to Washington, DC, to work with the Resettlement Administration, Jackson hitched himself to Sande. The two younger brothers moved into an apartment at 46 East 8th Street, where Jackson was to stay for the next ten years. He remained in the house even after Sande married his girlfriend, Arloie Conaway, early in 1936.

Shortly before Charles's departure for Washington, Jackson

had signed up for the Works Progress Administration, or WPA—the government program that kept thousands of artists (including for a time de Kooning) employed during the Depression. Joining meant a reliable salary (it started at $103.40 per month) in return for producing approximately one painting every two months. (The obligation fluctuated according to the work's size and the artist's normal rate of production.) The arrangement helped Pollock. But he was barely capable of meeting his quota. His drinking became heavier and more destructive, and then, ominously, in the fall of 1936, he wrecked a car that Charles had signed over to him.

POLLOCK HAD HIS FIRST encounter with Lee Krasner just a month or two later. Krasner was born in Brooklyn in 1908, the daughter of Ukrainian Jews who had fled pogroms and massacres to seek refuge in America in the new century's first decade. In her teens she had taken to art, studying at the Women's Art School of Cooper Union, in Greenwich Village, and then uptown at the National Academy of Design. After going with her classmates to see a show of modern paintings by Picasso, Matisse, and Braque, she began—like de Kooning—to kick against her conservative training, and she soon fell in with the small but expanding group of American modernists, part of a downtown scene that was sustained and held together by the WPA.

Krasner would later become Pollock's girlfriend and wife, the most important figure in his adult life. They were together from 1941 until Pollock's death in 1956. Their relationship was messy, and particularly toward the end they were the kind of couple who, for all their obvious reliance on each other, nonethe-

less seemed bent on mutual destruction. And yet they enjoyed many periods of happiness, and no one seems to believe that Pollock would have enjoyed the brief but stupendous success he did without Krasner in his corner (and just as often, right there in the ring with him). She was his greatest champion.

But their first encounter was anything but auspicious. At the time Pollock was deep into one of his periods of extended binge drinking. He would spend long nights rambling from bar to bar in lower Manhattan, yelling and shouting, urinating ostentatiously in the snow ("spraying the stream from side to side," according to one friend, "and bellowing, 'I can piss on the whole world!'"), and picking ill-advised fights, then waiting to be rescued—as he was, time and again—in the early-morning hours by Sande. He was on the cusp of a major breakdown—a menace as much to others as to himself. And he was drunk again when he came across Krasner at an Artists Union party. Having clumsily cut in on the man she was dancing with, Pollock rubbed his pelvis against her leg, whispered a bald invitation to sex in her ear, and repeatedly stepped on her feet. Krasner responded by slapping him, hard.

But the funny thing about Pollock was that he had an instinct—as many helplessly dependent men do—for turning bad situations back in his favor. Taciturn, thwarted, often belligerent, he nevertheless possessed the ability to charm. "He'd start a fight and then try to get out of it," recalled his friend Herman Cherry. "It's like insulting somebody, then going up and kissing them and saying 'Oh, I didn't mean it.'" He would flash a smile, apologize with effusive sincerity, even resort to flattery—whatever it took (assuming he wasn't too drunk). Not only women but men would be disarmed, and thrilled, too, by the

volatility behind these sudden reversals. Pollock, said another friend, Reuben Kadish, "had a way of firing the situation."

Whatever he did or said that night, Krasner seems to have relented, and her initial hostility toward Pollock was tempered. She may or may not have gone home with him that night; there are differing accounts. But it was five years before she saw him again. That second time she fell for him quickly. But in between, it so happened that she developed a prolonged and painful crush on another artist living in New York: Willem de Kooning.

LOOKING BACK AT DE KOONING in the 1930s, it's clear that he was on his way to greatness of some kind. He was ambitious; he was utterly in earnest; he was freakishly gifted. And yet for many years his way ahead remained obscured. Struggling against the riptides of influence, he spent a lot of time thrashing about and failing to finish things. He was quivering with potential—everyone who came into his orbit sensed it. But what he had actually achieved amounted to very little. He was broke. He spoke broken English. And, by leaving Holland so precipitously all those years ago, he had severed himself from both his family and his cultural patrimony. He never regretted this. But his general frustration was palpable. According to Denby, friends would say, "Listen, Bill, you have a psychological block about finishing; you're being very self-destructive, you ought to see an analyst." De Kooning would laugh in response. "Sure, the analyst needs me for his material, the way I need my pictures for mine."

Nonetheless—or in some ways precisely because of the heroic nature of his struggle—de Kooning had acquired an out-sized reputation for seriousness and authenticity among New

York's nascent avant-garde. His fellow artists revered him and sought out his company. It helped that he seemed self-effacing, sincere, and supportive of others—and that he had a mischievous sense of humor. Women, in particular, loved him. With his Dutch accent, his gruff good looks, and his physical charisma (he was short but well built), he churned up little storm systems of ardor wherever he went.

Krasner likely learned about de Kooning through her boyfriend at the time, the society portraitist Igor Pantuhoff. She and Pantuhoff had both studied under Hans Hofmann, the hugely influential German émigré who was a champion of modernism, of Matisse and Picasso, and of abstraction. Krasner, like many others, was susceptible to Hofmann's ideas. She was already, at this stage, a much finer artist than Pantuhoff. Her discerning eye, her brilliant, intuitive color sense, and her devotion to modernist precepts had won her plenty of admirers in avant-garde circles of the 1930s.

Pantuhoff, for his part, found it easier—and more rewarding, both financially and sexually—to turn out stylized society portraits on commission. His good looks and his exotic, amorphous background (he claimed to be a White Russian—an opponent of the Bolshevik Red Army during Russia's post-revolution civil war) attracted Krasner. But he was a heavy drinker, he was vain, and he had a mean streak. "I like being with an ugly woman," he said, in reference to Krasner, "because it makes me feel more handsome."

Krasner was independent and resolutely bohemian. She disdained conventional notions of femininity. She was not pretty, as such, but many men found her sexy: She was forthright and flirtatious, and seemed hungry for physical contact. She "had a

great deal of aggressiveness and she came on strong with men," according to the artist Axel Horn. Yet for all her independence and talent, Krasner had a tendency to subordinate herself to her male partners, and she put up with behavior many women would likely find atrocious. She tolerated Pantuhoff's cruelty, as she would later put up with Pollock's endless tantrums. According to Fritz Bultman (who may have been right, but may not): "The masochistic part of Lee loved every minute of it."

Despite his success with more conventional art, Pantuhoff liked to feel he was part of the small but burgeoning modernist circle, and he kept a close eye on artists he admired. One of them was the émigré Dutchman de Kooning. Pantuhoff owned a study of one of de Kooning's WPA murals; he kept it on the wall in his studio, where Krasner would have seen it often.

The affair between Pantuhoff and Krasner gradually disintegrated, largely because of Pantuhoff's infidelities. And as it did, Krasner became quietly—and then not so quietly—besotted with de Kooning. She encountered him intermittently on the downtown scene, and Pantuhoff would often speak about him. She was impressed by what she saw, and before long she was smitten. She was heard describing him as "the greatest painter in the world." And then, at a New Year's Eve party, well lubricated by alcohol, she chose to make her move. In a playful, affectionate mood, she seated herself on de Kooning's lap. He appeared to play along. But then suddenly, without warning—and just as she was about to kiss him—he thrust his legs apart, causing her to crash to the floor. Humiliated, Krasner nursed her bruised ego back to fighting health with a brisk series of drinks. Thus fortified, she began spraying de Kooning with insults. Her friend Bultman eventually intervened, push-

ing Krasner into the shower with her clothes still on and turning on the taps.

Krasner never forgot that night. And she never forgave de Kooning.

POLLOCK MAINTAINED A CLOSE connection with the Bentons up until 1937, and would spend several weeks each summer with Tom and Rita in Martha's Vineyard. Since 1935, Tom had been teaching and working in Kansas City. But they stayed in touch, and the older artist's advice and encouragement still counted for a lot.

Nonetheless, what eventually helped Pollock make significant strides as an artist was nothing Benton prescribed. It was a decision to abandon conventional ideals of "skilled drawing" altogether, and instead to embrace chance. More of a gradual and instinctive unfolding than a conscious choice, this new development had many traceable causes. Pollock's work in 1936 with the Mexican muralist David Siqueiros, who set up a "Laboratory of Techniques in Modern Art" in his New York loft and encouraged experiments with unexpected materials, was one of them. So was his exposure to the Chilean-born émigré Roberto Matta. Promoting the Surrealist idea of psychic automatism, Matta encouraged Pollock and others to draw with blindfolds. His ideas appealed to Pollock, who in 1939 began sessions with a Jungian analyst called Dr. Joseph Henderson. Henderson encouraged him to bring his drawings to therapy, using them as interpretive tools. Jung's ideas and Siqueros's and Matta's techniques all dovetailed with Pollock's long-standing interest in mysticism, visionary art, and the workings of the unconscious.

———

WHILE HE WAS EXPERIMENTING in this new vein, Pollock came into the ambit of John Graham, a tall, charismatic artist who shaved his head and wore Savile Row suits. Graham had piercing eyes and an arresting, aristocratic manner, and he stirred up Manhattan's narrow, impecunious milieu of modern artists with his haughty airs and infectious passion for painting. He had met de Kooning back in 1929, and by the mid-1930s was describing the Dutchman as "the best young painter in the United States." When, a few years later, he met Pollock and began spending time with him, he was similarly impressed. He acknowledged the anarchic, oftentimes puerile side of Pollock's personality. But he was also the first to see, as de Kooning himself would later admit, that Pollock had it in him to be "a great painter." "Who the hell picked him [Pollock] out?" asked de Kooning, looking back years later. "It was hard for other artists to see what Pollock was doing—their work was so different from his," he continued, "but Graham could see it."

Graham did more than perhaps anyone else to prod American art out of its provincialism. *Graham*, mind you, was not his real name. He was born Ivan Gratianovich Dombrowski in 1886, and he came from a family of minor Polish nobles in Kiev. Before the 1917 revolution he served in the czarist cavalry. The Bolsheviks imprisoned him after the revolution, but he was released (he liked to say he escaped), and he came to the United States in 1920. Many of the claims he made about his early life (that he earned a St. George's Cross, for instance) have the ring of fabrications. But in Moscow, it seems, Graham did become acquainted with many of that country's best-known avant-garde artists. He

had also been a regular visitor to the home of the Russian collector Sergei Shchukin, where he saw works by Matisse and Picasso from the early, most intense period of their rivalry (1906–16). He was impressed in particular by Picasso. The Spaniard became a touchstone not only for him, but now for Gorky, Pollock, and de Kooning.

All through the 1920s, Graham had regularly crossed the Atlantic. He was given two solo shows in Paris—an achievement that carried enormous cachet among most American modern artists. And his annual trips played a vital, catalyzing role back in New York. "In the grim Depression years," wrote Stevens and Swan, "John Graham was a marvelous, other-worldly apparition" who "elevated every occasion he attended." He also had a perspective on life—a feeling for grandeur—that was exactly what both Pollock and de Kooning craved.

IN NOVEMBER 1941, SHORTLY before the Japanese attack on Pearl Harbor, Graham began organizing a show that, for the first time, sprinkled the talented American painters he was getting to know among much better-known modernists from Europe, including Matisse and Picasso. It was through this show that Pollock and de Kooning finally met. They and Krasner were among the Americans whom Graham selected for the show, which opened at McMillan Inc., an antiques and fine furnishings store on East 55th Street, on January 20, 1942. Krasner was the only woman in the group. She was to be represented by a painting, since lost, called simply *Abstraction*, while Pollock was to be represented by *Birth*, a powerful, congested, vertically oriented work—and probably the most compelling single image he had produced

until then. Its splintered and spiraling forms, carved out in black and white, with outbreaks of red, yellow, and blue, were inspired partly by Native American art.

Looking over the list of her fellow exhibitors, the one name Krasner didn't recognize—despite their brief meeting years earlier—was Pollock's. Asking around, she drew mostly blanks. De Kooning simply shrugged. But later, at a gallery opening, Louis Bunce, an artist friend, said he recognized the name. He told Krasner that Pollock lived at 46 East 8th Street, just around the corner from her own studio apartment on East 9th, where she had set up on her own after splitting from Pantuhoff. And so she paid an unannounced visit.

Pollock was in his tiny bedroom, recovering from yet another binge. His art may have been growing more and more interesting with each year, but his personal circumstances seemed tawdrier than ever. He had only recently recovered from a period of such heavy drinking and wayward behavior that Sande had had to admit him to a psychiatric hospital. To make things worse, Sande and his wife, Arloie, who had just had a baby, were talking about leaving New York. (Arloie had previously sworn to Sande that she would never bear a child while Pollock was living with them.) In early May 1941, Pollock's psychiatrist, Dr. de Laszlo, had written to the draft board describing Pollock as "a shut-in and inarticulate personality of good intelligence, but with a great deal of emotional instability who finds it difficult to form or maintain any kind of relationship." Stopping short of diagnosing schizophrenia, she nonetheless noted "a certain schizoid disposition" in him. After a psychiatric examination at Beth Israel Hospital, Pollock was classified 4F—unfit for military service. None

of this had been good for his self-esteem. He was feeling more isolated than ever.

When he came to the door to let Krasner in, she recognized him from their earlier encounter. Even in his hungover state, he struck her as virile, earthy, and authentically American in a way that she—a Jewish girl from Brooklyn intent on escaping her background—found irresistible. "I was terribly drawn to Jackson," she later recalled, "and I fell in love with him—physically, mentally—in every sense of the word. I had a conviction when I met Jackson that he had something important to say. When we began going together, my own work became irrelevant. He was the important thing."

Reginald Wilson, an old painter friend of Pollock's, once said that Pollock "accepted any space that opened up to him." He was describing Pollock's dangerous manner of driving a car, but the insight applied equally to his swarming style of painting and also to his relationships. He accepted the space that Krasner now sacrificed to him. She gave up painting, and didn't try returning to it until the summer of 1948.

BEFORE THE MCMILLAN SHOW opened, Krasner took Pollock to see a man she felt he should know about. A Dutchman. Talented. Charismatic. Devoted to painting. A man she had once found as irresistible as she now found Pollock. De Kooning's studio was on West 21st Street. The couple walked over and Krasner introduced her new man, the "cowboy" painter born in Cody, Wyoming. Two different men, two very different voices: de Kooning with his rough, Dutch drawl; Pollock with his nasal

midwestern cadences. Neither man was inclined to say much at all, and Krasner, who had put the humiliation of her early encounter with de Kooning behind her, was probably the one trying hardest to carry the encounter. Back in Rotterdam, as he fretted and fantasized, de Kooning had liked the romantic idea of the American West. Here, now, was a real-life representative of it. He couldn't help but be intrigued. Pollock, for his part, was alert to the effect that the story of his origins could have on people who were looking for something "authentic," for an antidote to East Coast urban malaise, and he knowingly played it up. "I have a feeling for the West," he told an interviewer the following year: "the vast horizontality of the land, for instance."

And yet this first, potentially momentous encounter between two artists who would go on to change the face of twentieth-century art somehow misfired. Krasner's recollection was blunt: "I don't think either of them was very impressed."

People other than de Kooning were, however, beginning to be impressed by Pollock, and Krasner's estimation of him was soon buttressed by the opinions of others. No opinion, in these early days, was more important than Graham's. The three artists—Graham, Krasner, and Pollock—were one night walking from Graham's apartment when they encountered the artist and architect Frederick Kiesler, a friend of Graham's. "This is Frederick Kiesler," said Graham. "And this," he said, turning to Pollock, "is Jackson Pollock, the greatest painter in America."

IN OUR OWN HEDGED and skeptical times, the midcentury avant-garde art scene's obsession with "greatness"—with who was great, with who was up and who was down—can be exas-

perating, grating, even comical. Who did these people think they were? Who were they trying to convince?

Yet "greatness" was undoubtedly a preoccupation—a kind of idée fixe—among New York's fledgling artists, critics, and dealers at the time. It fed rivalries even as it fostered camaraderie. In the broadest cultural sense, it was a function of optimism, of a largeness of vision that saw potential and grandeur wherever it looked. Drawn precipitously into the global war, its very survival at stake, America itself was increasingly absorbed by the question of its own latent greatness, its potential to mend and remake the world in its own image. Artists were as keyed in to this as the rest of the nation.

Yet the preoccupation with "greatness" also grew out of something pinched and negative. Modern art in those days was, truly, a minuscule concern. Barely more than a handful of dealers were trying to sell it, and even they had only vague inklings about who might buy it. And so the fight for primacy among New York's artists was partly a symptom of just how isolated and ignored they felt. If worldly rewards are scarce, otherworldly values come into play.

Graham's flattering introduction of Pollock may have been offhand—a spontaneous overflow of high spirits and enthusiasm—but it was rocket fuel for Pollock's fragile ego. And it had no less an effect on Krasner: Within a year, she was introducing Pollock to Clement Greenberg, the critic who would do more than any other to advance Pollock's reputation, in exactly the same way. "This guy," she said, "is a great painter."

Greenberg took her seriously. He had spent many hours in the late 1930s talking about and looking at art with Krasner, and these sessions together had played into Greenberg's decision to

turn from literary criticism to art criticism. His early ideas about art were deeply inflected by hers. And so pretty soon, Greenberg had joined the chorus that had started with Krasner and then drawn in Graham. In a review published in *The Nation* that would ignite Pollock's career, Greenberg described Pollock as "the strongest painter of his generation and perhaps the greatest one to appear since Miró."

Such accolades meant a lot to Pollock, but they meant just as much to Krasner. For her, it was vindication, proof that her instincts were sound—and even more, that the sacrifice of her own artistic ambitions to Pollock's was worthwhile. Together, the two of them formed a potent, extraordinary double act, and for several years Krasner succeeded in turning Pollock's life around. Faced with his helplessness, but fired by his almost astral ambition, she devoted herself to looking after him and to advancing his career. Many looking on were dismayed. "It was such a shock," recalled Bultman, "that a woman so strong could subordinate herself to that extent."

AT THE END OF 1942, Pollock unleashed three paintings in quick succession—*Stenographic Figure*, *Moon Woman*, and *Male and Female*—that were his first major breakthroughs. Bold, sinuous shapes or totemic figures, inspired in part by Picasso, were combined with repeating patterns and an overlay of scribbled notation. The results had real presence. They were unfussy. What they showed was obscure, coded, hard to decipher. But they had the immediacy and urgency of direct feeling.

Up until this point, Pollock had been involved in a long struggle to find a way forward—a way that felt true to his instincts

and inspirations, but sidestepped, or somehow transcended, his problems with drawing. He had taken up doodling. He had made exploratory, free-associative pictures for his analyst. He had explored automatic writing and experimenting uninhibitedly in different media. He was attracted to the idea that success would come to him in a flash of inspiration rather than through sweat and toil, via intuition rather than dogged calculation.

Now, finally, it was as if something within Pollock had clicked. He had finally found a gear that had traction, and was no longer pedaling in air.

For large portions of his life, he had been a deadbeat, a no-hoper, a drain on all those around him. He borrowed money. He crashed cars. He bummed cigarettes and drinks. And he relied entirely on the generosity, the almost saintly forbearance, of his brothers and their wives. As an artist, with one eye on his older brothers—and especially on Charles—he had continually talked himself up. But it was obvious to almost everyone that he was not technically gifted, and that this lack of aptitude at drawing compromised everything he tried to do in paint. There were other failures, too—above all, his inability to stay off the drink. The members of his family hoped for the best, but they inevitably feared the worst. The worry was unending.

One can only imagine, then, what it must have been like for Charles, Frank, and Sande Pollock, for Tom and Rita Benton, for John Graham, and indeed for de Kooning (who was now well aware of Pollock, although their social contacts were only intermittent), to watch as Pollock—allied now with Krasner—turned everyone's expectations upside down.

The success, when it came, came all in a rush. There were several good angels involved, smoothing the way. But, apart from

Krasner, none played a more prominent role than the flamboyant and headstrong collector and socialite Peggy Guggenheim.

GUGGENHEIM HAD COME TO New York with her lover, the Surrealist artist Max Ernst, in July 1941. She had shipped her collection of modern art—it included works by Picasso, Ernst, Miró, Magritte, and Man Ray—ahead of her earlier that year. Her father had gone down with the *Titanic* in 1912, leaving a very useful inheritance—although it was small change when compared with her fabulously rich relatives. Her uncle was Solomon Guggenheim, who went on to establish, with Hilla von Rebay, the Museum of Non-Objective Painting, later to be renamed the Solomon R. Guggenheim Museum, in New York. Peggy had fallen in love with artists and bohemia while working in a bookstore in Paris in the early 1920s, and had since become friends with the likes of Marcel Duchamp, Constantin Brancusi, Man Ray, and Djuna Barnes (whose novel *Nightwood* had been written under Guggenheim's patronage). In London, she had opened her first gallery, called Guggenheim Jeune, where she showed work by Jean Cocteau, Wassily Kandinsky, and Yves Tanguy, among others. She saw herself, increasingly, not just as a gallerist but as a kind of impresario. She began planning the creation of a museum for modern art in London. The outbreak of war derailed that idea, so she shifted the site of the proposed museum to the Place Vendôme in Paris. But then the Nazis invaded France. Just days before they reached the French capital, Guggenheim fled to the south of France, and from there, several months later, to America.

In New York, little more than a year after her arrival, she opened a new gallery, Art of This Century, with considerable

fanfare. The building occupied two spaces on the seventh floor at 30 West 57th Street, not far from the fledgling Museum of Modern Art. At first, Guggenheim showed only work by her European émigré friends, mostly Surrealists (she and Ernst had married by now). She was not much interested in the American modernists. But she had an assistant, Howard Putzel, who believed passionately in Pollock and now tried to persuade Guggenheim to give him a show.

Guggenheim was skeptical. When Putzel put forward *Stenographic Figure* for inclusion in a juried group show for young artists, Guggenheim appraised it in the company of her five fellow jurors, among whom were Marcel Duchamp and Piet Mondrian. The painting was dominated by an arresting bright blue, with a receding black, windowlike rectangle. An undulating, polenta-colored swathe crossed the canvas horizontally. Two totemic figures are seated at a table. The dominant one, at left, is a Picassoid female figure with outstretched, oversized arms and a face constructed of bold strokes, both curved and angular. She has one big, frightening eye and an open maw, red with black teeth. Indecipherable notation, akin to shorthand or a mathematician's hasty blackboard cogitations, is loosely scrawled across the surface.

Guggenheim was unimpressed. But Mondrian seemed to have other ideas. A few moments later, unnerved by his continuing absorption in the work, Guggenheim spoke up: "There is absolutely no discipline at all. This young man has serious problems . . . and painting is one of them. I don't think he's going to be included." But the reticent Mondrian was not to be steamrolled. "I'm not so sure," he finally said. "I'm trying to understand what's happening here. I think this is the most interesting work I've seen so far in America . . . You must watch this man."

Since Guggenheim's admiration for Mondrian ran deep, she didn't need extra convincing. She included *Stenographic Figure* in the show, which, when it opened, received strong notices. Robert Coates, *The New Yorker*'s art critic, was one of the reviewers, and he reserved special praise for Pollock: "We have a real discovery," he wrote.

POLLOCK WAS LAUNCHED. Toward the end of that same, momentous year—1943—Guggenheim (persuaded by Duchamp, Putzel, and others) offered him his first solo show. She gave him a contract, too—something no other American modernist enjoyed. It guaranteed him a regular, much-needed income, and it included a commission to paint a mural for Guggenheim's apartment. Pollock was working as a janitor at Hilla von Rebay's Museum of Non-Objective Painting. To prepare for the show, he quit that job, tore down the wall separating his studio from Krasner's, and got to work.

The solo exhibition produced by this unexpected gush of industry was a financial flop. Only one drawing sold. But it garnered reviews in no fewer than eight publications, including *The New York Times, The New Yorker, The New York Sun, Partisan Review,* and *The Nation.* Suddenly, it seemed, people were paying attention to modern art. "Extravagantly, not to say savagely romantic" was how Edward Alden Jewell described Pollock's paintings in the *Times.* To Coates, in *The New Yorker,* Pollock was "an authentic discovery," while to a reviewer in *Art Digest* the artist was "out a-questing . . . he goes hell-bent at every canvas . . . plenty of whirl and swirl." Other critics were less persuaded: Henry McBride, in the *Sun,* compared the works to "a

kaleidoscope that has been insufficiently shaken." But it scarcely mattered. Never before in America had a young modern artist been showered with so much attention.

In May 1944, Alfred Barr, the influential curator at the Museum of Modern Art, overcame his reservations about Pollock and acquired his painting *The She-Wolf* for $650. And in March of the following year, Guggenheim gave Pollock a second show at Art of This Century. It was in his review of this show that Greenberg called Pollock "the strongest painter of his generation."

"I cannot," concluded the critic, "find strong enough words of praise."

DE KOONING WATCHED ALL this unfold with some envy—but also with gathering excitement. He was already forty, eight years older than Pollock. He had sold exactly one painting up to this point. The worldly success that now swirled around Pollock reminded him of his own precariousness and isolation. And yet unlike many of his fellow painters, he did not begrudge the younger man his unlikely triumph. He was seeing more and more of Pollock on the downtown scene, and they got along well. He knew Pollock had struggled to get to this point, and he admired his personality—his independent ways, his "contempt for people who talk."

What's more, de Kooning saw clearly what was going on. He sensed that Pollock's success was the kind that, with any luck, would rebound and bring benefits to him. There was a buzz building around modern art—art, what's more, that was being turned out not by some supercilious European Surrealist with patrician airs, but by a young, wild, and previously unknown

American. This was crucial. Pollock's paintings, noted a reviewer in *ARTNews,* after his first show, "are free of Paris, and contain a disciplined American fury."

"Pollock was the leader," de Kooning said later. "He was the painting cowboy, the first to get recognition . . . He had come much further than I. I was still seeking my way."

POLLOCK FINALLY HAD WHAT he wanted: Measurable success. Proof against the naysayers.

And yet, this first worldly breakthrough—which, when compared with the crashing wave of fame it foreshadowed, was but a ripple—still felt frustratingly precarious. All the acclaim and all the encouraging reviews had failed to translate to sales. Pollock's contractual arrangement with Guggenheim inspired jealousy among fellow artists, but it was hardly lavish: It kept him and Krasner on a financial knife-edge. Former comrades, meanwhile, from the heavily politicized WPA days bitched and bellyached behind Pollock's back, which in turn only fueled his insecurities, increasing the pressure he felt to build on his success, and forcing him back to the bottle.

The commission to paint the mural for Guggenheim was a particular trial. As Pollock prepared for the challenge, he found he was blocked. He procrastinated endlessly. The night before the deadline, he had not even begun. Krasner went to bed that night convinced that the mural would never be completed and that, as a consequence, they would lose Guggenheim's patronage.

But the cliff-edge scenario culminated in a famous triumph:

Pollock painted the whole work—180 square feet of canvas—in a single night. The result was dazzling: a rhythmic, edge-to-edge configuration of looping, hooked forms in black overlaid with lines in different hues, some of them almost fluorescently bright, each layer confidently carving out space even as neighboring marks roll over it. The work resembled nothing else that had been painted up to that time, either in Europe or in America. It was a triumph of spontaneity, intuition, and risk—a triumph (despite the anguish that led up to it) of *nerve*.

And yet this success, too, took its toll. At the party to celebrate the mural's installation, Pollock got riotously drunk. He ended up wandering into Guggenheim's living room and urinating in the fireplace.

The psychic turbulence that had plagued him for so long persisted, and in some ways intensified under the pressure of mixing with Guggenheim's uptown circle of wealthy collectors, European artists, and miscellaneous bohemians. Having drawn Pollock into her intoxicating but confusing social world, Guggenheim then tried to seduce him (her amorous tastes were notoriously indiscriminate). The result was a clumsy encounter, a one-night stand that Pollock chased down with another frenetic episode of bingeing.

THROUGH ALL THIS PERIOD, de Kooning had remained, if not exactly stuck, then at least thwarted. He was like a dancer performing arabesques inside a cramped and shadowy labyrinth. And yet he was stubborn. He put almost as much effort into scraping back his own paintings as actually applying paint. His

reputation as an artist who spent long hours in his studio, struggling with problems that were partially self-imposed, was a perverse source of pride.

Howard Putzel, who had done so much to persuade Guggenheim to back Pollock, tried to do the same for de Kooning, about whose work he was equally enthusiastic. But his efforts misfired. De Kooning himself—more proof of his perversity—might have been partly to blame: Putzel one day brought Guggenheim to de Kooning's downtown studio. Expensively attired, she appeared bored and complained extravagantly about having a hangover. Her arrogant, distracted state aroused all of de Kooning's deep-dyed animosity toward the well-off, fashionably rich. He said little as she looked over his work. She finally selected a single painting, saying she wished it to be delivered to Art of This Century.

"It's not finished," replied de Kooning. Unperturbed, Guggenheim replied that he could finish it and bring it over himself in two weeks. At which point she left.

"Bill made sure the painting was even less finished two weeks later," said de Kooning's friend Rudy Burckhardt.

AT THE TIME, DE KOONING was living with his wife, the artist Elaine Fried, in an apartment on Carmine Street. They had met in 1938, when she was a twenty-year-old art student. Seeing him in a bar she was struck, she later said, by "his seaman's eyes that seemed as if they were staring at very wide spaces all day." He invited her to his studio, and was more or less immediately smitten. He adored her forthrightness, her beautiful hair, her strange, unplaceable accent. He admired her frank ambition, too. Fried

had studied for several years at the Leonardo da Vinci Art School on the Lower East Side, and then the American Artists School, where the modernist Stuart Davis taught. She cared deeply about painting, which mattered enormously to de Kooning. Elaine was slight, but she had a natural physical confidence and a circle of admirers, many of whom came to depend on her advice and her extroverted, adamant persona. When she met de Kooning, she was earning money modeling for artists, and painting city scenes and portraits in a Social Realist vein. They married in December 1943. She later told her friend, the artist Hedda Sterne, that she had married him "because someone told her he would be the greatest painter."

The couple enjoyed an intense period of happiness in the early 1940s, but after that their relationship was forever fraught. They were both, in different ways, excessive and unreasonable. Elaine was gregarious, sociable, and theatrical, while de Kooning preferred solitude. He was, for all his native charisma, anxious and self-absorbed. They painted together, but at different rates, and in different states of mind. Elaine, who needed silence when she painted, nevertheless worked quickly, with a headlong bravura that was utterly foreign to de Kooning. Neither liked to cook or had any interest at all in keeping house. (A famous story has de Kooning standing in their apartment, surveying the chaos, and declaring to Elaine: "Vot ve need is a vife!") There were blistering fights, and numerous infidelities on both sides.

Eventually, in the late 1940s, the marriage unraveled. But through all the turbulence, the couple had forged a permanent bond. Long after their split, Elaine actively promoted de Kooning's career, especially when it seemed under threat. She was always especially combative in the company of Lee Krasner.

———

IN LATE NOVEMBER 1946, de Kooning rented a studio opposite Grace Church on Fourth Avenue, between East 10th and East 11th streets. Increasingly, he slept there at night. He had very little money. (When he went to fill out an income tax form, he found that he hadn't earned enough to owe any.) He soon began painting abstract works primarily in black and white—largely, he later claimed, because there was no money to buy paints more expensive than black and white enamels. They featured transient shapes that came in and out of focus: Picasso-inspired heads, biomorphic blobs, buttocks, breasts, stretched-out arms, dementedly grinning teeth, and monstrous bodies. They recalled the teeming, fantastical forms of Bosch and Bruegel, and bore similarities to the recent work of the young Francis Bacon, who was forging his own compelling new painterly language on the other side of the Atlantic.

De Kooning's friend Charles Egan, who had opened a gallery in a tiny studio apartment on 57th Street, was desperate to give him a show. He was also, as it happened, in love with Elaine, and sometime in 1947, not long after marrying another woman, Betsy Duhrssen, he began a long-running but surreptitious affair with her. De Kooning's relationship with Elaine had already sputtered out by this time, and when he eventually learned of the affair, he carried on as if nothing were different. Monogamy was evidently low on the ladder of expectation in their bohemian milieu; there were plenty of women already offering themselves up to de Kooning. His friendship with Egan, whose company he liked, and whose championing of de Kooning was sincere, could apparently withstand it.

Egan and Elaine were by no means the only ones who believed passionately in de Kooning: To many of the struggling downtown painters, the Dutchman's presence had become almost talismanic. De Kooning stood for authenticity, for struggle, and he was wrapped in all the earthy glamour and charisma that can attach to such qualities. He was onto something.

FOR POLLOCK, THINGS HAD calmed down after the confusion and disarray prompted by his successes with Peggy Guggenheim. And as the war, whose privations and shocks had done so much to color their lives, came to a close, he and Krasner made the decision to marry. They enjoyed an idyllic summer on Long Island, where Pollock seemed both soothed and creatively energized by the open sky and far-stretching sea (the Atlantic, he had said, was the one thing that could compare to the open landscapes of the West). Then, to the surprise of many, they took out a mortgage on a nineteenth-century clapboard farmhouse on Fireplace Road in the Springs. The house had neither plumbing nor heating, and they had to endure a brutal first winter without a bathroom or a car. But they made it through, working together to make the place habitable. Pollock, after not painting at all for several months, soon resumed, and embarked on the most sustained and fruitful effort of his career.

The year 1946 turned out to be the happiest of Pollock's life. "He always slept very late," recalled Krasner. "Drinking or not, he never got up in the morning . . . While he had his breakfast I had my lunch . . . He would sit over that damn cup of coffee for two hours. By that time it was afternoon. He'd get off and work until it was dark. There were no lights in his studio. When the

days were short he could only work for a few hours, but what he managed to do in those few hours was incredible." On Long Island, he was freed from the competitiveness and social confusions of New York. He had Krasner attending to all his needs and constantly professing her belief in him. And slowly, over a period of liberated experimentation, he hit upon a way of painting that was to revolutionize Western art.

LATE IN HIS LIFE, LUCIAN FREUD liked to tell the story of the cartoon strip writer who went on vacation, leaving his hero "chained up at the bottom of the sea with an enormous shark advancing from the left and a huge octopus approaching. And the man who takes over the job can't figure out how to get the hero out of danger, and after several sleepless nights, he finally sends a telegram to the writer, asking him what to do. And the telegram comes back: WITH ONE TREMENDOUS BOUND THE HERO IS FREE."

Pollock's signal achievements, beginning with the mural of 1943–44 and climaxing with his even bigger breakthrough in 1946, have this quality of improbable escape, a Houdini-like liberation from a self-imposed prison. In truth, the process was somewhat more gradual. But Pollock's creativity at this point did have a volcanic quality. It was fired by a species of inner conviction that had no regard for rules, and was willing, in a spirit of almost naïvely unguarded play, to invent new ones.

In his new studio on Fireplace Road, Pollock began by using the wrong end of his brush and even sticks to gouge marks into the surfaces of his paintings. This had been common practice among painters for centuries, but Pollock took to it with unusual

aggression. He bought fluid industrial paints so that he didn't have to go through the wearisome business of mixing paint from tubes with thinner. Discovering that the industrial paints had properties of their own, he began to explore them by spreading his canvas on the studio floor and moving himself around it so that he could approach from every angle. And then he began dripping and pouring paint—or, more accurately, dipping sticks, and sometimes a brush, into cans of paint and drawing in the air above the canvas. He let the paint fall in looping skeins onto the surface as he lunged forward and back, waving his wrist and arm like a grimly controlled conductor transported by the music in his head.

In the midst of these experiments, the critic Clement Greenberg came to visit Krasner and Pollock. He saw, on the floor of Pollock's studio, an unfinished painting covered in a tangle of yellow lines stretching from one end of the canvas to the other. On the walls were other, finished paintings that seemed less bold, since most of the paint had been applied more traditionally. But Greenberg squinted at the work on the floor and said, "That's interesting. Why don't you do eight or ten of those?"

Pollock took his advice. Working like this, day after day, he created paintings that covered his large canvases from edge to edge. The results were not just arrestingly physical and direct; they were also remarkably various—in color, texture, and emotional key. Some, with their pools of aluminum paint crisscrossed by meandering splatter lines or slashed by thin flicks, like streaking comets or wind-whipped rain, had an overall gauzy or spidery look. The resulting images twinkled and pulsed, evoking distant galaxies and the deep recession of space. Henry McBride, writing in *The New York Sun* in 1949, described the spattering of one such painting as "handsome and organized," creating the ef-

fect of "a flat, war-shattered city, possibly Hiroshima, as seen from a great height in the moonlight." Others were heavily congested, with thick layers of paint buttressed by foot- and handprints or pebbles or studio detritus, all of it vying tumultuously on the surface. Alert to their idiosyncrasies, Pollock gave them fittingly evocative titles, from *Galaxy* and *Phosphorescence* to *Full Fathom Five, Enchanted Forest, Lucifer,* and *Cathedral* [see Plate 13].

According to the critic Parker Tyler, writing in 1950, "Pollock's paint flies through space like elongating bodies of comets and, striking the blind alley of the flat canvas, bursts into frozen visibilities." His skeins of paint were like a labyrinth that "has no main exit any more than it has a main entrance, for every movement is automatically a liberation—simultaneously entrance and exit."

PEGGY GUGGENHEIM WAS ONE of the first people to see these paintings and to acquire them. She would also have been the first to show them, but she had been growing tired of New York, and in 1947 she decided to close Art of This Century and move to Venice. Before she left, she managed to cajole another dealer, Betty Parsons, into taking on Pollock. So it was at the Betty Parsons Gallery that the drip paintings were first displayed en masse.

They were by no means universally admired. Some critics decried them as infantile and primitive blurts. Others found them decorative, complacent, devoid of tension. But everyone could see that they were unprecedented. No one had painted like this before. And something about them caught on in people's

imaginations—in the minds not only of critics such as Green-berg (who continued to encourage Pollock down the path he was on), but also of Pollock's fellow artists. Few of these artists could articulate what excited them about Pollock's achievement. Fewer still had anything openly admiring to say. But several of the best of them—including de Kooning—sensed that some-thing extraordinary had happened, and watched all the more intently.

BACK IN DOWNTOWN MANHATTAN, stories of Pollock's anar-chic behavior—his penchant for picking fights, lewdly proposi-tioning women, and shattering decorum wherever he sniffed it—had spread all through the fledgling avant-garde artist scene. For most people, Pollock's behavior suggested a disturbed psy-chology. It was hard to fathom, harder to abide. But de Kooning, who would spend time with Pollock whenever Pollock came down from Long Island (usually in the company of other artists, such as Franz Kline), responded with instinctive sympathy. He was himself a man in whom ruthlessness, perversity, and a yearn-ing for freedom ran deep. He talked unexpectedly about the younger man's joy—his "desperate joy"—and he looked at Pollock—the person as much as the artist—with frank envy:

> I was jealous of him—his talent. But he was a remarkable person. He'd do things that were so terrific . . . He had this way of sizing up new people very quickly. We'd be sitting at a table and some young fellow would come in. Pollock wouldn't even look at him, he'd just nod his

head—like a cowboy—as if to say, "fuck off." That was his favorite expression—"Fuck off." It was really funny, he wouldn't even look at him . . .

De Kooning continued:

Franz Kline told me a story about one day when Pollock came by all dressed up. He was going to take Franz to lunch—they were going to a fancy place. Halfway through the meal Pollock noticed that Franz's glass was empty. He said, "Franz, have some more wine." He filled the glass and became so involved in watching the wine pour out of the bottle that he emptied the whole bottle. It covered the food, the table, everything. He said, "Franz, have some more wine." Like a child he thought it was a terrific idea—all that wine going all over. Then he took the four corners of the table cloth—pick[ed] it up and set it on the floor. In front of all those people! He put the goddamn thing on the floor—paid for it and they let him go. Wonderful that he could do that. Those waiters didn't take any shit and there was a guy at the door and everything. It was such an emotion—such life.

Another time we were at Franz's place. Fantastic. It was small, very warm and packed with people drinking. The windows were little panes of glass. Pollock looked at this guy and said, "You need a little more air," and he punched a window out with his fist. At the moment it was so delicious—so belligerent. Like children we broke all the windows. To do things like that. Terrific.

What de Kooning admired in Pollock, in other words, was not unlike what Freud saw in Francis Bacon: It was a quality that had as much to do with Pollock's perspective on life as with his achievement as an artist—although what seemed most marvelous, perhaps, was that the two things were impossible to separate. If the attraction was linked in some way to aesthetics, it was not primarily about the beauty of paint on canvas. It was about the beauty of life unshackled. It was about the appeal of liberating oneself—from expectations, from decorum, from morality—and touching an inner core of innocence.

And so when de Kooning saw Pollock's Betty Parsons show in 1948—eighteen paintings in all—he took notice. When he began to pay attention to Pollock's intoxicating attitude, his outrageous behavior, and above all his manner of painting, he could see exactly what it was he was missing in his own work. "On the floor I am more at ease," Pollock had explained. "I feel nearer, more a part of the painting, since this way I can walk around it, work from the four sides and literally be in the painting . . . When I am in my painting, I'm not aware of what I am doing. It is only after a sort of 'get acquainted' period that I see what I have been about."

De Kooning wanted a share of this same feeling—this sense of being in his paintings, unaware of what he was doing. Pollock's lack of self-consciousness, the sense of unimpeded, rippling release his paintings conveyed, offered an antidote to everything—all the endless revisions and erasures—that were holding de Kooning back. The eighteen paintings Pollock showed at Betty Parsons gave off a feeling almost of impudence. They weren't waiting for anyone's approval.

———

So de Kooning began now to cut loose in his own painting. He embraced a level of spontaneity he had resisted up until then, slathering on paint with a loaded brush—and, as he put it, "going to town." Unlike Pollock, he still worked primarily with brushes, and at an upright easel. But he painted wet-into-wet, making use of drips and different levels of viscosity and resistance, not all of it under his control. And he often, like Pollock, rotated the canvas. (You can tell because some of the drips change direction.) On the strength of the resulting work, a series of abstract paintings in black and white, de Kooning finally consented—after years of resisting, saying he wasn't yet ready—to making his first real stand in public: a solo show at Charlie Egan's.

The show opened in April 1948. It included ten pictures, all painted within the previous year. Touches of bright color showed through the blacks and dirty whites in glimpses that tickled and mobilized the eye. Ostensibly abstract, many of the works actually had incidental figurative elements. Others were made up of large letters or numbers in random formations. Contours that begin to suggest three-dimensional forms fall back into shadow; others fasten the eye to their surfaces with passages of drips or textured impasto. The Dutchman frequently mixed his paints on the canvas, so that his curved and hooking white lines smeared into shades of gray. Fluid white paint that was applied on top of the more settled and glossy blacks often broke up into textured marks suggesting speed and blur, or animal fur. Positive forms and negative space continually switched places as de Kooning tried both to compress space and to carve it out, now with line, now with tone, now with the paint's facture, with erasures and

ghost contours, with smudges, scrapes, and swipes. There is something ferocious and hard-won about the results. They testify to de Kooning's excitement. You know as you look at them that the artist is in the grip of something—and murderously close to finding it.

EGAN DID ALL HE COULD to generate interest in de Kooning's show. In a letter to Alfred Barr, the Museum of Modern Art curator, he claimed that de Kooning was "creating the most important paintings of our time." But as the show's scheduled one-month run came to a close, Egan's efforts looked to have failed. Nothing had sold. With little to lose, he decided to extend the show for a second month. Again, there were no bites. The longer it went on, the more humiliated de Kooning felt. "It made things seem more hopeless," remembered Elaine, still closely involved with de Kooning, despite their separation.

And yet all was not lost. The show may have been ignored by the mainstream press, but critics from several art magazines showed up. Their reviews were intelligent, and in some cases enthusiastic. Sam Hunter couldn't decide whether de Kooning's method added up to "an impression of imprisonment . . . or one of lugubrious vacillation"—an amazingly acute observation. The ambivalence in de Kooning's work was precisely what Greenberg warmed to. Ever on guard against the tendency for artistic virtuosity to descend into kitsch, Greenberg appreciated work that made a virtue of its own birth pangs. Gaucheness, evidence of effort, and a lack of finish were all signs of sincerity in Greenberg's eyes, signs of genuine striving rather than spiritual coasting. "Having chosen at last, in his early forties, to show his

work, [de Kooning] comes before us in his maturity, in possession of himself, with his means under control, and with enough knowledge of himself to exclude all irrelevancies," he wrote. He was alert to the tension in de Kooning's work between virtuosity and the search for a truthful originality. "Emotion that demands singular, original expression tends to be censored out by a really great facility, for facility has a stubbornness of its own and is loath to abandon easy satisfactions." The "indeterminateness or ambiguity" in de Kooning's paintings was the outcome, he suggested, of the artist's heroic "effort to suppress his facility." At this stage, believed Greenberg, de Kooning still lacked "the force of Pollock" and the "sensuousness of Gorky," and he was "more enmeshed in contradictions than either," but he had it in him "to attain a more clarified art and to provide more viable solutions to the problems of painting." All that was enough, according to Greenberg, to make him "one of the four or five most important painters in the country."

Thanks largely to Egan's persistence, a handful of works from the show did eventually sell, including one to the Museum of Modern Art. And now, suddenly, there was a wider buzz around de Kooning—almost comparable to the excitement Pollock had generated three years earlier. This expatriate Dutchman, so widely admired by his fellow painters, so full of integrity that he had refused to show his work as he struggled through years of poverty, was at last revealing himself to the world. And what he had to show looked good.

To his fellow painters, moreover, it pointed a way forward. Where Pollock's outlandish manner of dripping and pouring paint remained beyond the pale for many artists who were still committed to varieties of easel painting based in drawing, de

Kooning had come up with a manner of painting that was direct, robust, and even explosive, but still within the bounds of tradition.

POLLOCK, BY THIS TIME, was again careening about in a state of despair and rising panic. Despite many warm reviews (and de Kooning's evident enthusiasm), his breakthrough Betty Parsons show had been a financial disaster. Abstract art remained a hard sell in New York. Abstract art made by a man from the Midwest who splattered paint onto a canvas on the floor was harder yet. That was the reality. What's more, Peggy Guggenheim's precipitous departure for Venice had left Pollock and Krasner without crucial financial support. They had received their last check from her when the Parsons show closed. Pollock wouldn't get a comparable contract out of Parsons until the following June. By March, he and Krasner were in a hole.

So when de Kooning's show started winning plaudits— quietly at first, but snowballing, so that the excitement continued to build well after the show had closed—Pollock felt threatened and lost his composure. Conscious that all the young painters were suddenly talking about de Kooning, he arrived at a party for artists at Jack the Oysterman's fish restaurant on 8th Street with anarchy in his eyes. "He lashed out at everyone, and no-one could say anything to please him," remembered Ethel Baziotes. "He was insulting to his good friends in a way I'd never seen before." The episode culminated in a confrontation not with de Kooning but with de Kooning's former mentor and comrade-in-arms Arshile Gorky.

Gorky was not in a good way at the time, as Pollock must

have known. Two years previously, his studio had burned down. He had then undergone a colostomy for cancer of the colon. He now had to rely on a bag attached to an opening in his abdomen to eliminate waste. At the party, he was using a knife to whittle away at a pencil when Pollock approached and started shouting insults at him, mocking his paintings. There was a tense standoff. Gorky held his tongue and simply kept on whittling. The tirade ended only when the artist William Baziotes cut in, insisting that Pollock shut up.

Pollock was not one to calculate far in advance. But it's likely that, given de Kooning's earlier attachment to Gorky, Pollock saw an attack on him as an indirect way of discharging his jealousy over de Kooning's success. If so, it wouldn't be the last time Pollock suppressed and garbled his emotions in such a way.

BOTH POLLOCK AND DE KOONING were acutely conscious of the roles in which they had already been cast by critics and contemporaries: trailblazers, leaders, and therefore—inevitably— rivals. They were naturally wary of each other. Yet whatever tensions existed between them soon relaxed into a gruff camaraderie and a sincere, mutual admiration.

That spring, before taking up an invitation to teach over the summer at Black Mountain College in North Carolina, de Kooning made his first trip to Long Island. He visited Pollock and Krasner in the company of Elaine, Franz Kline, and Charlie Egan. Nothing is recorded of what passed between them. But the trip evidently had its effect: Over the next few years, de Kooning

spent more and more time in the region, and eventually moved to East Hampton. He chose a house just a few minutes away from Pollock and Krasner—right across from the cemetery where Pollock is now buried.

POLLOCK WAS PRODUCTIVE THAT summer and fall as he continued to develop his new style of painting. But he was as erratic and dangerous as ever. He had purchased a used and battered Model A Ford for $90 and was now driving about Long Island in various states of inebriation. Krasner worried. Pollock's mother, Stella, who heard about the car, wrote an eerie admonition to his brother Frank: "He should not drive & drink [or] he will kill himself or someone."

At a party in Manhattan, Pollock's behavior veered from the bewildering to the terrifying. Having picked a fight with William Phillips, the editor of *Partisan Review,* he prepared to launch himself at him, before suddenly choosing instead to seize the expensive shoe of Clement Greenberg's girlfriend, Sue Mitchell, and, in front of everyone, rip it to pieces. He then went to the window, which was several stories up, and began to climb out, seemingly ready to jump. Mark Rothko and Phillips got to him just in time, pulling him to the floor.

Gorky was also at the party. To add to his woes—the studio fire, the cancer—his neck had recently been broken in a car accident. The driver of the car was his dealer, Julien Levy. The catastrophe came shortly after he discovered that his beloved wife, Agnes, had had an affair with the artist Roberto Matta. He could take no more. He hanged himself in July.

—

IT COULDN'T GO ON. It went on, and on. And then, for a while, it didn't: Pollock stopped drinking.

The ostensible catalyst was straightforward: He had begun seeing a new doctor. His name was Edwin Heller, and immediately, Pollock trusted him. That was enough. Living at Springs with Krasner, enveloped in space and light, surrounded by Long Island's flat, sandy terrain cradled by swampy inlets and open seas, he was clearheaded for the first time in years, and creatively on fire. The couple's money worries were eased by a one-year grant—four quarterly payments of $1,500. And then, midway through 1949, Pollock obtained a contract with Parsons along the same lines as his earlier arrangement with Guggenheim. More important, he was now beginning to get the kind of attention he had always wanted. He was becoming, that is, spectacularly famous.

Pollock had his second solo show at Betty Parsons in January 1949: twenty-six works, including large drip paintings and various works on paper. Once again, the critical responses varied hugely. One reviewer said the paintings reminded her of "a tangled mop of hair I have an irresistible urge to comb out." But Greenberg held firm: Writing in *The Nation*, he said Pollock had done more than enough to justify the claim that he was "one of the major painters of our time." Addressing Pollock's painting *Number One* (since renamed *Number 1A* and acquired in 1950 by the Museum of Modern Art), he declared: "I do not know of any other painting by an American that I could safely put next to this huge baroque scrawl in aluminum, black, white, madder, and blue. Beneath the apparent monotony of its surface composition

it reveals a sumptuous variety of design and incident, and as a whole it is as well contained in its canvas as anything by a Quattrocento master."

The previous fall, 1948, *Life* magazine had organized a round-table discussion in which a panel of invited participants was asked to address the question of whether "modern art, considered as a whole, [was] a good or bad development." *Life* felt that it had a stake in the debate. A mildly conservative publication, it was, with a weekly readership of around five million people, the largest-selling magazine in America. Its editors' concern was that modern art appeared to have divorced itself from morality, that it had no "ethical or theological references." And so, with a view to exploring the issue, it assembled a panel of public intellectuals and critics, including Aldous Huxley and Clement Greenberg, to consider various modern works, one of the more "extreme" of which was Pollock's vertically oriented 1947 drip painting *Cathedral*.

Huxley, for one, was unimpressed: "It seems to me," he said, "like a panel for a wallpaper which is repeated indefinitely around the wall." Another participant, a professor of philosophy, thought Pollock's painting would make "a pleasant design for a necktie."

Greenberg, however, was there to defend Pollock, and modern art in general, and he did so with his usual punchy vigor. He was a man who loved passing judgment. Over the next few years, he vigorously promoted his own particular vision of art and its place in the postwar world. If the criteria he applied did not always withstand skeptical scrutiny, his writing was nonetheless trenchant and clear and he always impressed with the speed and confidence of his appraisals.

Later on, as Greenberg's influence flourished, he became no-

torious for coming to artists' studios and telling them how and
what to paint. De Kooning experienced this himself: Greenberg
had visited his studio and, unbidden, offered advice. "He knew
all about everything," remembered de Kooning, who quickly
tired of the encounter and "got rid of him. I said, 'Get out of my
house.'" Yet in truth, Greenberg's advice could often be helpful.
It certainly had been for Pollock in 1946. And now, at the discus-
sion organized by *Life,* he was defending not just modern art,
but the modern artists he most admired. Speaking up fearlessly,
he called *Cathedral* a "first-class example of Pollock's work, and
one of the best paintings recently produced in this country."

Life knew it was onto something. It had a vigorous culture
department, and its chief editor, Henry Luce, enjoyed stirring up
debate with editorials denouncing modern art as a hoax. So a few
months after the issue with the discussion of modern art ap-
peared, the magazine sent the portrait photographer Arnold
Newman to Pollock's studio to take pictures of him at work.

The results of Newman's sessions at the Fireplace Road stu-
dio were so compelling that *Life*'s editors decided to go ahead
with an article they had been pondering since the roundtable dis-
cussion. They commissioned new photographs of Pollock at
work—this time taken by Martha Holmes—and in July, Pollock
and Krasner turned up at the offices of *Life* in Rockefeller Center
to be interviewed by a young journalist called Dorothy Seiber-
ling. The ensuing conversation was wide-ranging. In the tran-
script, Krasner's contributions are not differentiated from
Pollock's, so it's hard to be sure of who said what. But some of
what was said Pollock must later have regretted—including the
claim, which appears in the transcript, that Pollock was the first
painter in his family. The implication, left dangling, was that

Charles and Sande had been inspired to take up art by him, rather than the other way around.

But if that claim was a blatant fabrication, another claim Pollock made in the interview was touchingly sincere. Asked to name his favorite artists, he nominated two: Wassily Kandinsky—a familiar name, long established as a central figure in modernist abstraction—and then a name almost no reader of *Life* would have recognized: Willem de Kooning.

THE FOLLOWING MONTH, A two-and-a-half-page spread appeared in the magazine under the title: IS HE THE GREATEST LIVING PAINTER IN THE UNITED STATES? The spread had a photo of Pollock posing in front of one of his long, horizontal drip paintings. His arms were folded, his head cocked arrogantly to one side, and a cigarette dangled from his lips. With his right leg crossed in front of the weight-bearing left, he seemed to be leaning back against the painting as if it were an old pickup truck. He looked for all the world, said de Kooning, "like some guy who works at a service station pumping gas."

The *Life* article played a crucial role not just in the story of Pollock's life but, soon enough, in the annals of American culture. Its appearance went beyond mere controversy. The article, and all the interest it generated, acted as a seed crystal for inchoate forces in American culture that cannot easily be summarized. They included both America's vaunting postwar confidence—a confidence that yearned to see a reflection of itself in art—and a post-Holocaust, post-Hiroshima consciousness of existential extremity. A consciousness that yearned, above all, perhaps, for transcendence. Pollock became famous, in part, because his

paintings seemed to answer to these collective yearnings. They were indubitably modern, they were aggressive, they were difficult. And yet they could also be seen as beautiful, decorative, and transcendent, too. They looked like nothing that had come before them. Even as they triggered widespread dismay among many of *Life*'s readers, the sheer jolt of their appearance—and the photogenic force of Pollock himself—was enough to overcome any attempt to downplay their significance—to dismiss them as "wallpaper" or "a mop of tangled hair" or any of the other pejoratives they picked up.

WHEN POLLOCK'S THIRD SHOW at Betty Parsons opened in November 1949, it was clear that everything had changed. The gallery overflowed, not just with the usual crowd of artists and strivers, but with bejeweled women in fashionable dresses and men in sharp suits. De Kooning turned up with his friend Milton Resnick, who remembered noticing, as he walked in the door, that "people were shaking hands. Most of the time when you went to an opening, all you saw were other people that you knew, but there were a lot of people there that I'd never seen before. I said to Bill, 'What's all this shaking about?' And he said, 'Look around. These are the big shots. Jackson has broken the ice.'"

Pollock's triumph made de Kooning acutely conscious that he, like every other struggling American avant-garde artist, was in Pollock's shadow. But he was smart enough to realize that the game had changed. Pollock had achieved what none of them had hitherto looked capable of: He had forced people to look at his work. And he had made sure that once they did, they would not look away without having formed a response that was geared to

the aggression in the art itself. He had done more than just break the ice; he had put his fist through the glass pane separating modern American art from its potentially enormous public. New vistas opened up.

De Kooning saw all this. But of course, Pollock's achievement wasn't simply about connecting modern art with a public. It was about generating possibilities for the creation of art itself.

Pollock's new pictorial language was in many ways a dauntingly private one—skeins of paint veiling imagery inscribed in the air—and it gestured precisely at what Pollock could never directly communicate: his dramatic and oftentimes intolerable inner life. But it was expansive, it was urgent, and it was full of potential.

Now, as de Kooning built on breakthroughs at least partly inspired by Pollock's shows at Betty Parsons, he seemed to sense that all bets were off. Nothing need hold him back any longer. The moment was his to seize.

AND YET DE KOONING, ever the equivocator, still seemed hesitant. It was as if he were standing on a threshold, trying to decide which room he wanted to be in, and relishing the uncertainty; a state of ambivalence was his creative sweet spot. In his own work he was alternating between figurative and abstract imagery—between, on the one hand, luridly colored canvases of seated women and, on the other, predominantly black-on-white abstractions that, like Pollock's drip paintings, had no focal points, just curved and hooking black lines that went in and out of focus, the overall effect recalling the Cubism of Picasso and Braque but with more Matissean voluptuousness, more explo-

siveness, more mess. His paintings were heavily worked, full of erasures and second thoughts. "Whenever a figure would start to appear de Kooning would cross-hatch it out," explained the artist Ruth Abrams. But the end results were much freer, and also more unified, than his earlier pictures. Loaded with doubts and ambiguities, they nevertheless managed to carve out what felt like a coherent pocket of space and time, rather than an endless and anguished unspooling in dissonant registers.

At the beginning of 1950, de Kooning started work on *Excavation* [see Plate 14]. More than six feet high by more than eight feet wide, it was the largest canvas he had ever painted. He worked on it for four or five months. It began as a multi-figure composition—most likely three figures in an interior—but slowly the figures dissolved into their surroundings, and the pictorial space flattened out into a stretched scrim of fleeting forms twisting and breaking and puncturing the surface. The dominant color is an off-white, tinged with a yellow-green, and differentiated by black and gray lines of different widths, hooking and curving as if twisting against the painting's vertical and horizontal limits. Glimpses of bright, lavish, colors—especially the three primaries: red, yellow, and blue—burst through at seemingly random points, as do glimpses of grinning teeth and leering eyes. And yet, as Harold Rosenberg wrote in 1964, "For all the protracted agitation that produced it, 'Excavation' was a classical painting, majestic and distant, like a formula wrung out of testing explosives."

Excavation was de Kooning's masterpiece. It was painted with brushes, not with poured or dripped paint. But it was, in the manner of Pollock's drip paintings, an "all-over" composition.

The painting's energy and interest were evenly distributed from top to bottom and from left to right. There may have been wisps of figurative imagery, but the painting was essentially abstract. Looking at a reproduction of it in 1983, de Kooning described its making to the writer Curtis Bill Pepper, for a story in *The New York Times Magazine:*

"'I think I started here,' he observed, pointing to the upper left-hand corner. 'I said, "We'll make a stab at it here." I wasn't thinking about any method or manner that had realities. So you do a little bit, and you feel comfortable with it. Then you say, "I'll make it open here and closed here," and that way you go around and around, a little bit at a time. It's always coming out nice, because you can keep going on what's connected to it. Because if you keep a section you're comfortable with, you can build out from it, little by little.'"

De Kooning's way of getting into the canvas appeared to relate to Pollock's notion of being in the canvas; but there remained one crucial difference: Pollock didn't work "little by little."

SUDDENLY, BOTH MEN WERE riding high. Pollock had become famous in a way that even he could never have imagined. His work was talked about by all the people who counted and was acclaimed on both sides of the Atlantic. He was being described as the best painter in America, an artist who made even Picasso look dated.

De Kooning's first major financial windfall did not come until the following year, when *Excavation* was awarded a prize by the Art Institute of Chicago (and was subsequently purchased by the

museum). But other rewards were already coming his way. In April 1950, Alfred Barr chose *Excavation* and three other de Kooning paintings to represent the United States, alongside work by Pollock and six other painters, at the 25th Venice Biennale. (Four years later, both Bacon and Freud represented Great Britain at the same event.) Both men's works were purchased by the Museum of Modern Art and by major collectors. They were featured in popular magazines, debated by high-minded critics.

But having painted *Excavation*, de Kooning chose to retreat from abstraction. He embarked instead on a series of huge, aggressive works showing big-busted women with monstrous faces and bared teeth who all seemed to have emerged, in a vengeful mood, from behind the scrim of paint in *Excavation*. Their presence was conjured by a welter of agitated brushstrokes, repeatedly blurred, erased, and reapplied in unruly colors. De Kooning struggled with the first of them, *Woman I*, for almost two years. Pollock's influence may have helped to free him in some ways. But he was still tortured by doubts, and by a technique that did not allow for anything like the freedom Pollock had embraced. At one point, despairing of ever finishing *Woman I*, de Kooning actually threw it out. He was only persuaded to retrieve it from the trash by the critic Meyer Schapiro.

The struggle to pull off the *Woman* paintings set off rising anxiety and heart palpitations in de Kooning. To quell these symptoms he turned to alcohol. Still, at least on the face of it, success was tangibly his; it was no longer just a future possibility.

FOR POLLOCK, ON THE OTHER HAND, 1950 marked the beginning of a sudden decline—a fall so precipitous, in fact, that,

looking back, it is as if his life had simply imploded; as if all the straining and striving and—finally—the fertile gushing forth had simply been switched off, his life forced into a sudden, ignominious, and directionless collapse.

What happened? Pollock's fame, when it finally arrived, was unmanageable. His creative breakthrough had been made possible by the absence in his personality of the very tools he now needed to cope: a sense of restraint and proportion; what in the social realm is called perspective or maturity; what the short story writer Alice Munro once witheringly called the "decent narrowness of range" of most responsible men. The lack of these very things was what de Kooning, for one, found so attractive in Pollock. But if these absent constraints were engines of creativity and excitement, they were also, in the social sense—and perhaps even in the existential sense—deep flaws: Pollock's drinking bore directly on his capacity to survive.

HIS DISINTEGRATION BEGAN AT the height of his acclaim when, in March 1950, his therapist, Dr. Edwin Heller—who had done so much to keep Pollock's alcoholism at bay—died in a car crash. Then, in July, Pollock's family descended on the house at Fireplace Road for a reunion. Rather than basking in the glow of newfound fame and the massive validation it implied, Pollock was a soul in turmoil during these few days. In front of his family—including the brothers he had tried so hard to emulate, and who had rescued him from abjection time and time again—he did not know how to handle himself. His behavior lurched dementedly between sweet hospitality and insufferable showing off. His brothers and their skeptical spouses were initially dis-

mayed, then disgusted. And so Pollock's proudest, most triumphant moment turned acrid.

A few months later, after repeatedly visiting the studio to take photographs, Hans Namuth came to film Pollock at work. The filming, which took place out of doors, dragged on over several excruciating weeks as the temperatures slowly fell. Namuth had no compunction about directing Pollock in front of the camera, telling him what to do and how to do it. He was looking for imagery that would be as dramatic and compelling as possible. And indeed the finished film is intensely memorable. It shows the painter hypnotically absorbed in what he is doing. Concentrating fiercely, he seems as in tune with nature and magic and instinct as one of the "Indian sand painters of the West" for whom, in a brief voiceover, the artist expresses a special affinity. "Because a painting has a life of its own," he says at one point—"I try to let it live." And: "There is no accident, just as there is no beginning and no end."

Ironically, given the tremendous psychological toll it would take on Pollock, Namuth's footage went on to seal the painter's legend. The images, as much as Pollock's actual paintings, prepared the way for an endless cultural unfurling over the following decades. They were understood and transposed in countless ways. They led to—or tangentially inspired—everything from avant-garde dance, performance art, "happenings," Land Art, and graffiti art to Jimi Hendrix setting his guitar on fire at Monterey in 1967 and Andy Warhol urinating on copper to produce his so-called piss paintings in the 1970s. But what they communicated, above all, was abandon—a yearning for liberation and a volatility that might as easily result in destruction as creation.

——

POLLOCK BEGAN NAMUTH'S FILMING as a willing participant. But he had always detested the idea of "phoniness." As the sessions went on he felt more and more like a fraud, so that by the end, he was spiritually scooped out. The weather had turned frigid as Pollock was posed, now pulling on paint-splattered boots, now painting on glass with Namuth's camera recording his drips and flicks and puddling pools from beneath. When the sessions finally ended, Krasner had a belated Thanksgiving dinner waiting for everyone inside. The ordeal of filming day after grinding day had reduced Pollock to despair. His faith in what he was doing and what he had done, in his whole achievement to date, had seemed to drain from him visibly as the camera rolled. He now came inside and poured himself a drink.

And that was the beginning of the end. By 1951, after three years off alcohol—years when anything seemed possible—Pollock was once more a violent, drunken wreck, who could find no convincing way to advance his art.

It's easy to say that Pollock's problems began and ended with drinking. But what is not so clear—what is never clear, since blurred vision is the whole point of drinking—is why he drank. Naifeh and Smith wrote that for Pollock, "drunkenness was humiliation." But, they added, "it was manly humiliation." That was surely part of its attraction. There was a framework, an established tolerance, for the macho drunk who rumbled and caroused and called out abuse, like Hemingway, or who grew menacing like Stanley Kowalski in Tennessee Williams's *A Streetcar Named Desire*. (Interestingly, Williams wrote his play after spending time with Pollock in Provincetown.) Pollock's ex-

aggerated displays of machismo were in sync, moreover, with the times. They were one more symptom of a homophobic reaction in American art in the 1930s against the perceived threat of "sissification"—of an effete and enfeebled culture. Benton's Regionalist polemics, which played up narrowly masculine values as much as rural American ones, were one aspect of this. In many ways, the heroic, existentialist, and very macho rhetoric of the Abstract Expressionists who came to prominence in the late 1940s was but a continuation of the same theme.

Many commentators also believe that Pollock's psychic confusion—and thus also his drinking—was entangled to some uncertain degree with sexual confusion. When Jeffrey Potter was composing an oral history of Pollock, he delicately asked de Kooning about the rumors that Pollock may have been gay. De Kooning called it "the most bizarre idea I ever heard in my life." Pressed, however, he remembered how Pollock might "put you in his arms and give you a big kiss and I [would] kiss him back." But this, he said, was hardly unusual: "Maybe artists are a little bit more sentimental or romantic about kissing each other," he speculated, a combination of irritation and amusement in his voice. If Pollock was gay, he concluded, "it was so deep inside of him [that] every man has it too."

Pollock's biographers, Naifeh and Smith, laid out masses of evidence to undermine de Kooning's certitude. And yet it may be that Pollock was simply as confused in his sexual identity as he was in other aspects of his identity. This confusion bubbled to the surface as anguish, self-loathing, and extreme social behavior that routinely spilled over into physicality. Misogynistic outbursts blurred into clumsy passes (made with no apparent expectation that they might lead anywhere), unwanted groping, and

actual assaults on women, all on a regular basis. Rumbling with men—especially fellow artists who triggered confused feelings of admiration and competition—was also routine, and the line between friendly high jinks, actual ardor, and frightening aggression was extremely permeable.

The stories of Pollock's physical fights with other men are legion. In 1945, Pollock's old and frequently tense friendship with Philip Guston, who had been a fellow student back at Manual Arts in California, had come to a head at a party thrown by Sande. Pollock had already embraced abstraction at this point and was entering his most fruitful phase. He turned on Guston, who was painting allegorical works in a figurative style that was beginning to look old hat. "Goddamn it," exploded Pollock, "I won't stand for the way you're painting! I won't stand for it!" He threatened to throw Guston out the window. A drawn-out fist-fight ensued.

Three years later, Pollock was at a dinner party held by John Little and Ward Bennett. (Bennett, who was gay, later claimed he could tell that Pollock was sexually interested in him.) Igor Pantuhoff, Krasner's former lover, was also at the party. Pollock began drunkenly chasing him through the house. The two men, in front of a mortified Krasner, ended up outside on the rain-soaked lawn. According to Bennett, "They started rolling in the mud, but it was very bizarre. They weren't really fighting, they were sort of wrestling and sort of kissing each other at the same time" (not unlike the men in *Two Figures*, Francis Bacon's 1953 painting of wrestlers, or lovers, which Lucian Freud had acquired).

In the 1950s, as Pollock and de Kooning's fame peaked, drinking, braggadocio, and violence became a fixture in the bars they

frequented—most famously, the Cedar Tavern. Shoves and punches were par for the course. Stevens and Swan tell of a time when Pollock kept pushing Franz Kline, de Kooning's closest friend, off his barstool. "He did it once, he did it twice, and then Kline, suddenly, turned on Pollock, slammed him against the wall, and slugged him in the gut with a left and then a right. 'Jackson was much taller,' said an observer, 'and so surprised, and happy—he laughed in his pain and bent over, as Franz told me, [and] whispered, 'Not so hard.' "

POLLOCK MAY HAVE ACHIEVED fame by midcentury, but despite all the notoriety and critical acclaim, most people still found his paintings intolerably radical. His shows were failing to sell, which led to fights with his dealer, Betty Parsons, over money. For a period of two years, between 1951 and 1953, he virtually banished color from his painting, turning out dozens of works of overlapping skeins of black enamel paint that meshed with one another and with the canvas itself. Many were powerful: Pollock's November 1951 show at the Betty Parsons Gallery was filled with these paintings of diluted black enamel squirted and flicked and dripped onto unprimed beige cotton duck, and the cumulative impact was nothing if not arresting. Most had recognizable figurative elements—faces and bodies that were demarcated by clear lines and carved out by patches of pitch black. These elements were obscured and tangled up in other lines, but they were indisputably a return to figurative drawing, and they suggested the deep interest with which Pollock had been looking both at the black-and-white paintings de Kooning had been mak-

ing over the previous four years, and at the spectral figures that haunted *Excavation*.

Pollock's relationship with Krasner, meanwhile, was deeply strained. As Pollock's drinking had resumed, Krasner was in the invidious position of being the only one close enough to him to impose even a semblance of control on his life. She accepted the role, and even played it to the hilt. Some who knew the couple accused her of being too controlling, and exacerbating his problems. But there are no winners in such situations, and no right answers. Pollock's alcoholism was extreme. In her attempts at dealing with it, Krasner was trying to protect not only his reputation and his ability to function as a creative artist but his life. No one—least of all a spouse—can play such a role and escape recriminations.

WITH HIS UNBOUNDED, CHILDLIKE PERSONALITY, Pollock was poorly equipped for fame. According to his friend, the artist Cile Downs: "He never got over the fact that people don't love you as much when you're big and successful as they did when you are poor and a nonentity." Like all boasters (and Pollock's boasting bordered on the hysterical), he was undermined by self-doubt. He simply didn't know if he could continue to produce work as commanding as his early drip paintings. And for all his bluster, he remained vulnerable to criticisms even of those works. He never quite accepted their legitimacy.

By 1952, a backlash had set in. Critics who had formerly championed him had turned against him. Fellow artists, envying his success but doubting its validity, bickered about him. They

mocked him openly, ignoring his incessant demands for attention and respect, preferring instead the company of the more good-humored and socially fluent de Kooning. An artists' club had formed—it was called, with ominous literal-mindedness, "The Club." De Kooning presided. Pollock, who rarely attended, was pointedly marginalized when he did.

The impulse, perhaps, is to shake one's head and think, *Poor misguided Pollock. He was a genius. If only he had believed in himself.* But it is not so simple. His decline has been analyzed binge by binge, month by month, each disastrous misdeed appropriately cross-referenced with childhood episodes and other early warning signs. What emerges most strongly is a sense of his incredible loneliness during these final years. Constantly seeking connections, Pollock found himself instead on a permanent war footing. He was a tormented man withdrawing step by step into the solitude of a private catastrophe. But he was not, throughout this time, wrestling only with his private demons. He was wrestling, often literally, with others, continually butting heads with the individuals—including de Kooning—whose camaraderie he craved the most.

LOOKING BACK, IT CAN sometimes seem as if, from 1950 on, Pollock and de Kooning were both playing parts in a play, an intimate two-hander, acted out before a vast crowd obscured in the proximate dark. They knew they were being watched more closely than any of their fellow artists. "Everyone's shit but de Kooning and me," as Pollock bluntly told the artist Grace Hartigan in 1950.

But even as both artists grasped what was at stake (triumph, vindication, lasting acclaim), they both seemed to register the essential absurdity of the "Who is the greatest?" game that was presently taken up all around them. It's possible that, had Pollock and de Kooning been left alone, their relationship may have continued to be good-humored, intimate, and creatively generative. But they were not left alone. Instead, extras poured onto the stage in increasing numbers, drowning out the two leads.

None of these bit players was louder, more hectoring and possessive than the era's two leading critics, Harold Rosenberg and Clement Greenberg.

A familiar presence on the downtown art scene since before the war, Rosenberg was a tall, voluble, mustachioed man bristling with intellectual ambition. He was also a regular fixture in de Kooning's studio. He had a meaty lower lip and dark, lavish eyebrows, and he was—for all his intellectual hauteur—a congenial and witty companion who loved to carouse and be one of the boys.

Rosenberg had known Pollock, too, since the WPA days. His wife, May, had been the only witness to Pollock's wedding to Krasner. Rosenberg admired Pollock as a painter, but had begun to find his behavior hard to tolerate. Their friendship had been souring for several years. It was hard for Rosenberg to forgive the night Pollock drove Krasner over to the house the Rosenbergs were renting in the Springs. Leaving a mortified Krasner in the car, he had banged on the door yelling for May. (Harold was away in Manhattan.) Pollock was intoxicated and out of control, and out to prove something to Krasner. Standing at the door, he began yelling.

"He said terrible, terrible things," May told Naifeh and Smith, "threatening what he was going to do to me, using the foulest language, saying that I'd never have it so good." The Rosenbergs' seven-year-old daughter was woken by the abuse and appeared in due course, crying hysterically and waving a huge kitchen knife at Pollock. May had come to the window to shoo him away. It was only then that she saw Krasner in the car. It was immediately clear to her that Pollock was abusing her simply to get at Krasner. "He was taunting her and she was just taking it," she said.

Unlike de Kooning, who had quick wits and a gangster's feeling for sophistry, Pollock didn't have an intellectual bone in his body. If this was a source of insecurity in him, it was also a cause of ongoing frustration and dismay for Rosenberg, who thrived on intellectual disputation and soon came to the conclusion that Pollock just wasn't up to it.

Rosenberg's authority over Pollock was not just intellectual, however; it was physical. "Harold was a big man," remembered de Kooning. "He wasn't scared of anybody. Not that he wanted to fight, but he would take anybody on . . . Jackson couldn't do nothing, particularly when he was drunk." Pollock was powerless before Rosenberg's rising contempt. And after so many years, the critic was well and truly fed up. He was tired of Pollock's alcoholism, his fumbling inarticulacy, his social disruptiveness. On one occasion, when Pollock came to visit, he once again began acting abrasively. Rosenberg rose to his full height (a good six feet five inches), took a very tall glass, filled it to the top with liquor, and handed it to Pollock. "Drink it," he said.

Pollock took a few sips and then left.

In early 1953, de Kooning came over to the Pollock-Krasner residence in a buoyant mood. He had recently read an article by Rosenberg published in *ARTNews*. Pollock and Krasner had both already read the essay. "American Action Painters," as it was called, was the critic's first serious—and truly influential—foray into art criticism after more than a dozen years spent fraternizing with artists. Without mentioning any names, it championed the work that Rosenberg saw emerging from New York studios at midcentury—a time when, as he wrote, "the canvas began to appear to one American painter after another as an arena in which to act—rather than as a space in which to reproduce, re-design, analyze or 'express' an object, actual or imagined."

In ringing, rhythmic sentences that expressed an almost Olympian self-confidence, Rosenberg argued that this new work constituted a radical break from the art of the past. For the new American artists, what mattered, he said, was now no longer the image, be it abstract or representational, but the act of painting. "What was to go on the canvas was not a picture," he wrote, "but an event."

Rosenberg's essay was in many ways a high-minded reprise of the old Romantic trope of the individual pitted against the world. But his idea of the individual was very much in tune with his own historical moment—with a world that had just seen Europe and Japan reduced to rubble, had witnessed the Holocaust and Hiroshima, and was now studded with long-range nuclear weapons pointing at one another. The individual—unless he could muster up some real heroics—stood ready to be crushed.

In such a world, insisted Rosenberg, important art could only be made by great individuals—individuals who accepted the new, existential realities, and were in revolt against false consciousness. Artists who were utterly sincere in the moment of creation.

On the face of it, Rosenberg's prescriptions sounded like a resounding validation of Pollock—his liberating new method; his treatment of the canvas as a physical arena; his willingness to risk all; his decisive break with the past. Even today, more than half a century after Rosenberg's essay appeared, the terms *drip painting* (coined to describe Pollock's method) and *action painting* are all but interchangeable.

So de Kooning was surprised when, after he mentioned the essay approvingly, Krasner blew up. She attacked Rosenberg's motives and integrity. She accused him of an underhanded attack on her husband, and of stealing the phrase *action painting* from a conversation he'd had with Pollock. Taken aback, de Kooning tried defending Rosenberg. But Krasner was in a vengeful mood, and before long, de Kooning beat a retreat. The following day, in a flurry of phone calls to friends, she accused de Kooning himself of "betraying her, betraying Jackson, betraying art."

ROSENBERG LATER TRIED TO DENY that his essay was aimed at Pollock. But Krasner was right. She had read "The American Action Painters" all the way through. She had seen how, having laid out his case for greatness in contemporary painting, Rosenberg proceeded to rail against the kind of painting that, though it seems to answer to all his criteria, lacks integrity and is actually fraudulent. Even as the essay valorized de Kooning's idea of painting as an ongoing struggle, combining thousands of deci-

sions and calculated risks, it seemed to disparage Pollock for producing canvases that "lacked the dialectical tension of a genuine act, associated with risk and will," and were merely decorated with the artist's "own daily annihilation." Using phrases that seemed to be aimed specifically at Pollock—like "commodity with a trademark" and "apocalyptic wallpaper"—he savaged art that peddled in mysticism and was corrupted by commerce.

Even so, in the end, the essay was perhaps less an attack on Pollock than an intellectual assault on Pollock's preeminent champion, Clement Greenberg. It was the most concerted offensive so far in Rosenberg's hitherto unsuccessful struggle against Greenberg's dominant influence over New York's burgeoning avant-garde art scene.

IN THE SPACE OF just a few years, Greenberg had developed from being a mediocre Marxist literary critic with scant knowledge of art to an immensely influential tastemaker. His success was galling to Rosenberg. The two critics—both brilliant and bellicose—detested each other and had to be kept apart socially; their encounters too often descended into fistfights. Ironically, it had been Rosenberg who had introduced Greenberg to the editors of the Communist journal *Partisan Review,* which went on to publish Greenberg's most important early essays on art—including "Avant-Garde and Kitsch" and "Towards a Newer Laocoön." In these now canonical pieces, Greenberg, following Trotsky, had insisted on the need for avant-garde art to retain its independence not only from bourgeois values, but also from explicitly leftist habits of thought: Only by retaining total independence, believed Greenberg, could art offer effective resistance to

forces of standardization and control in society at large. To maintain this autonomy, he argued, progressive art had to burn away everything that was incidental to the medium itself. That meant ridding painting of its traditional preoccupation with creating illusions of three-dimensionality and depth. And it meant the end of all other gambits that were in less-than-total accord with the innate properties of the medium. The artwork, he believed, must be made to surrender to "the resistance of the medium."

To bolster this rather flimflam argument, Greenberg laid out a historical trajectory of modern artists who had advanced art by making pictures that were increasingly self-critical, or "honest," about their own construction, and less and less concerned with the game of illusionism. His roll call of approved artists led from Manet, who dispensed with traditional modeling, to Cézanne and Matisse, whose styles dispensed in ever-greater degrees with the illusion of depth. And now, with Pollock's drip paintings (which Greenberg himself had encouraged into being), a new chapter was beginning. Here was a whole new style of painting—a style that was abstract (there was no subject matter), direct (there was no underdrawing), depthless (his paint had been splattered straight onto the canvas), and "all-over" (there was no composition; the painting established an even field without center or edge).

Rosenberg's "American Action Painters" framed developments in recent American avant-garde art differently, and in so doing, it triggered a proxy war between the two critics—a war in which Pollock and de Kooning were essentially used as pawns. When the essay appeared, Greenberg declined to respond. But the critics' tussle for supremacy fanned out into the wider scene.

The majority of critics and artists rallied around de Kooning and Rosenberg, turning on Pollock and on his main champion, Greenberg. The artists' and critics' wives joined the battle, with Elaine de Kooning and May Rosenberg pitting themselves against the "pompous" Greenberg and the "abrasive" Lee Krasner, both of whom, they felt, manipulated Pollock, promoting him at the expense of other artists. The atmosphere became toxic—and quite the reverse of the camaraderie that had reigned among these same people during the difficult WPA days and the war.

The money, success, and public attention they craved had finally arrived—but they were unevenly distributed, and the party was spoiled.

THE INTELLECTUAL TUSSLE BETWEEN Greenberg and his foes was partly an argument over whether the future of painting lay solely in abstract (or "non-objective") imagery, as Greenberg believed, or whether figurative imagery still had a place. De Kooning's masterpiece *Excavation* had seemed to most observers to be entirely abstract and was praised accordingly by Greenberg. But de Kooning himself saw no clear distinction between abstract and figurative idioms. And in the immediate aftermath of *Excavation*, he had returned to painting figures.

Greenberg was appalled by this. But for Pollock, who so admired de Kooning, it was more complicated. He felt torn. Part of the problem was that he was confused about where to take his own painting. Friends were urging him to try new things, to develop his work. He remained intrigued by the possibilities of figurative imagery, which he had returned to in his black paint-

ings of the previous two years. He was sensitive to the criticism that his drip paintings were empty and decorative. He worried that the champions of abstract painting, especially Greenberg, would be "disturbed" by the reappearance of recognizable shapes in his work—a face here, a body there. But he was also getting a lot of heat, both in the press and from a skeptical public, for the apparent ease of his drip painting method, and he wanted to prove a point to "the kids who think it's simple to splash a 'Pollock' out." The resulting paintings were compelling, but they had failed to sell at Betty Parsons, and Pollock reverted to a state of creative block.

JUST A FEW MONTHS after Rosenberg's "American Action Painters" appeared, de Kooning showed his *Woman* series for the first time, at Sidney Janis's. Pollock came to the opening. He was surely impressed. The paintings conveyed feelings about women—a fascinated loathing and ecstatic dread, bordering on bruising defeat—he surely recognized. And de Kooning's violent, splashy idiom, full of bravura brushwork but nonetheless boldly chancy, released from the painstaking methods of his earlier work, may have reminded him of his own breakthroughs.

But Pollock was also confused by the paintings. They were figurative, not abstract. These were unmistakably representations of women. Pollock was still ripped up about the role figurative images had, or might go on to have, in his own faltering work. Had his own renewed experiments with figurative imagery constituted a retreat, a failure of nerve, as he suspected—and as he knew Greenberg believed? Or had they been a legitimate step forward? One thing was certain: The *Woman* paintings were

at odds with the drive toward abstraction that Greenberg had so pungently theorized, using Pollock as his heroic exemplar.

At the opening, feeling anything but heroic, Pollock became drunk—drunker than at least one friend, George Mercer, had ever seen him. Then, at a certain point, seeing de Kooning across the room, Pollock yelled at him: "Bill, you've betrayed it. You're doing the figure, you're still doing the same goddamn thing. You know you never got out of being a figure painter."

De Kooning's response, according to onlookers, was cool. It was his show, there were supporters around. He said, "Well, what are you doing, Jackson?"

It has never been clear what de Kooning intended by the question. Was he merely trying to remind Pollock that he, too, had tentatively included figurative imagery in his last show at Betty Parsons? Or was it instead a taunting reference to the situation everyone knew about by now: Pollock's creative block, his struggle to come up with something new, and even to paint at all?

However he took the question, Pollock was hushed by it. He left the opening and went to a bar. A short while later, he stepped out from the curb in front of an oncoming car. It had to swerve wildly to avoid him.

POLLOCK WAS INDEBTED TO GREENBERG. The critic had done so much to boost his success at crucial junctures—not just by offering him advice in the studio and declaiming his "greatness" on many occasions, but also by using him as the prime exemplar of his theories about the development of advanced art. It was not surprising, then, that Pollock depended on Greenberg's

approval. So when others began to attack him, to question his achievement or remark on his having lost his way, he naturally looked to Greenberg for support.

But Greenberg by now had bigger, more cerebral battles to fight. Watching Pollock's personal decline, he seems to have realized that he could not afford to hitch his reputation to a self-destructive drunk. And so over the next few years, as Pollock's work seemed to fall off in quality and the creative gush of the late 1940s slowed to a desultory trickle, he quietly withdrew his support. He did organize a retrospective of Pollock's work—eight paintings at Bennington College in Vermont—in 1952. And he wrote two articles to try to boost Pollock's late-1951 show at Betty Parsons. But prior to that, he hadn't reviewed Pollock's work for three years. When, unhappy with her inability to find buyers, Pollock left Betty Parsons in 1952 to go to Sidney Janis (who by now was also de Kooning's dealer), Greenberg described his first show there as "wobbly."

All artists, said Greenberg, "have their run," and Pollock's "run was over." Greenberg didn't review the Janis show, or Pollock's next show in 1954. And then, in 1955, with Pollock at his lowest ebb, he wrote an essay in *Partisan Review* announcing openly that Pollock had lost it—that his latest work was "forced," "pumped," and "dressed up," that creatively he was washed up.

Reviewing a survey of Pollock's work at the Sidney Janis Gallery in 1955, the young critic Leo Steinberg noted that "more than any other living artist's, Pollock's work has become a shibboleth; I have heard the question 'What d'you think of Jackson Pollock' shouted from the floor of a public gathering in a tone of 'Are you with us or against us?'" For Steinberg, the work itself "blasted" all such questions "out of relevance." To him Pol-

lock's paintings were "manifestations of Herculean effort, . . . evidence of mortal struggle between the man and his art." But by then, to most people who had any contact with him, Pollock was looking less and less herculean, and more and more pathetic.

POLLOCK CONTINUED LOOKING FOR FIGHTS. At the Cedar Tavern he once goaded de Kooning into punching him in the mouth. The blow drew blood, and the gathered crowd urged Pollock to retaliate, but Pollock refused: "What? Me hit an artist?" he said.

The nadir of the two artists' physical relationship came in the summer of 1954. De Kooning had gone with friends to help Carol and Donald Braider move house. The Braiders owned the House of Books and Music, a sanctuary in East Hampton beloved by artists and poets alike. They had named their son Jackson after Pollock. De Kooning was hoping to take some furniture from the Braiders back to the Red House, a property he was renting in nearby Bridgehampton. Pollock arrived at the Red House, a little inebriated, before de Kooning got there. He was in a mood to cause trouble. Elaine de Kooning was there and, seeing Pollock's state, she called her husband, suggesting he return soon. When de Kooning and Franz Kline, de Kooning's closest friend, arrived, remembered Elaine, "they threw their arms around Jackson, and began to horse around." They hugged and refused to let go, lurching around the yard until they came upon an outside path that was deeply recessed through years of use. The sudden dip caused Pollock to fall heavily, pulling de Kooning on top of him. Pollock's ankle snapped under the weight.

He was immobilized for most of the rest of the summer. The

injury coincided with, and to some degree exacerbated, his accelerating decline. He grew more dependent on Krasner, who had only recently returned to making her own art with real resolve (she was combining strips cut out of her own old paintings with those cut from Pollock's discarded works to make collages inspired in part by Matisse). Pollock's dependence—physical now, as well as psychological—only made him more resentful, and jealous of her return to art-making. His physical helplessness, and everyone's awareness of what had caused it, made it all too clear that he was helpless in other ways, too.

Whatever invisible battle it was he'd been fighting, Pollock was now visibly defeated. A year later the ankle was rebroken after another reckless rumble. But somehow, that first intimate break—de Kooning landing on top of Pollock, Pollock coming off second best—came to represent the new reality of their relationship.

NEAR THE END OF POLLOCK'S LIFE, Robert Motherwell was hosting a party at his Upper East Side townhouse. De Kooning and Franz Kline and about sixty others were there. Pollock had not been invited.

"I knew that there was an effort to replace Pollock with them [de Kooning, Kline, and other members of The Club] and . . . I didn't want him to get wildly drunk and disrupt everything," explained Motherwell. "Everyone had arrived and the party was in full swing when the doorbell rang. Pollock was standing sort of sheepishly and asked if he could come in . . . He was absolutely sober. De Kooning and Kline were high, and the two of them began to taunt Pollock as a has-been, etc. He had every

right to get drunk or to slug them, but in fact he just took it. Obviously, he had made up his mind to keep his cool and after a while he left . . . Strange way to see Pollock for the last time."

BY THE FINAL YEAR of his life, 1956, Pollock was visibly unraveling in front of an appalled and fascinated world. He was the most famous artist in America, but he hadn't painted anything in eighteen months. People used to turn up at the Cedar Tavern, where he went to drink after sessions with his latest therapist, and try to touch him for good luck. They would buy him drinks in the hope of getting him to act out—which he reliably did. If there was a couple having supper together in the bar, he would sit down at their table, and—ignoring the man—throw all his addled attention at the woman. When the man protested, he would sweep his arm theatrically over the surface of the table, knocking salt, pepper, silverware, cream pitcher, Parmesan, bread, place mats, and drinks to the floor. It was all a performance. Pollock knew it was what people expected from him. And conforming to expectations was all he could manage.

His face, as photos show, gave away his condition: It was gluey, and strangely characterless. His eyes, which used to seethe with ferocious intent, seemed weak and sheeplike, as if reconciled to a state of permanent, underlying apology. His liver, too, was diseased and swollen, ravaged by years of alcoholism. But he couldn't stop drinking, and in fact was drinking more than ever. Beer mostly. Scotch, too. And then, whatever was poured into his glass. Along with the drinking came rolling waves of maudlin weeping and ragged boasting and general incoherence. In company, he had become the phony that in private he had al-

ways secretly feared he was. At parties and gatherings he was treated as a kind of jester, despised or sentimentally loved, but always with a certain reserve. To almost everyone in his ambit—from his wife to his friends, his dealer, the critics who had written in praise of his breakthrough work, and the smattering of bold collectors who had bought it—his behavior had become embarrassing.

He and Krasner had been a formidable team. Even as their relationship had lurched from crisis to crisis, it had generated stupendous things. Her determination to remain in control of a situation that had been sliding toward chaos for years had been heroic, if also, to many who knew her, disconcerting: Did she exert too much control over him? friends wondered. Was her own devotion to his career, her fierce need to protect and promote him, ultimately good for him, or good for her? Did it not isolate them both further? In any case, having endured years of psychological abuse and even (according to some) physical beatings, she had reached a breaking point. What was between them had been slowly but thoroughly poisoned. Month by month, year by year, the toxicity had accumulated, until it was no longer endurable.

AND THEN, IN THE SUMMER of 1956, Pollock, as if to goad Krasner—but also, perhaps, out of other kinds of desperation—took up with a glamorous younger woman. Her name was Ruth Kligman. From the outside, nothing about the affair seemed quite serious. Kligman was an artist and an art student. She was also trying to run a gallery. In the circle of avant-garde artists and enablers known to Pollock and Krasner she was a stranger,

until she appeared one day at the Cedar Tavern. Kligman related to the world around her in a breathless way. The writer John Gruen said she "looked like a plumper and taller Elizabeth Taylor," and "had a kind of film star image of herself." She wore tight dresses and had a seductive, whispering manner that men found arousing and women tended to resent. Elaine de Kooning called her "pink mink."

But if Kligman was in some ways calculating when it came to attracting men, she was also shy and naïve. Clinging to a deeply romantic notion of creative genius, she yearned to have some contact with it. When Pollock, puffy and glowering, walked into the Cedar Tavern, most people saw pathos. To Kligman, "he was monumental and magical." "A genius walked in, and we all knew it," she wrote in her memoir, *Love Affair*. "The trumpet had sounded, the greatest of the matadors had arrived . . ."

Kligman had never had a boyfriend. Unlike many of the women artists and the various wives and girlfriends of male artists who made up the rambunctious, bohemian downtown artists' scene, she felt defenseless without makeup. The bustle and back-slapping of the Cedar Tavern ("Finally I was with a group of real artists," she wrote) reduced her to an awed silence. She felt out of place, and on some level like a fraud.

And maybe all of that is what attracted Pollock to her. For he, too, felt fraudulent, insecure, defenseless—"a clam without a shell," as he said. He, too, was sexually inexperienced (Krasner had been his only long-term partner). He, too, was obsessed with the idea of genius.

The two began seeing each other. Pollock flaunted her in front of Krasner. He would have held on to both women if he could, and in fact he behaved almost as if he were merely waiting

to be told that he couldn't. Krasner saw Kligman emerge one morning from the studio just beyond their house on Long Island, and quickly made her position clear: The new relationship was not something she could tolerate. He would have to choose. But he continued to ignore reality, and in the end, Krasner had no choice but to act. She resolved to travel to Europe, leaving Pollock and Kligman to their own devices.

For a short time, the lovers were euphoric. Pollock felt liberated from Krasner's controlling, frustrated, and suffocating presence. Kligman, meanwhile, was at last free to indulge her adolescent dream of being with a great artist without having to think about the fact that he was married to Krasner (and helpless without her).

But sure enough, after a few brief weeks of happiness, the chaos and self-loathing that were always sloshing at the edges of Pollock's psyche flooded back in. Krasner had been powerless to do anything about it. And so, too, now, was Kligman.

On the night of August 11, driving drunk and at high speed along Fireplace Road at ten thirty at night, with two passengers, Kligman and her friend Edith Metzger, in the car with him, Pollock lost control. The car, a 1950 Oldsmobile convertible he had recently bought on impulse, veered off the road and plowed into two elm trees. The impact killed him instantly. It also killed Metzger.

Kligman was the sole survivor.

AT POLLOCK'S FUNERAL, DE KOONING was among the last of the mourners to leave. Afterward, he was at the artist Conrad Marca-Relli's home, not far from Fireplace Road. Unable to find

their master, Pollock's dogs came into the house. "It gave me the creeps," recalled Marca-Relli. "I said something and Bill said: 'It's all right. That's enough. I saw Jackson in his grave. And he's dead. It's over. I'm number one.'"

He went into the garden, where he was later discovered in tears.

DE KOONING WAS INDEED now number one. But of course, in most people's eyes, he already had been. Clearly, while Pollock was alive, de Kooning—acutely aware of his debt to Pollock—had remained unconvinced.

Now there could be no doubt.

Or could there? De Kooning behaved now as if he still had a point to prove. Within a year of Pollock's death, he began an affair with his dead rival's girlfriend, Ruth Kligman. Acquaintances and friends were astonished. The news was the equivalent of a dream that, upon waking, seems so nakedly available to interpretation that it embarrasses the dreamer into silence. "Going with Ruth," as one onlooker said, "really put the stone on Jackson's grave."

The relationship between de Kooning and Kligman actually lasted several years—many times longer than the brief and doomed dalliance between Kligman and Pollock. And yet, perhaps because it lacked the romantic drama that violent death had imposed on Kligman's relationship with Pollock, it seems it had nothing like the same significance, for either party. When Kligman later wrote *Love Affair*, it was not about her time with de Kooning—it was about her much briefer time with Pollock. De Kooning, likewise, when asked about Kligman by Jeffrey Potter

many years later, answered that she "must have cared for him [Pollock] a lot." And then, trailing off: "She kind of cared for me, too, later. She meant it," he continued, speaking of Kligman's feelings for him, "but not like, you know, a great passion or anything like that."

THREE YEARS AFTER POLLOCK'S DEATH, de Kooning and Kligman spent the summer and fall in Europe. Things between them were beginning to fester. De Kooning was struggling with the same problems that had overwhelmed Pollock. Five years earlier, barely anyone outside a circle of art lovers in Manhattan had heard of him. He was an illegal immigrant who didn't even have a bank account. Now he was internationally famous. The incessant adulation and toadying, the partying, the hard drinking—which de Kooning had now taken to with a vengeance—were undermining him. He was continuously irritable, and that irritability slid regularly into outright belligerence.

Just as Pollock had done at regular intervals throughout his adult life, he began roaming the streets at night, inciting needless arguments, which often turned violent. He provoked one woman to strike at his head with a bottle; he knocked out another man's teeth, prompting a lawsuit.

Now, in Europe with Kligman, he bickered and fought. The lovers separated in Venice and met up again later in Rome—the Rome of Fellini. They were photographed by paparazzi as they went to a hotel and thence to a nightclub. And there, in the early hours of the morning, they began to fight.

"It was absolutely awful," Gabriella Drudi, a friend who was

there, told Stevens and Swan. "They were screaming at each other. Finally Bill said, 'Why don't you go into the grave with your Jackson Pollock.' ... And Ruth said, 'I had two months with Jackson Pollock but he's jealous.'"

THE FINAL YEARS OF the 1950s saw de Kooning achieve the kind of near-universal endorsement that Pollock had craved, and improbably achieved, but enjoyed all too briefly. Thomas Hess talked of "l'école de Kooning," and wrote the first monograph on his work. Published in 1959, it was part of a series called Great American Artists. The Dutch stowaway had become a US citizen just as his paintings were being sent abroad to represent the apex of American visual culture during the Cold War. The critics were crazy for his cavalier, liberated painting style. The popular press, too, swung behind de Kooning and his tough, romantic persona.

A scene—far larger and more dynamic than the intimate huddle of avant-garde artists in the 1930s and '40s—had coalesced and achieved a kind of critical mass. De Kooning was crowned its king. "He took a whole generation with him, like the pied piper," Greenberg later noted.

Better still, a healthy market for contemporary painting had magically sprouted. At the opening of his 1959 solo show at Sidney Janis's, collectors began queuing outside by 8:15 A.M. By midday, nineteen of the show's twenty-two paintings were sold. De Kooning, observed Fairfield Porter, was "rich now for the first time in his life."

But he was far from content. Even as the adulation peaked, he seemed increasingly harried, frustrated, and petulant. Alone at

the top, he behaved as if under permanent threat—just as Pollock had. He was pining, too, for lost comrades—"imaginary brothers" gone missing. He was missing Gorky, his old sidekick, long dead. And he was pining, obscurely, for Pollock. More than anyone else, Pollock would have understood what de Kooning was now going through; what it was like to be at the top of the pile; what forces buffeted you up there and made you want to drink yourself to oblivion.

For that is what, by now, de Kooning was doing. And he didn't really stop—not for more than three decades (he died in 1997). De Kooning drank to quell his anxieties, and the heart palpitations they set off. He once woke Marca-Relli at 2 A.M., banging on his door and saying, "Jesus Christ I think I'm going to die. I can't stop." Marca-Relli told Stevens and Swan that de Kooning's doctor had told him to calm himself: "You're over-anxious. This whole idea of painting a figure and destroying it . . . this is doing something to you." Over the next few decades, de Kooning was regularly hospitalized; he sabotaged his relationships, one after the other, through alcohol and infidelities, and his body was subjected to all manner of ignominy, from feet so swollen that he couldn't put on shoes to tremors so savage he couldn't sign his name. "Don't forget," said Marca-Relli, de Kooning "could draw like Ingres and could paint with the sweet quality of any master. And yet he had to cut it off, destroy it all, slap it off, all these violent strokes."

DE KOONING'S LIFE WAS LONG, but his ascendancy, like Pollock's, was surprisingly brief. By the early 1960s, his reputation

was in eclipse. A new generation of artists was emerging, and they had little interest in de Kooning's kind of painting—still less in the grandiloquent rhetoric that bore it aloft. More and more, the heroic aura around de Kooning the "action painter" seemed ripe for ridicule. He was a massive, cynically inflated target just asking to be punctured. The younger generation—beginning with Robert Rauschenberg (who convinced de Kooning to give him a drawing so he could erase it and present it as a work of his own called *Erased de Kooning Drawing*) and Jasper Johns, followed by the Pop Artists, then the Minimalists, the Conceptualists, and so on were more or less allergic to the idea of easel painting pursued passionately and in earnest. Their tastes were cooler, more cerebral, wittier. They were turned off by the outsized personalities of the Abstract Expressionists and the rampant mythmaking of their boosters. To them, de Kooning's masterly way with contour and color, his ardent relationship with oil paint, his love of landscape, the sea, and all things sensuous and visceral seemed increasingly passé.

Ironically, Pollock's posthumous reputation soared. It had been languishing—if not cratering—while he was still alive. But death purified him, made him freshly eligible for sanctification. More important, his work began to look more and more relevant, and even unexpectedly prescient. Conceptually, technically, and spiritually, it pulsed with possibilities, and to succeeding generations of artists it was constantly suggesting new ways forward. Pollock's method of dancing around the canvas on the floor, for instance, attacking it from all angles, inspired new modes of experimental performance art. The gap between his touch and the surface he marked gave his paintings a curiously

objective quality, too: Color Field painters, hard edge abstractionists, Minimalists, and even Land Artists found this compelling, and in many ways an antidote to the histrionic, blowsy self-expression they perceived in de Kooning's manner.

With every new development in avant-garde art, and with every passing year, Pollock looked more and more deserving of his reputation as a revolutionary, a trailblazer. De Kooning, on the other hand, looked admirable enough, but somehow slightly shopworn—someone operating valiantly at the end of a tradition rather than boldly inaugurating a new one.

Reflecting on their achievements, Irving Sandler called de Kooning "the painter" and Pollock the "genius."

DE KOONING CAME TO TERMS with all this. He *was* the painter, instinctual and sensuous, and he didn't try to hide from it—not even when historical currents were against him. In an era that increasingly celebrated coolness, minimalism, and impersonality in art, he was more than happy to go against the grain. "Art never seems to make me peaceful or pure," he had said in 1951. "I always seem to be wrapped in the melodrama of vulgarity."

His painting had always been more carnal than Pollock's. "Flesh," he famously said, "is the reason oil paint was invented." It was an attitude that was to resonate profoundly with, among others, Francis Bacon and Lucian Freud.

THE STORY OF DE KOONING'S post-Pollock life is not just the story of a long string of audacious advances as a painter, or of a body of work that was so bold, so expressive, and so ambitious

that it finally transcended the fads and moods of its historical moment. It is also, sadly, the story of an endless concatenation of self-annihilating binges.

And it is something else, too: It is the story of a life that was never entirely "post-Pollock," and that perhaps never could be. De Kooning was at once too indebted to Pollock and too caught up in admiration and rivalry ever to leave him behind. His whole attitude toward Pollock was deeply ambivalent. He lived his own life, and it was certainly not contained or defined by Pollock. But through his relationship with Kligman, and even through his 1963 move to the Springs—to a house directly opposite the cemetery where Pollock was buried—he seemed bent on maintaining a connection with his dead friend and rival.

SOURCES AND ACKNOWLEDGMENTS

Several major biographies and exhibition catalogs were crucially important to me in writing this book, and I wish to thank the relevant authors, curators, and institutions for making the stories and information in them publicly available in such clear-eyed, exciting, and authoritative ways. I wholeheartedly recommend the relevant books to all readers interested in the subjects I have addressed.

They are: (for the chapter on Freud and Bacon) Michael Peppiatt's exhibition catalog *Francis Bacon in the 1950s* (New Haven, CT, and London: Yale University Press, 2006), Michael Peppiatt's biography *Francis Bacon: Anatomy of an Enigma* (New York: Skyhorse Publishing, 2009), and William Feaver's exhibition catalog, *Lucian Freud* (London: Tate Publishing, 2002); for the chapter on Manet and Degas: Roy McMullen's *Degas: His Life, Times, and Work* (Boston: Houghton Mifflin, 1984), *Degas,*

the catalog for the exhibition organized by Jean Sutherland Boggs with Douglas W. Druick, Henri Loyrette, Michael Pantazzi, and Gary Tinterow (New York and Ottawa: Metropolitan Museum of Art and National Gallery of Canada, 1988), and *Manet 1832–1883*, the catalog of the exhibition organized by François Cachin and Charles S. Moffett with Michel Melot (New York: Metropolitan Museum of Art, 1983); for the chapter on Matisse and Picasso: Hilary Spurling's *The Unknown Matisse: A Life of Henri Matisse*, Volume 1, *1869–1908* (London: Hamish Hamilton, 1998) and *Matisse the Master: A Life of Henri Matisse*, Volume 2, *The Conquest of Color, 1909–1954* (London: Hamish Hamilton, 2005), John Richardson's *A Life of Picasso*, Volume 1, *1881–1906* (London: Pimlico, 1992) and *A Life of Picasso, 1907–1917: The Painter of Modern Life*, Volume II, (London: Pimlico, 1997), and *Matisse Picasso*, the catalog for the exhibition organized by Elizabeth Cowling, John Golding, Anne Baldassari, Isabelle Monod-Fontaine, John Elderfield, and Kirk Varnedoe (London: Tate Publishing, 2002); for the chapter on Pollock and de Kooning: Mark Stevens and Annalyn Swan's *de Kooning: An American Master* (New York: Alfred A. Knopf, 2005), John Elderfield's exhibition catalog, *De Kooning: A Retrospective* (New York: Museum of Modern Art, 2011), Steven Naifeh and Gregory White Smith's *Jackson Pollock: An American Saga* (Aiken, SC: Woodward/White, 1989), and Kirk Varnedoe and Pepe Karmel's exhibition catalog, *Jackson Pollock* (New York: Museum of Modern Art, 1998).

In addition to these books, I was inspired and provoked by two superb essays. The first, James Fenton's "A Lesson from Michelangelo," was published in *The New York Review of Books* on March 23, 1993. The second, Adam Phillips's "Judas' Gift," ap-

peared in the *London Review of Books* 34, no. 1, on January 5, 2012.

I would like to express my indebtedness to the Newport Beach Public Library Foundation, especially Janet Hadley and Tracy Keys, whose generous invitation to deliver a talk crystallized the idea for this book. A special order of thanks goes to early readers David Ebershoff, Cecily Gayford, Andrew Franklin, Caitlin McKenna, Michael Heyward, Rebecca Starford, Sam Nicholson, Thomasine Berg, William Feaver, Andrea Rose, my wonderful agent Zoe Pagnamenta, and above all my wife, Jo Sadler. Moral support and encouragement were provided along the way by Daniel Crewe, Jeremy Eichler, James Parker, Geordie Williamson, Royal Hansen, Susan Hamilton, Adam Gopnik, Helen A. Harrison, Ben and Judy Watkins, Anne Dunn, William Corbett, Mark Feeney, Peter Schjeldahl, George Shackelford, Rebecca Ostriker, Veronica Roberts, Michael Smee, Ann-Margrete Smee, Stephanie Smee, Margery Sabin, Dan Chiasson, and William Cain, among others. My deepest thanks to them all.

Other books and sources that supplied valuable information are listed here by chapter:

LUCIAN FREUD AND FRANCIS BACON

BOOKS

Bruce Bernard and Derek Birdsall, *Lucian Freud* (London: Jonathan Cape, 1996).

Caroline Blackwood, Anne Dunn, Robert Hughes, John Russell, and an Old Friend, *Lucian Freud Early Works* (exhibition catalog) (New York: Robert Miller Gallery, 1993).

Leigh Bowery and Angus Cook, *Lucian Freud: Recent Drawings and Etchings* (New York: Matthew Marks Gallery, 1993).

Cressida Connolly, *The Rare and the Beautiful: The Lives of the Garmans* (London: Harper Perennial, 2005).

Cecil Debray, *Lucian Freud: The Studio* (exhibition catalog) (Paris: Éditions du Centre Pompidou/Munich: Hirmer Verlag GmbH, 2010).

Daniel Farson, *The Gilded Gutter Life of Francis Bacon* (London: Vintage, 1993).

William Feaver, *Lucian Freud* (exhibition catalog) (Milano: Electa, 2005).

————, *Lucian Freud* (New York: Rizzoli, 2007).

————, *Lucian Freud Drawings* (exhibition catalog) (London: Blain/Southern, 2012).

Starr Figura, *Lucian Freud: The Painter's Etchings* (exhibition catalog) (New York: Museum of Modern Art, 2007).

Lucian Freud, *Some Thoughts on Painting* (Paris: Éditions du Centre Pompidou, 2010).

Matthew Gale and Chris Stephens, *Francis Bacon* (exhibition catalog) (London: Tate Publishing, 2008).

Martin Gayford, *Man in a Blue Scarf: On Sitting for a Portrait by Lucian Freud* (London: Thames & Hudson, 2010).

Lawrence Gowing, *Lucian Freud* (London: Thames & Hudson, 1984).

Geordie Grieg, *Breakfast with Lucian: A Portrait of the Artist* (London: Jonathan Cape, 2013).

Kitty Hauser, *This Is Francis Bacon* (London: Laurence King Publishing, 2014).

Phoebe Hoban, *Lucian Freud: Eyes Wide Open* (New York: New Harvest/Houghton Mifflin Harcourt, 2014).

Sarah Howgate, Michael Auping, and John Richardson, *Lucian Freud Portraits* (London: National Portrait Gallery, 2012).

Sarah Howgate, Martin Gayford, and David Hockney, *Lucian Freud: Painting People* (London: National Portrait Gallery, 2012).

Robert Hughes, *Lucian Freud Paintings* (London: Thames & Hudson, 1989).

Hosaka Kenjiro, Masuda Tomohiro, and Suzuki Toshiharu, *Francis Bacon* (exhibition catalog) (Tokyo: National Museum of Modern Art, 2013).

Michael Kimmelman, *Portraits* (New York: Modern Library, 1999).

Catherine Lampert, *Lucian Freud: Early Works 1940–58* (exhibition catalog) (London: Hazlitt Holland-Hibbert, 2008).

Andrew Lycett, *Ian Fleming: A Biography* (London: Orion Publishing, 2009).

Robin Muir, *John Deakin/Photographs* (Munich, Paris, London: Schirmer/Mosel, 1996).

Pilar Ordovas, *Girl: Lucian Freud* (exhibition catalog) (London: Ordovas, 2015).

Nicholas Penny and Robert Flynn Johnson, *Lucian Freud Works on Paper* (London: Thames & Hudson, 1989).

David Plante, *Becoming a Londoner: A Diary* (New York, London: Bloomsbury, 2013).

Francis Poole, *Everybody Comes to Dean's* (New York: Poporo Press, 2012).

John Richardson, *Sacred Monsters, Sacred Masters* (London: Jonathan Cape, 2001).

John Russell, *Lucian Freud* (exhibition catalog) (London: Arts Council of Great Britain, 1974).

———, *Francis Bacon* (London: Thames & Hudson, 1979).

Nancy Schoenberger, *Dangerous Muse: The Life of Lady Caroline Blackwood* (Cambridge, MA: Da Capo Press, 2002).

Wilfried Seipel, Barbara Steffen, and Christoph Vitali, editors, *Francis Bacon and the Tradition of Art* (exhibition catalog) (Milan: Skira, 2003).

Sebastian Smee, *Lucian Freud Drawings 1940* (New York: Matthew Marks Gallery, 2003).

———, *Lucian Freud 1996–2005* (London: Jonathan Cape, 2005).

———, *Lucian Freud* (Cologne: Taschen, 2007).

———, *Lucian Freud on Paper* (London: Jonathan Cape, 2008).

Sebastian Smee, David Dawson, and Bruce Bernard, *Freud at Work* (London: Jonathan Cape, 2006).

David Sylvester, *The Brutality of Fact: Interviews with Francis Bacon* (London: Thames & Hudson, 1993).

————, *Looking Back at Francis Bacon* (New York: Thames & Hudson, 2000).

Michael Wishart, *High Diver: An Autobiography* (London: Blond & Briggs, 1977).

ARTICLES, FILMS, AND WEBSITES

Caroline Blackwood, "On Francis Bacon 1909–1992," *New York Review of Books,* September 24, 1992.

Jonathan Jones, "Bringing Home the Bacon," *Guardian,* June 22, 2001.

Michael Kimmelman, "Titled Bohemian; Caroline Blackwood," *New York Times Magazine,* August 2, 1995.

Catherine Lampert, "The Art of Conversation," *Financial Times,* November 30, 2011.

Jennifer Mundy, "Off the Wall," *Gallery of Lost Art,* galleryoflostart.com.

Tom Overton, "British Council Venice Biennale," www.venicebiennale.britishcouncil.

David Sylvester, "All the Pulsations of a Person," *Independent,* October 24, 1993.

Randall Wright, *Lucian Freud: Painted Life* (documentary), UK, 2012.

ÉDOUARD MANET AND EDGAR DEGAS

BOOKS

Bridget Alsdorf, *Fellow Men: Fantin-Latour and the Problem of the Group in Nineteenth-Century French Painting* (Princeton, NJ, and Oxford: Princeton University Press, 2013).

Carol Armstrong, *Manet Manette* (New Haven, CT: Yale University Press, 2002).

————, *Odd Man Out: Readings of the Work and Reputation of Edgar Degas* (Los Angeles: Getty Research Institute, 2003).

Charles Baudelaire, *The Flowers of Evil*, edited by Marthiel Matthews and Jackson Matthews (New York: New Directions, 1989).

————, *Intimate Journals* (London: Picador, 1989).

————, *The Painter of Modern Life and Other Essays* (London: Phaidon, 1995).

Walter Benjamin, *The Writer of Modern Life: Essays on Charles Baudelaire* (Cambridge, MA, and London: Belknap Press of Harvard University Press, 2006).

Joseph M. Bernstein, *Baudelaire, Rimbaud, Verlaine: Selected Verse and Prose Poems* (New York: Citadel Press, 1993).

Beth Archer Brombert, *Edouard Manet: Rebel in a Frock Coat* (Chicago: University of Chicago Press, 1996).

Anita Brookner, *The Genius of the Future: Essays in French Art Criticism* (New York: Cornell University Press, 1971).

Roberto Calasso, *La Folie Baudelaire* (London: Allen Lane, 2012).

T. J. Clark, *The Painting of Modern Life: Paris in the Art of Manet and His Followers* (Princeton, NJ: Princeton University Press, 1984).

Guy Cogeval, Stéphane Guegan, and Alice Thomine-Berrada, *Birth of Impressionism: Masterpieces from the Musée d'Orsay* (San Francisco: Fine Arts Museums of San Francisco and DelMonico Books, 2010).

Marjorie Benedict Cohn and Jean Sutherland Boggs, *Degas at Harvard* (Cambridge, MA: Harvard University Art Museums, 2005).

Jeffrey Coven, *Baudelaire's Voyages: The Poet and His Painters* (Boston: Bullfinch Press, 1993).

James Cuno and Joachim Kaak, editors, *Manet Face to Face* (exhibition catalog) (London: Courtauld Institute of Art, 2004).

Jill DeVonyar and Richard Kendall, *Degas and the Dance* (exhibition catalog) (New York: Harry N. Abrams/American Federation of the Arts, 2002).

Ann Dumas, Colta Ives, Susan Alyson Stein, and Gary Tinterow, *The Private Collection of Edgar Degas* (exhibition catalog) (New York: Metropolitan Museum of Art, 1997).

John Elderfield, *Manet and the Execution of Maximilian* (exhibition catalog) (New York: Museum of Modern Art, 2006).

Gloria Groom, *Impressionism, Fashion, and Modernity* (exhibition catalog) (Chicago: Art Institute of Chicago, 2012).

Stéphane Guegan, *Manet: Inventeur du Moderne* (exhibition catalog) (Paris: Musée d'Orsay/Gallimard, 2011).

George Heard Hamilton, *Manet and His Critics* (New Haven, CT: Yale University Press, 1954).

Louisine W. Havemeyer, *Sixteen to Sixty: Memoirs of a Collector* (New York: Ursus Press, 1993).

Anne Higonnet, *Berthe Morisot* (New York: Harper Perennial, 1999).

Kimberly A. Jones, *Degas Cassatt* (Washington, DC: National Gallery of Art, 2014).

Richard Kendall, editor, *Degas by Himself* (London: Time Warner, 2004).

John Leighton, *Edouard Manet: Impressions of the Sea* (exhibition catalog) (Amsterdam: Van Gogh Museum, 2004).

Nancy Locke, *Manet and the Family Romance* (Princeton, NJ: Princeton University Press, 2001).

Patrick J. McGrady, *Manet and Friends* (exhibition catalog) (University Park, PA: Palmer Museum of Art, 2008).

Jeffrey Meyers, *Impressionist Quartet: The Intimate Genius of Manet and Morisot, Degas and Cassatt* (Orlando, FL: Harcourt, 2005).

Rebecca A. Rabinow, editor, *Cézanne to Picasso: Ambroise Vollard, Patron of the Avant-Garde* (exhibition catalog) (New York, Metropolitan Museum of Art, 2006).

Theodore Reff, *Degas: The Artist's Mind* (exhibition catalog) (New York: Metropolitan Museum of Art, 1976).

———, *Manet and Modern Paris* (exhibition catalog) (Washington, DC: National Gallery of Art, 1982).

John Rewald, *The History of Impressionism* (New York: Museum of Modern Art, 1973).

John Richardson, *Edouard Manet: Paintings and Drawings* (New York: Phaidon, 1958).

Anna Gruetzner Robins and Richard Thomson, *Degas, Sickert, and Toulouse-Lautrec, London and Paris 1870–1910* (London: Tate Britain, 2005).

MaryAnne Stevens, *Manet: Portraying Life* (exhibition catalog) (London: Royal Academy of Arts, 2012).

Gary Tinterow and Geneviève Lacambre, *Manet/Velázquez: The French Taste for Spanish Painting* (exhibition catalog) (New York, Metropolitan Museum of Art, 2002).

Gary Tinterow and Henri Loyrette, *Origins of Impressionism* (exhibition catalog) (New York: Museum of Modern Art, 1994).

Paul Valéry, *Degas, Manet, and Morisot* (New Jersey: Princeton University Press, 1989).

Juliet Wilson-Bareau, *Manet by Himself* (London: Time Warner Books, 2004).

Juliet Wilson-Bareau and David C. Degener, *Manet and the American Civil War* (exhibition catalog) (New York: Metropolitan Museum of Art, 2003).

———, *Manet and the Sea* (exhibition catalog) (Philadelphia: Philadelphia Museum of Art, 2003).

ARTICLES

Norma Broude, "Degas's 'Misogyny,'" *Art Bulletin* 59, no. 1 (March 1977), pp. 95–107.

———, "Edgar Degas and French Feminism, ca. 1880: 'The Young Spartans,' the Brothel Monotypes, and the Bathers Revisited," *Art Bulletin* 70, no. 4 (December 1988), pp. 640–59.

Andrew Carrington Shelton, "Ingres Versus Delacroix," *Art History* 23, no. 5 (December 2000), pp. 726–42.

HENRI MATISSE AND PABLO PICASSO

BOOKS

Dorthe Aagesen and Rebecca Rabinow, *Matisse: In Search of True Painting* (New York: Metropolitan Museum of Art, 2012).

Janet Bishop, Cecile Debray, and Rebecca Rabinow, *The Steins Collect: Matisse, Picasso, and the Parisian Avant-Garde* (New Haven, CT, and San Francisco: Yale University Press and San Francisco Museum of Modern Art, 2011).

Yves-Alain Bois, *Matisse and Picasso* (exhibition catalog) (Paris: Flammarion, 1998).

Elizabeth Cowling, *Picasso Style and Meaning* (London: Phaidon, 2002).

Stephanie D'Alessandro and John Elderfield, *Matisse: Radical Invention 1913–1917* (exhibition catalog) (Chicago: Art Institute of Chicago with Museum of Modern Art, New York, and Yale University Press, 2010).

Alex Danchev, *Georges Braque: A Life* (London: Hamish Hamilton, 2005).

John Elderfield, *Henri Matisse: A Retrospective* (New York: Museum of Modern Art, 1992).

Jack Flam, *Matisse on Art* (Oxford: Phaidon, 1990).

———, *Matisse and Picasso: The Story of Their Rivalry and Friendship* (New York: Westview, 2003).

Françoise Gilot, *Matisse and Picasso: A Friendship in Art* (London: Bloomsbury, 1990).

Lawrence Gowing, *Matisse* (London: Thames & Hudson, 1996).

John Klein, *Matisse Portraits* (New Haven, CT: Yale University Press, 2001).

Dorothy Kosinski, Jay McKean Fisher, and Steven Nash, *Matisse: Painter as Sculptor* (exhibition catalog, Baltimore and Dallas: Baltimore Museum of Art and Dallas Museum of Art, 2007).

Brigitte Leal, Christine Piot, and Marie-Loure Bernadac, *The Ultimate Picasso* (New York: Harry N. Abrams, 2000).

Henri Matisse and Pierre Courthion, *Chatting with Henri Matisse: The Lost 1941 Interview* (Los Angeles: Getty Research Institute, 2013).

Ellen McBreen, *Matisse's Sculpture: The Pinup and the Primitive* (New Haven, CT: Yale University Press, 2014).

Fernande Olivier, *Loving Picasso: The Private Journal of Fernande Olivier* (New York: Harry N. Abrams, 2001).

Rene Percheron and Christian Brouder, *Matisse: From Color to Architecture* (New York: Harry N. Abrams, 2004).

Peter Read, *Picasso and Apollinaire: The Persistence of Memory* (Berkeley: University of California Press, 2008).

John Richardson, *Picasso and the Camera* (New York: Gagosian Gallery, 2014).

Joseph J. Rishel, editor, *Gauguin, Cézanne, Matisse: Visions of Arcadia* (exhibition catalog) (Philadelphia: Philadelphia Museum of Art, 2012).

William H. Robinson, *Picasso and the Mysteries of Life: "La Vie"* (Cleveland: Cleveland Museum of Art, 2012).

William Rubin, *"Primitivism" in 20th Century Art: Affinity of the Tribal and the Modern* (exhibition catalog) (New York: Museum of Modern Art, 1984).

Hilary Spurling, *La Grande Thérèse: The Greatest Scandal of the Century* (Berkeley: Counterpoint Press, 2000).

Gertrude Stein, *Picasso: The Complete Writings* (Boston: Beacon, 1970).

————, *The Autobiography of Alice B. Toklas* (New York: Vintage, 1990).

Leo Stein, *Appreciation: Painting, Poetry, and Prose* (Lincoln: University of Nebraska Press, 1996).

Brenda Wineapple, *Sister Brother: Gertrude and Leo Stein* (New York: Putnam, 1996).

FILM

Christopher Bruce and Waldemar Januszczak, *Picasso: Magic, Sex, Death,* presented by John Richardson (London: Channel 4, 2001).

WILLEM DE KOONING AND JACKSON POLLOCK

BOOKS

William C. Agee, Irving Sandler, and Karen Wilkin, *American Vanguards: Graham, Davis, Gorky, de Kooning, and Their Circle, 1927–1942* (exhibition catalog) (Andover: Addison Gallery of American Art, 2011).

David Anfam, *Abstract Expressionism* (London: Thames & Hudson, 1990).

Leonhard Emmerling, *Jackson Pollock 1912–1956* (Cologne: Taschen, 2003).

Harry F. Gaugh, *De Kooning* (New York: Abbeville, 1982).

Barbara Hess, *Willem de Kooning 1904–1997: Content as a Glimpse* (Cologne: Taschen, 2004).

Thomas B. Hess, *Willem de Kooning* (exhibition catalog) (New York: Museum of Modern Art, 1968).

Nancy Jachec, *Jackson Pollock: Works, Writings, and Interviews* (Barcelona: Ediciones Polígrafa, 2011).

Norman L. Kleeblatt, editor, *Action/Abstraction: Pollock, de Kooning and American Art, 1940–1976* (exhibition catalog, New York: Jewish Museum, 2008).

Ruth Kligman, *Love Affair: A Memoir of Jackson Pollock* (New York: Cooper Square Press, 1999).

Francis V. O'Connor, *Jackson Pollock* (exhibition catalog) (New York: Museum of Modern Art, 1967).

Frank O'Hara, *Art Chronicles 1954–1966* (New York: Venture, 1975).

Jed Perl, *New Art City* (New York: Alfred A. Knopf, 2005).

Jed Perl, editor, *Art in America 1945–1970: Writings from the Age of Abstract Expressionism, Pop Art, and Minimalism* (New York: Library of America, 2014).

Sylvia Winter Pollock and Francesca Pollock, *American Letters 1927–1947: Jackson Pollock and Family* (Cambridge, UK: Polity Press, 2011).

Jeffrey Potter, *To a Violent Grave: An Oral Biography of Jackson Pollock* (Wainscott, NY: Pushcart Press, 1987).

Harold Rosenberg, *The Anxious Object: Art Today and Its Audience* (New York: Horizon Press, 1964).

Deborah Solomon, *Jackson Pollock: A Biography* (New York: Cooper Square Press, 2001).

Ann Temkin, *Abstract Expressionism at the Museum of Modern Art: Selections from the Collection* (exhibition catalog) (New York: Museum of Modern Art, 2010).

Evelyn Toynton, *Jackson Pollock* (New Haven, CT: Yale University Press, 2012).

ARTICLES AND WEBSITES

"Jackson Pollock: Chronology," Museum of Modern Art, New York, www.moma.org/interactives/exhibitions/1998/pollock/website100/chronology.

Peter Schjeldahl, "Shifting Picture," *New Yorker*, September 26, 2011.

GENERAL

Rona Goffen, *Renaissance Rivals: Michelangelo, Leonardo, Raphael, and Titian* (New Haven, CT: Yale University Press, 2005).

Frederick Ilchman, *Titian, Tintoretto, Veronese: Rivals in Renaissance Venice* (Boston: Museum of Fine Arts, 2009).

Gershom Scholem, *Walter Benjamin: The Story of a Friendship* (New York: New York Review of Books, 2003).

INDEX

Page numbers of illustrations appear in italics.